D1163678

The Visual Novel

The Visual Novel

Emile Zola and the Art of His Times

William J. Berg

The Pennsylvania State University Press
University Park, Pennsylvania

Library of Congress Cataloging-in-Publication Data

Berg, William J.
 The visual novel : Emile Zola and the art of his times / William
J. Berg.

 p. cm.
 Includes bibliographical references and index.
 ISBN 0-271-00826-1
 1. Zola, Emile, 1840–1902—Technique. 2. Zola, Emile, 1840–1902
—Knowledge—Art. 3. Art and literature—France—History—19th
century. 4. Visual perception in literature. 5. Description
(Rhetoric) I. Title.
PQ2543.B47 1992
843'.8—dc20 91–26749
 CIP

It is the policy of The Pennsylvania State University Press to use
acid-free paper for the first printing of all clothbound books.
Publications on uncoated stock satisfy the minimum requirements of
American National Standard for Information Sciences—Permanence of
Paper for Printed Library Materials, ANSI Z39.48–1984.

Contents

Preface and Acknowledgments

The nineteenth-century novel is, in many respects, a visual art form. Novelists have repeatedly stressed the visual nature of their craft. To Emile Zola's claims that creativity is an "optical phenomenon," genius a "personal way of seeing," one can add, among a multitude of others, the judgments of Henry James ("the province of art is all life, all feeling, all observation, all vision"), Guy de Maupassant ("it is a personal vision of the world that [the novelist] seeks to communicate to us"), Gustave Flaubert ("style being in and of itself an absolute manner of seeing things"), and Marcel Proust, through the narrator of *A la recherche du temps perdu* ("style for the writer, just like color for the painter, is a matter not of technique but of vision," and "the writer's work is simply a type of optical instrument").[1]

1. James, *The Future of the Novel*, ed. Leon Edel (New York: Random House, Vintage Books, 1956), 20; Maupassant ("C'est une vision personnelle du monde qu'il [le romancier]

Critics have explored several key areas in which vision exerts an impact on the novel, particularly viewpoint (though not, perhaps, with the degree of precision that a systematic comparison with the visual arts, defining notions like angle, scope, elevation, and mobility, would produce). Looking (*le regard*) is also recognized as a major mode of interaction among fictional characters; like verbal language, looking constitutes a system of exchange, governed by codes, which deserves to be described with greater semiotic accuracy. As Roland Barthes has stated (though in passing) in *S/Z,* "every literary description is a *view*" (his emphasis);[2] he goes on to suggest that such texts might be approached by using "painting as a model," a suggestion to which I might add another model, the experimental sciences, for which perception was the primary area of investigation in the late nineteenth century.

Approaching the visual novel through the domains of painting and experimental psychology leads us inevitably to Emile Zola. A boyhood friend of Cézanne and among the first art critics to defend Manet and later the impressionists,[3] Zola also incorporated the principles of physiologists like Hippolyte Taine, Théodule Ribot, and Claude Bernard into his texts, and was himself examined by a medical team interested in investigating his perceptual faculties. Above all, the Rougon-Macquart series is undoubtedly the largest and richest testing ground of its times for studying the verbal representation of visual phenomena.

Zola's twenty-novel cycle looms over the literary landscape; like its contemporary, the Eiffel Tower, it is remarkable and compelling, yet somewhat obtrusive and unwieldy. Indeed, some might see Zola's work structured in steel, reflecting its times like the monuments and machines celebrated in the novels: the market-place pavilions in *Le Ventre de Paris,* the sleek locomotive in *La Bête humaine,* the revamped department store

cherche à nous communiquer"), Preface to *Pierre et Jean* (Paris: Garnier Frères, 1959), 9; Flaubert ("le style étant à lui tout seul une manière absolue de voir les choses"), *Correspondance,* nouvelle édition augmentée (Paris: Conard, 1926–33), II, 70; Proust ("le style pour l'écrivain, aussi bien que la couleur pour le peintre, est une question non de technique mais de vision"; "l'ouvrage de l'écrivain n'est qu'une espèce d'instrument optique"), *A la recherche du temps perdu* (Paris: Gallimard, Bibliothèque de la Pléiade, 1963), III, 895 and 911. I shall return to all of these novelists in the Conclusion. Unless otherwise indicated, all translations throughout this book are my own.

2. *S/Z,* trans. Richard Miller (New York: Hill and Wang, 1974), 54. Originally published as *S/Z* (Paris: Editions du Seuil, 1970).

3. Despite its familiarity, the term "impressionist" remains problematic. The painters to whom it refers in this study are listed in Chapter 1, note 5; the characteristics it denotes are discussed in Chapter 4, especially in the section "Impressionism: 'Light Motifs' in Monet's *Impression: Sunrise.*"

in *Au Bonheur des Dames,* the winding-house in *Germinal.* Others, struck by the tangle of interwoven threads formed by family ties, financial dealings, and political maneuvering, might liken Zola's work to a labyrinth, citing the complex corridors of apartment buildings in *L'Assommoir* and *Pot Bouille,* the winding streets of L'Ile Saint-Louis in *L'Oeuvre,* or the darkened theater wings in *Nana.* Those, like myself, undaunted by fears of anachronism, might compare the series to the Paris Metro, a structure combining the modernity of the machine and the complexity of the labyrinth with Zola's fascination for systems (such as the railways in *La Bête humaine*), movement (like that of the armies in *La Débâcle*), underground passages (like the mineshafts of *Germinal* or the cellars of *Le Ventre de Paris*), and, of course, the sweaty rush-hour crowds that populate most of Zola's novels. One might even claim that reading *Les Rougon-Macquart* is not unlike riding the metro. The reader moves through a maze of passages, seeking connections among lines, guided by a series of signs and signals. One hopes to arrive at a chosen destination by the least circuitous route, a task that can be accomplished only by grasping the structure of the entire system. Few would question the need for an overall plan, one that would provide directions, suggest connections, and propose alternate routes for making one's way through *Les Rougon-Macquart.* Fewer still would accuse Zola of neglecting to furnish information for such a task, in the form of genealogical trees, preliminary notes, volumes of critical pronouncements, and numerous self-applied labels, such as "naturalist," "determinist," and "experimental."

However, one essential clue to a global mapping of *Les Rougon-Macquart* deserves further attention. In a letter written in 1885, during the composition of *L'Oeuvre,* Zola exhorts his disciple, Henry Céard, to dissect the mechanism of his eye in order to understand the creative process:

> Vous n'êtes pas stupéfait, comme les autres, de trouver en moi un poète. J'aurais aimé seulement vous voir démonter le mécanisme de mon oeil. J'agrandis, cela est certain; mais je n'agrandis pas comme Balzac, pas plus que Balzac n'agrandit comme Hugo. Tout est là, l'oeuvre est dans les conditions de l'opération. Nous mentons tous plus ou moins, mais quelle est la mécanique et la mentalité de notre Mensonge? Or—c'est ici que je m'abuse peut-être—je crois encore que je mens pour mon compte dans le sens de la vérité. J'ai l'hypertrophie du détail vrai, le saut dans les étoiles sur le tremplin de l'observation exacte. La vérité monte d'un coup d'aile jusqu'au symbole. Il y aurait là beaucoup à dire, et je voudrais un jour vous voir étudier le cas.

(You are not stupefied, like the others, to discover the poet in me. I would only have liked to see you take apart the mechanism of my eye. I enlarge, to be sure; but I don't enlarge like Balzac, any more than Balzac enlarges like Hugo. Everything depends on that, one's work depends on the modes of operation. We all lie, more or less, but what are the mechanics and mentality behind our Lie? Well—I may be deluding myself here—I still believe that for my part I lie on the side of truth. I have a case of hypertrophy for real details, of leaping toward the stars on the springboard of precise observation. Truth takes wing toward the symbol. There would be a lot to say about this, and I'd like to see you study the problem one day.)[4]

Of course, the novelist's confessions of being a "poet," of exaggerating, lying, going beyond truth "toward the symbol," have become commonplaces of Zola criticism.[5] However, the crucial link between creation and vision—"the mechanism of my eye," "hypertrophy for real details," "precise observation"—has gone relatively unnoticed. It is my contention that vision, in its most concrete, physiological sense, that is to say, visual perception, is among the most important keys to Zola's literary creation, in its broadest sense. Alongside naturalism and determinism, mythology and ideology, along with all of the other myriad categorizations of Emile Zola's art, it is the particular and often peculiar characteristics of his visual processes that characterize his style, inform the thematic content of his novels, and lend coherence to his work. This book utilizes a visual approach to explore the key role of vision in the major areas of Zola's art and, by extension, that of his contemporaries.

The Introduction describes Zola's visual faculties, based on the 1896 report of a medical team headed by Dr. Edouard Toulouse, the evidence of Zola's nonfictional writings, and his contact with the major painters of his times, for whom visual innovation was paramount. Zola's dissection of the visual act into three stages, paralleled by the findings of his contem-

4. *Correspondance,* 635–36. All references to Zola's nonfictional writings, unless otherwise indicated, are from the *Oeuvres complètes,* ed. Maurice Le Blond, 50 vols. (Paris: Typographie François Bernouard, 1927–29). Subsequent references will be included in the text, with volume title and page number, as here. In general, for quotes from Zola's work, both the original French and my own translation will be given in the body of the chapter, not in the notes, where the French version of other authors' quotes will be placed. However, in some cases, when the Zola quotes are short and of anecdotal rather than thematic or stylistic interest, only the English version is given, in order to contribute to the flow of the argument and conserve space (not to mention the reader's patience!).

5. See, for example, Chapter 5, notes 2–8.

poraries Taine and Ribot, and verified by those of modern physiologists and art critics, underpins the rather simple terminology for visual perception as well as the overall schema used in this book.

Chapter 1 details the predominant role of vision in Zola's theories and criticism of art, both visual and verbal. Identifying his program for a direct and immediate, yet analytic and imaginative, visual process enables us to reevaluate the much-maligned theories of *Le Roman expérimental,* while situating them more clearly in relation to the thought of Zola's contemporaries, especially in the domains of experimental psychology (Bernard, Taine, Ribot) and art criticism (Jules Laforgue, John Ruskin, Conrad Fiedler).

Chapter 2 documents the overwhelming impact of vision on thematics, especially involving the interaction among characters. Optical devices, like binoculars and mirrors, along with visual effects, like shadows and viewing (*le regard*), occupy a prominent place in Zola's novels, as they do in impressionist paintings, such as Mary Cassatt's *Woman with a Pearl Necklace in a Loge,* analyzed here in some detail. Moreover, visual perception informs and even dominates the content of several novels, where it complements themes as varied as voyeurism and narcissism (*Nana*), self-discovery (*La Curée, L'Assommoir*), communication (through a visual language replete with its own sign system [*La Fortune des Rougon, Une Page d'amour*]), and suicide (*L'Oeuvre*).

Chapter 3 charts the close relationship between "viewing" and "viewpoint," again drawing from impressionist painting. An analysis of Berthe Morisot's *On the Balcony, Meudon* facilitates the definition of the main components of viewpoint (distance, level, angle, scope, mobility). The chapter then traces Zola's use of dramatized viewers, mobile viewing (scanning and tracking), and multiple vantage points to carry out his program of objective narration and to shape thematic and ideological content; for example, viewpoint functions to underscore alienation in *Une Page d'amour,* class consciousness in *Germinal,* and the conflict between past and present, art and reality, in *L'Oeuvre.*

Chapter 4 demonstrates the role of Zola's visual faculties, characteristics, and preferences in his descriptive passages. The interplay of color and light with composition and line points to a dynamic conception of vision, which fosters a reexamination of the relationship between impressionism and naturalism in Zola's works. The dissection of the visual process into stages reveals a progressive focusing from the soft, hazy impression to the solid, linear identification of complete objects. This process constitutes a main ordering principle of Zola's descriptive units, from the sentence to the paragraph to the chapter. The analysis of the visual act enables one to probe the concept of causality and describe the

many modes of interaction—ranging from determinism to projection—between object and observer, décor and character, *paysage* and *personnage*.

Chapter 5 describes Zola's preferred forms of figuration (metaphor, metonymy, and synecdoche) in order to explore the role of vision in imagination and literary creation. Between the hazy "impression" and the solid "identification" lies the space of "imagination," stimulated by light and color but shaped by fear and desire. The frequency of hallucination in Zola's novels and its link to creativity find parallels in the practice of certain late nineteenth-century painters and the thought of experimental scientists like Taine and Ribot, while pointing to a merging of observer and object, an "integral phenomenism," typical of the times.

Vision clearly constitutes a prime characteristic of Zola's creative process, a central principle lending coherence to his art and thought. By "taking apart the mechanism" of Zola's eye, by taking an alternate route through the network of his novels, the goal here is to achieve a new overall mapping of the Rougon-Macquart series.

Moreover, this new route is not a back road leading to remote areas, far removed from the main critical issues concerning art and culture. During the course of this study I systematically explore many of the major aspects of novelistic activity, from viewpoint and style to imagery and ideology, and I repeatedly assess the importance of vision in artistic creation, stressing its role in the art and thought of Zola's times as well as in the study of the novel as genre.

Vision, along with the representation of light and movement, is a main area of innovation in the plastic arts of the late nineteenth century. According to Zola, impressionism was, above all else, "a new way of seeing," or, in the words of his contemporary, the young poet Jules Laforgue: "The Impressionist is a modernist painter who, endowed with uncommon ocular sensitivity . . . has managed to rediscover the natural eye, to see naturally and paint naively, just as he sees."[6]

Vision also occupied a key role in experimental psychology in late nineteenth-century France: as two present-day psychologists note, "less than a hundred years ago sensation and perception *were* experimental psychology" (their emphasis).[7] The present study, based on visual percep-

6. "L'impressionniste est un peintre moderniste qui, doué d'une sensibilité d'oeil hors du commun . . . est parvenu à se refaire un oeil naturel, à voir naturellement et à peindre naïvement comme il voit." "Critique d'art—L'Impressionnisme," in *Mélanges posthumes,* vol. 3 of *Oeuvres complètes,* 4th ed. (Paris: Mercure de France, 1903), 133–34.

7. David Beardslee and Michael Wertheimer, eds. *Readings in Perception* (Princeton: D. Van Nostrand, 1958), v.

tion, leads to a reevaluation of Claude Bernard and a resurrection of Hippolyte Taine and Théodule Ribot, by relating their work to the writing and painting of their times.

The evolution and theory of the novel is also inseparable from the study of visual perception, as evidenced by the pervasiveness of the term "viewpoint" and by the pronouncements of novelists such as those already cited. In the Conclusion the visual approach evolved in the book is used to identify stylistic traits common to Zola, Flaubert, Maupassant, Proust, and Mark Twain, then to distinguish among them. This approach proves to be a powerful methodological tool, capable not only of defining the style of an era, but also of distinguishing the areas of individuality occupied by particular authors operating within a general mode.

After his statement in *S/Z* that "every literary description is a *view*," Barthes goes on to ask "where and when did this pre-eminence of the pictorial code in literary mimesis begin?"[8] The present study attempts to provide some leads and, most of all, to develop a methodology, for tackling such a fascinating question.

Emile Zola provides a test case, an ideal one, supporting a critical approach based on vision, which adds to an understanding of the cultural history of late nineteenth-century France and to an appreciation of that visual genre—the novel.

Thanks go first and foremost to my colleague, best friend, and wife, Laurey Martin, for her numerous readings, perceptive comments, and constant support. I would also like to express my gratitude to Professors Patrick Brady, Alfred Glauser, George Mauner, and Philip Walker for reading the manuscript and making many constructive suggestions. I am especially grateful to Philip Winsor, Senior Editor at Penn State Press, for his advice and encouragement throughout the project. I also appreciate Keith Monley's careful copyediting of the manuscript and Cherene Holland's efficiency in seeing it through production.

8. *S/Z*, trans. Richard Miller, 55.

Introduction:
The Visual Process

Je n'ai pas seulement soutenu les Impressionnistes, je les ai traduits en littérature. (I not only supported the Impressionists, I translated them into literature.)

—Emile Zola[1]

If Emile Zola provides an ideal test case for the study of vision, as contended in the Preface, the direct evidence provided by a team of medical examiners during his lifetime is essential for substantiating such claims and exploring their consequences. Of equal relevance to the present study is Zola's contact with the painters of his times, for many of whom visual experimentation was a major concern. I shall examine here the contents of the medical reports and the extent of the novelist's contacts with various painters before describing the dynamic sense of visual process that emerges from Zola's nonfictional writings. In effect, Zola's verbal representation of the visual act involves three distinct stages,

1. Interview quoted in Henri Hertz, "Emile Zola, témoin de la vérité," *Europe* 30, nos. 83–84 (November–December 1952): 32–33.

which define our terminology and determine, to some degree, the organization of our study and the premises underlying our approach.

Zola's Visual Faculties

In 1896, a team of psychologists led by Dr. Edouard Toulouse examined Zola, then fifty-six years old, concentrating heavily on his visual faculties; their findings were later published as *Enquête médico-psychologique sur la supériorité intellectuelle: Emile Zola.* The very link between visual capacity and "intellectual superiority," suggested by the report's title, is itself typical of the climate of the times and serves to further justify a study of vision such as mine.

Toulouse states that "the faculty of observation is highly developed and, incidentally, frequently used by M. Zola."[2] He adds that "memory of objects is a synthesizing faculty involving shape, color, and sometimes even movement. It is highly developed for M. Zola. The least important objects—if they interest him—leave visual memories; this is true for inanimate objects as well as for physionomies and landscapes."[3] Zola's own statements confirm Toulouse's findings: "Mes souvenirs visuels ont une puissance, un relief extraordinaire. . . . Quand j'évoque les objets que j'ai vus, je les revois tels qu'ils sont réellement avec leurs lignes, leurs formes, leurs couleurs, leurs sons. C'est une matérialisation à outrance; le soleil qui les éclairait m'éblouit presque; l'odeur me suffoque." ("My visual memories have extraordinary power and contour. . . . When I evoke objects I have seen, I see them again just as they really are, with their lines, their shapes, their colors, their sounds. It's materialization to excess; the sun that illuminated them almost dazzles me; their odor suffocates me.")[4]

If Zola's overall powers of observation and his memory of visual phenomena demonstrate exceptional development, Toulouse points out that this is particularly true of the novelist's sensitivity to the retention of color: "It would thus seem that the sensation of color was more intense

2. "la faculté d'observation est très développée et d'ailleurs très exercée chez M. Zola." *Enquête* (Paris: Société d'Editions scientifiques, 1896), 227. Further references to this work will be listed parenthetically in the notes as *Enquête,* followed by the page reference.

3. "la mémoire des objets est une mémoire synthétique de la forme et de la couleur et parfois même du mouvement. Elle est très développée chez M. Zola. Les objets les moins importants—s'ils l'intéressent—laissent des souvenirs visuels; cela est vrai pour les objets inanimés comme pour les physionomies et les paysages" (*Enquête,* 195).

4. Quoted in Armand Lanoux, *Bonjour Monsieur Zola* (Paris: Hachette, 1954), 228.

and consequently produced the illusion of a longer duration than the others. Remember that M. Zola is very struck by the color of things, as he shows in his descriptions."[5] Dr. Sauvineau, another member of the examining team, notes that "color vision is very good; the finest nuances of violet are caught very well."[6] According to the report, Zola's color preferences, expressed in painterly terms, are for "the red, yellow, and green palette of Delacroix, faded nuances, and, for complementary colors, yellow combined with blue."[7] When filling out a newspaper questionnaire several years earlier, Zola chose red as his favorite color.[8]

However, according to the Toulouse report, if Zola's color sensitivity is exceptionally strong, his perception of line is far from sharp: "Visual acuity is weak for M. Zola, who is nearsighted and astigmatic."[9]

In formulating a general assessment of Zola, Toulouse concludes that, as a "great visualizer, he must have easily rendered the exterior world, through which we represent life,"[10] a remark that illustrates the extent to which, at that time, vision was construed as defining the individual, dominating his relationship to reality, and determining his capacity to portray human experience. The doctor adds a detail that is useful to this study, since I will make some reference in later chapters to the terminology of Théodule Ribot: "One can state that M. Zola fits the concrete type, as described by M. Ribot."[11]

Although no systematic and consequential study of the novelist's visual perception has as yet been attempted, several critics have proposed interesting perspectives on the topic. The art historians Hélène and Jean Adhémar point out that Zola's visual faculties have drawn considerable commentary from literary historians, who often invoke his visual imagination and memory in explaining his preference for descriptive novels

5. "Il semble donc que la sensation de couleur ait été plus intense et par conséquent ait donné l'illusion d'une plus longue durée que les autres. Il est à rappeler que M. Zola est très frappé par la couleur des choses, ainsi qu'il le montre dans ses descriptions" (*Enquête*, 177).

6. "la vision des couleurs est très bonne, les nuances les plus faibles du violet sont très bien saisies" (*Enquête*, 159).

7. "la palette rouge, jaune et vert de Delacroix, les nuances fanées, et, dans les tons complémentaires, le jaune uni au bleu" (*Enquête*, 259). Note that most color theory, even in Zola's time, considers yellow to be the complement of violet, and orange to be that of blue (see, for example, *L'Oeuvre*, R-M, IV, 248 and Mitterand's note, 1463).

8. *Enquête*, 228.

9. "L'acuité visuelle est faible chez M. Zola qui est myope et astigmate" (*Enquête*, 170).

10. "grand visuel, il devait rendre facilement l'extérieur des choses, par lequel nous nous représentons la vie" (*Enquête*, 267).

11. "On peut dire que M. Zola appartient au type concret décrit par M. Ribot" (*Enquête*, 244).

over psychological studies.[12] Marc Bernard wonders to what degree
Zola's visual capacities lend his novels their cinematographic quality.[13]
Jean Adhémar sees in Zola's nearsightedness the explanation of the novel-
ist's penchant for hazy landscapes and links this visual peculiarity to
Zola's tastes in modern painting.[14]

Whether Zola was directly influenced by the painters of his era or
whether, as Adhémar suggests, he was simply predisposed to appreciate
them, it should be pointed out that the painters commonly referred to as
the "impressionists" were particularly concerned with vision, visual ef-
fects, and optical devices—and as a result a study of their work, along
with Zola's attitude toward it, sheds considerable light on the role of
visual perception in Zola's own theories and practices.

Zola and the Visual Arts

Zola's personal contact with the painters of his time was as intensive as it
was extensive and has been amply documented by art historians as well as
literary critics.[15] Zola indicates the extent of his involvement with these
artists when he says, in the *Figaro* of 2 May 1896:

12. "Emile Zola avait une imagination et une mémoire visuelle extrêmement dé-
veloppées. Les médecins qui l'avaient examiné en avaient été frappés et depuis 70 ans, tous
les historiens de la littérature insistent sur ce point, disant d'ailleurs que ces qualités excep-
tionnelles ont engagé Zola à écrire des romans où la description avait plus de place que
l'étude psychologique." ("Zola et la peinture," *Arts,* no. 389 [12–18 December 1952]: no
page numbers.)

13. "à quel point les moyens de Zola, sa perception visuelle, sa façon de penser par
images le rapprochent d'un metteur en scène et donnent à la plupart de ses romans l'allure de
films" (*Zola par lui-même* [Paris: Seuil, 1952], 100).

14. "En tout cas, myope se privant par coquetterie de ses lunettes, Zola ne voyait
forcément l'univers qu'à travers une sorte de brouillard. Cette impression de brume,
d'atmosphère fumeuse, se retrouve très souvent lorsqu'il décrit un paysage. . . . La myopie
de Zola a eu, aussi, une influence considérable sur ses goûts artistiques. Le docteur Toulouse
a été frappé par sa curieuse perception des couleurs, par sa sensibilité particulière aux mots
de couleurs. Et on s'aperçoit que cette infirmation a déterminé le genre de ses collections"
("La Myopie de Zola," *Aesculape* 33 [November 1952]: 195 and 197). Henri Mitterand adds
that "oui, ce myope savait voir, et si sa myopie . . . explique tout au plus certains caractères
de sa vision, elle n'a en rien empêché son regard d'être singulièrement efficace" ("Le Regard
d'Emile Zola," *Europe* 46, nos. 468–69 [April–May 1968]: 184).

15. See especially John Rewald's *The History of Impressionism* (New York: The Museum
of Modern Art, 1946) and his *Cézanne, sa vie, son oeuvre, son amitié pour Zola* (Paris: Albin
Michel, 1939).

J'avais grandi presque dans le même berceau, avec mon ami, mon frère, Paul Cézanne, dont on s'avise seulement aujourd'hui de découvrir les parties géniales de ce grand peintre avorté. J'étais mêlé à tout un groupe d'artistes jeunes, Fantin, Degas, Renoir, Guillemet, d'autres encore, que la vie a dispersés, a semés aux étapes diverses du succès. . . . Hier, j'étais allé à ce Salon de 1866, avec Manet, avec Monet et avec Pissarro, dont on avait rudement refusé les tableaux.

(I had practically grown up in the same cradle with my friend, my brother, Paul Cézanne, the great abortive painter whose brilliant aspects are being discovered only today. I mingled with a whole group of young artists—Fantin, Degas, Renoir, Guillemet, and others—whom life dispersed, sowing them at varying stages of success. . . . [It seems like] yesterday [that] I had gone to the Salon of 1866, with Manet, with Monet, and with Pissarro, whose paintings had been harshly refused.)[16]

Most of these friendships, not counting that of Cézanne, with whom Zola grew up in Aix-en-Provence in the 1850s, began in 1863, when he first frequented the studios of the artists who then formed the "Batignolles" group, later to be known as the impressionists. Zola was also a regular visitor to the group's frequent rendezvous at the Café Guerbois in 1866, the same year he established himself as a perceptive, influential, and controversial art critic. He is the subject of the famous portrait by Manet, in which the novelist's pamphlet defending the painter is included, and figures in the well-known group portraits by Bazille, *Atelier de l'artiste, rue de la Condamine* (1870) and Fantin-Latour, *Atelier aux Batignolles* (1870). His career as an art critic and his contact with various painters lasted until 1880 or 1881, when he drastically reduced his contributions to journalism and when his enthusiasm for the directions of modern painting began to wane. With the publication of *L'Oeuvre* in 1886, his discouragement with many of his earlier painter friends and their break with him was nearly complete, as the above allusion to Cézanne as a "great abortive painter" suggests.

The vast majority of critics who have studied this contact conclude that Zola's novels owe a great deal to the visual arts. F. W. J. Hemmings, the dean of British Zola critics, proclaims in his preface to Zola's *Salons* that "no important nineteenth-century writer had closer or more constant personal relationships with the great painters of his time. *A priori,* such evi-

16. Quoted in *Salons,* ed. F. W.J. Hemmings and R. J. Niess (Geneva: Droz, 1959), 266.

dence must not be ignored."[17] Henri Mitterand, the premier French Zola scholar, states unequivocally that "Taine taught Zola a system of thought. But it is his friends Chaillan, Cézanne, Bazille, Manet, Pissarro, Renoir, Fantin-Latour, who taught him to look with a painter's eye, adept at capturing the interplay of shapes, colors, movement, and lighting."[18]

In acknowledging and assessing the impact of Zola's relationship with the visual arts, critics have explored its consequences in a variety of ways, which I will lay out briefly here in order to illustrate a spectrum of approaches and to set apart my own premises and directions:

1. Thanks mainly to Zola's penchant for self-documentation, *biographical* relationships have been firmly established. Emblematic of this type of approach is John Rewald's *Cézanne, sa vie, son oeuvre, son amitié pour Zola*.

2. *Theoretical* approaches, though scarce, have sought a common scientific or philosophical bond between Zola and the painters of his times, as have Marianne Marcussen and Hilde Olrik,[19] who identify Taine as the common source of color and image theory, and Philippe Bonnefis,[20] who sees the concept of the image as basic to "naturalism" in painting and literature.

3. The presence of the painter Claude Lantier as the central character in *Le Ventre de Paris* (1873) and *L'Oeuvre* (1886) has spawned several studies concerning the fictional painter's relationship to specific artists of Zola's time. Typical of this *character* approach is Robert Niess's *Zola, Cézanne, and Manet*. Niess finds Lantier to be a composite of all three, while embodying traits of Monet and the caricaturist André Gill, among others.

4. Another tactic, which we might term *iconographical,* seeks to link Lantier's fictional paintings to real works, both in terms of subject and style. This approach, with varying ends, has characterized part of the work of Patrick Brady, from his early articles, through the important

17. "aucun écrivain important du XIXe siècle n'a eu des rapports personnels plus proches et plus suivis avec les grands peintres de son temps. A priori, un tel témoignage ne saurait être négligé." *Salons,* 10.

18. "Taine a enseigné à Zola un système de pensée. Mais ce sont ses amis Chaillan, Cézanne, Bazille, Manet, Pissarro, Renoir, Fantin-Latour, qui lui ont appris à regarder la vie moderne et à la regarder avec l'oeil du peintre, habile à capter le jeu des formes, des couleurs, des mouvements et des éclairages." "Le Regard," 187.

19. Marianne Marcussen and Hilde Olrik, "Le Réel chez Zola et les peintres impressionnistes: Perception et représentation," *Revue d'histoire littéraire de la France* 80, no. 6 (November–December 1980): 965–77.

20. Philippe Bonnefis, "Fluctuations de l'image, en régime naturaliste," *Revue des sciences humaines* 39, no. 154 (April–June 1974): 283–300.

"*L'Oeuvre*" *de Emile Zola: Roman sur les arts, manifeste, autobiographie, roman à clef,* to the provocative *Le Bouc émissaire chez Emile Zola.* The relationship of Lantier's *Plein Air* to Manet's *Déjeuner sur l'herbe* serves as a constant point of interest, anchoring the evolution of Brady's approaches.

5. Studies of *motifs* abound. Among the most striking examples of "transposition" (discussed by Joy Newton, based on leads suggested by Henri Mitterand)[21] is Manet's *Nana* (1877). Inspired by the appearance of Zola's character toward the end of *L'Assommoir* (published in installments from April 1876 to January 1877), the painting in turn inspires a scene in Zola's novel *Nana* (1880). Common subjects range from laundresses, to race scenes, to Paris itself.[22]

6. *Thematic* investigations have focused on the role of looking (*le regard*) in Zola's novels. In addition to the pioneering studies of John Lapp, Roger Ripoll, Philip Walker, David Baguley, and Brady,[23] Philippe Hamon's excellent book, *Le Personnel du roman: Le Système des personnages dans les "Rougon-Macquart" d'Emile Zola,* details the use of the characters' viewpoint to implement the principles of naturalism.

7. In addition to the seminal (and sometimes semiotic) studies of color symbolism by Walker, Marcel Girard, Baguley, and Josette Féral,[24] Joy Newton was among the first to concentrate on the *visual* characteristics manifested in Zola's descriptive passages and their relationship to

21. Newton has published several interesting studies, including "Emile Zola and the French Impressionist Novel," *L'Esprit créateur* 13 (1973): 320–28, and "Emile Zola impressionniste," *Cahiers naturalistes* 33 (1967): 39–52, 34 (1967): 124–138. For a recent study of the case of *Nana*, see Adeline Tintner, "What Zola's *Nana* owes to Manet's *Nana*," *Iris: Notes in the History of Art* 8 (December 1983): 15–16. Mitterand also lists similarities of motifs throughout his notes for *Les Rougon-Macquart*, 5 vols. (Paris: Gallimard, Bibliothèque de la Pléiade, 1960–67) and in his provocative article "Le Regard d'Emile Zola" cited in note 14, this chapter.

22. See especially Mitterand, "Le Regard."

23. Lapp, "The Watcher Betrayed and the Fatal Woman: Some Recurring Patterns in Zola," *PMLA* 74, no. 3 (June 1959), 276–84; Ripoll, "Fascination et fatalité: Le Regard dans l'oeuvre de Zola," *Cahiers naturalistes* 32 (1966), 104–16; Walker, "The Mirror, the Window, and the Eye in Zola's Fiction," *Yale French Studies* 42 (June 1969): 52–67; Brady, "Pour une nouvelle orientation en sémiotique: A propos de *L'Oeuvre* d'Emile Zola," *Rice University Studies* 63, no. 1 (1977): 43–84 (also included in *Le Bouc*); Baguley, "Les Paradis perdus: Espace et regard dans *La Conquête de Plassans* de Zola," *Nineteenth-Century French Studies* 9, nos. 1–2 (Fall–Winter 1980–81): 80–92.

24. Walker, "Zola's Use of Color Imagery in *Germinal*," *PMLA* 77, no. 4, pt. 1 (September 1962): 442–49; Girard, "L'Univers de *Germinal*," *Revue des sciences humaines* 69 (January–March 1953): 59–76; Baguley, "Image et symbole: La Tache rouge dans l'oeuvre de Zola," *Cahiers naturalistes* 39 (1970): 36–46; Féral, "La Sémiotique des couleurs dans *Germinal*," *Cahiers naturalistes* 49 (1975), 136–48. See also Susan Van Deventer, "Color in Zola," *Papers in Romance* 5, no. 2 (Spring 1983): 65–83.

impressionist techniques, focusing especially on the use of light.[25] In two recent studies, Bettina Knapp and Philip Duncan describe the liberation of forms that accompanies Zola's adoption of painterly techniques involving light and color in his own "landscapes," particularly those in *L'Oeuvre*.[26] However, Zola's incorporation of other impressionist innovations has received little attention, except for several brief remarks on point of view by Newton,[27] a suggestive comment on composition by Hamon,[28] and a provocative recent article on the manipulation of form and space by Laurey K. Martin.[29]

8. A further approach, where literary analogues are sought for impressionist techniques in rendering effects of light, atmosphere, and form, can be termed *linguistic* or stylistic. Despite Zola's reputed (because reported) statement—"Je n'ai pas seulement soutenu les Impressionnistes, je les ai traduits en littérature par les touches, notes, colorations, par la palette de beaucoup de mes descriptions. Dans tous mes livres j'ai été en contact et échange avec les peintres." ("I not only supported the Impressionists, I translated them into literature by the strokes, notes, colors, and palette of many of my descriptions. In all of my books I have been in contact and exchange with these painters.")[30]—relatively little has been published concerning the linguistic techniques by which Zola carried out such a "translation." Many (even most) of the critics mentioned above utilize detailed stylis-

25. "Cette observation des changements que la lumière fait subir au même motif est l'apport le plus frappant que Zola ait fait à la transposition du style impressionniste dans le roman" ("Emile Zola impressionniste [II]," *Cahiers naturalistes* 34 [1967]: 134).

26. Knapp, "The Creative Impulse—to Paint 'Literarily': Emile Zola and *The Masterpiece*," *Research Studies* 42 (June 1980): 71–82; Duncan, "The 'Art' of Landscape in Zola's *L'Oeuvre*," *Symposium* 39, no. 3 (Fall 1985): 167–76.

27. "Emile Zola impressionniste (II)," 124–27. On Zola's handling of viewpoint (though not linked to impressionist innovations), see especially Newton and Basil Jackson, "Gervaise Macquart's Vision: A Closer Look at Zola's Use of 'Point of View' in *L'Assommoir*," *NCFS* 11, nos. 3–4 (Spring–Summer 1983): 313–20, and Baguley, "Le Récit de guerre: Narration et focalisation dans *La Débâcle*," *Littérature* 50 (May 1983): 77–90.

28. "Il faut prendre l'oeuvre d'un seul bloc; impressionniste dans le détail, Zola ne l'est pas dans l'ensemble. . . . Là est sa grande et fondamentale originalité, dans la réunion, en apparence contradictoire, de qualités de spontanéité et de composition. L'imagination de l'architecte qui combine prime toujours chez lui l'imagination du peintre qui décrit. Le motif n'est jamais là pour son côté simplement 'joli' ou descriptif, mais pour son côté architectural; l'unité jaillit de la variété par des structures, des contrastes, des répétitions." ("A propos de l'impressionnisme de Zola," *Cahiers naturalistes* 34 [1967]: 144.)

29. "L'Elaboration de l'espace fictif dans *L'Assommoir*," *Cahiers naturalistes* (forthcoming); several other recent studies, discussed in Chapter 4 (description), deal with Zola's handling of space, but few explore the role of painting.

30. In Henri Hertz, "Emile Zola, témoin de la vérité," 32–33.

tic analysis to sustain their arguments, and I have also attempted to approach the relationship between impressionism and naturalism in Zola's novels from a linguistic perspective in a recent article.[31] However, rarely does the linguistic approach constitute the prime component of methodology or the main thrust of the argument, and in no case does it produce a comprehensive study. This lack of attention is somewhat surprising, given the longstanding, lengthy, and systematic description of "literary impressionism," particularly in French criticism.[32]

The methodology used here, combining elements of the thematic, visual, and linguistic approaches mentioned above, is based on a systematic study of the impact of Zola's visual characteristics on his theories and practice in several main areas of novelistic creation: thematics, viewpoint, description, and figuration. Zola's relationship to the impressionists is of secondary importance and only interesting to us insofar as it elucidates his visual characteristics.

My goal is not to label Zola an impressionist, or even a naturalist, to squeeze him into or out of one or another category. Rather, the two artistic movements, seen in terms of their oppositions in each of the areas of creation, set the limits and define the gradients for a *scale* of possibilities along which Zola's art and thought can be located and evaluated. In nearly all cases, Zola fails to situate himself statically at one end or another, but moves dynamically from point to point through that same sense of *process* that typifies every aspect of his art, just as it characterizes his vision.

The Visual Process

Zola's writings reveal a visual characteristic not described by the Toulouse team, namely, the overwhelming sense of emergence, of dynamics,

31. "*L'Oeuvre:* Naturalism and Impressionism," *L'Esprit créateur* 25, no. 4 (Winter 1985): 42–50.

32. See especially the pioneering Ferdinand Brunetière, "L'Impressionnisme dans le roman," *Revue des deux mondes,* 15 November 1879: 446–59, repr. in *Le Roman naturaliste* (Paris: Calmann Lévy, 1892), 81–110; the influential Charles Bally, "Impressionnisme et grammaire," in *Mélanges Bernard Bouvier* (Geneva: Sonor, 1920), 261–79; the oft-cited Beverly Jean Gibbs, "Impressionism as a Literary Movement," *Modern Language Journal* 36, no. 4 (April 1952): 175–83; and the complete J. Theodore Johnson, Jr., "Literary Impressionism in France: A Survey of Criticism," *L'Esprit créateur* 13 (1973): 271–97.

of process, that characterizes the visual act. Rarely does an object, a color, or a value appear in isolation; it "emerges" through interaction with its surroundings and according to a discernible pattern. As J. H. Matthews has remarked, "Zola's eye notes a color bursting forth against a neutral background."[33] This type of definition by contrasting planes, where the visual phenomenon detaches itself from its setting, permeates Zola's non-fictional writings, which can serve as a prelude to the study of his novels.

In his *Salons,* Zola notes that Manet "groupe les figures devant lui, un peu au hasard, et . . . il n'a ensuite souci que de les fixer sur la toile telles qu'il les voit, avec les vives oppositions qu'elles font en se détachant les unes sur les autres" ("groups figures before him, somewhat by chance, and . . . is later concerned only with fixing them on the canvas just as he sees them, with the vivid contrasts they form in detaching themselves from one another," *Salons,* 92). The reflexive verb *se détacher* is again applied to Manet's art in the following example, clearly involving depth perception: "Ce qui me frappe avant tout dans ses tableaux, c'est l'observation constante et exacte de la loi des valeurs. Par exemple, des fruits sont posés sur une table et se détachent contre un fond gris" ("What strikes me above all in his paintings is the constant and precise observance of the law of values. For example, various fruits are set on a table and detach themselves from a gray background," *Salons,* 191; see also 90).

This type of visual definition by contrasting values of colors is not limited to analyses of Manet's painting, nor even to Zola's art criticism; it occurs frequently when he records his own perception of phenomena, as in the preliminary material for his novels. In the notes describing the Halles, to be incorporated in *Le Ventre de Paris,* for example, he describes "lueurs derrière les persiennes de fonte qui se détachent en lignes noires . . . en haut le ciel est clair, et les Halles se détachent en noir. . . . La foule dans le soleil. Des bottes émergent" ("a faint glow behind the iron blinds, which detach themselves in black lines . . . above, the sky is light, and the Halles detach themselves in black. . . . The crowd in sunlight. Bundles [of food] emerge").[34] All of these examples involve a perception in depth, where one value (usually dark) defines itself against a background (usually light). In the above cases the verbs *se détacher* and *émerger* convey the sense of process, which is augmented by the use of the present participle in the following examples from the notes for

33. "L'oeil de Zola note la couleur qui éclate sur un fond neutre." *Les Deux Zola: Science et personnalité dans l'expression* (Geneva: Droz, 1957), 66.

34. *Le Ventre de Paris,* no 10.338, fols. 166–78, Département des Manuscrits, Nouvelles Acquisitions Françaises, Bibliothèque Nationale. I would like to express my gratitude to the American Philosophical Society and to the University of Wisconsin graduate school for travel grants that enabled me to examine the preliminary dossiers for Zola's novels.

Germinal—"l'ingénieur m'apparaissait en silhouette noire, se détachant sur une lueur vague" ("the engineer appeared in black silhouette, standing out against a vague glow")—and for *Le Docteur Pascal*—"des bois de pins sombres, se détachant sur le ciel très bleu" ("forests of dark pine, detaching themselves from a deep blue sky"). Similarly, the notes for *L'Oeuvre* depict "le quai Voltaire, découpé en noir . . . des chaises se détachant . . . un tableau trouant le mur" ("the Quai Voltaire, outlined in black . . . chairs detaching themselves . . . a painting piercing the wall").[35] In the latter case, the painting might appear to recede into, even through the wall rather than thrust forward toward the viewer, but in all cases we witness a dynamic depiction of the visual act, where visual phenomena—an object, a color, a value—interact with their surroundings to achieve solidity and definition through a contrast involving depth perception.

To this spatial relationship, involving a contrast of planes in the third dimension, can be added what will stand out over the course of this study as the most salient feature of Zola's vision: the progressive emergence, definition, and identification of the visual phenomenon through the fourth dimension, time. This dynamic process will be shown to dominate Zola's theories, his nonfictional writings, and, especially, the passages of his novels, from the sentence to the paragraph and the chapter. This process should not be confused with mobile viewpoint (tracking) or with eye movement (scanning), treated in some detail in Chapter 3 (viewpoint); instead, it comprises the stages inherent in the very act of visual perception, the sequence of steps through which the stationary eye confronts, records, and grasps the visible world.

Zola believed, as did many of the painters he knew, that the sensation of light was the first step in the visual act. As he says of Manet, "le peintre a procédé comme la nature procède elle-même, par masses claires, par larges pans de lumière" ("the painter proceeded as nature itself proceeds, by bright masses, by broad sections of light," *Salons,* 97). However, for Zola this luminous stage was only a step in a temporal sequence that comprised the act of perceiving. He believed that the perception of line, form, and tactile, palpable matter (downplayed by many of the mainstream impressionists) was the next step in the visual act, the essential stage that lent solidity and strength to the perception and representation of reality. Zola perceived phenomena naturally according to this temporal sequence of visual events, and the structure of his documentary writing often reveals his effort to capture the chronological order of this sequence. In an example typical of his technique of analytic introspection,

35. *Les Rougon-Macquart,* III, 1837; V, 1630; IV, 1432, 1441, and 1475.

Zola dissects his own perception of a Manet painting: "L'oeil n'aperçoit d'abord que des teintes plaquées largement. Bientôt les objets se dessinent et se mettent à leur place; au bout de quelques secondes, l'ensemble apparaît, vigoureux et solide" ("At first the eye perceives only shades of color laid on broadly. Soon objects take form and assume their place; after several seconds, the whole [scene] appears, vigorous and solid," *Salons*, 91). Zola's eye rarely entertains a total, static perception of reality. He goes beyond what one might term the "impression" of broad shades, until he is able to distinguish specific objects and finally assign solidity and defintion to the entire scene. Temporal adverbs delineate systematically the steps by which his eye is able to stabilize the chaos and solidify the haziness of the initial, luminous impression.

This depiction of the visual process, broken down into its basic components, is by no means reserved for Zola's appreciation of specific paintings; it is present throughout the documents detailing his visual contacts with reality. He says of the rooms occupied by the official Salon of 1868:

> Les salles s'étendent grises, monotones, plaquées de taches aigres et criardes, pareilles aux bouquets de fleurs imprimés sur les fonds neutres des papiers peints. Une lumière crue tombe, jetant des reflets blanchâtres dans les toiles luisantes, égratignant l'or des cadres, emplissant l'air d'une sorte de poussière diffuse. La première sensation est un aveuglement, un ahurissement qui vous plante sur les jambes, les bras ballants, le nez en l'air. On regarde avec une attention scrupuleuse le premier tableau venu, sans savoir seulement qu'on le regarde. A droite, à gauche, partent des pétards de couleur qui vous éborgnent. Peu à peu, on se remet, on reprend haleine. Alors on commence à reconnaître les vieilles connaissances.

> (The rooms stretch out, gray, monotonous, covered with shrill, garish patches, like floral bouquets printed on plain wallpaper. A raw light falls, casting whitish reflections onto the glowing canvases, scratching their golden frames, filling the air with a sort of diffuse dust. The first sensation is one of being blinded, a stupefaction that leaves your legs riveted, your arms dangling, your nose in the air. One looks at the first painting one falls upon with scrupulous attention, without even realizing that one is looking. On the right, on the left, fly firecrackers of color that poke your eyes out. Little by little, one recuperates, recovers one's breath. Then one begins to recognize old acquaintances. *Salons*, 119; see also 148–49)

Here the rooms appear as a vague patchwork, due less to the canvases than to the quality of the light and its luminous effects. As a result, Zola is besieged by a total, yet ill-defined, impression, conveyed by the nominalization of adjectives (*un aveuglement, un ahurissement*). But this impression is only the initial stage, the first sensation in a dynamic visual process; by training the eyes on certain objects, step by step, the eye is able to control the impression and convert it to solid form, until finally the act of recognition begins to take place.

This same process of impression, then identification, this same temporal sequence characterizing perception, is also evident in Zola's notes for his novels. In the preparatory dossier for *Le Ventre de Paris,* for example, he writes, "Enfin, quand le soleil est tout à fait levé, au fond coup de soleil; par l'ouverture des portes, tombe le soleil en poudre, en haut le ciel est clair, et les Halles se détachent en noir, avec leurs fines nervures de fonte." ("Finally, when the sun has completely risen, [there is] a sunburst in the background; through the doorways falls powdery sunlight, above, the sky is light, and the Halles detach themselves in black, with their thin ribs of iron.")[36] Although this sentence is situated within a larger passage describing the sun rising and contains within it an example (cited earlier) of spatial definition by contrasting planes of light and dark value, the clauses of the sentence also constitute a temporal sequence that parallels Zola's conception of the act of seeing. The eye is initially struck by the sun, then by effects of light, before the pavilions of the Halles begin to emerge and define themselves in linear detail and, finally, solid materiality.

In his documentary writings, then, Zola's style reveals a sequence that notes first the impression and then the more solid, well-focused perception, a sequence that conforms with scientific hypotheses in late nineteenth-century Europe concerning the nature of visual perception. For Zola and the experimental scientists of his time, visual sensation depends initially and essentially on the light waves that emanate from a luminous entity, such as the sun or a gas lamp, are reflected by physical objects, and provoke a physiological reaction in the energy receptors of the eye. It is only after the transmission of light waves and their decoding by the eye that the observer can begin to assign line, form, volume, position, and relationships to the objects that the waves have struck. These elements of a visual communication schema (sender, message, receiver) and its processes (transmission, decoding), as well as their application to Zola's novels, will be discussed in Chapters 2 (thematics) and 4 (description).

36. No. 10.338, fol. 176, N.A.F., B.N.

Paralleling Zola's conception of the visual process and typifying the scientific thought of the time, Hippolyte Taine notes, in the following example, the initial importance of color and light, while linking their exploration and utilization to the painters of his era:

> The sensations procured for us by the retina are those of the different colors and different degrees of light and dark . . . and that is the first foundation on which the whole edifice of our visual perceptions will be constructed. In this state, which is that of a person blind at birth right after an operation [to restore his sight], the eye has the sole sensation of patches that vary in color and are more or less light or dark. . . . The colorist painters know this state well, since they are returning to it; their talent consists of seeing their model as a *patch* whose only characteristic is its color, which is more or less diversified, muted, enlivened, or mixed.— Up to this point [there is] no idea of the distance and position of the objects, until an induction based on touch situates them in relation to the eye. It is now that additional, auxiliary sensations must be added, little by little, to the pure retinal sensations.[37]

Taine's approach to visual perception corresponds closely to Zola's analysis of the visual act into a series begun by a luminous impression, continued by a more solid, well-defined perception of the scene's material qualities, and leading progressively to the identification and recognition of a specific, individual object or person.

Laforgue, a student of Taine's at the Ecole des Beaux Arts in 1880 and 1881, and well versed in the experimental sciences, echoes this theory: "Essentially the eye must know only luminous vibrations, just as the acoustic nerve knows only sound vibrations."[38] For Laforgue, as for

37. "Les sensations que nous procure la rétine sont celles des différentes couleurs et des différents degrés du clair et de l'obscur . . . et voilà la première assise sur laquelle s'établira tout l'édifice de nos perceptions visuelles.—En cet état, qui est celui de l'aveugle-né aussitôt après l'opération; l'oeil n'a que la sensation de taches diversement colorées plus ou moins claires ou obscures. . . . Les peintres coloristes connaissent bien cet état, car ils y reviennent; leur talent consiste à voir leur modèle comme une *tache* dont le seul élément est la couleur plus ou moins diversifiée, assourdie, vivifiée et mélangée.—Jusqu'ici nulle idée de la distance et de la position des objets, sauf lorsqu'une induction tirée du toucher les situe tout contre l'oeil. Il faut maintenant ajouter peu à peu aux sensations rétiniennes pures, des sensations auxiliaires et de surcroît." *De l'intelligence,* 8th ed. (Paris: Hachette, 1897), II, 162–63.

38. "Essentiellement l'oeil ne doit connaître que les vibrations lumineuses, comme le nerf acoustique ne connaît que les vibrations sonores." "Critique d'art—L'Impressionnisme," in *Mélanges posthumes,* vol. 3 of *Oeuvres complètes,* 4th ed. (Paris: Mercure de France, 1903), 135.

Taine and Zola, the exploration of this initial luminous stage is a distinctive feature of contemporary painting: "a natural eye forgets tactile illusion with its convenient dead language—drawing—and acts solely through its faculty of prismatic sensitivity. It manages to see reality in the living atmosphere of forms, decomposed, refracted, reflected through beings and things, with its endless variations. This is the primary characteristic of the impressionist eye."[39]

While "impressionism" is generally considered a French phenomenon, it flourished in an intellectual climate that extended throughout late nineteenth-century Europe, where it emerged in the sciences, painting, and criticism. The linking of luminosity and artistic innovation by Taine, Laforgue, and Zola, for example, was paralleled in England by the critic John Ruskin (admired greatly by Proust), writing here in reference primarily to Turner's art:

> The perception of solid Form is entirely a matter of experience. We *see* nothing but flat colours; and it is only by a series of experiments that we find out that a stain of black or grey indicates the dark side of a solid substance, or that a feint hue indicates that the object in which it appears is far away. The whole technical power of painting depends on our recovery of what may be called the *innocence of the eye;* that is to say, of a sort of childish perception of these flat stains of colour, merely as such, without consciousness of what they signify,—as a blind man would see them if suddenly gifted with sight.[40]

In commenting on Ruskins's judgment, the eminent art historian Ernst Gombrich reminds us that these ideas "had been propounded more than a century earlier by Bishop Berkeley in his *New Theory of Vision* in which a long tradition came to fruition: The world as we see it is a construct, slowly built up by every one of us in years of experimentation. Our eyes merely undergo stimulations on the retina which result in so-called 'sensations of color.' It is our mind that weaves these sensations into perceptions, the elements of our conscious picture of the

39. "un oeil naturel oublie les illusions tactiles et sa commode langue morte: le dessin-contour et n'agit que dans sa faculté de sensibilité prismatique. Il arrive à voir la réalité dans l'atmosphère vivante des formes, décomposée, réfractée, réfléchie par les êtres et les choses, en incessantes variations. Telle est cette première caractéristique de l'oeil impressionniste." Ibid., 135–36.

40. Quoted by E. H. Gombrich, *Art and Illusion: A Study of the Psychology of Pictorial Representation* (Princeton: Princeton University Press, The Bollingen Series, 1960), 296.

world that is grounded on experience, on knowledge."[41] While one might argue that it was the discovery of light waves in physics, more than the influence of Berkeley in philosophy, that catapulted such a theory into prominence, it is clear that the notion of the primacy of light in perception occupied the main line of nineteenth-century physiological thought.[42] As Gombrich states in concluding his evaluation of Ruskin's judgment: "Given this theory, which was accepted by nearly all nineteenth-century psychologists and which still has its place in handbooks, Ruskin's conclusions appear to be unimpeachable. Painting is concerned with light and color only, as they are imaged on our retina. To reproduce this image correctly, therefore, the painter must clear his mind of all he knows about the object he sees, wipe the slate clean, and make nature write her own story—as Cézanne said of Monet: '*Monet n'est qu'un oeil—mais quel oeil!*'"[43]

Indeed, the perceptual primacy (few would question the physical primacy) of light and color still finds its place in the handbooks of art critics as well as those of psychologists. Rudolph Arnheim, author of several influential studies on art and perception, sees the dynamics of vision in terms of reception (impression) and projection: "Broadly speaking, in color vision action issues from the object and affects the person; but for the perception of shape the organizing mind goes out to the object."[44] Ruth Moser, who has studied the incidence of impressionism across the arts, draws a similar distinction between the sensual element of color and the intellectual nature of line.[45]

41. Ibid., p. 297.

42. This theory of the order of perception is far from universal and timeless. Leon Battista Alberti, in his *De Pictura* of 1435, writes that "In the first place, when we look at a thing, we see it as an object which occupies a space. . . . Then as we look, we discern how the several surfaces of the object are fitted together. . . . Finally, in looking we observe more clearly the colours of surfaces." In Joel Snyder, "Picturing Vision," in *The Language of Images*, ed. W.J.T. Mitchell (Chicago: University of Chicago Press, 1974), 242.

43. *Art and Illusion*, 297.

44. *Art and Visual Perception: A Psychology of the Creative Eye*, rev. ed. (Berkeley and Los Angeles: University of California Press, 1974), 336.

45. "Le dessin est un art matériel puisqu'il est lié à la matière; son objet est l'imitation, ou la représentation, ou la création des corps et de l'espace. C'est un art intellectuel en tant qu'il *signifie*, que l'esprit reconnaît les objets et les nomme, en tant qu'il obéit aux lois géométriques élaborées par l'esprit et qu'il les fait secrètement présider à la représentation des corps. Et voici la couleur, qui est l'élément sensuel, certes, de la peinture . . . cependant, je ne l'appellerai pas seulement un élément sensuel, mais encore immatériel, ce qui n'est pas une antinomie. La couleur agit immédiatement, à travers les sens, sur l'esprit de l'homme, sans rien signifier, sans rien représenter." (*L'Impressionnisme français* [Geneva: Droz, 1952], 27–28.)

Terminology and Directions of This Study

Although the occasions will be rare when I shall have to call on precise scientific terms to describe vision, the technical vocabulary associated with visual perception is useful for the distinctions it engenders. The following description of visual perception as a three-part process is suitable to the examination of vision in the novel: "First, the organism gets set or prepared in a certain way, selectively tuned toward some class of stimuli or events in the environment. When the organism is thus set or tuned, it is said to have an hypothesis. The second step consists of the input of stimulus information. . . . In the third step of the cycle the hypothesis is confirmed or infirmed. Given a certain quantity and kind of information, an hypothesis will be confirmed and lead to a stable perception."[46]

The first step of this process, visual readiness, the setting or tuning of the eye toward external phenomena, is adequately captured by the terms "observation" and "looking," used often in this study. This step is also the point of departure for the studies of phenomenologists like Jean Starobinski, who uses the term "gaze" (*le regard*) to describe the eye's selection of the targets of perception according to the laws of desire.[47] This step will be the main area of exploration in Chapters 2 (where looking is among the visual themes treated) and 3 (viewpoint).

The second step involves the input of sensory information from the world outside the viewer and is usually referred to as "sensing" or "sensation."[48] Far from a static or mechanical process, this is the area where color and light on the one hand, line and shape on the other, interact to form impressions and images. It involves senses and the intellect, reception and projection. It is the stage of seeing (*voir* and *apercevoir*) and also seeming (*sembler* and *apparaître*). This step will serve as a focal point in Chapters 4 (description) and 5 (imagination).

46. Jerome Bruner, Leo Postman, and John Rodrigues, "Expectation and the Perception of Color," in *Readings in Perception,* ed. David Beardsley and Michael Wertheimer (Princeton: D. Van Nostrand, 1958), 267.

47. "Le regard constitue le lien vivant entre la personne et le monde, entre le moi et les autres: chaque coup d'oeil chez l'écrivain remet en question le statut de la réalité (ou du réalisme littéraire)" (*L'Oeil vivant* [Paris: Gallimard, 1961], 17). Among the numerous studies in the wake of Starobinski's work on "le regard," see especially Jean Paris, *L'Espace et le regard* (Paris: Seuil, 1965).

48. Zola had, in fact, become familiar with the term *sensation* from reading Letourneau's *Physiologie des passions* in 1868–69 while undertaking his overall preparation for the *Rougon-Macquart* series. In his notes for Letourneau's work, Zola distinguishes, for example, between the *sensation* (input) and the *impression* (a feeling of pleasure or displeasure), seeing both as stages of perception: "La sensation devient impression quand les fibres nerveuses vibrent normalement" (in *Les Rougon-Macquart,* v, 1689; see also 1681 and 1684).

In step three, for which I use the broad term "perception," the phenomenon is solidified, stabilized, secured in the observer's mind. For Starobinski, "sensation, which belongs in the realm of the body, or at least does not exceed a certain level of obscure consciousness, is an immediate given. Perception, on the other hand, organizes the sensation into clear consciousness, lends it the dignity of a considered phenomenon."[49] Perception occurs through the intervention of visual memory, as noted in one modern definition—"Perceptions: Sensations Plus Memory Images"[50]—and substantiated in another: "The seeing of objects involves many sources of information beyond those meeting the eye when we look at an object. It generally involves knowledge of the object derived from previous experience. . . . Objects are far more than patterns of stimulation. Objects have pasts and futures."[51] This then is the step of recognition (reconnaître), knowledge, identification, and naming (c'était). Jean-François Lyotard, discussing the impressionists in typically paradoxical fashion, also distinguishes this stage from that of sensation in noting that "learning to see means unlearning to recognize."[52] Like the preceding stage, this one will be of central importance in Chapters 4 (description) and 5 (imagination).

The schema in Diagram 1 (which will be reexamined and modified on several subsequent occasions) can serve to represent the visual process graphically.

observation	\longrightarrow	sensation	\longrightarrow	perception
(set)		(input)		(confirmation)
looking		seeing/seeming		recognizing/naming
(le regard)		(voir/sembler)		(reconnaître/être)

Diagram 1.

Despite the number of leads already noted—the pronouncements of writers proclaiming vision the key to their art, the concurrence of nearly all critics concerning Zola's debt to the visual arts, the inherent role of vision in literature and language suggested by Barthes, Starobinski, and

49. "La sensation, qui appartient à la vie du corps, ou qui du moins ne dépasse pas un certain champ de conscience obscure, est donnée dans l'immédiat. La perception, au contraire, organise la sensation en conscience claire, lui donne la dignité du phénomène réfléchi." L'Oeil vivant, 226.

50. Julian E. Hochberg, Perception (Englewood Cliffs, N.J.: Prentice-Hall, 1964), 32.

51. R. L. Gregory, Eye and Brain: The Psychology of Seeing (New York: McGraw-Hill, 1966), 8.

52. "Apprendre à voir est désapprendre à reconnaître." Discours/Figures (Paris: Klincksieck, 1974), 157.

Lyotard—relatively little attention has been given to visual perception in the criticism of the novel. Roger Shattuck's ground-breaking *Proust's Binoculars*[53] is a notable exception. Shattuck moves from thematics (optical instruments) and stylistics (visual metaphors) to an overall approach to Proust's work based on three modes of visual perception and representation (cinematographic, montage, binocular). Although Shattuck bypasses the intermediate areas of artistic endeavor—like viewpoint, description, and imagination—that are of interest here, his study remains the closest in goal and scope to my own, and I shall return to it in some detail in the Conclusion.

Starobinski's early work, such as *L'Oeil vivant* (and that of other phenomenological critics of the "Geneva school," including Poulet and Richard), deals more with the psychological preparations and motivations behind the act of perceiving, and its aftermath in the psyche, than with the middle steps, the mechanics of visual perception. Starobinski states quite clearly that his studies "seek less to describe the specific universe of vision than to trace the moving path of the *libido sentiendi* in its relationship with the world and other centers of human consciousness," and he explains that he "did not find it necessary to inventory all of the perceptual data (viewpoint, interplay of surface and depth) that relate to the practice of vision."[54]

It is, in fact, these "perceptual data" that I shall examine in this book. I shall trace their impact on the theories and practice of Emile Zola, while suggesting their potential for a study of the cultural climate of late nineteenth-century Europe and for developing an approach to that would-be visual genre, the novel. For numerous artists at that time (and, indeed, for many today), it is precisely in the "interplay between surface and depth," in the dynamics of reception (of light and color) and projection (of line and shape, not to mention fear and desire), that the creative imagination resides, namely, in the realm of the visual.

53. *Proust's Binoculars: A Study of Memory, Time and Recognition in "A la recherche du temps perdu"* (New York: Vintage Books, 1967). Shattuck has recently published a collection of essays, *The Innocent Eye: On Modern Literature and the Arts* (New York: Washington Square Press, 1986), which focuses more on the relationships between literature and the arts than on the question of vision itself.

54. "ces . . . études cherchent . . . moins à décrire l'univers spécifique de la vue qu'à retracer le destin mouvant de la *libido sentiendi* dans son rapport avec le monde et les autres consciences humaines . . . je n'ai pas cru nécessaire d'inventorier toutes les données perceptives (optique du monde, jeu des surfaces et des profondeurs) qui se rapportent à l'exercice de la vision." *L'Oeil vivant,* 18 and 17.

1 A Poetics of Vision: Zola's Theory and Criticism

Chaque oeil a ainsi une vision particulière. Enfin, il y a des yeux qui ne voient rien du tout. (Each eye has its own vision. Still, there are some eyes that see nothing at all.)
—Zola, *Le Roman expérimental* (167)

Vision dominates Zola's theories and criticism—both for the visual arts, where one might expect it to, and for the novel, where one might not. Neither corpus of criticism predominates in its influence on the other; rather, the prime role of vision precedes and shapes both. In effect, Zola evolves a poetics where literature, painting, and science intersect in the realm of the visual.

Approaching Zola's poetics through vision enables one to reassess the underrated theories of *Le Roman expérimental*, not as aberrations grafted onto Zola's critical writings for polemic purposes, but in the context of his overall criticism, where they assume a central position. Furthermore, the role of vision in Zola's theoretical program shows itself to be emblematic of the positivist thought of his times, which posits the potential of a scientifically analytic yet imaginative visual process capable of combining freshness of vision with the sophistication of an "educated eye."

Vision and Painting

Although his articles, along with his ardor, began to wane around 1880, Zola's writings on painting span a period of thirty years, from 1866 to 1896, his most dynamic and controversial output occurring at the beginning of his career. Zola's attacks on the established painters exhibiting in the 1866 Salon and his defense of Manet, in particular, in the newspaper *L'Evénement* elicited the violent public reaction described by his disciple Paul Alexis: "Some fanatics went so far as to rip up the paper right on the boulevard, in front of the newstands. The salon critic for *L'Evénement* received up to thirty letters a day, some containing words of encouragement, most insults; he almost had a duel."[1] After the tumultuous effect of his articles in the late sixties, Zola's art criticism diminished considerably until he was asked by the Russian newspaper *Viestnik Evropy* (*Messenger from Europe*) to chronicle the Salons of 1875 to 1880, a period that, fortunately, paralleled the independent shows of the artists who came to be known as the impressionists, about whom Zola commented in some detail. After a long hiatus, Zola did a final retrospective article on the arts for *Le Figaro*, the paper that, ironically, had replaced *L'Evénement*.

Zola's art criticism is as frustrating as it is fascinating and fruitful, due in part to the loss of the original French version of the Russian articles, but mostly to the evolution of the various painters themselves and of the terms Zola uses to describe them—such as realism, naturalism, positivism, and, finally, impressionism—the relationships among which we shall attempt to unravel as we proceed.

Zola's reasons for appreciating the painting of his times can be reduced to two categories, both pertaining to vision: First, he finds the artists of his generation to be concerned with the purely visual aspects of painting (as opposed, for example, to style or message) considerably more than any other movement in the history of art. For Zola, Manet and, later, the impressionists were able to strip away certain prejudices, not only of technique, but of seeing, and thus attain a far more natural and accurate vision than was previously possible. Second, and somewhat paradoxically, Zola believed that, despite the purely natural, wholly visual nature of their painting, Manet and the impressionists were able to achieve a studied and "scientific" analysis of certain visual effects and of the visual

1. "Des forcenés allèrent jusqu'à déchirer le journal en plein boulevard, devant les kiosques. Le salonnier de *L'Evénement* recevait jusqu'à des trente lettres par jour, contenant quelques-unes des encouragements, la plupart des injures; il faillit avoir un duel." *Emile Zola, notes d'un ami* (Paris: Charpentier, 1882), 68.

act itself, which was remarkably consistent with the positivist aims of his generation.

The Natural Eye

The repeated recurrence in Zola's theories (particularly in definitions) of visual terms—such as "observation," "seeing," "vision," and "the eye"—not only verifies his conviction that the painters of his generation had initiated what was essentially a visual revolution but also constitutes a concrete link between these theories and those concerning literature. This link is evidenced by the formula Zola uses to end his Salon article of 11 May 1866, entitled "Les Réalistes du Salon": "La définition d'une oeuvre d'art ne saurait être autre chose que celle-ci: *Une oeuvre d'art est un coin de la création vu à travers un tempérament*" ("The definition of a work of art could not be other than the following: *A work of art is a corner of creation seen through a temperament*").[2] This formula—where object ("a corner of creation") is welded to observer ("a temperament") through the mediation of observation ("seen")—is repeated on several occasions in Zola's art criticism, just as it assumes a key role in his literary theories. Of course, since painting is a visual art, all painters are concerned to a major degree with seeing, but Zola finds the painters of his generation to possess "une nouvelle vision de la nature" ("a new vision of nature," 261). Indeed, if Edmond Duranty coined the term "new painting" to describe the art of his times,[3] Zola's concept of modern painting might be characterized by the term "new vision," denoting a novel way of seeing based on the rediscovery of the natural eye.

Zola's first assessment of Manet, for example, in an article of 7 May 1866, emphasizes the role of direct perception devoid of visual inheritance: "Le talent de M. Manet est fait de simplicité et de justesse . . . il aura refusé toute la science acquise, toute l'expérience ancienne, il aura voulu prendre l'art au commencement, c'est-à-dire à l'observation exacte des objets" ("M. Manet's talent consists of simplicity and accuracy . . . he will have refused all acquired knowledge, all former experience, he will have wanted to take art from the beginning, that is, from the exact observation of objects," 67). In his pamphlet on Manet, published the

2. *Salons*, 73. Unless otherwise indicated, this and further page references to Zola's art criticism are from the volume *Salons*, collected and edited by F.W.J. Hemmings and R. J. Niess (Geneva: Droz, 1959), and will be included parenthetically in the text.

3. *La Nouvelle Peinture*. Paris: Marcel Guérin, 1876.

following year, Zola continues his emphasis on unfettered vision, attributing the painter's success to his "facultés de vision et de compréhension" ("faculties of vision and understanding," 87), noting that "il fit effort pour oublier tout ce qu'il avait étudié dans les musées" ("he made an effort to forget everything he had studied in museums," 87) and concluding boldly that "toute la personnalité de l'artiste consiste dans la manière dont son oeil est organisé; il voit blond, et il voit par masses" ("the artist's entire personality consists of the way in which his eye is organized; he sees in blond, and he sees by masses," 91). In 1875, in the first of the "Letters from Paris" for his Russian public, Zola defends Manet's original use of color in *Argenteuil* by stressing, not the role of color on the surface of the canvas, or the interaction of various colors, or their symbolic value, but solely their visual accuracy: "Le peintre a vu ce ton, j'en suis persuadé" ("The painter saw this tone, I'm convinced of it," 158; see also 67). If Manet does have a weakness, as Zola contends in his "Letter" of 1879, it is one of technique, not of vision:

> Je n'ai pas nommé Edouard Manet, qui était le chef du groupe des peintres impressionnistes. Ses tableaux sont exposés au Salon. Il a continué le mouvement après Courbet, grâce à son oeil perspicace, si apte à discerner les tons justes. Sa longue lutte contre l'incompréhension du public s'explique par la difficulté qu'il rencontre dans l'exécution—je veux dire que sa main n'égale pas son oeil. . . . Si le côté technique chez lui égalait la justesse des perceptions, il serait le grand peintre de la seconde moitié du XIXe siècle.

> (I have not [yet] named Edouard Manet, who was the leader of the group of impressionist painters. His paintings are exhibited in the Salon. He continued the [naturalist] movement after Courbet, thanks to his perceptive eye, so apt in discerning precise tones. His long struggle against lack of public understanding can be explained by the difficulties he encounters in producing—I mean that his hand doesn't equal his eye. . . . If his technical side equaled the accuracy of his perceptions, he would be the great painter of the second half of the nineteenth century. 227)

Zola repeats this clear distinction between visual mastery and technical inadequacy in his preface to the catalogue for an exhibition of Manet's works, shortly after the painter's death in 1884: "Les doigts n'obéissaient pas toujours aux yeux, dont la justesse était merveilleuse" ("His fingers didn't always obey his eyes, whose accuracy was marvelous," 260).

Zola's concept of a "new vision" was not confined to Manet, whom he

considered, nonetheless, to be the greatest (if not "the great") artist of his times. A similar visual revolution was evident in French landscape art, the "glory" of modern French painting, according to Zola, who assessed its break with classic landscape art as follows: ". . . des artistes révolu-tionnaires . . . emportèrent leur boîte de couleurs dans les champs et les prés, dans les bois où murmurent les ruisseaux, et tout bêtement, sans apprêt, ils se mirent à peindre ce qu'ils voyaient de leurs yeux autour d'eux" (". . . revolutionary artists . . . carried their boxes of colors into the fields and meadows, into the woods where streams babble, and quite simply, without adornment, they began to paint what they saw around them with their eyes," 166; see also 68, 86, and 241). Zola alludes here primarily to Courbet, Théodore Rousseau, Millet, and Corot, whom he often calls "naturalists"[4] and considers forerunners of the "impression-ists," painters whom he also defines according to their visual prowess.

Zola first used the term "impressionist" in his "Letter from Paris" of 1876, shortly after if was coined, pejoratively, by the critic Louis Leroy upon seeing Monet's *Impression: Sunrise* in 1874, and adopted, defiantly, by the group of painters who had undertaken independent shows rather than risk further rejection by the Salon jury. In this group Zola places, among others, Monet (whom he names as their leader), Renoir, Pissarro, Degas, Caillebotte, Morisot, Sisley, Guillaumin, Cassatt, and even Cé-zanne, but not Manet, whom Zola calls a "realist and positivist" in his 1875 letter (158) and a "naturalist" in his 1880 article "Le Naturalisme au Salon" for *Le Voltaire* (244).[5] In 1868, Zola had applied the term "natural-

4. The term "naturalism" was first applied to landscape art as early as 1839 and denotes merely the realistic representation of nature. Zola first applied the term to literature in 1868, extending its meaning to encompass the scientific representation of reality through deter-minism and, later, the experimental method. (For a recent discussion of Zola's naturalism, see William J. Berg and Laurey K. Martin, *Emile Zola Revisited* [Boston: G. K. Hall, Twayne's World Authors Series, 1992]). In his references to the painters of his generation, the "new painters," Zola tends to meld the two definitions of naturalism, no doubt relishing the combination for polemic purposes, that is, in order to advance the fledgling notion of naturalism in literature.

5. Although Manet often met with these painters, sometimes worked with them, and briefly adopted their light palette and loose brushwork (see, for example, the rue Mosnier or rue de Berne paintings of 1877–78), his preference for contrasting values and the predomi-nance of line and design distinguish his work from that of mainstream impressionism, as we shall see in further detail in Chapter 4. (It should be noted in passing, however, that many of these same qualities apply, at various times and to varying degrees, to Degas, Cassatt, and Renoir, among others). Cézanne, also a "colorist" according to Zola (see his article, "Une Exposition," cited in note 6 below), is ultimately concerned more with the geometrical forms and planes underlying a landscape than with the play of light on the surface, which caught the impressionists.

ist," again defined by the key role of vision, to both Pissarro—"il n'est ni poète ni philosophe, mais simplement naturaliste, faiseur de cieux et de terrains. Revez si vous voulez, voilà ce qu'il a vu" ("he is neither a poet nor a philosopher, but simply a naturalist, a maker of skies and terrains. Dream if you want, here is what he saw," 127)—and Monet—"je le félicite encore davantage de savoir peindre, d'avoir un oeil juste et franc, d'appartenir à la grande école des naturalistes" ("I congratulate him even more for knowing how to paint, for having an eye that is accurate and free, for belonging to the great school of naturalists," 132). Of course, Zola did not yet have the term "impressionism" at his disposal, but even in 1880 he links the two movements, through the notion of modernism: "c'est que le naturalisme, l'impressionnisme, la modernité, comme on voudra l'appeler, est aujourd'hui maître des Salons officiels" ("it's [clear] that naturalism, impressionism, modernity, however one calls it, is today master of the official Salons," 244).

For Zola, impressionism is an offshoot of naturalist painting, since both involve the direct observation of nature through the natural eye. However, the impressionists form a distinct group, based precisely on a common "vision"—"Ce qu'ils ont de commun entre eux, je l'ai dit, c'est une parenté de vision. Ils voient tous la nature claire et gaie" ("What they have in common, as I said, is a kindred vision. They all see nature as light and gay").[6] It is their studies of light that distinguish the impressionists from Manet and the naturalists, but, like their forerunners, they too are characterized by the importance of freshness of vision:

> Les artistes dont je parle on été appelés "des impressionnistes," parce que la plupart d'entre eux s'efforcent visiblement de communiquer avant tout l'impression véridique donnée par les choses et les êtres; ils veulent la saisir et la reproduire directement, sans se perdre dans les détails insignifiants qui ôtent toute fraîcheur à l'observation personnelle et vivante. Mais chacun, par bonheur, a son trait original, sa façon particulière de voir et de transmettre la réalité.
>
> (The artists I'm talking about have been called "impressionists," because most of them clearly aspire to communicate above all the true impression produced by things and beings; they want to seize [the impression] and reproduce it directly, without getting lost in the small details that remove all freshness from the per-

6. From an article dated 16 April 1887, entitled "Une Exposition: Les Peintres impressionnistes," first published in *Le Sémaphore de Marseille* on 19 April 1877. In *Mon Salon/ Manet/Ecrits sur l'art,* ed. Antoinette Ehrard (Paris: Garnier Flammarion, 1970), 282.

sonal, living observation. But each of them, fortunately, has an original trait, his or her own way of seeing and transmitting reality. 194)

In short, Manet, the naturalists, and the impressionists have been able to divest their painting and their seeing of the lessons of the past, of such aquired concerns as composition, design, line, and perspective. They have managed to achieve a more natural eye, one whose approach to reality is fresh and directed at the visual essence of experience.

Zola attributes this same visual freshness to Claude Lantier, the painter-hero of *Le Ventre de Paris* (1873) and *L'Oeuvre* (1886). Claude frequently expresses the wish to free his eyes from the blinders of the past, noting that "on doit apprendre son métier. Seulement, ce n'est guère bon de l'apprendre sous la férule de professeurs qui vous entrent de force dans la caboche *leur* vision à eux" ("one has to learn one's trade. But it's no good learning it under the iron rule of professors who force *their* vision into your noggin").[7] Claude wishes to liberate his sight, even from the influence of those painters he most admires; he says of Courbet: "ce fameux réalisme n'était guère que dans les sujets; tandis que la vision restait celle des vieux maîtres" ("this famous realism was solely in his subjects; while his vision remained that of the old masters," 45)—and adds of Delacroix: "Nom d'un chien, c'est encore noir! J'ai ce sacré Delacroix dans l'oeil" ("Doggone it, it's still black! I've got that damned Delacroix in my eye," 47). Of the great painters in the Louvre, Claude believes that their vision does not adequately translate what the eye encounters in reality: "Il en arrivait à déclamer contre le travail au Louvre, il se serait, disait-il, coupé le poignet, plutôt que d'y retourner gâter son oeil à une de ces copies, qui encrassent pour toujours la vision du monde où l'on vit" ("He began to declaim against the works in the Louvre; he said he'd rather cut his wrists than go back there and spoil his eye on one of those copies, which foul up one's vision of the world where one lives," 43–44; see also 109 and 124). Finally, after a lengthy apprenticeship "unlearning" the lessons of the past, Claude manages to attain the same natural virginity of sight that Zola attributes to Manet and the impressionists: "Son long repos à la campagne lui avait donné une fraîcheur de vision singulière" ("His long rest in the countryside had given him a singular freshness of vision," 204).

7. *L'Oeuvre*, 83. This and all further page references to the Rougon-Macquart novels, unless otherwise noted, are from the five-volume Pléiade edition, edited (brilliantly) by Henri Mitterand (Paris: Fasquelle et Gallimard, Bibliothèque de la Pléiade, 1960–67). *L'Oeuvre* is in vol. 4.

For Zola, then, the principal characteristic of impressionism, the one that defines the movement and determines its main directions, is the purely visual nature of its approach to reality, the immediacy of the "impression," the primacy of the "natural eye." Nor does Zola's evaluation appear to be overly simplified or idiosyncratic. Although technical innovations like the accentuated brush stroke and the use of a pale ground are sometimes considered as the principal innovations of late nineteenth-century art,[8] many critics, both at that time and today, see a new conception of visual sensation, returning to the primitive, nonabstract eye, as a major legacy of the impressionist movement.

The French critic Georges Rivière, writing in 1877, characterizes the impressionists as having a "virgin eye,"[9] while Diego Martelli, an Italian critic writing in 1880, further confirms Zola's position in stating that *"Impressionism* is not only a revolution in the field of thought, but is also a physiological revolution of the human eye. It is a new theory that depends on a different way of perceiving sensations of light and of expressing impressions."[10] Jules Laforgue, writing in 1883, proposes the following definition of impressionism, again insisting on the qualities that define the painter's eye: "The Impressionist is a modernist painter who—endowed with uncommon ocular sensitivity, forgetting the paintings amassed over centuries in museums, forgetting the optical education of schooling (draw-

8. On the use of a pale ground, see, for example, *Techniques of the World's Greatest Painters,* ed. Waldemar Januszczak (Secaucus, N.J.: Chartwell Books, 1980), especially the entry on Monet, 102–5. Concerning brushwork, see Oscar Reutersvärd, "The Accentuated Brush Stroke of the Impressionists," *Journal of Aesthetics and Art Criticism* 10, no. 3 (March 1952): 273–78.

9. "oeil vierge." In Lionello Venturi, *Les Archives de l'impressionnisme* (Paris: Durand-Ruel, 1939), I, 52. Throughout the twentieth century, art critics have done little to weaken this notion. André Fontainas repeats Zola's distinction between 'pure visual sensation' and 'preconceived rules coupled with prejudiced abstractions' as approaches to painting: "Manet détermine les courants nouveaux. Il ne voit que par les sens, indépendamment de toute théorie préconçue et de tout préjugé qu'on lui a enseignés" (*Historie de la peinture française au XIXe et au XXe siècles* [Paris: Mercure de France, 1922], 218). Pierre Francastel adds that the achievement of a pure vision, uninhibited by abstraction, is the real innovation of these painters: "L'Impressionnisme, tel que nous l'avons conçu, apparaissait comme un effort des artistes pour rendre, avec le moins d'abstraction possible, des sensations avant tout optiques; c'est en ce sens seulement que les artistes de la fin du XIXe siècle apportent des nouveautés techniques" (*L'Impressionnisme: Les Origines de la peinture moderne* [Paris, 1937], 183). The editors of *Réalités* speak of the "raw experience of the optical sensation in its instantaneous confrontation with the visible. Now, this is precisely the final aim of the principal Impressionists, namely, to free the mind of all memory, of all visual culture, of all preconceived knowledge of nature" (*Impressionism* [Secaucus, N.J.: Chartwell Books, 1973], 91–92).

10. "Gli Impressionisti," *Impressionism and Post-Impressionism,* ed. Linda Nochlin (Englewood Cliffs, N.J.: Prentice-Hall, 1966), 25.

ing and perspective, coloring), by dint of living and looking openly and primitively in the luminous spectacles of the open air (that is, outside the studio lit at a forty-five-degree angle), whether it be in the street, the countryside, or inside—has managed to recreate a natural eye, to see naturally and paint naively as he sees."[11] Thus, the first and foremost characteristic of impressionism, identified by Zola and substantiated by other art critics of his era, is its purely visual nature, its break with the abstractions of the past and its rediscovery of the natural eye.

The Analytic Eye

After freshness of vision, Zola identifies as the second major characteristic of Manet, the naturalists, and the impressionists their rigorous analyses, their sophisticated "studies" of nature. This notion may seem somewhat at odds with the first, and yet many modern painters appeared to assume a scientific and analytic approach to their subjects while remaining purely visual; they seemed to possess a type of vision that was at once "virgin and abstract," as Mallarmé put it in reference to Monet's eye.[12]

Indeed, in Zola's art criticism the term "observation," whose occurrence we have just studied, is often coupled with "analysis," as in the following judgment concerning Manet, from Zola's pamphlet of 1867: "Il est un enfant de notre âge. Je vois en lui un peintre analyste. Tous les problèmes ont été remis en question, la science a voulu avoir des bases solides, et elle en est revenu à l'observation exacte des faits" ("He is a child of our era. I see in him an analytic painter. All issues have been reevaluated, science has sought solid bases, and it has returned to the exact observation of facts," 92). In 1880 Zola links this coupling "of observation and analysis" (251) to the triumph of naturalism in landscape art and goes so far as to proclaim that "tout artiste de talent s'appuie aujourd'hui sur l'observation et l'analyse" ("any talented artist relies today on observation and analysis," 254).

11. "L'Impressionniste est un peintre moderniste qui, doué d'une sensibilité d'oeil hors du commun, oubliant les tableaux amassés par les siècles dans les musées, oubliant l'éducation optique de l'école (dessin et perspective, coloris), à force de vivre et de voir franchement et primitivement dans les spectacles lumineux en plein air, c'est-à-dire hors de l'atelier éclairé à 45°, que ce soit la rue, la campagne, les intérieurs, est parvenu à se refaire un oeil naturel, à voir naturellement et à peindre naïvement comme il voit." "Critique d'art—L'Impressionnisme," in *Mélanges posthumes,* vol. 3 of *Oeuvres complètes,* 4th ed. (Paris: Mercure de France, 1903), 133–34.

12. "vierge et abstrait." In André Fontainas, *Histoire de la peinture française,* 215.

Zola greatly admired the "study" of light effects that Manet achieved in his painting, while remaining faithful to the principle of direct observation:

> Ce qui me frappe avant tout dans ses tableaux, c'est l'observation constante et exacte de la loi des valeurs. Par exemple, des fruits sont posés sur une table et se détachent contre un fond gris. Il y a entre les fruits, selon qu'ils sont plus ou moins rapprochés, des différences de coloration, formant toute une gamme de teintes, et il faut dire à l'honneur de Manet qu'il s'est soucié constamment de l'étude de ces teintes, dont l'existence n'est évidemment pas soupçonnée des élèves de l'Ecole des Beaux-Arts.
>
> (What strikes me above all in his paintings is the constant and precise observance of the law of values. For example, various fruits are set on a table and detach themselves from a gray background. Among these fruits, depending on their distance, there are differences in coloration, forming an entire range of tints, and it must be said to Manet's credit that he has constantly been concerned with the study of these tints, the existence of which is clearly not suspected by students of the Ecole des Beaux-Arts. 191; see also 90)

Zola was particularly interested in the way Manet was able to study the effect of this decomposed, analyzed light, color, and atmosphere on the objects and people they enveloped, as he noted in 1884: "Une seule règle l'a guidé, la loi des valeurs, la façon dont un être ou un objet se comporte dans la lumière qui dessine autant qu'elle colore, c'est la lumière qui met chaque chose à sa place, qui est la vie même de la scène peinte" ("A single rule guided him, the law of values, the way in which a being or an object behaves in light, which contours as much as it colors; it is light that puts each thing in its place, that is the very life of the painted scene," 260). Indeed, Zola considers this investigation of light and atmosphere to be the defining characteristic of the impressionist group, as he states in his Russian Letter of 1879: "Les impressionnistes ont introduit la peinture en plein air, l'étude des effets changeants de la nature selon les innombrables conditions du temps et de l'heure" ("The impressionists introduced open air painting, the study of the changing effects of nature according to the innumerable conditions of climate and time," 226). He goes on to use the term "analysis" in describing their efforts in this area: "ils poussent l'analyse de la nature plus loin, jusqu'à la décomposition de la lumière, jusqu'à l'étude de l'air en mouvement, des nuances des couleurs, des

variations fortuites de l'ombre et de la lumière, de tous les phénomènes optiques qui font qu'un horizon est si mobile et si difficile à rendre" ("they push the analysis of nature even further, up to the decomposition of light, to the study of air in movement, of color nuances, of random variations in shadow and light, of all the optical phenomena that render a horizon so mobile and so difficult to depict," 226–27).

As of 1880, coinciding (perhaps not coincidentally) with the publication of *Le Roman expérimental*, Zola's praise for the impressionists extends beyond their study of light itself to include its relationship with and its effect on the objects and people of reality. He uses phrases such as "peindre les figures dans l'air où elles vivent" ("painting figures in the air where they live," 252) to describe their achievements and begins to apply the term "milieu," at the core of his theories of determinism, to the air and light that the painters were examining through direct observation: "On voit tous les jeunes talents, tous ceux qui ont un besoin de vie et de succès, venir à la nouvelle formule, aux sujets modernes, à l'observation exacte de la nature, à cette peinture du plein air qui baigne les personnages dans le milieu de lumière vraie où ils vivent" ("We see all the young talent, all who need life and success, come to the new formula, to modern subjects, to the exact observation of nature, to this open air painting that bathes figures in the milieu of real light where they live," 249; see also 254).

Zola finds the studies undertaken by the "new" painters to be eminently scientific, rivaling those of the chemist and physicist and conforming closely to determinism's ideal of identifying the causes and effects of natural phenomena:

> Aujourd'hui nos jeunes artistes ont fait un nouveau pas vers le vrai, en voulant que les sujets baignassent dans la lumière réelle du soleil, et non dans le jour faux de l'atelier; c'est comme le chimiste, comme le physicien qui retournent aux sources, en se plaçant dans les conditions mêmes des phénomènes. Du moment qu'on veut faire de la vie, il faut bien prendre la vie avec son mécanisme complet. De là, en peinture, la nécessité du plein air, de la lumière étudiée dans ses causes et ses effets.

> (Today our young artists have taken a new step toward truth, in wanting their subjects to bathe in the real light of the sun, and not in the false light of the studio; it's like the chemist, like the physicist returning to their sources, placing themselves within the very conditions of phenomena. From the moment that one wants to represent life, one has to take life with its complete mechanism.

Whence, in painting, the necessity of open air, of light studied in
its causes and its effects. 241)

In short, Zola finds, within the visual arts, direct confirmation of the
central premise of naturalism—the causal determination of natural and
human phenomena by the physical milieu. Small wonder that he should
embrace impressionism so firmly, both through natural inclination and
for polemic purposes.

If Zola does eventually find fault with Monet, it is precisely because, at
a certain point, the latter seems to have abandoned his scientific preten-
sions and promise: "Les impressionnistes sont précisément, selon moi,
des pionniers. Un instant ils avaient mis de grandes espérances en Monet;
mais celui-ci paraît épuisé par une production hâtive; il se contente d'à
peu près; il n'étudie pas la nature avec la passion des vrais créateurs"
("The impressionists are precisely, in my judgment, pioneers. For a mo-
ment they had put high hopes in Monet; but he seems worn out by hasty
production; he's content to be close; he doesn't study nature with the
passion of true creators," 227). Zola felt that Monet and others of the
impressionist group had begun to exhibit a nonscientific approach to
visual sensation, and, while these painters continued to maintain their
purely visual approach, they had failed to achieve the analysis of cause
and effect, the synthesis with scientific method, that Zola admired in
Manet.[13]

It is in fact the relationship of sensation and science that best informs
Zola's conception of the painter Claude Lantier in *L'Oeuvre,* especially
concerning the extent to which Claude's failure constitutes a condemna-
tion of impressionism, as is often alleged.[14] Claude is originally intended

13. Zola is not alone in this view, echoed by a present-day critic of some standing:
"They practically never followed out their theories in a logical fashion. If it has been said
that Claude Monet 'was only an eye; but great heavens, what an eye!' it has also been said
that Impressionism was a vast eye, capable of capturing the subtlest nuances and values but
incapable of taking it a stage further and realizing the synthesis between that eye and the
intellect. Its fervent masters do not work out logically or scientifically the effects they
desired to evoke; they put down their blobs of color as rapidly as they perceived them"
(Maurice Sérullaz, *The Impressionist Painters,* trans. W. J. Strachan [New York: Universe
Books, 1960], 11).

14. The issue of Zola's intent (or effect) in *L'Oeuvre* has spawned considerable contro-
versy in literary criticism as well as in art history. It is the principal focus of books by the
literary critics Patrick Brady ("*L'Oeuvre*" *de Emile Zola* [Geneva: Droz, 1967]) and Robert
Niess (*Zola, Cézanne, and Manet: A Study of* "*L'Oeuvre*" [Ann Arbor: University of Michi-
gan Press, 1968]), both of which are discussed briefly in the Introduction. Many art histori-
ans of the period have also dealt with *L'Oeuvre,* among them John Canaday (*Mainstreams of
Modern Art* [New York: Holt, Rinehart and Winston, 1959], 347), Phoebe Pool (*Impression-*

to reflect the visual and scientific characteristics attributed in Zola's *Salons* to naturalism and, for a time, to impressionism. Zola notes, in the *ébauche* (sketch) for the novel: "Maintenant, il faudrait bien régler mon Caude, J'en fais naturellement un naturaliste" ("Now I should sort out my Claude; naturally I'll make him a naturalist")—and he later adds: "Je prendrai en outre pour Claude quelques théories des impressionnistes, le plein air, la lumière décomposée, toute cette peinture nouvelle qui demande *un génie pour être réalisée*" ("In addition, I'll give Claude some of the theories of the impressionists, open air, decomposed light, all this new painting that demands *a genius to be achieved*"). Zola conceives Claude initially as critical of his would-be "impressionist" followers, and the novelist uses the same word "hasty" that had been applied to Monet: "Mais je reviens aux impressionnistes: Claude s'élèvera contre leur travail hâtif, le tableau fait en deux heures, l'esquisse qui contente" ("But I return to the impressionists: Claude will rise against their hasty work, the painting done in two hours, the sketch that suffices").[15]

At the outset, Claude embodies the positivist/determinist synthesis of the purely visual and the scientific. He exclaims, early in the novel, that his painting must represent the effect of light on the objects and people that it envelops: "les choses et les êtres tels qu'ils se comportent dans de la vraie lumière" ("things and beings as they behave in real light," 45). He later develops his visual faculties and painterly techniques to achieve a scientifically accurate representation of these effects in his art: "Après cette année de repos en pleine campagne, en pleine lumière, il peignait avec une vision nouvelle, comme éclaircie, d'une gaieté de tons chantante. Jamais encore il n'avait eu cette science des reflets, cette sensation si juste des êtres et des choses, baignant dans la clarté diffuse" ("After this restful year in the countryside, in the open air, he painted with a new vision, as if enlightened, with a singing gayness of tones. Never before had he had this knowledge of reflections, such an accurate sensation of beings and things, bathing in diffuse light," 45).

However, Claude, like his eponym Monet, falls prey to the "hasty impression" and fails to realize his analytic and scientific potential, as his friend Sandoz, the novelist and *porte-parole* par excellence, concludes:

ism [New York: Praeger Publishers, 1967], 217–18), and John Rewald (*The History of Impressionism* [New York: MOMA, 1973], 4th rev. ed., 534–36). Pool's opinion of *L'Oeuvre*—"The novel in which Zola travestied Impressionism" (217)—is not atypical of the general consensus among art historians. However, our argument here, paralleling especially that of Brady, suggests that some nuancing may be appropriate.

15. Ms. no. 10.316, fols. 276, 300–301, and 302, Département des Manuscrits, Nouvelles Acquisitions Françaises, Bibliothèque Nationale.

Non, il n'a pas été l'homme de la formule qu'il apportait. Je veux dire qu'il n'a pas eu le génie assez net pour la planter debout et l'imposer dans une oeuvre définitive. . . . Et voyez, autour de lui, après lui, comme les efforts s'éparpillent! Ils en restent tous aux ébauches, aux impressions hâtives, pas un ne semble avoir la force d'être le maître attendu. N'est-ce pas irritant, cette notation nouvelle de la lumière, cette passion du vrai poussée jusqu'à l'analyse scientifique, cette évolution commencée si originalement, et qui s'attarde, et qui tombe aux mains des habiles, et qui n'aboutit point, parce que l'homme nécessaire n'est pas né? . . . Bah! l'homme naîtra, rien ne se perd, il faut bien que la lumière soit.

(No, he wasn't man enough for the formula he discovered. I mean that he didn't have a clear enough genius to plant it upright and impose it in a definitive work. . . . And look around him, after him, how their efforts are scattered! They're all stuck on sketches, on hasty impressions, not a one appears to have the force to be the long-awaited master. Isn't it irritating, this new notation of light, this passion for truth pushed to [the level of] scientific analysis, this evolution begun so originally, which is lagging, falling into profiteering hands, and is leading nowhere, because the right man isn't born? . . . Bah! he'll be born, nothing is lost, the light won't fail. 359)

Indeed, during the course of *L'Oeuvre*, Claude progressively loses his directly analytical vision and turns to abstract notions such as the theory of complementary colors:[16]

16. The principle of complementary colors—developed in the studies of the chemists Chevreul, Maxwell, and Rood—conformed with the discoveries of the physiologists Young and Helmholtz, and was applied by the neo-impressionists, most notably Seurat, Pissarro, and Signac, beginning in 1884 and 1885. Paul Signac, while reading *L'Oeuvre* in the *Gil Blas*, noticed a mistake in Zola's interpretation of this principle and sent him the following letter on 8 February 1886: "Monsieur: Peintre—dit impressionniste—je suis avec énormément d'intérêt votre beau roman sur l'art contemporain. Je vous demande, Monsieur, la permission de vous signaler dans votre feuilleton d'hier une petite erreur sur la théorie des couleurs complémentaires. Gagnière dit: 'Mon drapeau rouge se détachant sur un ciel bleu devient violet . . .' Le ciel étant *bleu* a pour complémentaire de l'orangé. Cet orangé vient s'ajouter au rouge du drapeau, qui au lieu de devenir violet tire au contraire sur le *jaune*. Pour que le drapeau devint violet—comme le dit Gagnière—il aurait fallu que le ciel soit orangé ou jaune" (in *R-M,* IV, 1452). Zola corrected his mistake to conform with Signac's suggestion before *L'Oeuvre* was published in novel form two months later. The irony is, of course, that he did so in order to criticize abuses of the notion.

Il en tirait cette conclusion vraie, que les objets n'ont pas de couleur fixe, qu'ils se colorent suivant les circonstances ambiantes: et le grand mal était que, lorsqu'il revenait maintenant à l'observation directe, le tête bourdonnante de cette science, son oeil prévenu forçait les nuances délicates, affirmait en notes trop vives l'exactitude de la théorie; de sorte que son originalité de notation, si claire, si vibrante de soleil, tournait à la gageure, à un renversement de toutes les habitudes de l'oeil, des chairs violâtres sous des cieux tricolores. La folie semblait au bout.

(He drew this true conclusion, that objects don't have a fixed color, that they are colored according to surrounding circumstances: and the great misfortune was that, when he returned now to direct observation, his head buzzing with this knowledge, his prejudiced eye exaggerated the delicate nuances, confirmed the accuracy of the theory in notes that were too vivid; so that his originality of notation, so light, so vibrant with sunlight, became impossible, turned into a reversal of all ocular habits, violet flesh under tricolored skies. Madness seemed inevitable. 248)

It is clear that the French word "science" here means prior knowledge and principle, not the scientific analysis that results from direct observation. Zola alludes, of course, to the neo-impressionists (particularly Seurat, Signac, and even Pissarro), for whom pointillist technique and color theory were replacing the direct analytical observation of reality. Ten years after the publication of *L'Oeuvre*, Zola expresses his disapproval of current trends in his final *Salon:*

Mais où ma surprise tourne à la colère, c'est lorsque je constate la démence à laquelle a pu conduire, en trente ans la théorie des reflets. . . . Très justement, nous soutenions que l'éclairage des objets et des figures n'est point simple, que sous des arbres, par exemple, les chairs nues verdissent, qu'il y a ainsi un continuel échange de reflets dont il faut tenir compte, si l'on veut donner à une oeuvre la vie réelle de la lumière. Sans cesse, celle-ci se décompose, se brise et s'éparpille. . . . Seulement rien n'est plus délicat à saisir et à rendre que cette décomposition et ces reflets, ces jeux du soleil où, sans être déformées, baignent les créatures et les choses. Aussi, dès qu'on insiste (dès que le raisonnement s'en mêle), en arrive-t-on vite à la caricature. Et ce sont vraiment des oeuvres déconcertantes, ces femmes multicolores, ces paysages violets et ces chevaux oranges, qu'on nous donne, en nous expliquant

scientifiquement qu'ils sont tels par suite de tels reflets ou de telle
décomposition du spectre solaire.

(But where my surprise turns to anger is when I see the madness
stemming, in thirty years, from the theory of reflections. . . .
Quite rightly, we contended that the lighting of objects and fig-
ures is not at all simple, that under trees, for example, nude flesh
becomes greenish, that there is a continual play of reflections that
one must acknowledge, if one wants to lend a work the real life of
light. Constantly it decomposes, breaks up, and scatters. . . .
However, nothing is more difficult to grasp and represent than
this decomposition and its reflections, this play of sunlight where
creatures and things bathe, without being deformed. Thus, as
soon as one stresses this [as soon as reason intervenes], caricature
quickly ensues. And these are truly disconcerting works, these
multicolored women, these violet landscapes with orange horses
that they're giving us, explaining scientifically that things are thus
due to such and such a reflection or such and such a decomposition
of the solar spectrum. 267)

Again the word "scientifically" is used ironically, to suggest the abuse of
precept and prejudice rather than to convey a link with the experimental
method based on direct observation and analysis, to which Zola and the
positivists were committed.

In essence, the criticism that emerges from *L'Oeuvre* concerns the "dos-
age" of science in vision: Monet and the mainstream impressionists, after
promising beginnings, turned out to have too little; Seurat and the neo-
impressionists (Cézanne no doubt among them)[17] too much. Claude
Lantier's evolution—from having a balanced "dosage," to too little, to too
much—is meant to reflect, not that of one painter, or even one movement,
but that of the painting of his era.[18] *L'Oeuvre* is not a condemnation of
impressionism but of its aftermath. In fact, throughout his final Salon,
Zola confirms his appreciation for the impressionists as they once were and
his belief that their "new vision" was being undermined by the neo-
impressionists' emphasis on technique at the expense of observation. Pre-
cept had replaced the natural eye; principle had replaced the analytic eye.
The visual artist, like the novelist, must maintain a correct proportion
between sensation and science in order to achieve stability and solidity.

17. Although Cézanne is by no means a "pointillist" or "divisionist," his use of color to
underscore forms and even to create mood is often nonrepresentational, to say the least.
18. This conclusion is hardly new (see especially Patrick Brady, *"L'Oeuvre" de Emile
Zola*), but it does incorporate new evidence from a slightly different angle.

Again, Zola's description of the scientific analysis initally inherent in impressionist vision finds considerable support among art critics, both his contemporaries and ours.[19] Edmond Duranty contends of the "new painters" that "from the standpoint of ocular precision, the subtle understanding of coloring, the result is completely extraordinary. The most learned physicist could fault nothing in their analyses of light."[20] Armand Silvestre, writing in 1876, finds in impressionism "a sort of analytic impression . . . outside of the longstanding conventions of modern landscape art, [impressionism] discovered certain unexplored aspects of things, analyzed them with infinite subtlety, and thus expanded the field of pictorial research."[21] Perhaps the most striking depiction of the impres-

19. Among modern critics, André Fontainas sums up the hopes placed in the scientific aspects of impressionism in the following judgment: "Pour la première fois peut-être, à la suite des physiciens, les artistes examinent les fondements de leur métier; d'inépuisables richesses sont issues de ces investigations; un renouveau fécond, une fraîcheur, une vigueur qu'on n'eût osé espérer. . . . Ces observations scientifiques, un peu ardues, mais aisément vérifiables pour chacun (il suffit de juxtaposer des bandes de papier coloré), sont à la base du métier des impressionnistes; il importait de les énoncer avec le plus de simplicité possible" (Histoire de la peinture française, 228–29). Oscar Reutersvärd, speaking of the widespread interpretation of impressionism as a positivist movement, notes also the strange synthesis of visual and scientific at the root of positivism. This proponent of the accentuated brush stroke articulates the position of the visualists with particular cogency: "This doctrine [the positivistic ideology of art] was an offspring of Comte's philosophy and consequently rejected everything creative in art which did not emerge from 'positive experience', from cognizance of the senses. This meant a revolutionizing emphasis being placed on the visual moment in art. The painter was to discover new values with the aid of his eyes and not improvise on the deal with literary subjects which in themselves lacked visual effect. And exactly as in the positivistic epistemology, they made a study of deciding the 'actual subjects' of art, the empirically gained visual phenomena right down to their slightest constituents, and to determine the capability and function of the organ of cognizance—the eye. Thus a sensual aestheticism crystallized, recognizable by its peculiar admixture of physiological and optic-physical principles. Painting was to be upheld by the geniuses of sight who could master the world as a visual appearance and analyse it and reproduce it in detail. . . . And the impressionists were held up as those who applied the new aesthetic doctrine. Their painting was propounded as being scientific reports of the chromoluminaristic conditions in nature, the decomposed structure was said to correspond with the disaggregation of sunlight into different prismatic elements, and by fusing on the observer's retina, the impressionists' touches of color would give rise to the same effects as the spectral phenomena in physical reality" ("The Accentuated Brush Stroke," 276–77).

20. "Au point de vue de la délicatesse de l'oeil, de la subtile pénétration du coloris, c'est un résultat tout à fait extraordinaire. Le plus savant physicien ne pourrait rien reprocher à leurs analyses de la lumière." La Nouvelle Peinture (Paris: Marcel Guérin, 1876), 39.

21. "une sorte d'impression analytique . . . en dehors de la longue convention du paysage moderne, elle a découvert certains aspects inexplorés des choses, les a analysés avec une subtilité infinie, en a agrandi le champ des recherches picturales." L'Opinion (2 April 1876) in Venturi, Les Archives de l'impressionnisme, ii, 286.

sionists' synthesis of sight and science comes again from the pen of Laforgue, who explains clearly why he thinks the impressionist eye is both "natural" (visual) and "refined" (analytic):

> Thus a natural eye (or refined, since, for this organ, before going forward it must become primitive again by getting rid of tactile illusions), a natural eye forgets tactile illusion and its convenient dead language—drawing—and acts solely through its faculty of prismatic sensitivity. It manages to see reality in the living atmosphere of forms, decomposed, refracted, reflected through beings and things, with its endless variations. This is the primary characteristic of the impressionist eye.[22]

French critics were not alone in recognizing the positivist solution to the dualism between fresh seeing and refined thinking. The extent to which impressionist vision, if not painting, extends throughout late nineteenth-century Europe is evident in the writings of Conrad Fiedler (1841–95), the German art critic whose major works include *On Judging Works of Visual Art* (1876), *Modern Naturalism and Artistic Truth* (1881), and *On the Origin of Artistic Activity* (1887). After stating that "it is to the independent and free development of perceptual experience that we must look for the peculiar power of artistic talent,"[23] Fiedler adds that "only he will be able to convince himself of the infinite possibilities for the visual comprehension of the world who has advanced to the free and independent use of his perceptive faculties" (*On Judging*, 41). He notes, however, that a meaningful relationship with the world, a learning one, involves conceptualizing and abstraction, and "each time that abstract concepts appear, perception (i.e., pure sensory experience) vanishes" (*On Judging*, 37). This paradox within the act of seeing has a solution, however, which Fiedler expresses by noting: "It should be understood that man can attain the mental mastery of the world not only by the creation of concepts but also by the creation of visual conceptions" (*On Judging*, 40). He concludes

22. "Donc un oeil naturel (ou raffiné puisque, pour cet organe, avant d'aller, il faut redevenir primitif en se débarrassant des illusions tactiles), un oeil naturel oublie les illusions tactiles et sa commode langue morte: le dessin-contour et n'agit que dans sa faculté de sensibilité prismatique. Il arrive à voir la réalité dans l'atmosphère vivante des formes, décomposée, réfractée, réfléchie par les êtres et les choses, en incessants variations. Telle est cette première caractéristique de l'oeil impressionniste." "Critique d'art—L'Impressionnisme," 135–36.

23. *On Judging Works of Visual Art,* trans. Henry Schaefer-Simmern and Fulmer Mood (Berkeley and Los Angeles: University of California Press, 1949), 27. Further references to Fielder's work are from the above translation, unless otherwise indicated, and will be cited in the text as *On Judging,* followed by the page number.

that "it is the essential characteristic of the artist's nature to be born with an ability in perceptual comprehension and to use that ability freely" (*On Judging,* 42), and it is precisely this ability that joins modern painting with the scientific discoveries of the postivist era: "Art as well as science is a kind of investigation, and science as well as art is a kind of mental configuration" (*On Judging,* 46).

At the very root of positivism, then, is a combination of the purely visual and the scientific, an amalgamation that involves an analytic way of seeing, a creative vision that Mallarmé, Duranty, Laforgue, Fiedler, and numerous other critics join Zola in locating at the root of late nineteenth-century painting. Zola distinguishes himself from many of his contemporaries, however, in finding this same conjunction to be operable in literature; the writer must also combine observation and analysis to achieve a "new vision" that is direct and immediate yet "experimental."

Vision and Literature

For Zola, painting and literature merge precisely at the point where seeing is necessary to each. Obviously, the two art forms are governed by different sign systems—the visual and the verbal. My purpose here is not to explore the bonds and boundaries between these sign-systems but the extent to which Zola finds vision essential to each. At the stage of creation, he describes painting and writing identically (see Chapter 5); at the stage of representation, he recognizes the necessity of "translating" the visual into verbal terms, but, given Zola's faith in the referential function of language, this is not an undertaking that is problematic by nature but rather a question of finding an adequate "translation" (see Chapter 4).

Zola undertakes in literature a visual revolution like that of Manet and the impressionists in painting—against the precept and prejudice of abstract thought, which, he maintains, has long dominated the arts, verbal as well as visual. He notes as early as 1864 that "les règles n'ont leur raison d'être que pour le génie, d'après les oeuvres duquel on a pu les formuler; seulement, chez ce génie, ce n'étaient pas des règles, mais une manière personnelle de voir" ("rules are applicable only to the genius from whose works they were formulated; except that, for the genius, they weren't rules, but a personal way of seeing," *Correspondance,* 252). Zola frequently speaks of creative vision as the single most essential attribute of the artist, noting that "le don de voir est moins commun encore que le don de créer" ("the gift of seeing is even less common than the gift of creating," *Roman expérimental,* 169). He goes so far as to

characterize his times by phrases such as "c'est l'heure de la vision nette" ("it's the hour of clear seeing," *Roman ex., 79*).

To Zola, unfettered vision and the return to direct observation become the highest goals to which the author, like the painter, can aspire. Consequently, the words "observe," "vision," "see," and "eye" permeate his literary theories, just as they do his art criticism, and assume within them the important positions by which they come to define many of the major components of naturalism. Seeing is inseparable from knowing and creating in Zola's following description of his aspirations: "Je voudrais coucher l'humanité sur une page blanche, tout voir, tout savoir, tout dire" ("I would like to lay humanity out on a white page, see all, know all, tell all").[24] He uses strictly similar terms in praising the work of his contemporaries at a banquet for students in 1893: "ma génération . . . s'est efforcée d'ouvrir largement les fenêtres sur la nature, de tout voir, de tout dire" ("my generation . . . attempted to open wide the windows onto nature, to see all, to tell all," *Mélanges, préfaces et discours, 286*).

Zola frequently stresses the importance of the visual aspects of verbal representation, as in his renowned definition of a work of art as a "corner of creation seen through a temperament," which was cited in relation to his Salons. The same formula appears throughout his literary criticism, as in the following example from *Mes Haines,* where visuality is emphasized:

> Ainsi, il est bien convenu que l'artiste se place devant la nature, qu'il la copie en l'interprétant, qu'il est plus ou moins réel selon ses yeux, en un mot, qu'il a pour mission de nous rendre les objets tels qu'il les voit, appuyant sur tel détail, créant à nouveau. J'exprimerai toute ma pensée en disant qu'une oeuvre d'art est un coin de la création vu à travers un tempérament.
>
> (Thus, it is agreed that the artist places himself before nature, that he copies it while interpreting it, that his mission is to represent objects as he sees them, insisting on a given detail, creating anew. I will express my whole thought in saying that a work of art is a corner of creation seen through a temperament. *Mes Haines,* 176)

Zola stresses the importance of visual concerns in his assessment of specific writers as much as in his theoretical pronouncements. He notes of the predecessor he admired most that "Balzac regarde et raconte; le choix de l'objet sur lequel tombent ses regards lui importe peu, il n'a que le souci de tout regarder et de tout dire" ("Balzac looks and recounts; the choice of

24. Quoted in Armand Lanoux, *Bonjour Monsieur Zola* (Paris: Hachette, 1954), 136–37.

object on which his eyes fall matters little to him; his only concern is to look at everything and tell everything," *Mes Haines,* 146). He says of Daudet that he records human experience, "ayant tout vu avec ses yeux de myope, jusqu'aux petits détails qui auraient échappé à de bons yeux" ("having seen everything with his nearsighted eyes, even the fine details that would have escaped the best of eyes," *Les Romanciers naturalistes,* 216). The following quotation, concerning the Goncourts, illustrates Zola's understanding of the way a painterly vision came to characterize their perception of reality and, thus, the nature of their writing:

> Ils ont commencé par être tellement sensibles au monde visible, aux formes et aux couleurs, qu'ils ont failli être peintres. . . . Même, plus tard, quand ils ont eu à faire une description capitale, ils sont allés prendre une vue de l'horizon, ils ont rapporté, dans leur cabinet, une aquarelle, comme d'autres rapportent des notes manuscrites sur un agenda. . . . A chaque page, on retrouvera ainsi la touche vive et sentie, le croquis de l'artiste.

> (They began by being so sensitive to the visible world, to shapes and colors, that they almost became painters. . . . Indeed, later, when they had an important description to do, they would go and locate a view of the horizon, they would take a watercolor back to their study, much as others use handwritten notes. . . . Thus on every page one will find the lived and felt touch, the artist's sketch. *Les Romanciers naturalistes,* 192–93)

Zola makes the same link to painting in describing a forerunner whose work he did not particularly admire: "en somme, Théophile Gautier avait l'oeil d'un peintre, et telle était sa qualité maîtresse. Toute sa vie littéraire, toute son oeuvre découlait de là. Il écrivait comme on peint, avec le seul souci des lignes et des couleurs" ("in short, Théophile Gautier had a painter's eye, and this was his predominant trait. All of his literature, all of his work stemmed from that. He wrote, much as one paints, with the sole concern for lines and colors," *Documents littéraires,* 115).

The coupling of "painter" and "observer" is applied to his disciple J.-K. Huysmans (*Une Campagne,* 205) and even to Petronius![25] These were two of the most complimentary epithets in Zola's repertoire; in 1868, he wrote for the first time to Flaubert, whom he admired above all other

25. "Si maintenant j'interroge la littérature latine, je ne trouve guère chez les Romains que deux romanciers, Apulée et Pétrone. Ce dernier fut un véritable romancier, un observateur clairvoyant, un peintre fin et spirituel" (quoted in Guy Robert, "Trois textes inédits de Zola," *Revue des sciences humaines* 51–52 [July–December 1948]: 200).

living novelists, sending him a copy of *Madeleine Férat:* "Veuillez accepter le volume ci-joint comme un hommage à votre talent d'observateur et de peintre" ("Please accept the enclosed volume as a hommage to your talent as an observer and painter," *Correspondance,* 353).

Of the many visual terms recurring in Zola's definitions of art, "observer" and "observation" are the most common and significant. Zola regarded naturalism, in literature as in painting, as being essentially a "new vision," a return to direct observation: "On me demande pourquoi je ne me suis pas contenté du mot réalisme, qui avait cours il y a trente ans; uniquement parce que le réalisme d'alors était une chapelle et rétrécissait l'horizon littéraire et artistique. Il m'a semblé que le mot naturalisme élargissait, au contraire, le domaine de l'observation" ("I've been asked why I wasn't content with the word realism, which was being used thirty years ago; solely because realism was a hallowed realm narrowing the literary and artistic horizon. It seemed to me that the word naturalism, on the other hand, expanded the domain of observation," *Le Naturalisme au théâtre,* 147). He insisted on characterizing himself as "simplement un observateur qui constate des faits" ("simply an observer who confirms facts," *Roman ex.,* 92), and he spoke categorically of "le roman naturaliste, le roman d'observation et d'analyse" ("the naturalist novel, the novel of observation and analysis," *Roman ex.,* 166).

Zola believed that the ability to observe correctly and critically was a contemporary phenomenon (Petronius notwithstanding!), contending that "l'observation, l'étude de la nature, est devenue aujourd'hui une méthode qui était à peu près inconnue au XVIIe siècle" ("observation, the study of nature, has become today a method that was more or less unknown in the seventeenth century," *Nat. au théâtre,* 80). In fact, with characteristic temerity, he located its inception in the eighteenth century: "On partait d'un fait observé, on avançait ainsi d'observation en observation, en évitant de conclure avant de posséder les éléments nécessaires. En un mot, au lieu de débuter par la synthèse, on commençait par l'analyse" ("One began with an observed fact and then proceeded from observation to observation, avoiding concluding before possessing the necessary elements. In a word, instead of beginning with synthesis, one began with analysis," *Roman ex.,* 94)—and its flourishing in the nineteenth century with thinkers like Taine[26] and writers like Balzac (*Documents littéraires,* 199–200) and Daudet (*Une Campagne,* 309).[27]

26. See, for example, *Lettres de Paris,* ed. Phillip Duncan and Vera Erdeley (Geneva: Droz, 1963), 34.

27. But not Stendhal (*Romanciers naturalistes,* 75) and Dumas (*Documents littéraires,* 199–200).

Although the words "observation" and "observer" may have other connotations, Zola is careful to qualify them in such a way as to ensure that only their most concrete, visual meanings could be inferred by the reader. In the following passage, for example, he links the word "observation" to the critic's eyesight: "Le critique est semblable au médecin . . . il note ses observations au fur et à mesure qu'il les fait, sans se soucier de conclure ni de poser des préceptes. Il n'a pour règle que l'excellence de ses yeux et la finesse de son intuition" ("The critic is like the doctor . . . he notes his observations as he makes them, without concern for concluding or postulating precepts. His only rule is the excellence of his eyes and the insight of his intuitions," *Mes Haines,* 164). In another remark, made to a scientific congress, Zola directly associates the term "observation" with a number of clearly visual expressions: "La vie fiévreuse et emportée de Paris déjoue les délicatesses de l'observation. . . . Que les jeunes écrivains qui ont de bons yeux se mettent donc à l'oeuvre. Ils n'ont qu'à regarder autour d'eux et dire ensuite ce qu'ils ont vu" ("The feverish and excessive pace of Paris thwarts the insights of observation. . . . Let the young writers with good eyesight go to work. They have only to look around and then recount what they have seen").[28]

The term "observation," then, in its most visual sense, is virtually synonymous with "naturalism" and recurs in many of Zola's theories, definitions, and critical judgments concerning modern literature. We frequently find the epithet "observer" linked with those of "painter," "analyst," and "creator," but, by far the most common coupling, especially after the publication of *Le Roman expérimental* in 1880, is with the word "experimenter." Zola notes, for example, that "le romancier est fait d'un observateur et d'un expérimentateur" ("the novelist is made of an observer and an experimenter," *Roman ex.,* 16), and it is precisely these two terms that ultimately come to characterize naturalism: "Seulement, je constate la grande évolution d'observation et d'expérimentation qui caractérise notre siècle, et j'appelle naturalisme la forme littéraire amenée par cette évolution" ("However, I note the great evolution of observation and experimentation that characterizes our century, and I

28. In Guy Robert, "Trois textes inédits de Zola," 207. A. David-Sauvageot, an art critic and a contemporary of Zola, uses the term "observation" in the same purely visual, nonabstract way as the author of *Les Rougon-Macquart* when he says: "C'est l'observation qui est le premier et le principal outil. Remarque souvent faite, pour qualifier un bon ouvrage on disait autrefois: bien imaginé; tandis qu'aujourd'hui l'on dit: bien observé. Les yeux des réalistes de toute école sont comme braqués sur la réalité" (*Le Réalisme et le naturalisme* [Paris: Calmann Lévy, 1890], 197).

call naturalism the literary form brought on by this evolution," *Nat. au théâtre*, 149).[29]

As "observation" (the most recurrent of the many words denoting vision in Zola's theories) becomes increasingly linked to the term "experimentation," this formula comes to figure in most of Zola's definitions concerning naturalism. Consequently, following the thread of visual concerns through Zola's theoretical works leads inevitably to *Le Roman expérimental*, where Zola defines these key terms, delineating the relationships between them.

Creative Vision in the Experimental Novel

The sheer number of Zola's remarks related to observation and vision confirms the extent to which vision had penetrated and even dominated his poetics, but few cited thus far have offered any precise definition of visual terms. It is in *Le Roman expérimental* that Zola systematically describes his concept of observation. By adopting the theories of the French experimental scientist Claude Bernard, Zola is able to define a type of creative, analytic vision capable of yielding significant discoveries in the arts as well as the sciences. This concept of seeing, when related to the innovations of Manet and the impressionist painters and to Zola's own descriptive and imaginative techniques in literature, will facilitate a reassessment of the role and reputation of *Le Roman expérimental*, called "embarrassingly naive"[30] and "unbelievably naive"[31] by critics today and which elicited a cry of "Poor Claude Bernard!"[32] at the time of its publication.

Zola's frequent linking of observation with some other quality, particularly analysis or experimentation, seems to indicate a realization on his part that pure observation does not alone constitute a meaningful approach to art or experience. In fact, he had recognized the necessity for "cheating" against the principle of direct observation as early as 1868, while he was planning the Rougon-Macquart series; he tells himself in the preliminary notes:

29. In his criticism he applies these two epithets to the artists he admires most, his disciple Céard (*Une Campagne*, 207), his ancestor Balzac (*Une Campagne*, 104; *Romanciers naturalistes*, 64), and his "master" Flaubert (*Romanciers naturalistes*, 162).

30. Angus Wilson, *Emile Zola: An Introductory Study of His Novels* (New York: William Morrow, 1952), 25.

31. F. W. J. Hemmings, *Emile Zola*, 2nd ed. (Oxford: The Clarendon Press, 1966), 151–52.

32. A. de Pontmartin, *Souvenirs d'un vieux critique* (Paris, 1881) in Le Blond's notes for *Le Roman expérimental*, 345.

Avoir surtout la logique de la déduction. Il est indifférent que le fait générateur soit reconnu comme absolument vrai; ce fait sera surtout une hypothèse scientifique, empruntée aux traités médicaux. Mais lorsque ce fait sera posé, lorsque je l'aurai accepté comme un axiome, en déduire mathématiquement tout le volume, et être alors d'une absolue vérité.

(Use deductive logic especially. It is unimportant that the initial fact be recognized as absolutely true; this fact will mainly be a scientific hypothesis, borrowed from medical treatises. But once this fact is in place, once I have accepted it as an axiom, deduce the whole volume from it mathematically, and thus be of absolute truth.)[33]

Zola increasingly found observation to be either too passive, thus degenerating into a merely photographic and purely representational faculty, or too personal and subjective, thus becoming no more than an orgy of visual sensation, self-satisfying but sterile.

Basically, two novelistic needs propel Zola beyond the boundaries of pure observation—the need for scientific analysis and experimentation on the one hand and for fictional freedom on the other. Zola's naturalism differs from what he terms "photographic realism" precisely because of the naturalist's proposal to study, in scientific fashion, the influence of heredity and milieu on the human being and because of its highly figurative language and imaginative rendering of characters and events. Within this context, it is easy to imagine why Zola must have been struck by the first words of Bernard's essay on experimental medicine: "Man can only observe the phenomena surrounding him within highly restrictive limits; the majority escapes his senses naturally, and observation is insufficient. . . . man does not limit himself to seeing; he thinks and wants to know the meaning of phenomena whose existence was revealed to him by *observation*."[34]

According to Bernard, observation alone does not constitute scientific procedure; it must be complemented by hypothesis and analysis. The

33. In Pierre Martino, *Le Roman réaliste sous le Second Empire* (Paris: Hachette, 1913), 283.

34. "L'homme ne peut observer les phénomènes qui l'entourent que dans des limites très restreintes; le plus grand nombre échappe naturellement à ses sens, et l'observation ne lui suffit pas. . . . l'homme ne se borne pas à voir; il pense et veut connaître la signification des phénomènes dont *l'observation* lui a révélé l'existence." *Introduction à l'étude de la médecine expérimentale*, 17. This and all further page references are from the Classiques Larousse edition (Paris: Librairie Larousse, 1951), subsequently referred to parenthetically in the text as *Introduction*, followed by the page number.

doctrine of determinism, for example, exacts a strict analysis of each phenomenon in terms of the causal relationships that it establishes with other phenomena. Zola paraphrases Bernard's conception of this doctrine as follows:

> Il appelle "déterminisme" la cause qui détermine l'apparition des phénomènes. Cette cause prochaine, comme il la nomme, n'est rien autre chose que la condition physique et matérielle de l'existence ou de la manifestation des phénomènes. Le but de la méthode expérimentale, le terme de toute recherche scientifique, est donc identique pour les corps vivants et pour les corps bruts: il consiste à trouver les relations qui rattachent un phénomène quelconque à sa cause prochaine, ou autrement dit, à déterminer les conditions nécessaires à la manifestation de ce phénomène.

> (He calls "determinism" the cause that determines the occurrence of phenomena. This immediate cause, as he terms it, is nothing other than the physical and material condition for the existence or manifestation of phenomena. The aim of the experimental method, the goal of all scientific research, is therefore identical for living bodies and for inanimate bodies: it consists of finding the relationships that link a given phenomenon to its immediate cause, or otherwise stated, of determining the conditions necessary for the manifestation of that phenomenon. *Roman ex.*, 13)

A "relationship" is a bond between two observable phenomena but is not itself observable, so that the scientist is inevitably forced to extend analyses beyond the visible and into the realm of the abstract. Bernard further explains that the complexity of such relationships necessitates the implementation of analytic experimentation in addition to observation: "However, in the experimental sciences these relationships are surrounded by numerous phenomena that are infinitely complex and varied, which hide them from our eyes. With the help of experimentation, we analyze, we dissociate these phenomena, in order to reduce them to progressively simpler relationships and conditions" (*Introduction*, 78).[35]

Like the scientist for Bernard, the novelist, according to Zola, must not be content with mere observation but must set further goals: "Il lui

35. "Seulement dans les sciences expérimentales ces rapports sont entourés par des phénomènes nombreux complexes et variés à l'infini, qui les cachent à nos regards. A l'aide de l'expérience nous analysons, nous dissocions ces phénomènes, afin de les réduire à des relations et à des conditions de plus en plus simples."

faudra voir, comprendre, inventer" ("he has to see, understand, invent," *Roman ex.,* 19); "voir n'est pas tout, il faut rendre" ("seeing isn't everything; one has to depict," *Roman ex.,* 171). Zola must seek, then, to mold the principal tenet of naturalism, the return to direct observation, to conform with the exigencies of analysis and imagination—faculties required by both scientist and artist—and, indeed, the novelist comes to ask himself: "en littérature, où jusqu'ici l'observation paraît avoir été seule employée, l'expérience est-elle possible?" ("in literature, where observation alone appears to have been used up to now, is experimentation possible?" *Roman ex.,* 14).

This question is at the very root of positivism, because it expresses the fundamental disparity between the movement's methodology, based on direct observation, and its chief goal, scientific knowledge. The solution to this basic rift in the tenets of positivism preoccupied thinkers during the second half of the nineteenth century and was often on Zola's mind as well as those of his closest friends. In fact, Cézanne's objective has been described as "preserving sensibility's essential role while substituting conscious reflection for empiricism,"[36] and, as has been shown, the synthesis of the natural and the analytic was the principal legacy of impressionist painting, according to Zola and numerous contemporaries. Although this synthesis was reflected in the thought of many of the great minds of the late nineteenth century, Zola found its most cogent expression and most applicable resolution in Bernard's treatise.

The experimental method, as described by Bernard, solves the dualism between observation and experiment by wresting the latter from the abstract, reflective position it had previously occupied in scientific thought and making it primarily external and observational. In short, Bernard, as quoted by Zola, resolves the disparity between the basic components of positivism by asserting that "l'expérience n'est au fond qu'une observation provoquée" ("basically, an experiment is only an induced observation," *Roman ex.,* 12). Zola's paraphrase of Bernard continues with a description of the sophisticated, dialectical process by which the experimenter becomes observer, by which thought becomes visual and external:

> L'observateur constate purement et simplement les phénomènes qu'il a sous les yeux. . . . Il doit être le photographe des phénomènes; son observation doit représenter la nature. . . . Mais une fois le fait constaté et la phénomène bien observé, l'idée arrive, le

36. Maurice Denis, "Cézanne," *L'Occident* 12 (September 1907), in John Rewald, *The History of Impressionism,* 414.

raisonnement intervient, et l'expérimentateur apparaît pour inter-
préter le phénomène. Dès le moment où le résultat de
l'expérience se manifeste, l'expérimentateur se trouve en face
d'une véritable observation qu'il a provoquée, et qu'il faut con-
stater, comme toute observation, sans idée préconçue. L'expéri-
mentateur doit alors disparaître ou plutôt se transformer in-
stantanément en observateur.

(The observer notes purely and simply the phenomena in front of
his eyes. . . . He must be the photographer of the phenomena; his
observation must represent nature. . . . But once the fact is noted
and the phenomenon well observed, thought arrives, reasoning
intervenes, and the experimenter appears in order to interpret the
phenomenon. . . . From the moment when the result of the ex-
periment occurs, the experimenter finds himself before a veritable
observation that he has induced, and that he must note, as with
any observation, without preconception. The experimenter must
then disappear or, rather, transform himself instantly into an ob-
server. *Roman ex.*, 15)

For Bernard, the experimental method is not primarily reflective, but
occurs simultaneously with observation; the seemingly disparate pro-
cesses of observation and experimentation, and, indeed, the rift between
the visual and scientific aspects of positivism, are synthesized into one
direct, immediate, visual process: "With experimental reasoning, the ex-
perimenter is not separate from the observer . . . he must himself be at
once observer and experimenter" (*Introduction*, 37; see also *Roman ex.*,
15–16).[37]

The experimental method, as outlined by Bernard, thus enabled Zola
to proceed beyond "photographic realism," while remaining faithful to
its doctrine of direct observation, by incorporating analysis and experi-
mentation into the act of seeing: "Un reproche bête qu'on nous fait, à
nous autres écrivains naturalistes, c'est de vouloir être uniquement des
photographes. . . . Eh bien! avec l'application de la méthode expérimen-
tale au roman, toute querelle cesse. L'idée d'expérience entraîne avec elle
l'idée de modification" ("A stupid criticism made against us naturalist
writers is that we want to be merely photographers. . . . Well! with the
application of the experimental method to the novel, debate ceases. The
idea of experimentation entails with it the idea of modification," *Roman*

37. "Dans le raisonnement expérimental, l'expérimentateur ne se sépare pas de
l'observateur . . . il doit être lui-même à la fois observateur et expérimentateur."

ex., 18). In a later example, Zola again denies the title "photographer," here on the grounds of the role of imagination in his art:

> Les gens qui ont fait la naïve découverte que le naturalisme n'était autre chose que de la photographie, comprendront peut-être cette fois que, tout en nous piquant de réalité absolue, nous entendons souffler la vie à nos reproductions. De là style personnel, qui est la vie des livres. Si nous refusons l'imagination, dans le sens d'invention surajoutée au vrai, nous mettons toutes nos forces créatrices à donner au vrai sa vie propre.

> (Those who made the naive discovery that naturalism was nothing other than photography will perhaps understand this time that, while priding ourselves on absolute reality, we mean to breath life into our reproductions. Whence personal style, which is the life of books. If we deny imagination, in the sense of invention added on top of truth, we put all of our creative energies into giving truth its own life. *Roman ex.,* 200)

Unlike "invention"—the indulgence in subjective fantasy—"imagination," like experimentation, is a part of the visual process. In fact, the experimental method encourages the liberal exercise of imagination as part of scientific procedure; Bernard notes that "one must certainly refrain from prohibiting the use of hypotheses and ideas in instituting the experiment. To the contrary, one must give full reign to one's imagination" (*Introduction,* 40).[38] Indeed, as one critic has stated, concerning imagination in *Le Roman expérimental:* "Zola follows Bernard closely on the absolute necessity and primary importance of an initial insight derived from observation. For both men, this idea is the special inspiration of genius, without which there can be nothing. The core of Zola's analogy between art and science rests upon this common point, from which one may progress either to the acquisition of new knowledge or to the creative act."[39]

However, the scientific imagination of Zola and Bernard, founded on deduction and hypothesis, must not be confused with pure fantasy. As Zola notes, the scientist's imagination, contrary to that of the idealist, must be firmly grounded in the observable phenomena of external reality: "Comme le dit Claude Bernard: 'L'idée expérimentale n'est point

38. "il faudrait bien se garder de proscrire l'usage des hypothèses et des idées quand il s'agit d'instituer l'expérience. On doit, au contraire, comme nous le verrons bientôt, donner libre carrière à son imagination."

39. Gordon Dewart, "Emile Zola's Critical Theories on the Novel "(Ph.D. diss., Princeton University, 1953), ii, 69.

arbitraire ni purement imaginaire; elle doit toujours avoir un point d'appui dans la réalité observée, c'est-à-dire dans la nature'" ("As Claude Bernard says, 'The experimental idea is not at all arbitrary or purely imaginary; it must always have a basis in observed reality, that is, in nature,'" *Roman ex.*, 18–19; see also 23, 36, and 181).

Zola draws the same distinction between types of imagination elsewhere in stating that "l'imagination, j'entends le rêve, la fantaisie, ne peut que vous égarer. L'imagination . . . devient de la déduction, de l'intuition" ("imagination, meaning dream or fantasy, can only lead you astray. Imagination . . . is becoming deduction and intuition," *Nat. au théâtre*, 201). Far from contradicting reality by offering an alternative to it, an escape from it, imagination must be in the nature of a deduction derived from and remaining faithful to the phenomena of the external world. Imagination, firmly controlled by observation, thus fosters scientific discovery, which understands and affirms reality instead of rejecting it, as Zola felt the idealists did. By making the artist's *eye,* rather than his brain, heart, or spleen, the seat of his imagination, Zola attempts to adapt the personal and deforming qualities of artistic creation to the principal tenet of naturalism, the return to the direct and immediate observation of natural phenomena. By expanding his conception of vision to include imagination, Zola is able to avoid abstraction and invention on the one hand and mere photographic realism on the other. His theories point toward a creative and imaginative visual process that will blend and synthesize the acute observation of the camera's lens with the poetic re-creation of the artist's temperament.

Zola's radically scientific poetics distinguish him from most of his French contemporaries, but his thought on visual creativity rejoins that of Conrad Fiedler, the German art critic who outlined a similar program for creative yet direct vision, which he, too, felt to be at the root of modern artistic activity. Fiedler, like Zola, condemned photographic realism: "The so-called realists are not . . . to be blamed because in their works they put the main stress upon sensuous appearance, but on account of the fact that, commonly, they cannot perceive in sensuous appearance anything more than what the most limited perceptive faculty can gain from it" (*On Judging,* 59). Like Zola, Fiedler chastised the idealists for their "invention," which tends to deny nature altogether: "The idealists, however, by neither feeling satisfied with nature as they observe it nor being able to develop their perceptions of nature to ever higher levels, try to remedy the artistic insufficiency of their own creations by giving them a non-artistic content" (*On Judging,* 60). Fiedler, like Zola, contended that true art must remain faithful to visible reality: "The origin and existence of art is based upon an immediate mastering of the visible

world" (*On Judging*, 43); thus, it is visual prowess that defines artistic temperament and talent: "It is to the independent and free development of perceptual experience that we must look for the peculiar power of artistic talent" (*On Judging*, 27).

Elsewhere, Fiedler defines the artist in terms of visual acuity and activity:

> Artistically gifted people differ from others only in the ways their eyes function; in every other respect they are equal. Unfolding and developing awareness of reality specializes in a particular manner in the artistically gifted, solely by virtue of the visual faculty. In the artist seeing develops in a way peculiar to him; it exhausts itself neither by aiding in the formation of images and concepts nor by the partially passive function of receiving impressions. Rather, it attaches to this passive function an advancing activity, for basically the behavior of the visual organ cannot be termed passive and purely receptive.[40]

Fiedler concludes, as did Zola, that the seat of artistic creation is solely in the artist's *eye:*

> It seems strange that an organ, common to all men and extensively used by all, should be the active center of a performance limited to a few. Men readily admit that the activity of the artist is not only based on the use of the eye, but is unthinkable without it. Nevertheless, they assume a special artistic power apart from the eye and served by it only in an auxiliary capacity. And yet we may peer within the workshop of artistic activity only when we realize that in essence this activity depends entirely on the eye. Only such realization can strip the artistic process both of the semi-mystical character which it possesses for some and of the trivial meaning attributed to it by others. Only such realization reveals it as a natural process which unfolds from the simplest beginning to endless breadth and height.[41]

Thus, Zola's complaint that "the gift of seeing is even less common than the gift of creating" and his contention that creativity was, in fact, "an

40. From "Three Fragments," in *From the Classicists to the Impressionists,* ed. Elizabeth Gilmore Holt, vol. 3 of *A Documentary History of Art* (New York: Doubleday Books, 1966), 449.

41. Ibid., 452.

optical phenomenon," "a personal way of seeing," clearly reflect the spirit of his generation, which Fiedler articulates in Germany, as Zola does in France.[42] Moreover, the importance of creative vision in Zola's theories of imagination adds credence to his claim, cited in the Preface, that he could leap "toward the stars on the springboard of precise observation" and demands attention to his warning that in order to discover the secret of his imagination, the reader must literally be prepared to "take apart the mechanism of [his] eye" (*Correspondance*, 635–36).

On a purely theoretical level, the experimental method marks a synthesis of science and vision, a resolution of a basic disparity in the thought of Zola and the entire positivist movement. *Le Roman expérimental* is Zola's most systematic statement concerning certain visual notions that were always present in his work, and, consequently, this theoretical tract gives unity and direction to the otherwise isolated and underdeveloped theories concerning vision and visual effects that permeate Zola's poetics.

Zola's literary theories express clearly his belief that the eye could embrace, within the act of seeing, the faculties of cognition and imagination required for scientific analysis and literary creation. Nor was he alone in this belief: Conrad Fiedler, the German art critic, and Jules Laforgue, the French poet, along with Claude Bernard, the experimental scientist, expressed similar theories of "pure visuality," and, indeed, Manet and the impressionist painters, whom Zola knew intimately and defended publicly, had manifested this same purely visual, yet analytic and imaginative, manner of seeing in their work. In dissecting the workings of Zola's eye, the traces of analytic vision will be treated in Chapter 4 (description), while the manifestations of creative vision will be dealt with in Chapter 5 (imagination).

42. Among those late nineteenth-century French artists who embraced a doctrine of "pure visuality" similar to that of Zola and Fiedler were Jules Laforgue, who was, as one critic notes, directly influenced by Fiedler—"En se rattachant à l'esthétique de la 'visualité pure' de Fiedler, Laforgue affirme que la peinture la plus admirable est non pas celle où se retrouvent les chimères d'écoles, mais celle qui révèle l'oeil qui est allé le plus loin dans l'évolution de la visualité 'par le raffiné de ses nuances ou le compliqué de ses lignes'" (Venturi, *Les Archives de l'impressionnisme*, I, 67)—and Paul Valéry, who contended that "Je tiens qu'il existe une sorte de mystique des sensations, c'est-à-dire une 'Vie Extérieure' d'intensité et de profondeur au moins égales à celles que nous prêtons aux ténèbres intimes et aux secrètes illuminations des ascètes, des soufis, des personnes concentrées en Dieu" (from "Autour de Corot," *Pièces sur l'art* [Paris: Gallimard, 1946], 147).

2 Visual Interaction: Vision and Thematics

J'ai vu, de mes yeux vu. (I saw, saw with my eyes.)
—Jordan. *L'Argent* (350)

Vision constitutes a major, overt theme in virtually every Zola novel. The visual interaction among characters or between character and world is highlighted on the most obvious level by numerous verbs denoting perception (505 in *L'Oeuvre,* for example) and by frequent reference to the eyes (245 times in *L'Oeuvre*), often in a position of prominence. The visual field is circumscribed only by the infinitely large limits of the universe on the one hand—"ces atomes planétaires que l'oeil humain ne peut découvrir" ("these planetary atoms that the human eye cannot discover," *Une Page d'amour,* 973)—and by the infinitely small boundaries of genetic structure on the other—"ce monde de ressemblances que transmettent le spermatozoïde et l'ovule, où l'oeil humain ne distingue absolument rien, sous le grossissement le plus fort du microscope!" ("this world of resemblances transmitted by spermatozoa and ova, where the human eye distinguishes absolutely nothing, [even] under the micro-

scope's strongest magnification!" *Le Docteur Pascal,* 946). Within these vast parameters, a seemingly limitless number of modes, manners, and means of seeing are dramatized and explored in Zola's universe.

Ocular instruments (like opera glasses), optical effects (like shadows), and visual devices (like mirrors) reinforce the thematic role of vision in nearly every novel, much as they characterize a painting like Mary Cassatt's *Woman with a Pearl Necklace in a Loge* (Fig. 1), where opera glasses and mirrors transform the central theme into seeing itself. In several of Zola's novels, certain optical phenomena, through prominence and repetition, come first to function as themes, then to shape the very structure of the novel, while suggesting the keys to its interpretation. Binoculars can reveal the tracings of military strategy, success, and failure (*La Débâcle*). Mirrors are a means of capturing the elusive other (*Le Ventre de Paris*) or one's self (*La Curée*); reflected images can lead to narcissism (*Nana*) or communication (*La Fortune des Rougon*). Similarly, shadows, "impressions" hinting at some absent object, can create mystery (*La Conquête de Plassans*) or knowledge (*Nana*). Looking (*le regard*) can be a symptom, even a cause, of jealousy and rivalry, as suggested by previous studies, but also of communication and understanding, a visual language with its own sign system, as will be demonstrated here. However, the human eye, our link to life, can also reveal the detachment of madness, castration, and death (*L'Oeuvre*).

While the number of visual motifs places seeing among the principal master themes of *Les Rougon-Macquart,* the very diversity of those motifs precludes any fixed thematic or symbolic value associated with vision. Rather, vision acquires its meaning from its interplay with other themes within the context of the individual work and provides a unique point of entry into the thematic networks governing many of Zola's novels. The strategy of presentation adopted in this chapter and, indeed, throughout this study is first to cite a number of examples of a given visual phenomenon, in order to establish the extent of its impact on Zola's work, and next to analyze in detail several examples of the phenomenon in individual novels, in order to trace its interaction with other themes.

Eyesight and Optical Aids

A character is often defined in terms of his or her visual characteristics. Zola lends his own myopia, for example, to several characters. When Renée first appears in *La Curée* she is blinking her eyes because of weak

eyesight (319), a tic common to nearsightedness and not without its charm in her case (336, 455) or Nana's (1172). A nearsighted secretary, his nose buried in a book, appears episodically but noticeably in the opening scene of *Son Excellence Eugène Rougon* (13), while in *L'Oeuvre* the woman-izing journalist Jory's myopia leads him to rub noses with old women (73) and even to seduce an old hag, thinking she is younger (175).

However, exceptional visual acuity also marks many of the major characters in the Rougon-Macquart series and is usually associated with their occupations. The brothers Lantier are possessed of fine eyesight, especially the artist Claude in *Le Ventre de Paris* and *L'Oeuvre* and the railway engineer Jacques in *La Bête humaine,* as is their uncle Jean, a peasant in *La Terre,* then a soldier in *La Débâcle.* But the latter's sight hardly matches that of Françoise, his future wife: "Elle avait ce coup d'oeil de matelot, cette vue longue des gens de la plaine, exercée aux détails, capable de reconnaître un homme ou une bête, dans la petite tache remuante de leur silhouette" ("She had a sailor's sight, that farsightedness of plains people, trained for details, capable of recognizing a man or an animal from the small moving mark of its shadow," 372). Pascal, the physician-protagonist of the final novel in the series, has eyesight of similar caliber: "Pascal, de son coup d'oeil de médecin, avait fouillé à fond son neveu" ("Pascal, with his doctor's eyesight, had inspected his nephew to the core," 966).

The visual field becomes playing field, even battlefield, as various characters equip themselves with a variety of optical instruments for a multitude of purposes. The monocled Malignon seeks social standing in *Une Page d'amour* (979); rakes use opera glasses (*jumelles*) to ogle fashion-able women in *Nana* (1103), while the titular character uses the same instrument to follow the progress of her namesake, a horse, at Long-champs (1386). The nearsighted Renée, when out of public view in *La Curée,* takes up her man's pince-nez (*binocle*) (320, 448), and, for spotting those microscopic details that reveal the flaws of female foes in photos, she and Maxime take to using a strong magnifying glass (428; see also *Le Ventre de Paris,* 812). Doctor Pascal's microscope also plays a prominent role, more detached and scientific in purpose (949).

By far the most consistent, striking, and significant use of optical instruments occurs in *La Débâcle,* for obvious military purposes and not-so-obvious thematic and narrative strategy. Weiss, who wears eyeglasses only on special occasions, when he needs very clear sight (576), doubles the power of his pince-nez by placing one lense on top of the other in a vain attempt to spot the invisible enemy (571), alternates between his glasses and his pince-nez in fighting the Prussians (577), and is finally able

to see by putting the pince-nez over the glasses (583).[1] Weiss's visual difficulties underscore the elusiveness of the Prussian army, and his futility is reflected in his broken glasses and unstable pince-nez: "Il venait de casser ses lunettes, il en était désespéré. Son binocle lui restait, mais il n'arrivait pas à le faire tenir solidement sur son nez" ("He had just broken his glasses, which drove him to despair. His pince-nez remained, but he couldn't get it to stay solidly on his nose," 634). Finally, the only clear image to appear through the pince-nez is that of his own death before a Prussian firing squad: "Weiss, dont le binocle avait glissé, dans les adieux, venait de le remettre vivement sur son nez, comme s'il avait voulu bien voir la mort en face" ("Weiss, whose pince-nez had slipped off during his goodbyes, had just replaced it sharply on his nose, as if he had wanted to see death clearly before him," 640).

Delaherche's more cautious and distant personality is reflected by the telescope (*lunette d'approche*) that he uses to scan the battlefield from the relative safety of his rooftop (622); he is able to discern the very group of soldiers that eluded Weiss (583) and even locates the Prussian King William and his entire escort, all of them equipped with binoculars (*lorgnettes*, 687), calmly surveying the giant battlefield chessboard from a position whose elevation suggests Prussian dominance.[2] While the narrative value of these optical instruments will be discussed in the next chapter (viewpoint), their thematic importance is evident here. The visual demise of Weiss, the detachment of Delaherche, and the dominance of the Prussians are signaled by their respective optical devices, which in turn reflect the personalities and positions in *La Débâcle*. The optical devices call the reader's attention to the importance of seeing, elevate it from the seemingly passive role it may assume in everyday life to the status of a major theme. The visual medium often dominates and even controls the verbal message, as it does in the case of another optical motif, the mirror.

 1. In his pioneering article—"The Mirror, the Window, and the Eye in Zola's Fiction," *Yale French Studies* 42 (June 1969): 52–67—Philip Walker discusses Weiss's preoccupation with eye-gear as an example of Zola's obsession with optics (54). Walker is among the first to point out the central thematic role of optical instruments in Zola's novels: "The window, the mirror, the eye—all those things which intervene between the observer and the object observed, which obstruct light, frame, filter, bend, transform it or interpret the data it transmits—are, indeed, among the most central, recurrent, and characteristic motifs of his art" (52).
 2. See David Baguley, "Le Récit de guerre: Narration et focalisation dans *La Débâcle*," *Littérature* 50 (May 1983): 77–90, for an excellent discussion of the role of these shifts of focus in Zola's narrative presentation of the battle scene. See also Philippe Hamon, *Le Personnel du roman: Le Système des personnages dans les "Rougon-Macquart" d'Emile Zola* (Geneva: Droz, 1983), 80, for a brief discussion of this scene in terms of military strategy ("lignes de tir" and "lignes de mir").

Mirror, Mirror . . .

Mirrors remove the object from the state of reality to that of image or, rather, remind us that the real is no more than an image, elusive at that. Mirrors also allow one to see oneself as other or, rather, to realize that the physical, visible self is an "other," often a "stranger." This other self—this image of the self—can grow remote, signaling madness or death, or can be recuperated, through the visual medium of the reflected image.

As Philip Walker demonstrates convincingly, mirrors play a key thematic role in many of Zola's novels.[3] Sometimes, however, their role is primarily decorative. The many mirrors of the Quenu-Gradelle delicatessen in *Le Ventre de Paris* open the shop up to infinity, while displaying its many culinary delights (653). A multitude of mirrors multiply mannequins in *Au Bonheur des Dames* (392), reflecting displays of goods (621) along with shoppers (627) in the department store whose name serves as the novel's title.

Mirrors are also used for narrative purposes. Zola's program of objective narration, calling for the disappearance of the narrator, often requires describing one character through the eyes of another character (see Chapter 3, viewpoint). When only a single character is present, the mirror affords the opportunity for self-description.[4] Thus, in *La Bête humaine,* Roubaud studies himself in the mirror for the reader's benefit (1000), while *L'Argent* begins in a similar manner, with Saccard describing his mirror image and musing about his past (15). The mirror can cause a character to assess the ravages of his own jealousy, as Hennebeau does in *Germinal* (1432), or to perceive the depths of his own passion, as with Muffat, in *Nana* (1207). The mirror can be a source of comparison, as when Madame Desforges studies herself alongside Denise in *Au Bonheur des Dames* (634), or motivation, as when Octave's image spurs him to seduce Valérie in *Pot Bouille* (59). The view of herself next to Henri causes Hélène to succumb to his advances in *Une Page d'amour:* "Ils étaient seuls, ils se voyaient dans la glace. Alors, tout d'un coup, sans se tourner, empaquetée dans sa fourrure, elle se renversa entre ses bras" ("They were alone; they saw themselves in the mirror. Then, suddenly, without turning, wrapped up in her fur, she leaned back into his arms," 986).

In an extended passage from *Le Ventre de Paris* Zola uses the mirror to dramatize Florent's problematic relationship with women:

3. See "The Mirror, the Window, and the Eye," especially 52–54 and 58–59.

4. See Hamon, *Le Personnel,* 72, for a discussion of the mirror within the context of Zola's narrative program.

Intimidé à mesure qu'il la regardait, inquiété par cette carrure
correcte, Florent finit par l'examiner à la dérobée, dans les glaces,
autour de la boutique. Elle s'y reflétait de dos, de face, de côté;
même au plafond, il la retrouvait, la tête en bas, avec son chignon
serré, ses minces bandeaux, collés sur les tempes. C'était toute une
foule de Lisa, montrant la largeur des épaules, l'emmanchement
puissant des bras, la poitrine arrondie, si muette et si tendue,
qu'elle n'éveillait aucune pensée charnelle et qu'elle ressemblait à
un ventre. Il s'arrêta, il se plut surtout à un de ses profils, qu'il
avait dans une glace, à côté de lui, entre deux moitiés de porcs.
Tout le long des marbres et des glaces, accrochés aux barres à
dents de loup, des porcs et des bandes de lard à piquer pendaient;
et le profil de Lisa, avec sa forte encolure, ses lignes rondes, sa
gorge qui avançait, mettait une effigie de reine empâtée au milieu
de ce lard et de ces chairs crues. Puis, la belle charcutière se
pencha, sourit d'une façon amicale aux deux poissons rouges qui
nageaient dans l'aquarium de l'étalage, continuellement.

(Increasingly intimidated as he watched her, bothered by her cor-
rect bearing, Florent ended up examining her on the sly, in the
mirrors, around the shop. She was reflected from the back, from
the front, from the side; even in the ceiling, he found her, her head
lowered, with her tight bun, her thin tresses clinging to her tem-
ples. It was a whole crowd of Lisas, showing her broad shoulders,
the powerful handles of her arms, her rounded chest, so mute and
tight that it awoke no carnal thoughts and looked like a belly. He
stopped, enjoying especially one of these profiles that he had in a
mirror, beside him, between two sides of pork. All along the
marble and the mirrors, stuck on the serrated bars, hung pork and
strips of bacon; and Lisa's profile, with its strong neck, its round
lines, its protruding bust, created an effigy of a coarse queen
amidst this bacon and raw flesh. Then, the beautiful butcher
leaned over, smiled amicably at the two goldfish swimming in the
display's aquarium, continually. 667)

Florent is able to overcome his notorious fear of women and deal with his
sister-in-law, Lisa, by removing her from raw, threatening reality, by
transforming her into mere images in the many mirrors of the delicates-
sen. The visual pleasure of multiplied images, varied angles, and surpris-
ing perspectives ("even in the ceiling") forms an uncanny prefiguration of
cubist experiments with multiple viewpoint three decades later and be-
trays the desire to see all, to surround and possess the object in its en-

tirety. While this desire is certainly sensual ("round lines . . . protruding bust"), it is hardly sexual ("no carnal thoughts"). Rather, it suggests the obsession with food and eating that confers themes and title on the novel, the latter reflected metaphorically here in the "belly." The greatest source of Florent's visual pleasure stems from a side view: her eyes cannot confront his, allowing him to possess her ("that he had") near to him ("beside him"), while degrading her ("between two sides of pork").[5] While it may suit Florent to elevate his captive into an effigy tinged with artifice and royalty, at the same time he sees her as "coarse" and surrounded by bacon and raw meat. At the end of the paragraph, the fish Lisa watches in the tank are a reflection, a *mise en abyme* of her own situation, trapped as she is in the mirrored walls of the shop for the visual pleasure and dominance of the watcher.

If Florent is able to possess the elusive and threatening other in the fixed and fascinating image of the mirror, several characters exhibit the narcissistic urge to study, capture, and understand themselves. Not surprisingly, the courtesan Nana and the fashionable Renée are chief among them.

Nana is given to staring at herself in various states of undress in front of the mirror, often in the company of men whose role it is to watch her. The pattern of such scenes, repeated in chapters V and VII, stems from the famous Manet painting of 1877 entitled *Nana*. Manet, struck by the character whose precocious sensuality blooms in the final chapters of *L'Assommoir* (1877), painted a scene where an undergarbed actress, standing before a small oval swing mirror (*psyché*), but looking toward the spectator, is being watched by a fully clothed gentleman. Zola then incorporated this scene into the pages of *Nana* (1880), a striking example of reciprocal influence, where text begets painting, which in turn spawns another text.[6] Apart from illustrating the importance of the visual arts in Zola's novels (and vice versa), the episodes are a showcase for vision, since viewing is the principal occupation of the characters. Count Muffat, the court chamberlain, is transfixed by Nana—"Muffat regardait toujours, obsédé, possédé" ("Muffat was still watching, obsessed, possessed," 1271)—but no more so than Nana herself: "Un des plaisirs de Nana était de se déshabiller en face de son armoire à glace, où elle se

5. The pattern is precisely that of Claude Lantier in *L'Oeuvre*. Timid with women in the flesh, he can control them through the painted image: "Ces filles qu'il chassait de son atelier, il les adorait dans ses tableaux, il les caressait et les violentait, désespéré jusqu'aux larmes de ne pouvoir les faire assez belles, assez vivantes" ("These women that he chased away from his studio, he adored them in his paintings, he caressed them and violated them, frustrated to the point of tears at not being able to make them beautiful enough, alive enough," 51).

6. See, for example, Adeline Tintner, "What Zola's *Nana* Owes to Manet's *Nana*," *Iris: Notes in the History of Art* 8 (December 1983): 15–16.

voyait du pied. Elle faisait tomber jusqu'à sa chemise; puis, toute nue, elle s'oubliait, elle se regardait longuement . . . absorbée dans un amour d'elle-même" ("one of Nana's pleasures was to undress in front of her mirrored armoire, where she saw herself from head to foot. She let even her chemise fall; then, completely nude, she was lost in herself, she watched herself for a long time, absorbed in self-love," 1269). She goes on to caress herself before the mirror during a three-page episode of autoerotism, and is finally so taken with her image that she kisses herself, while staring at her reflection and "riant à l'autre Nana, qui, elle aussi, se baisait dans la glace" ("laughing at the other Nana, who, also, was kissing herself in the mirror," 1271).

In *La Curée,* Renée, like Nana, enjoys watching herself in the mirror, an occupation in which she indulges with some frequency (333, 375, 406, 413, 439, 448, 455, etc.), though hardly more enthusiastically than her equally narcissistic stepson *cum* lover Maxime. He is as adept at reading others—"Maxime voyait dans la glace sa tête ardente" ("Maxime saw her ardent head in the mirror," 456)—as he is obsessed with viewing and studying himself: "il possédait un petit miroir qu'il tirait de sa poche, pendant les classes, qu'il posait entre les pages de son livre, et dans lequel il se regardait des heures entières, s'examinant les yeux, les gencives, se faisant des mines, s'apprenant des coquetteries" ("he had a small mirror that, during classes, he pulled out of his pocket, placing it between the pages of his book, watching himself for hours on end, examining his eyes, his gums, making faces, teaching himself cute expressions," 407; see also 555).

Throughout *La Curée,* Zola explores the visual play afforded by re-flected images—"Renée montait, et, à chaque marche, elle grandissait dans la glace" ("Renée went up [the staircase], and, with each step, she grew bigger in the mirror," 333)—while utilizing the mirror's potential for revealing personality (narcissism) and generating plot (seduction).

One prolonged scene, placed strategically in the penultimate chapter, is dominated by the mirror, which serves to provoke and reflect (literally and figuratively) a crystallization of Renée's consciousness of her situation and, in effect, to close the novel. Renée returns to her favorite companion, the mirror, and, ravaged by her experiences, sees herself as other, a sure sign of impending madness: "toute préoccupée par l'étrange femme qu'elle avait devant elle. La folie montait" ("completely preoccu-pied by the strange woman before her. Madness was mounting," 572). Contemplation of her image in the mirror stimulates first a series of images from her past (573), then the hallucinatory images of father and son (574). She sees them, her two lovers, speculating with her as collat-eral, and, acutely aware of her situation, comes to realize that it is they

who have turned her into a public spectacle (575). Finally, the mirror, stimulus, sign, and symbol of consciousness, reveals its harshest secret, impending death: "Quand elle rouvrit les yeux, elle s'approcha de la glace, se regarda encore, s'examina de près. Elle était finie. Elle se vit morte" ("When she reopened her eyes, she approached the mirror, looked at herself again, examined herself close up. She was finished. She saw herself as a dead person," 576). No reader even remotely familiar with Zola would doubt the imminent fulfillment of the vision. Similarly, two chapters before the end of Nana's tale, the sight of her estranged image in the mirror doubles the fallen courtesan's fear of death, soon to be realized (1410).

The reflected image, detached from one's self, divorced from reality, can become a sign of madness and death; however, according to the thematic context, it can also lead to escape from one's situation, into a zone of visual harmony and communication.

Through the Looking Glass

The first novel of the Rougon-Macquart series, *La Fortune des Rougon,* is a novel of closed space, of social and psychological barriers. As the young Republican insurgents, Silvère and Miette, longtime friends and would-be lovers caught in a "naive idyll of primitive love" (170), huddle together, awaiting death at the hands of the government troops, they reflect on their past. Miette, left alone when her father was sentenced to a penal colony, performed hard labor herself in the service of her guardians, the Rébufats, "spending her days enclosed, separated from the world" (174). Silvère, son of Ursule Mouret, née Macquart, was raised by his grandmother, the crazy, reclusive Tante Dide, who lived next to the Rébufats in the Saint-Mittre impasse, "this sad and silent hole where she lived absolutely alone and which she left not even once a month" (134). Not only were the two neighbor children removed from the rest of the world, they were separated from each other by a wall, which, for Tante Dide, was an "impassable rampart, which walled in her past" (177). For Miette, this wall represents the ultimate barrier, fear, lest she (or Silvère) be caught trying to cross it by her uncle or mean-spirited cousin, Justin (179). The barriers between Silvère and Miette are social and psychological, as well as physical, visual, and communicative.

The wall also divides a common well, whose waters reflect both sides so clearly that the well takes the form of twin mirrors: "deux glaces d'une netteté et d'un éclat singuliers" ("two mirrors of singular sharpness and

brightness," 179). It is through this looking glass that the young friends see each other, first as separate images, distorted by ripples—"l'eau agitée n'était plus qu'un miroir trouble sur lequel rien ne se reflétait nettement" ("the churned water became no more than a troubled mirror on which nothing was reflected clearly")—then reconstituted into sharply defined images: "Et à mesure que les rides de l'eau s'élargissaient et se mouraient, il vit l'apparition se reformer. Elle oscilla longtemps dans un balancement qui donnait à ses traits une grâce vague de fantôme. Elle se fixa, enfin. C'était le visage souriant de Miette" ("And as the ripples grew larger and faded, he saw the apparition reform. It oscillated for a long time with a swaying motion that lent its traits the vague grace of a phantom. Finally, it focused. It was the smiling face of Miette," 180).[7]

Once Miette's image is formed, Silvère then sees his own, beside hers; separated physically, they are joined in the reflected visual image, which then leads to communication: "Alors sachant tous deux qu'ils se voyaient, ils firent des signes de tête" ("Then both realizing that they could see each other, they made head signals," 180). What they cannot accomplish in reality—contact and communication—they achieve in the realm of the image, and visual reality far transcends physical reality: "Peu leur importait le mur qui les séparait, maintenant qu'ils se voyaient là-bas, dans ces profondeurs discrètes" ("The wall separating them mattered little, now that they could see each other there, in these discreet depths," 180). Communication through the visual medium creates an "infinite charm" (181), an "unexpected joy" (181), a "lively pleasure" (183), as unanticipated by them as it is by the reader, in the all too often barren emotional landscape of Zola's novels.

The visual play of the water's surface, reflecting the sky as well as the walls of the well "with uncanny accuracy" (179), creates superimpositions that suggest the kaleidoscopic images of Monet's water lilies or Proust's aquatic gardens.[8] Indeed the visual games caused by the water's movement—"les formes bizarres que prenaient leurs figures élargies, dansantes sur l'eau" ("the bizarre shapes assumed by their enlarged faces, dancing on the water," 183)—and the metaphoric transmutation of elements—"Ils aimaient à se pencher sur la nappe lourde et immobile, pareille à de l'argent en fusion" ("They loved to lean over the heavy, motionless sheet, resembling molten silver," 181)—create a type of plea-

7. The reader who recalls Zola's documentary and critical writings will recognize the dissected steps of the visual process, where the hazy, shapeless impression yields to the solid image of a well-defined perception, then to identification. This will become the main organizing principle of Zola's descriptive passages, as we shall see in Chapter 4 (description).

8. See *A la recherche du temps perdu,* vol. 1 (Paris: Gallimard, Bibliothèque de la Pléiade, 1963), 169–70.

sure that is entirely visual, devoid of apparent meaning, not unlike that which we have come to associate with pure impressionism.

But beyond the visual pleasure of free-floating images, Silvère and Miette (whose very name recalls *muette,* that is, "mute") seek a more profound communication and begin to develop a visual sign system, first as a complement to verbal language—"avec les gestes et les expressions de physionomie que demandaient les paroles" ("with the gestures and facial expressions elicited by the words," 180)—then as a replacement—"Ils ne parlaient guère que pour voir remuer leurs lèvres" ("They spoke almost solely to see their lips move," 181). The pleasure of visual communication is such that Silvère and Miette, hardly typical of Zola's highly libidinal characters, have no desire for physical contact: "Ils n'avaient aucun désir de se voir face à face, cela leur semblait bien plus amusant de prendre un puits pour miroir" ("They had no desire to see each other face to face; it seemed much more amusing to them to use the well as a mirror," 181).

Though seemingly an intermediary, the visual medium affords a more direct communication because it bypasses the codes, barriers, and taboos governing both physical contact and verbal language. Emotions are expressed with a freedom impossible in other forms of communication; the repression inherent in direct contact or verbal language disappears. When Silvère misses a morning meeting, Miette's anger is freely expressed: "Dès qu'elle l'aperçut, elle déchaîna une véritable tempête dans le puits; elle agitait le seau d'une main irritée, l'eau noirâtre tourbillonnait" ("As soon as she saw him, she unleashed a veritable storm in the well; she shook the bucket with an irate hand, the blackish water swirled," 183). In fact, it is this visual, prelinguistic expression that engenders not only communication, but love: "Ce bienheureux trou, avec ses glaces blanches et son écho musical hâta singulièrement leur tendresse" ("This happy chasm, with its white mirrors and its musical echo, hastened their tenderness considerably," 184).

It is, no doubt, surprising that Zola, a writer committed to the verbal medium, experiences and expresses such longing for purely visual communication. However, the gap between word and object, exacerbated in verbal language by the disparity between signifiers—strokes on a page or arbitrary sound units—and signifieds, between sign and referent, is certainly narrowed in the visual, where image evokes absent object, resembling and recalling it rather than underscoring its removal. Words *distinguish* and syntax *separates* into units of linear discontinuity, while images *meld,* superimposed on the mirror's surface. In Zola's description of visual pleasure—"regarder le visage de son amie, réfléchie dans la pureté de ses traits" ("watching his friend's face, reflected in the purity of its traits," 183)—the allusion to purity suggests another track in deciphering the

attraction of the visual, as does the repetition of "childhood" (twice on 181), along with that of "hiding place" and "hole" (181 and 183). The well provides a sheltered place, protected from the outside world,[9] which dispels repression and favors regression to a preintellectual, prelinguistic, prepubescent paradise—a "nid verdâtre tapissé de mousse" ("greenish nest carpeted with moss," 181). Silvère and Miette pass beyond the barriers of verbal language, through the looking glass, into the primitive realm of the purely visual.

However, within the visual play and pleasure is a hint of fragility, foreboding, and fear: "A un léger ébranlement qu'il donna au sceau, l'eau frémit, le sourire de Miette pâlit. Il s'arrêta pris d'une étrange crainte" ("With the slight shaking that he gave the bucket, the water shivered, Miette's smile faded. He stopped, seized with a strange fear," 181). As the lovers probe beneath the surface, wondering what lies in the depths of the hole, they become more and more aroused: "Et tout l'inconnu de cette source profonde, de cette tour creuse sur laquelle ils se courbaient, attirés, avec de petits frissons, ajoutait à leur joie de se sourire une peur inavouée et délicieuse" ("And all the unknown of this deep spring, this hollow tower over which they bent, attracted, with slight shivers, added to their joy in smiling at one another an unacknowledged and delicious fear," 181). This unknown, delightful, but repressed feeling, at once desire and fear, is, of course, that of their own sexuality.[10]

Finally, impatient with the constraints of communication through the well and overcome by the desire for direct, unmediated contact (186), they resolve to meet, signaling a loss of innocence that, as is all too often the case in Zola's universe, will lead to tragedy. Like Adam and Eve, not to mention Serge and Albine in *La Faute de l'abbé Mouret,* they must leave the garden; like Alice, they must come back through the looking glass.

Cassatt's Woman in a Loge

Zola's fascination with optical devices and mirrored images is paralleled in the painting of his generation, notably in impressionist art. Opera

9. Like so many such enclosed places in Zola's novels, most notably the Paradou garden in *La Faute de l'abbé Mouret* and Jeanlin's underground hideaway in *Germinal.*

10. And within the linking of sexuality and regression depicted here lurk the germs of death—"L'attrait qui les retenait accoudés aux margelles avait ainsi, comme tout charme poignant, sa pointe d'horreur secrète" ("The attraction that kept them leaning over the well's rim thus had, like all poignant charms, its touch of secret horror," 182)—as is often the case in Zola's novels (*La Bête humaine,* for example).

glasses occupy a central role in Renoir's *La Loge* and Degas's *Ballet de Robert le Diable,* while mirrors dominate Manet's *Bar aux Folies Bergère* and numerous canvases of Degas, from ballet classes to milliners' shops. Nowhere is this fascination more pronounced than in the work of Mary Cassatt, who was born in Pennsylvania, later became a protégée of Degas, and contributed to the fourth through eighth impressionist exhibitions. Indeed, in reviewing these shows, Zola had been struck by her paintings, referring to them as "oeuvres remarquables, d'une originalité singulière" ("remarkable works, of singular originality").[11]

Cassatt's *Woman in Black at the Opera* (1880) shows a male spectator using opera glasses to ogle a woman in the foreground, who herself is training opera glasses, not on the spectacle, but on some unseen object, no doubt of desire. Cassatt's *Mother and Child* (1905) shows a child holding a hand mirror, reflected, along with her mother, in a large mirror.

Woman with a Pearl Necklace in a Loge (1879), exhibited in the fourth impressionist show, features both mirror and opera glasses (Fig. 1). This painting of the Paris opera highlights neither the performance (Degas), nor the crowds (Manet), nor the building (Pissarro), but the woman herself, the artist's sister Lydia, whom we see facing us, though posed and turned away at roughly a forty-five-degree angle. Behind her is a full mirror, occupying the entire rear wall of her opera box and reflecting her back, along with the back of her armchair, and, above, the interior of the opera house with a chandelier and some dozen spectators, several of whom are armed with opera glasses. Apart from "doubling our pleasure," the mirror serves several purposes. The woman is seen simultaneously from two different yet complementary perspectives, which together create a dynamic interplay as the spectator brings them together and focuses them in "binocular" fashion. The mirror also extends the space of the composition beyond the frame of the painting, a technique typical of Degas and, indeed, characteristic of the entire impressionist group. Moreover, the "enlargement" and "rounding" of the red chair, effected by its repetition on the right, add to its sense of volume while augmenting its design quality on the surface of the canvas. Furthermore, since the very pearl necklace featured in the painting's title is not reflected in the mirror or, rather, is rendered so summarily as to make its identification problematic, the viewer is faced with a fascinating visual puzzle that

11. From "Le Naturalisme au Salon," an article that appeared in *Le Voltaire,* 18–22 June 1880. In Zola, *Mon Salon/Manet/Ecrits sur l'art,* ed. Antoinette Ehrard (Paris: Garnier Flammarion, 1970), 337.

FIG. 1. Mary Cassatt, *Woman with a Pearl Necklace in a Loge*. Oil on canvas, 1879. Courtesy Philadelphia Museum of Art, Bequest of Charlotte Dorrance Wright.

casts doubt on the reliability of the reflecting process or the capacity of art to reproduce it.[12]

At the same time, the reflection allows Cassatt to depict the interior of the theater, the boxes and spectators that otherwise would have remained absent from the picture space. This entails several consequences, all of which highlight the thematic role of vision in the painting. First, we are able to see what Lydia is watching, or, since she may be looking down at the spectacle (unlike most everyone else at the opera), at least what is within her field of vision. Second, we are able to see others watching, a theme underscored by the highly visible presence of opera glasses, much more noticeable than the naked eye. Not only is the viewer's visual intent verifiable, but so is the line of sight, and thus the object of vision/desire. This leads to a third point, which is that at least one of the spectators, by the combination of the angle of the opera glasses and the placement of the mirror, appears to be watching, not the spectacle, but Lydia, who then becomes the spectacle, as she is, in fact, for us. Fourth, the hypothetical viewer of the scene (and, by extension, the spectator of the painting, that is, we ourselves),[13] also becomes implicated, involved, because theoretically we should appear reflected in the mirror, since our implied vantage point would be caught by the reflection. The threshold between the space "inside" the painting and that of the spectator "outside" is crossed here, as it is so often in Manet's paintings, by either a look that engages us (*L'Olympia*) or a mirror that reflects the implied viewer's image (*Le Bar aux Folies Bergère*). The spectator has passed beyond the looking glass, into the space of the painting. The notion of spectacle has been redefined. The question of illusion and reality is posited.

Indeed, Cassatt's painting makes a "meta-artistic" statement, since it highlights its very mode of perception, the visual, and suggests its mechanism, the "binocular." In short, *Woman in a Loge* is about seeing and thus constitutes a self-commentary, a *mise en abyme,* on its own medium. Paradoxically, the Rougon-Macquart novels, by promoting the visual, often to the detriment of the verbal, also make a "metalinguistic" statement, but by a sort of *mise à l'envers,* where the very nature and efficacy of verbal language is put into question. In this regard, Zola can be situated somewhere after Stendhal and Flaubert, along a line pointing toward Proust, all of whom betray the same mistrust in the verbal, the same privileging of the visual.

12. I am indebted to the eminent art historian Professor George Mauner of Penn State University, author of *Manet, Peintre-Philosophe: A Study of the Painter's Themes* (University Park: The Pennsylvania State University Press, 1975) for pointing this out to me.

13. For a distinction between viewer and spectator and a discussion of the spaces they occupy in the perception of a painting, see Chapter 3 (viewpoint).

The Shadow Knows . . .

To this point, the visual images we have examined, though "detached,"
or at least distinct, from their sources, have been chiefly the fixed, static
images of photos, paintings, and mirrors. While the mirror may suggest
some minimal movement (Nana caressing herself, Renée hallucinating,
Silvère and Miette communicating), the fixed frame of these images
limits their capacity for depicting motion, and none displays the mobility
of the wide variety of shadows that populate the Rougon-Macquart nov-
els. To Gagnière, the sometime painter and would-be musician in
L'Oeuvre, the shadow is the very essence of impressionism: "une impres-
sion. . . . Pour moi, d'abord, c'est un paysage qui fuit, un coin de route
mélancolique, avec l'ombre d'un arbre qu'on ne voit pas" ("an impres-
sion. . . . For me, first of all, it's a fleeing landscape, a melancholy road-
side, with the shadow of an unseen tree," 84).

Unlike the mirror (which, despite distortions of its surface, reveals its
source, reflects it, captures it with all too accurate fidelity), the shadow
can detach itself from its source, which can become absent, unseen,
unknown, liberated. The shadow, because it lacks the precision of form
and detail of the mirror image, because it is unlimited by a frame, can
exist in a state of pure image, of pure effect devoid of cause, of pure
"impression" prior to identification, and hence devoid of name. Shadows
often appear as figures of pure metonymy, effects that fail to reveal their
hidden causes,[14] as when Silvère and Miette "n'apercevaient plus, dans
l'aire mélancolique et déserte, qu'un feu de bohémiens, devant lequel
passaient de grandes ombres noires" ("could see no more, in the melan-
choly, deserted lot, than a gypsies' bonfire, before which passed large,
black shadows," 195). As in all of Zola's novels, the decor of *La Fortune* is
filled with numerous types of unidentified formless objects, in the guise
of "vague black shapes" (156), "black masses" (250), and "red spots"
(251), but it is the shadows that dominate: "shadows fled rapidly along
the sidewalks" (245). Movement, denoted above by "passed" and "fled,"
is associated with most of the many passages involving shadows, and the
reader comes to recognize many of the same expressions: "large floating
shadows" (*Pot Bouille,* 115, and *Germinal,* 1151), "large shadows floated"
(*L'Assommoir,* 528), and "large shadows danced" (*La Terre,* 421).

As they were with mirror images, the characters are often caught up in
the pure visuality of shadows. In *La Fortune,* Miette "éprouvait une
émotion indéfinissable à suivre les jeux de l'ombre" ("experienced an

14. See my "*L'Oeuvre:* Naturalism and Impressionism," *L'Esprit créateur* 25, no. 4 (Win-
ter 1985): 42–50.

indefinable emotion in following the shadow's play," 202). In *Le Ventre de Paris,* Claude and Florent, returning to Paris after an idyllic afternoon in the country, are fascinated by the distorted images of their shadows, much like the grotesque deformations in a hall of mirrors—"suivant toujours des yeux leurs deux ombres que le soleil allongeait davantage . . . le soleil, au ras des coteaux de Suresnes, était si bas sur l'horizon, que leurs ombres colossales tachaient la blancheur du monument" ("their eyes still following their two shadows, which the sun lengthened even more . . . the sun, level with the Suresnes hills, was so low on the horizon that their colossal shadows stained the monument's whiteness," 805–6). In a scene that can't fail to recall the contact by reflected images from *La Fortune,* Claude willfully distorts the shape of his shadow so that it joins Florent's and stretches out of their physical milieu toward the heavens: "Avez-vous vu? Quand le soleil s'est couché, nos deux têtes sont allées toucher le ciel" ("Did you see [that]? When the sun set, our two heads rose to touch the sky," 806).

As with the mirror and ocular devices, shadows may well represent a game of purely visual pleasure in some instances, but invariably, by this very visuality, they are linked integrally to the most fundamental themes, so often visual, of Zola's novels. In *La Débâcle,* they suggest the general air of mystery surrounding war—"L'Ombre du colonel s'arrêta, appela une autre ombre qui se hâta, légère, fine et correcte . . . les trois ombres disparurent, noyées, fondues" ("The colonel's shadow stopped, called another shadow, which hastened, light, fine, and proper . . . the three shadows disappeared, drowned, melted," 418)—and, especially, fear of the elusive enemy—"pendant près d'un quart d'heure, des ombres noires qui s'agitaient en face, sur l'autre quai, les inquiétèrent" ("for nearly a quarter of an hour, black shadows moving across the way, on the other bank, troubled them," 891). Shadows heighten the same sense of mystery in *Une Page d'amour,* as Hélène approaches the Passage des eaux, a narrow corridor leading down steps from her self-sequestered world to one of danger and desire: "Tout d'un coup, une ombre sortait de l'obscurité; un frisson la glaçait, lorsque l'ombre toussa; c'était une vieille femme qui montait péniblement" ("Suddenly a shadow emerged from the darkness; a shiver froze her, then the shadow coughed; it was an old woman climbing [the steps] painfully," 995). The reader will no doubt have again recognized the familiar pattern of shapeless form, followed by identification, that is itself emerging as a major organizing principle of Zola's descriptive passages. Light yields to line, as ripples lead to reflection, as shadows cede to their sources.

Shadows often suggest those dramatic effects that have come to characterize the black-and-white film of early cinema and that Zola uses to

enhance the mystery surrounding certain characters, like the anarchist Souvarine in *Germinal,* who flicks his cigarette in a Bogart-like gesture as he heads off into the night: "Au loin, son ombre diminua, se fondit avec l'ombre" ("In the distance, his shadow grew smaller, merged with the darkness," 1548).

By the same token, Napoléon III becomes literally a shadow of himself and is depicted as such in both *La Débâcle* and in the following example from *Son Excellence Eugène Rougon,* where a group of shadows, including the emperor's mustached silhouette, leads to grotesque deformations and subsequent suppositions entirely suitable to the political machinations that dominate the novel:

> Brusquement il [Eugène] crut voir son ombre, une tête énorme, traversée par des bouts de moustaches; puis, deux autres ombres passèrent, l'une très grêle, l'autre forte, si large, qu'elle bouchait toute la clarté. Il reconnut nettement, dans cette dernière, la colossale silhouette d'un agent de la police secrète, avec lequel Sa Majesté s'enfermait pendant des heures, par goût; et l'ombre grêle ayant passé de nouveau, il supposa qu'elle pouvait bien être une ombre de femme.
>
> (Suddenly he [Eugène] thought he saw his shadow, an enormous head with protruding mustache ends; then, two other shadows passed, one quite frail, the other strong, so large that it blocked all the light. He clearly recognized, in the latter, the colossal silhouette of a secret police agent, with whom His Majesty shut himself in for hours, by choice; and the frail shadow having passed again, he supposed it could be a woman's shadow. 176)

The relationship of watcher to shadow, first explored by John Lapp and later by Roger Ripoll,[15] deserves further examination within the total context of vision in Zola's works. The status of shadow confers a high degree of mystification on the character and often suggests an elusive object of desire. In *Le Rêve,* for example, Angélique seems to see a male figure in the form of a shadow projected by the moon, through the cathedral, into the courtyard beneath her window: "Une nuit brusquement, sur la terre blanche de lune, l'ombre se dessina d'une ligne franche et nette, l'ombre d'un homme qu'elle ne pouvait voir, caché derrière les saules. L'homme ne bougeait pas, elle regarda longtemps l'ombre immo-

15. Lapp, "The Watcher Betrayed and the Fatal Woman: Some Recurring Patterns in Zola," *PMLA* 74, no. 3 (June 1959), 276–84; Ripoll, "Fascination et fatalité: Le Regard dans l'oeuvre de Zola," *Cahiers naturalistes* 32 (1966): 104–16.

bile" ("One night, suddenly, on the moonlit ground, the shadow was drawn with a sharp, fresh line, the shadow of a man she couldn't see, hidden behind the willows. The man didn't move; for a long time she watched the motionless shadow," 871). The repetition of the word "shadow," divorced from its source, calls into question the identity, even the reality, of the man, who, after several nights, finally emerges, revealing, of course, Angélique's future husband, Félicien: "Son ombre, ainsi que celle des arbres, s'était repliée sous ses pieds, avait disparu. Il n'y avait plus que lui, très clair" ("His shadow, along with that of the trees, had folded back under his feet, had disappeared. There was now only him, very clear," 873).

L'abbé Faujas, whose "intriguing" nature is underscored by the use of shadows in *La Conquête de Plassans,* is as elusive to Félicité Rougon ("seeming like a black shadow fleeing noiselessly," 942) as he is fascinating for her repressed mystic daughter, Marthe: "Une dernière lueur rouge alluma ce crâne rude de soldat, où la tonsure était comme la cicatrice d'un coup de massue; puis la lueur s'éteignit, le prêtre, entrant dans l'ombre, ne fut plus qu'un profil noir sur la cendre grise du crépuscule" ("A final red glow lit up this rugged soldier's skull, where the tonsure was like the scar from a club's blow; then the glow went out, and the priest, entering into the shadows, was no more than a black profile on the ashen gray of the setting sun," 911). It is all the more significant, then, that in the final scene of the novel, when Marthe's rejected husband, Mouret, escapes from an insane asylum to torch his own house, now controlled by Faujas, Mouret assumes the form of a shadow seen by a neighbor against the background of fire: "une ombre, qu'il ne reconnut pas d'abord, dansait au milieu de la fumée en brandissant un sarment allumé" ("a shadow, which he failed to recognize at first, was dancing amidst the smoke, brandishing a burning stalk," 1204). The recognition process, so characteristic of Zola's compositional principles, will take a full five pages: "Je reconnais ce malheureux, maintenant. Il était si effrayant que je restais perplexe, bien que sa figure ne me fût pas inconnue" ("I recognize the poor chap now. He was so frightening that I remained puzzled, even though his face seemed familiar," 1209).

If the shadow often suggests the object of desire for the opposite sex, it just as surely signals jealousy and rivalry, particularly between males. The shadow of the male rival becomes the symbol of betrayal, as in *La Terre,* when Hourdequin surprises the shadow (of Jean) and the belly (of his mistress, Jacqueline) in that most compromising of all positions (445). In *Une Page d'amour,* the married Doctor Deberle finds his rendezvous with his attractive neighbor, Hélène, blocked by shadows on the shade (1059). When Maxime in *La Curée* jokingly recounts "l'histoire, très

risquée, d'un mari trompé qui avait ainsi surpris, sur un rideau, l'ombre de sa femme en flagrant délit avec l'ombre d'un amant" ("the very risqué story of a betrayed husband who had thus surprised, on a shade, his wife's shadow in the act with a lover's shadow," 446), little does he suspect that he is merely previewing his own betrayal by Renée: " 'Mais il y a un homme chez toi, dit-il tout à coup.—Non, non, ce n'est pas vrai, balbutia-t-elle, suppliante, affolée.—Allons donc, ma chère, je vois l'ombre' " (" 'But there's a man in your room, he said suddenly.—No, no, it's not true, she mumbled, pleading, panic-stricken.—Come on, my dear, I see the shadow,' " 516).

The most famous of such betrayal scenes occurs in *Nana,* where Count Muffat, having been dragged to the depths of degradation by Nana and warned of his wife's infidelity with Fauchéry, posts himself in front of the window of the latter's apartment on a rainy night and stares at a band of light shining between the half-opened curtains, until he finally sees a shadow pass (1279). Following Lapp's comments on the betrayed watcher, Ripoll sets this scene in the context of forbidden scenes of sex and violence, but neither notes the role of the shadow itself in elevating the rival by removing him from the contingencies of perceived reality—"une main énorme" ("an enormous hand," 1279)—and in heightening the ultimate torture, doubt itself—"Ce fut si rapide, qu'il se crut s'être trompé" ("It happened so fast that he thought he was mistaken," 1279). As the shadows play out their silent charade, they appear to grow—"ces ombres aug- mentaient sans doute" ("the shadows were probably getting larger," 1280)—until they finally disappear. The silhouetted figures elude the watcher, evade reality, reside in another world, that of the purely visual, and Muffat's only consolation, ironically and significantly, comes when, in leaving, he is struck by the spectacle of his own shadow: "il ne voyait que son ombre tourner, en grandissant et en se rapetissant, à chaque bec de gaz. Cela le berçait, l'occupait mécaniquement" ("he saw only his shadow turning, growing and shrinking with each gaslight. That soothed him, occupied him mechanically," 1281). It is less the nature of the scene than the act of watching—in short, voyeurism—that becomes the ultimate symbol of sexual desire, penetration, and possession, and it is fitting that, before he emerges from his trance, we last see Muffat in the act of staring aimlessly but obsessively at the display windows in a nearby street—"sans pouvoir expliquer comment, il se trouvait le visage collé à la grille du passage des Panoramas, tenant les barreaux des deux mains. Il ne les secouait pas, il tâchait simplement de voir dans le passage, pris d'une émotion dont tout son coeur était gonflé" ("unable to explain how, he found his face glued to the grating of the passage des Panoramas, gripping the bars with both hands. He wasn't shaking them, he was simply trying to

see into the passage, seized by an emotion that swelled his whole heart,"
1281). Seeing, like consumerism and sex, is a libidinal activity, seeking an
object of desire.

Shadow-watching, like star-gazing (see *Une Page d'amour*, part III, chap-
ter V), also reflects the desire to know, to grasp the other or the even
more elusive self. Mlle Saget, for example, spies on the shadows of
Florent and his fellow conspirators from her "observation post" in *Le
Ventre de Paris*.[16] The shadows become familiar, form a sign system,
which Mlle Saget becomes adept at reading: "Elle devint très forte, inter-
préta les nez allongés, les doigts écartés, les bouches fendues, les épaules
dédaigneuses, suivit de la sorte la conspiration pas à pas, à ce point qu'elle
aurait pu dire chaque jour où en étaient les choses" ("She became highly
skilled, interpreted the lengthened noses, the spread fingers, the open
mouths, the haughty shoulders, and thus followed the conspiracy step by
step, to the point that she could have told, each day, where things stood,"
857; see also 752). Occasionally, the visual syntax governing this shadow
sign system breaks down, making the desire to know, to see directly, all
the more compelling: "Puis, lorsque les silhouettes s'échauffaient, deve-
naient absolument désordonnées, elle était prise d'un besoin irrésistible de
descendre, d'aller voir" ("Then, when the silhouettes got excited, became
completely disorganized, she was seized with an irresistible urge to go
down, to go see," 752; see also 857;.

The shadow can also be a silhouette, indeed a symbol, of the murky
self. In the penultimate chapter of her tale, in the same textual position as
Renée's scene of recognition before the mirror in *La Curée*, Gervaise
confronts her shadow in *L'Assommoir*. Short on money and hope, she
wanders the streets in an unsuccessful attempt at soliciting and sees her
shadow engaged in grotesque play:

> Et, brusquement, elle aperçut son ombre par terre. Quand elle
> approchait d'un bec de gaz, l'ombre vague se ramassait et se pré-
> cisait, une ombre énorme, trapue, grotesque tant elle était ronde.
> Cela s'étalait, le ventre, le gorge, les hanches, coulant et flottant
> ensemble. Elle louchait si fort de sa jambe, que, sur le sol, l'ombre
> faisait la culbute à chaque pas; un vrai guignol!

> (And suddenly she perceived her shadow on the ground. When
> she approached a gaslight, the vague shadow became more con-
> densed and precise, an enormous shadow, squat and grotesque
> through being so round. It spread out, the belly, the breast, the

16. See also Saccard's "threatening observation post" in *L'Argent*, 49.

thighs, flowing and floating together. Her leg limped so much that, on the ground, her shadow tumbled with each step; a real puppet! 771–72)

The perception verb at the beginning and the free indirect discourse punctuated with an exclamation point at the end signal self-awareness on Gervaise's part, and the narrator does not fail to stress the shadow's role in her self-consciousness: "Jamais elle n'avait si bien compris son avachissement. Alors, elle ne put s'empêcher de regarder ça, attendant les becs de gaz, suivant des yeux le chahut de son ombre" ("Never [before] had she understood her sloppiness so clearly. Then, she couldn't help but watch it, waiting for the gaslights, following the fall of her shadow with her eyes," 772). As she runs into Goujet and turns away in shame, she again encounters her shadow: "Et ça se passait sous un bec de gaz, elle apercevait son ombre difforme qui avait l'air de rigoler sur la neige, comme une vraie caricature. On aurait dit une femme soûlé. Mon Dieu!" ("And it happened under a gaslight [that] she perceived her distorted shadow, which seemed to laugh on the snow, like a real caricature. One would have said a drunken woman. My God!" 774). Like Renée, Gervaise's seeing her own image as independent, as unrecognizable, as other, leads to the awareness of her own madness. Like Renée, Gervaise's death is only one chapter away. Like the image in the mirror, the shadow knows.

Viewing, Looking, Watching

The French word *le regard* designates at once the faculty, action, and manner of viewing something as well as the expression of the person viewing.[17] To give some idea of the role of viewing in Zola's novels, the word *regard* (along with the verb *regarder*) occurs 270 times in *Une Page d'amour* alone, in a seemingly endless variety of ways and at the most significant moments. Since the number and variety underscore the importance of vision, I won't attempt to reduce them to a basic pattern, as do John Lapp (who discusses the obsessive nature of the betrayed and help-

17. In English, "vision" expresses the faculty; "viewing," the action; and "look," the viewer's appearance—but no one word encompasses the meanings of the others. "Staring" or "gazing" seem too strong; "glancing," too weak; all are too precise. In general, the terms "looking," "viewing," or "watching" will be used interchangeably here, unless other translations of *le regard* are dictated by the context.

less watcher), Roger Ripoll (who interprets viewing, especially of scenes involving sexuality and violence, as a form of transgression), David Baguley (who sees *le regard* as a manifestation of power), and Patrick Brady (for whom *le regard* is presented as a penetrating sexual organ, which becomes a petrifying, reifying, sadistic "gaze").[18] For all four, viewing involves sexuality and is primarily threatening, either for the watcher or the watched or, usually, both. Their work is excellent and exhaustive, and won't be repeated here, since the goal here is to detail some of the other purposes of "looking" in order to situate it within the framework of the overall visual patterns in Zola's novels.

Philippe Hamon sees *le regard* less as a matter of fiction than of function.[19] The "watcher-seer" (*le regardeur-voyeur*) is a delegate (316), an agent for transmitting information (106), a means of inserting the naturalist's documents and tenets into the fictional universe (19). As Hamon contends, viewing can serve the same expository function played by the mirror in justifying character description (151). When two or more characters are present they appear to encounter and describe each other, diminishing the narrator's need to intervene. In *L'Oeuvre,* for example, as soon as a light is lit, Claude steals a glance at Christine—"Lui, qu'une gêne gagnait à présent, l'avait examinée d'un regard oblique. Elle ne devait pas être trop mal, et jeune à coup sûr, vingt ans au plus" ("He, overcome at present by embarrassment, had examined her with an oblique glance. She didn't appear to be too bad, and young for sure, twenty at most")— while she reciprocates—"elle aussi l'examinait, sans le regarder en face, et ce garçon maigre, aux articulations noueuses, à la forte tête barbue, redoublait sa peur" ("She, too, examined him, without looking at him directly, and this skinny young man, with gnarled joints and large bearded head, doubled her fear," 15). The characters' examining each other justifies the description and its terms, absolving the narrator from accusations of gratuitous portraiture and judgmental description.

Looking serves a further dramatic purpose by rooting characters into the action; Zola uses this conventional technique to foster interaction

18. Lapp, "The Watcher Betrayed," 278; Ripoll, "Fascination et fatalité," 108; Baguley, "Les Paradis perdus: Espace et regard dans *La Conquête de Plassans* de Zola," *Nineteenth-Century French Studies* 9, nos. 1–2 (Fall–Winter 1980–81): 86; Brady, *Le Bouc émissaire chez Emile Zola* (Heidelberg: Carl Winter Universitätsverlag, 1981), 252.

19. *Le Personnel du roman* (page references follow parenthetically in the text). In an earlier article—"Qu'est-ce qu'une description?" *Poétique* 12 (1972): 465–85—Hamon is even more skeptical concerning the fictional value of looking, which he deems thematically "empty" or at best a "justification" for descriptive passages that Zola is intent on inserting into his novels. On the contrary, I see looking as a major theme, which Zola sometimes justifies by inserting descriptive passages. For me, looking is a goal, not just a means.

between fictional characters and real historical personages introduced into the fictional universe. The fictional character acquires referential validity and the real persons fictional weight by their visual interaction. Renée, for example, is struck by the emperor's eye in *La Curée*— "l'empereur, levant à demi les paupières, avait des lueurs fauves dans l'hésitation grise de ses yeux brouillés" ("the emperor, through half-raised eyelids, had a wild glow in the gray hesitation of his murky eyes," 440).[20] The emperor of *La Débâcle,* on the brink of defeat, has a far different "look": "Oui, il m'a regardé un instant de ses yeux troubles, pleins de défiance et de tristesse" ("Yes, he looked at me for an instant through his troubled eyes, full of defiance and sadness," 551). The Emperor is also the subject of numerous scenes in this novel involving hidden watchers (see 495, 550–51, 563, and 579). Yet another historical figure, King William, watches the French army in *La Débâcle* through naked eyes and binoculars, as we have noted above, while Bismarck watches Saccard in *L'Argent* (259).

The person's "look" also becomes a synecdoche of self, allowing the narrator to suggest "character" traits, while seemingly limiting himself to what can be strictly seen in the realm of the objective. Thus, we see Rougon's reactionary band in *La Fortune des Rougon:* "à se regarder d'un air louche, en échangeant des regards où de la cruauté lâche luisait dans de la bêtise" ("watching each other suspiciously, exchanging glances where cowardly cruelty shone through the stupidity," 224). Here the strongest, most subjective judgments are garbed in the cloak of narrative objectivity by associating them with the characters' eyes rather than with their personalities.[21] Indeed, attached to *le regard* is a seemingly endless list of judgmental adjectives ("furtive," *La Conquête,* 905), comparisons ("weaselly," *La Conquête,* 949), verbs ("rummaged," *La Faute,* 1367), and adverbs ("lovingly," *La Curée,* 387).

A character's look can serve to signal his strength, as with l'abbé Faujas: "Marthe rencontra de nouveau ce regard clair, ce regard d'aigle qui l'avait émotionnée. Il semblait qu'au fond de l'oeil, d'un gris morne d'ordinaire, une flamme passât brusquement, comme ces lampes qu'on promène derrière les façades des maisons" ("Marthe again encountered this clear gaze, this eagle's gaze that had moved her so. It seemed that from the depths of the eye, usually a sad gray, a flame passed suddenly,

20. Hamon discusses this technique and example of it in relation to Barthe's notion of the "effet de réel" (see *Le Personnel,* 65 ff.).

21. Alleged abuses of this technique have caused students of narrative technique, Wayne Booth among them, to rail against Zola (see *The Rhetoric of Fiction* [Chicago: University of Chicago Press, 1961], 184).

resembling lamps moving behind house façades," *La Conquête de Plas-sans,* 912). Here Faujas's power is suggested by the quality of his look, its mesmerizing effect, its depth and penetration, coupled with the mysteri-ous metaphoric mixture of animals ("eagle"), elements ("flame"), and ordinary objects ("lamps").[22]

In other thematic contexts, looking can be used to suggest a char-acter's helplessness. In the opening chapter of *L'Assommoir,* Gervaise, recently abandoned by her lover, Lantier, surveys her situation, first her room—"Et, lentement, de ses yeux voilés de larmes, elle faisait le tour de la misérable chambre garnie" ("And slowly, through tear-veiled eyes, she toured the miserable furnished room," 375)—next her children— "Lorsque le regard noyé de leur mère s'arrêta sur eux, elle eut une nouvelle crise de sanglots" ("When their mother's faraway look fell on them, she had another fit of sobbing," 376)—then her neighborhood— "Elle allait, les regards perdus, des vieux abattoirs noirs de leur massa-cre et de leur puanteur, à l'hôpital neuf, blafard, montrant, par les trous encore béants de ses rangées de fenêtres, des salles nues où la mort devait faucher" ("With lost eyes, she went from the old slaughterhouse, black with blood and stench, to the pale new hospital, displaying, through the still open holes of its banks of windows, naked rooms where death would come reaping," 380). The mobility of her eyes sharpens the contrast with her immobile situation, trapped between two endpoints, the slaughterhouse and the hospital, which foreshadow her fate. In the last words of this chapter, her looking leads her to conscious-ness of her situation: "et elle enfila d'un regard les boulevards extérieurs, à droite, à gauche, s'arrêtant aux deux bouts, prise d'une épouvante sourde, comme si sa vie, désormais, allait tenir là, entre un abattoir et un hôpital" ("and her eyes ran along the outside boulevards, to the right, to the left, stopping at both ends, seized with muted terror, as if her life, henceforth, were stuck there, between a slaughterhouse and a hospital," 403). Later, in the scene where she sees her shadow, prefigur-ing death, she will walk the same path that her eyes traced in opening the novel: "Elle descendait encore vers l'hôpital, elle remontait vers les abattoirs. C'était sa promenade dernière" ("She walked back down to-ward the hospital, she walked back up toward the slaughterhouse. It was her last walk," 771). From the outset, her looking reveals her

22. For a comprehensive analysis of *le regard* in *La Conquête,* especially its use to suggest Faujas's power, see David Baguley, "Les Paradis perdus," 80–92. Concerning the example cited here, we might add that Faujas's character traits and the combination of techniques used to convey them are reminiscent of Balzac's portraiture, as in his description of Vautrin, at the moment of his arrest, near the end of *Le Père Goriot.*

present situation as a form of entrapment, while suggesting the terms of her ultimate fate: as if, in the final pages, she carries out the sentence sealed earlier by sight.

Looking governs not only character revelation, but especially character interaction, much of which, in *Les Rougon-Macquart,* is confrontational. Metaphors of dueling occur in *Le Ventre de Paris*—where we see la belle Lisa and la belle Normande, whose "regards noirs se croisaient comme des épées, avec l'éclair et la pointe rapide de l'acier" ("black looks crossed like swords, with the flash and rapid taper of steel," 741)—and in *La Conquête,* where l'abbé Fénil encounters his fellow man of the cloth Faujas: "Leurs yeux s'étant rencontrés, ils se regardèrent pendant quelques secondes, de l'air terrible de deux duellistes engageant un combat à mort" ("Their eyes meeting, they looked at each other for several seconds, with the fearsome expression of two duelists engaging in combat to the death," 959). In *Germinal,* Etienne and Chaval may affect camaraderie, but "leurs regards se mangeaient, quand ils plaisantaient ensemble" (their looks were eating at each other, as they kidded together," 1250). The look reveals confrontations of a personal kind, as between Dr. Pascal and his niece, ward, and eventual lover, Clotilde: "Mais elle continuait à le regarder en face, sans plier devant lui, avec la volonté indomptable de sa personnalité, de sa pensée, à elle. . . . ils se contemplèrent de la sorte, sans se céder, les yeux sur les yeux" ("But she continued to stare him in the face, without backing down, with the indomitable will of her personality, of her thought, her own. . . . they contemplated each other like that, without yielding, their eyes on each other's eyes," 934–35). One's look is, in fact, one's will, one's thought, one's personality. The look also reveals confrontations of a social kind, suggesting, for example, a conflict of classes in *L'Argent,* where Clarisse, the maid, leads Delcambre to surprise Saccard *en flagrant délit* with her mistress (and his!) the baroness: "les deux femmes s'aperçurent, la maîtresse accroupie et nue, la servante droite et correcte, avec son petit col plat, et elles échangèrent un flamboyant regard, la haine séculaire des rivales, dans cette égalité des duchesses et des vachères, quand elles n'ont plus de chemise" ("the two women saw each other, the mistress squatting and naked, the servant upright and proper, with her small flat collar, and they exchanged a flaming look, the age-old hatred of rivals, in that equality of duchesses and milkmaids, when caught with their clothes off," 214).

Certainly, confrontations involving sexuality are among the most prominent examples of the dramatic function of looking.[23] Maxime's

23. As demonstrated by Lapp, Ripoll, Baguley, and Brady (see note 18 earlier in this chapter).

gaze possesses the power to undress women, and he does not fail to exercise it with some regularity (*La Curée*, 321, 404, 445). For the sensual Lisa, "her look was a caress" (*Le Ventre*, 647). Looking is an act of "tyrannical adoration" for Jeanne in *Une Page d'amour* (816), possession for Pauline in *La Joie de vivre* (816), and penetration for Lazare in the same novel (989).

Scores of scenes depict characters "spying" on others, often involving situations of sexuality and violence.[24] In *La Curée*, Renée spies on Louise and Maxime in the hothouse (354), then Louise spies on Renée and Maxime (512). We have followed Mlle Saget's surveillance of Florent's conspiring shadow (*Le Ventre*, 752, 856) and Muffat's vigil over his wife's unfaithful shadow (*Nana*, 1279). There are legions of lookers in *Les Rougon-Macquart*, the worst of whom literally take to the keyhole: Mouret in *La Conquête* (914); Muffat in *Nana* (1220); Delcambre in *L'Argent* (210); and Delhomme in *La Terre* (397). These "voyeurs" are among the least positive figures of the series, which is renowned for negative character portrayal.

However, though seeing is irrevocably linked to sexuality, it is not always painted negatively. When seeing is not a tool of combat or compensation—of possession, destruction, or exploitation—it can be the most positive of life forces.

The visual pleasure witnessed in the well waters of *La Fortune des Rougon* also occurs with more direct forms of looking. Angélique in *Le Rêve* experiences a visual awakening with sensual, even sexual, overtones, a sort of perceptual puberty. Up to the spring of her sixteenth year, she had "watched" but never "seen" the world around her; a heightened sensitivity to odors and sights now lends an emotional impact to perception: "Cette année, dès qu'elle le regardait, une émotion troublait ses yeux, tellement ce violet pâle lui allait au coeur" ("This year, as soon as she looked at [the garden], an emotion troubled her eyes, so much did this pale violet go to her heart," 861). The cathedral outside her window strikes her in new ways: "Chaque matin, elle s'imaginait la voir pour la première fois, émue de sa découverte, comprenant que ces vieilles pierres aimaient et pensaient comme elle" ("Each morning, she imagined seeing it for the first time, moved by her discovery, understanding that these old stones loved and thought, as she did," 862). Zola lends Angélique the same freshness of vision, stemming from sensitivity to light, that he had attributed to the impressionists; indeed, her perception of the cathedral seems to prefigure Monet's series of images of the Rouen Cathedral (1892–94) under varying circumstances of atmosphere and light: "Le

24. See Ripoll, "Fascination et fatalité," 108–12.

soleil enfin faisait vivre [la cathédrale], du jeu mouvant de la lumière,
depuis le matin, qui la rajeunissait d'une gaieté blonde, jusqu'au soir, qui
sous les ombres lentement allongées, la nouait d'inconnu" ("Indeed the
sun brought [the cathedral] to life, with the moving play of light, from
the morning, which rejuvenated it with a blond joy, to the evening,
whose slowly lengthening shadows bound it to the unknown," 863).

Angélique joins Silvère and Miette, Serge and Albine, Claude and
Christine, Dr. Pascal and Clotilde, on the rather short list of Zola charac-
ters who seem to experience authentic (albeit short-lived) happiness. For
all of these characters, happiness is a matter of profound contact with the
world and of direct communication with each other, in a preverbal state,
through the medium of the visual image.

Visual Communication

As we have seen in numerous examples, from the well waters in *La Fortune
des Rougon* to the conspirators' shadows in *Le Ventre de Paris*, vision, like
verbal language, constitutes a sign system with the potential for express-
ing, processing, and exchanging information, that is, communicating. As
such, it can be represented graphically by adopting a modified version of
Roman Jakobson's classic schema of communication (Diagram 2):[25] For
example, in a text examined earlier from *La Fortune des Rougon* (183),
Miette (sender) expresses her anger (referent) to Silvère (receiver) through
ripples (signs) in the well water (channel). Throughout *Les Rougon-
Macquart*, visual messages, often complex, are transmitted—"Jeanne le
disait avec ses regards profonds" ("Jeanne was saying it with her deep
looks," *Une Page*, 1051)—and received—"ayant lu dans son regard" ("hav-
ing read in his look," *La Curée*, 386).

<div style="text-align:center">

Context (referent)

Addresser (sender) ----- Message (signs) ----→ Addressee (receiver)

Contact (channel)

Code (metalanguage)

</div>

Diagram 2.

Analogies with verbal language are numerous and precisely coded; trans-
mission nearly always involves the oral *dire* (say) rather than the written

25. After Jakobson, "Linguistics and Poetics," in *Style in Language,* ed. Thomas Sebeok
(Cambridge, Mass.: MIT Press, 1966), 353.

écrire (write); reception, conversely, is hardly ever rendered by the oral *entendre* (hear) but by the written *lire* (read). Looks can question— "l'interrogeant du regard" ("interrogating him with a look," *La Conquête,* 907)—respond—"elle lui répondit d'un regard" ("she answered him with a look," *L'Oeuvre,* 197)—beg or protest—"Ce fut, dans le regard du misérable, une supplication dernière, une révolte aussi" ("It was, in the poor chap's look, a final plea, a revolt also," *La Débâcle,* 833).

Visual communication can fail, either through lack of contact (not seeing), excessive constraint, as when Pascal reads Clotilde's letters in *Le Docteur Pascal* (see 1162), or faulty coding, like that between Silvine and Goliath in *La Débâcle:* "Et leurs regards, à ce moment, se rencontrèrent: il la suppliait, éperdu, envahi par la peur; mais elle ne parut pas comprendre" ("And, at that moment, their looks met: he was begging her, distraught, overcome by fear; but she didn't appear to understand," 831). More often, however, visual communication succeeds.

Sustained exchanges occur, as between Saccard and his dying first wife, Angèle, who has overheard his scheme to remarry: "les yeux d'Angèle disaient qu'elle avait entendu la conversation de son mari avec Mlle Sidonie. . . . Saccard, poursuivi par ce regard de mourante, où il lisait un si long reproche" ("Angèle's eyes said that she had heard the conversation between her husband and Mlle Sidonie. . . . Saccard [was] pursued by this dying woman's look, where he read such a long reproach," *La Curée,* 377). Despite their intellectual limitations, the crazy Tante Dide and the hemophiliac child Charles communicate silently over several pages as he suffers a fatal attack in *Le Docteur Pascal:* "ils se regardaient profondément, d'un air d'imbécillité grave" ("they watched each other deeply, with a serious look of imbecility," 1101).

Entire conversations occur through visual language, often on subjects forbidden to verbal communication. When Claude conceives the idea of painting Christine's nude torso, the desire becomes an obsession: "Cela, lentement, avait germé, d'abord un simple souhait vite écarté comme absurde, puis une discussion muette sans cesse reprise, enfin le désir net, aigu, sous le fouet de la nécessité" ("Slowly it had germinated, first a simple wish quickly pushed aside as absurd, then a mute discussion repeated endlessly, finally the clear desire, sharpened by the whip of necessity," *L'Oeuvre,* 112). At first repressed ("pushed aside"), the idea remains entirely interior ("mute discussion"), until Claude begins to read in her look that she has read his—"il lut, au fond de son regard, qu'elle savait sa continuelle pensée" ("he read, in the depths of her look, that she knew his constant thought," 113)—a reading the narrator does not fail to confirm: "S'il la regardait, elle croyait se sentir déshabiller par son regard" ("If he looked at her, she felt herself undressed by his gaze," 113).

Significantly, the (verbally) repressed sexuality now expressed (visually) leads to self-awareness: "peu à peu, ils découvrirent une fièvre secrète, ignorée d'eux-mêmes" ("little by little, they discovered a secret fever, of which they had been unaware," 113). Claude's look finally achieves a clarity and directness of expression impossible in words—"Les yeux brûlants dont il la regardait, disaient clairement" ("The burning eyes through which he looked at her were speaking clearly")—while Christine "hears" these "words" unequivocally, registers their impact, and reacts accordingly: "Elle, toute droite, très blanche, entendait chaque mot; et ses yeux d'ardente prière exerçaient sur elle une puissance. Sans hâte, elle ôta son chapeau" ("She, completely upright, very pale, heard each word; and his fervently pleading eyes exerted a power over her. Slowly, she took off her hat," 114). From formulation to transmission to reception to action in the space of a few sentences, this is certainly one of the most efficient examples of communication in all of Zola's novels. The narrator stresses that the entire scene, one of capital importance in the novel, takes place without speaking—"elle n'avait pas prononcé une parole" ("she hadn't pronounced one word," 114)—and notes why—"Tous deux sentaient que, s'ils disaient une seule phrase, une grande honte leur viendrait" ("Both felt that, if they said a single sentence, a great shame would befall them," 115). The visual, devoid of the coding and study that leads first to taboo, then to repression in verbal language, favors the free expression (and realization) of desire.

Visual communication has a precision of expression—"elle le lisait nettement dans son regard" ("she read it clearly in his look," *La Bête humaine,* 115)—seldom attributed to the verbal in Zola's novels. Looking can bypass the blockade of words to read thoughts directly: "Elle lui avait planté ses yeux droit dans ses yeux. Pendant un instant ils se regardèrent, si profondément, qu'ils lisaient leurs pensées" ("She had planted her eyes right in his eyes. For an instant they looked at each other, so deeply that they read each other's thoughts," *Son Excellence Eugène Rougon,* 116). Looking can even bypass thoughts to communicate directly with the soul: "Les yeux de Roubaud avaient rencontré les siens, tous deux se regardaient jusqu'à l'âme" ("Roubaud's eyes had met his, both looked at each other even into their souls," *La Bête humaine,* 1097).

Une Page d'amour ranks with *L'Oeuvre* as the most "visual" of Zola's novels. In both cases, visual communication is clearly evident, but in *Une Page,* it is considerably more sustained and systematic. The very title of the novel implies reading ("page"), and the wall separating Hélène and the good Doctor Deberle is pierced by a "communicating door" (804). There is, indeed, a lot of reading and communicating in the novel, primarily through looking. As in the examples mentioned earlier from other

novels, the looks of Hélène and Deberle bypass the verbal and the mental to communicate deeply and directly: "Pendant un instant, leurs yeux se rencontrèrent et semblèrent lire au fond de leurs âmes" ("For an instant, their eyes met and seemed to read down into the depth of their souls," 844).

In contrast with the verbal, subject to censorship if not doomed to banality, their visual communication is often as free as it is effective: "Et souvent, en parlant, ses yeux rencontraient les yeux d'Hélène. Ni l'un ni l'autre ne détournait la tête. Ils se regardaient face à face, sérieux une seconde, comme s'ils se fussent vus jusqu'au coeur" ("And often, in speaking, his eyes met Hélène's eyes. Neither of them turned away. They looked at each other face to face, as if they could see into each other's hearts," 882). The narrator is quick to attribute their mutual understanding to the silence of words and the maintenance of visual contact; Hélène is described as "levant les yeux de loin en loin pour échanger avec le docteur ces longs regards qui les attachaient l'un à l'autre" ("raising her eyes here and there to exchange with the doctor those long looks that attached them to each other," 882). Unlike *L'Oeuvre,* where contact is profound but sporadic, or *La Fortune,* where it is limited to the wonder-land of the well, in *Une Page* it occurs from the beginning—"l'un près de l'autre, se regardant bien en face . . . ils se comprenaient souvent sans ouvrir les lèvres" ("near to each other, watching each other directly . . . they understood each other often without opening their mouths," 830)— and extends throughout the novel—"tous les deux . . . se disaient d'un regard qu'ils s'aimeraient là, et là encore; partout où ils passeraient ensemble" ("both told each other with a look they would love each other here, or there, wherever they might be together," 1058). As in *La Fortune,* the visual charm is broken by sexual contact ("never had they loved each other less than that day," 1024), leading to death (of Jeanne) and separation (of Hélène and Deberle).

Except for Stendhal, there is perhaps no other major French writer of the nineteenth century more profoundly attached to visual communication than Zola.[26] For Stendhal, the visual sign system is a makeshift substitute for verbal communication, fraught as it is with the dangers of censorship and interception. Indeed, the visual quickly yields to the verbal, as in *La Chartreuse de Parme,* when Fabrice and Clélia abandon eye contact and hand signals for communication by large letters, a visual nostalgia for the verbal. For Zola, play and pleasure reside in the visual, in the medium itself, which corresponds strikingly to Jakobson's defini-

26. See, for example, my "Cryptographie et communication dans *La Chartreuse de Parme,*" *Stendhal Club* 78 (1978): 170–82.

tion of the "poetic" function of language.[27] The purity, depth, and direct-
ness of visual communication bypasses the self-censorship inherent in
verbal language. The things we can't say, we can often see. But there are
many things we can't see, and sometimes we are doomed to see nothing
at all.

Visual Castration

It would be tempting to end on the positive note of pure visual communi-
cation and understanding, but Zola's novels seldom do, and neither will
this chapter.

If vision is linked to sexuality, communication, and life, it is as surely
and intimately bound to madness, failure, and death.[28] If certain charac-
ters can read their own madness in a mirror image (Renée) or a shadow
(Gervaise), others can read madness in a person's eyes: "Alice avait des
yeux de folie, où se lisait la mortelle douleur de son dernier orgueil, sa
virginité violentée" ("Alice had eyes of madness, where one could read
the mortal pain of her finished pride, her violated virginity," *L'Argent,*
372). At the moment of her death, "Jeanne regardait Paris de ses grands
yeux vides" ("Jeanne looked [out] at Paris with her large empty eyes"),
while Hélène "promenait devant elle des regards fous" ("cast her insane
looks in front of her," *Une Page,* 1071). Nana, dying from small pox, is
punished visually, as if she had seen too much (especially of herself): "Un
oeil, celui de gauche, avait complètement sombré dans le bouillonnement
de la purulence; l'autre, à demi ouvert, s'enfonçait, comme un trou noir
et gâté" ("One eye, the left, had completely sunk into the seething puru-
lence; the other, half open, was sinking, like a spoiled black hole," *Nana,*
1485). Séverine, strangled by her lover Jacques Lantier, dies "les yeux

27. "The set (*Einstellung*) toward the MESSAGE as such, focus on the message for its
own sake, is the POETIC function of language" ("Linguistics and Poetics," 356). Jakob-
son's use here of the term "message" involves the palpability of the signs, in contrast with
their referential value, and is not opposed to the later notion of "medium."

28. While I fully agree with the argument of Joy Newton and Basil Jackson ("Gervaise
Macquart's Vision: A Closer Look at Zola's Use of 'Point of View' in *L'Assommoir*,"
Nineteenth-Century French Studies 11, nos. 3–4 [Spring–Summer 1983]: 313–20)—"we
should like to trace Gervaise's gradually diminishing ability to see her surroundings and
herself clearly and suggest that it is through the failure of her vision, as much as through any
other factor, that Zola charts her decline" (313)—I can hardly concur with their conclusion
that "it is only in *L'Assommoir* that we find such a close correlation between modification of
the 'point of view' and the decline and fall of the protagonist" (319), as the examples that
follow in the text, particularly from *L'Oeuvre,* demonstrate.

bleus démesurément élargis, qui demandaient pourquoi" ("her blue eyes enlarged beyond measure, asking why," *La Bête humaine,* 1300). Silvère contemplates Miette's dead body "avec ses grands yeux qui regardaient en l'air" ("with her large eyes looking into the air," *La Fortune,* 221), while Silvère's blinding of Rengade (referred to henceforth as "the one-eyed man," *le borgne*) leads inevitably to the former's death (215, 308–14). We have already witnessed Weiss adjusting his glasses to "see death face to face" (*La Débâcle,* 640); as Rochas dies: "Il vécut encore une minute, les yeux élargis, voyant peut-être, monter à l'horizon la vision vraie de la guerre" ("He lived a minute longer, his eyes enlarged, seeing perhaps, rising on the horizon, the true vision of war," 704). Death and looking are irrevocably bound together, as Ripoll notes in citing several other examples;[29] he does not, however, discuss one of the most blatant and significant examples in *Les Rougon-Macquart,* that of Claude Lantier in *L'Oeuvre.* In Claude's case, eyes are not just a sign of madness and death, mirrors of the soul, but metonymically suggest the cause—a physiological failure of vision.

The freshness of vision that characterized Claude's early work begins to wane about halfway through *L'Oeuvre.* In fact, Claude's gradual loss of talent and sanity marks the main movement of the novel's plot, and Zola makes it clear that this demise is due to a visual defect. In the *ébauche* for *L'Oeuvre,* Zola notes of Claude: "La question est de savoir ce qui le rend impuissant à se satisfaire: avant tout, sa physiologie, sa race, la lésion de son oeil" ("The question is to determine what renders him impotent, [unable] to produce: above all, his physiology, his heredity, the lesion of his eye").[30] The optical impairment whose invasion Claude had dreaded

29. For example, Angèle in *La Curée* and Fouan in *La Terre* (see "Fascination et fatalité," 113).

30. *Les Rougon-Macquart,* IV, 1353. Edmond de Goncourt objected strenuously to Zola's use of this "lésion de l'oeil" on the grounds that "à la fin de *Manette Salomon,* Coriolis est pris d'une folie de l'oeil, il ne veut plus en ses toiles et ses tableaux que de la lumière de pierres précieuses. Eh bien, le Claude de Zola, avant de se tuer, est pris de la même folie. Mais sacredieu! C'est un roublard que mon Zola, et il en sait un peu tirer parti, de la folie de l'oeil qu'il m'a chipée! Il fait peindre à son artiste des rubis dans le nombril et les parties génitales de son modèle; et cette folie empruntée aux dernières années de Turner, cette folie tout bonnement esthétique, cette folie désintéressée et improductive chez moi, par la note cochonne, obscène qu'il y ajoute, à lui, ça lui vaudra la vente de quelques milliers d'exemplaires de plus" (from the *Journal,* 5 April 1886, quoted in *R-M,* IV, 1384–85). This kind of optical impairment was, however, such a common ailment among the painters of Zola's time, as Goncourt himself suggests in mentioning Turner's madness, that it seems more probable that Zola borrowed it from them than from *Manette Salomon.* John Rewald, in his *History of Impressionism* (New York: MOMA, 1973) notes, for example, that Degas had oversensitive eyes (230), and that Renoir's increasing sensitivity to light crippled completely for a time his ability to see line and form (370).

early in the novel—"Etait-ce une lésion de ses yeux qui l'empêchait de voir juste?" ("Was it a lesion of his eyes that kept him from seeing clearly?" 53)—finally overtakes him and destroys his most precious gift, creative vision: "Mais Claude ne voyait rien, ce n'étaient que des taches grises dans le jour brouillé et verdi" ("But Claude could see nothing, it was only gray spots in the murky green daylight," 299).

The narrator underscores the connection between Claude's loss of visual contact with reality and his impending madness by focusing on his eyes, especially in the final pages of the novel: "Mais ses yeux restaient fous, on y voyait comme une mort de la lumière, quand ils se fixaient sur l'oeuvre manquée de sa vie" ("But his eyes remained mad; one could see there [something] like a dead light, when they focused on the failed work of his life," 308; see also 324). Despite Christine's questions to Sandoz— "Mais ses yeux, avez-vous remarqué ses yeux? . . . Il a toujours ses mauvais yeux" ("But his eyes, have you noticed his eyes? . . . He still has his bad eyes," 309; see also 337)—and her exhortations to Claude— "Réveille-toi, ouvre les yeux, rentre dans l'existence" ("Wake up, open your eyes, come back to existence," 347)—Claude is unable to return to reality and finally hangs himself, partly from frustration and partly as a consecration to his ideal, in front of his final, uncompleted, grotesque "masterpiece." In this key passage Zola's insistence on Claude's eyes, bulging from their sockets and focused forever on his unfulfilled dream, serves as a grim reminder that creativity, like life itself, is above all a matter of vision:

> Claude s'était pendu à la grande échelle, en face de son oeuvre manquée . . . atroce avec sa langue noire et ses yeux sanglants sortis des orbites, il pendait là, grandi affreusement dans sa raideur immobile, la face tournée vers le tableau, tout près de la Femme au sexe fleuri d'une rose mystique, comme s'il lui eût soufflé son âme à son dernier râle, et qu'il l'eût regardée encore, de ses prunelles fixes.

> (Claude had hung himself from the large ladder, in front of his failed masterpiece . . . atrocious with his black tongue and his bloody eyes popped out of their sockets, he was hanging there, horribly enlarged in his stilled stiffness, his face turned toward the painting, right near to the Woman in whose pubic area flowered a mystic rose, as if he had breathed his soul into her with his last gasp, and were still looking at her with his fixed eyeballs. 352)

Claude's desocketed eyes, symbolizing his lack of contact with reality, his loss of creative power, his "impotence" (see Zola's remark on page 93),

cannot fail to evoke images of castration. The link seems all the more compelling, given Claude's sexual failure with Christine and obsession with the mystical woman (and her flowering pubic area!) in his painting throughout the final third of *L'Oeuvre*. However, it might be overstated to see Claude's blindness merely as a symbol of his castration. For Zola, loss of sight would be every bit as fearful as loss of sexuality. Bound as vision is, not just with sexuality, but with creativity and communication, loss of sight, not genitals, is the ultimate form of castration in Zola's universe.

Like verbal language, vision constitutes a communications system. As such it can be schematized, as shown above, by approaches to communication like Jakobson's. Vision can lead to authentic communication by simplifying or purifying codes and by avoiding the censorship, mystification, and loss of contact that often threaten verbal exchange. Vision can also lead to self-understanding, as in scenes like those involving the mirror, where sender and receiver are the same individual, but where these two components of the self require the transmission of a message along visual channels for communication to occur. Also, Zola's repeated insistence on visual motifs constitutes a metaliterary statement, pointing to the means of deciphering other aspects of his text. In Zola's descriptive passages (Chapter 4), for example, the decor becomes sender, transmitting light waves to the acute viewer who knows how to receive and decode them. In the workings of imagination (Chapter 5), a reversal can occur, whereby the viewer becomes a transmitter, projecting, imposing a message on the milieu. In all cases, from its paradoxical position within the verbal medium, the visual is highlighted and accorded a primal relationship with reality, whose contours the verbal seeks to capture in order to regain contact with the removed and remote referent.

3 *Viewpoint and Point of View*

Et le peintre ravi clignait les yeux, cherchait le point de vue afin de composer le tableau dans un bon ensemble. (And the delighted painter blinked his eyes, looked for the viewpoint in order to compose the painting as a whole.)

— Zola, *Le Ventre de Paris* (I, 624)

Viewpoint is certainly among the central issues of modern art and litera-ture,[1] one that governs composition, as noted in the above quote concern-ing the painter Claude Lantier, and one that shapes ideology throughout the *Rougon-Macquart*. But what exactly is viewpoint? or, as Henri Mitterand puts it more precisely in concluding a provocative article on "looking" in Zola's novels, "Who looks at what, from where, how, and

1. In fact, point of view is the most crucial issue in modern fiction for numerous critics, among them Percy Lubbock ("The whole intricate question of method, in the craft of fiction, I take to be governed by the question of point of view." *The Craft of Fiction* [New York: The Viking Press, Compass Books, 1957], 251) and Norman Friedman ("Thus the choice of a point of view in the writing of fiction is at least as crucial as the choice of a verse form in the composing of a poem." "Point of View in Fiction: The Development of a Critical Concept," in *Approaches to the Novel,* ed. Robert Scholes [San Francisco, Chandler Publishing Co., 1961], 137).

with what consequences?"[2] This chapter attempts to deal with the notion of viewpoint, by situating it within the context of other visual problems in Zola's work and, especially, by drawing upon the precise terminology utilized in visual art criticism. Several preliminary definitions and distinctions are necessary.

Viewpoint and Viewing

Viewpoint is used here in its most strictly visual sense ("who sees what"), rather than as a synonym for opinion ("who thinks what") or narration ("who says what"). The relationship of the three concepts—seeing, thinking, and saying (or showing, shaping, and telling)—has long been at the heart of distinctions (and confusions) in discussions of narrative technique. Indeed, it will form an important aspect of this chapter, especially concerning the role of vision and visual phenomena in Zola's program of impartial narration.

Furthermore, the term "viewing" (or "looking" or "watching"—i.e., *le regard*), a focal point of the previous chapter, must be distinguished clearly from viewpoint. Viewing denotes the eye direction, expression, and contact of the *characters* within a scene. It concerns the interaction of characters to form visual networks and themes within the space of the novel's story or the painting's picture. In the dressing room scene from *Nana,* for example, Count Muffat watches Nana, who watches herself in a mirror; in *Woman in a Loge,* the male spectator armed with binoculars watches Lydia, who watches the spectacle; in both cases the topic, the motif, is watching, and we might represent the networks of visual interaction as shown in Diagram 3. In both cases a narrator or implied viewer watches these characters

mirror

$$
\begin{array}{lll}
\leftarrow & & \text{mirror} \\
= \text{Nana} \leftarrow \text{Muffat} & = & = \\
\rightarrow & \text{Lydia} \leftarrow & \text{man} \\
& \downarrow &
\end{array}
$$

\rightarrow (line of force of looking)
$=$ (reflected image)

Diagram 3.

2. "Qui regarde quoi, d'où, comment, et avec quelles conséquences?" "Le Regard d'Emile Zola," *Europe* 46, nos. 468–69 (April–May 1968): 198.

from a certain hypothetical vantage point outside the scene portrayed (though not necessarily from outside the rooms or halls where the characters are situated, since narrative space or viewer space is still fictional); this is the *viewpoint,* and it can be represented as shown in Diagram 4. The narrative space and the implied viewer's space must still be distinguished from the space of the reader of the novel or the actual spectator of the painting, whose task it is to simulate as closely as possible the position of narrator and implied viewer, but who is forever locked out of fictional or represented space. While the distinction between narrator and reader is clear, because one tells (transmits), and the other reads (receives), in a painting, both implied viewer and spectator look. However, the implied viewer's position (or positions) is fixed forever, while the spectator is, like the reader, a multiple and mobile entity who retains many options, including the cessation of the viewing process. This addition to the visual schema can also be represented graphically (Diagram 5).

The *viewpoint* (narrative and viewer space) is defined by the *position* (*level, angle,* and *distance*) from which the narrator/reader or viewer/spectator is meant to view the scene depicted by the author/painter. Viewpoint is not a theme, but the form, mode, or manner by which visual motifs are presented. Watching always takes place within a scene or picture, although someone watching may not be the main scene, but a sort of "sub-scene" of what is being watched (as with the male figure watching Lydia). In painting, the viewpoint—the hypothetical position from which one views the scene—is always "outside" the scene itself, although the viewer's presence may be implied, even reflected within the scene, as in the mirror reflecting the male client in Manet's *Bar aux Folies Bergère,* or in any self-portrait. In literature, the viewpoint is also "outside" the scene, whether the reader sees an image through the eyes of Nana or Muffat, or even through a first-person narrator. Their status as proper nouns or pronouns makes them objects of another observer, either the third-person narrator, who holds a privileged position "overseeing" both the characters and their surroundings, or the first-person narrator, not to be confused with his or her role as character. That is, the "I" telling a story must see his or her own self as object in order to report the scene. The "I" teller occupies narrative space, not story space, from which the "I" is often banned by time (usually recounting the event after it has occurred); the reader can occupy neither space but may "project" himself or herself toward either. Both the implied viewer in painting and the narrator in literature, in terms of *viewpoint,* occupy a space analogous to that of the camera in a photograph or a motion picture.

The history of viewpoint, in both painting and literature, may be seen in terms of the relationships among these three spaces—the character's/

Diagram 4.

Diagram 5.

figure's, the narrator's/viewer's, and the reader's/spectator's. Although the boundaries delineating each space are inviolable, a prime thrust of nineteenth-century experimentation in viewpoint, in both art forms, is aimed at creating the illusion of merging or of crossing the boundaries between these spaces. First-person narration seeks to close the gap between narration and story, by using a pronoun that superimposes character (younger I) and narrator (older I).[3] At the same time, from the opposite direction of third-person narration, Zola's entire program of "impartiality" aims at rendering the narrator's space unobtrusive, transparent, in order to allow the reader to project himself/herself into the story. In particular, the adoption of the dramatized viewer, in both painting and literature, by situating a simulacrum of viewpoint within the story or picture space, represents the consistent effort of painter and author to forge and foster the illusion of bypassing the narrator/viewer space by having the reader/spectator identify more readily with the character/figure.

In painting, where the spatial precision of the visual image makes the distinction between the character's "look" and the viewer's vantage point quite clear, there can, nonetheless, be a "coincidence" of viewing. A dramatized viewer can be interposed between the implied viewer and the scene to serve as a further visual intermediary (Diagram 6). Such is the case

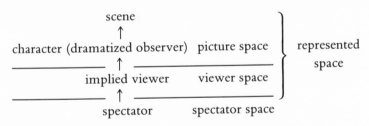

Diagram 6.

with numerous paintings of the impressionist era, like Monet's *Seine à Bennecourt* (1868), where the spectator simultaneously views the river and a woman watching the river, or Degas's *Mary Cassatt au Louvre* (1880), where the spectator ostensibly sees a gallery of the Louvre through the eyes of Mary Cassatt, herself being watched by her sister, whom the spectator watches (Diagram 7). These characters are not just a part of the scene, as in *Woman in a Loge;* the spectator also is meant to see the scene

3. In fact, in past-tense narration many authors, like Diderot and Chateaubriand, shift suddenly into the present tense, which projects the reader abruptly into the character's space.

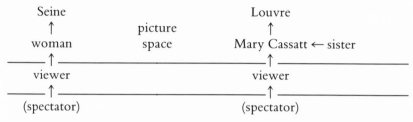

Diagram 7.

through them. They serve as intermediary and interpreter in filtering the surroundings through their eyes and consciousness for the spectator. The Seine becomes a subject of musing and meditation, and the Louvre gallery takes on the light palette and linear fluidity of Mary Cassatt's artistic style (radically different from that of the paintings one would expect to find in the Louvre). Such mediation also occurs in a painting by Berthe Morisot (Fig. 2), which we shall now examine in some detail.

Morisot's On the Balcony, Meudon

There are startling similarities between Berthe Morisot's *On the Balcony, Meudon* (1874)[4] and Emile Zola's *Une Page d'amour* (1878): in both, a woman and a female child command a panoramic view of Paris from a balcony of a *hôtel particulier* in Passy. This alone would be sufficient cause for comparing them; however, the fact that each also involves a cityscape seen from a striking viewpoint by multiple dramatized viewers makes such a comparison compelling.

Indeed, Zola expressed his admiration for Morisot on several occasions, from as early as 1868, through the independent shows of 1876, 1877, and 1880, extolling, respectively, her freshness of vision, her "extraordinary finesse," her accurate handling of color, and her personal touch.[5] By the same token, Morisot's correspondence bears evidence that she had met Zola as early as 1868, at Madame Auguste Manet's Thursday

4. The French title for the oil painting is *Femme et enfant au Balcon,* listed in Marie-Louise Bataille and Georges Wildenstein, *Berthe Morisot: Catalogue des peintures, pastels et aquarelles* (Paris: Les Beaux Arts, 1961), 25; the English title is for the watercolor study in the Art Institute of Chicago, which appears in Figure 2 here (see Bataille and Wildenstein, 61).

5. See Zola, *Mon Salon/Manet/Ecrits sur l'art,* ed. Antoinette Ehrard (Paris: Garnier Flammarion, 1970), 161, 280, 282, and 337.

Fig. 2. Berthe Morisot, *On the Balcony, Meudon*. Watercolor, with touches of gouache, over graphite, 1874. Courtesy The Art Institute of Chicago, Gift of Mrs. Charles Netcher in memory of Charles Netcher II, 1933.1.

gatherings, that she had greatly admired Manet's portrait of Zola exhibited at the Salon of 1869, and that she had encouraged her mother to read *Le Ventre de Paris,* noting a "parallel between this literature and the painting of the new school."[6]

Morisot—who, incidentally, was married to Eugène Manet, the painter Edouard's brother—was among the first of the nascent impressionist group to become interested in the panoramic cityscape. Her *La Seine en aval du Pont d'Iéna* of 1866 was exhibited in the Salon of 1867 and influenced Manet's first such work, *L'Exposition universelle de 1867* (1867). At about the same time, Monet was also exploring the possibilities of the panoramic cityscape in his *Jardin de l'Infante* and *Quai du Louvre,* both of 1867, which show views of Paris from the upper balconies of the Louvre. The elevated viewpoint is, of course, not just a startling innovation offering a "fresh view" of a subject, it allows the viewer to see more of the subject, to dominate it, and to organize it.

Morisot's *On the Balcony* follows both Manet and Monet in using domes (here, the Invalides) as reference points and anchor points of the composition; she has also adopted a viewpoint that is striking and innovative in several ways. The *level* is elevated, as in Monet's paintings, the *distance* is great, and the *angle* of vision is not direct, but at a bias (highlighted by the diagonal line of the balcony and railing), a feature often found in Degas's work. Perhaps the most significant innovation of Morisot's handling of viewpoint is to have personalized it, *dramatized* it, by including observers within the scene. The mother expresses her concern, perhaps protectiveness of the child by her intent stare:

mother → child

At the same time, the child serves as a mediating viewer of the cityscape, interposed between the implied viewer (who lurks invisibly behind the figures, presumably somewhere within the room leading to the balcony) and Paris (Diagram 8).

Circumscribed as it is by the implied viewer's position, the spectator's role is nonetheless more complex, since it involves several alternatives.

```
            Paris                                    ⎫
              ↑                                      ⎪
mother → child (dramatized observer)  picture space  ⎬  represented
────── ↑ ──────────────────────────────────────      ⎪  space
    implied viewer              viewer space         ⎭
```

Diagram 8.

6. See Denis Rouart, *The Correspondence of Berthe Morisot,* trans. Betty Hubbard (New York: Wittenborn, 1957), 26, 31, and 89.

The most probable reading of the painting, given the size, position (to the left), and value (dark dress) of the woman, would be to look first at her, then follow the line of force established by her look to the child, whose gaze, implying that of the spectator, then leads to the city. But the spectator also retains the option of bypassing the woman, to look directly at the child, or the child, to look directly at the city. This configuration might be depicted as shown in Diagram 9. The spectator, confronting the ambiguity of multiple viewing possibilities, becomes a synthesizer, an "overseer," whose vision encompasses that of the watcher (the woman), the dramatized observer (the child), and the implied viewer.

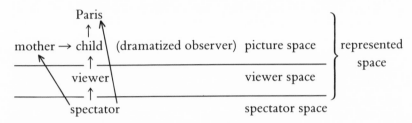

Diagram 9.

Morisot's use of multiple dramatized viewpoint is far from gratuitous; the very choice of this mode, as well as the pursuit of any of the particular viewing possibilities, entails specific thematic consequences, while the degree of complexity adds to the dynamism and thematic density of the painting.

By dramatizing the viewers, Morisot shifts the painting's focus from Paris to the balcony—as suggested by the English and French titles, respectively—and the thematic locus from the cityscape to the very act of viewing. Moreover, by placing the observers in a position analogous to the spectator's, she establishes a visual equivalence between viewing Paris and viewing a painting. Paris becomes less a city—a multifaceted site of interpersonal interaction—than a unified picture, a homogeneous "spectacle," or, as T. J. Clark terms it in discussing Manet's *Exposition universelle,* "simply . . . *an image,* something occasionally and casually consumed in spaces expressly designed for the purpose—promenades, panoramas, outings on Sundays, great exhibitions, and official parades. It could not be had elsewhere, apparently; it was no longer part of those patterns of action and appropriation which made up the spectators' everyday lives."[7]

7. *The Painting of Modern Life: Paris in the Art of Manet and His Followers* (Princeton: Princeton University Press, 1984), 36.

To Clark's list of privileged vantage points one can surely add the balcony, which Griselda Pollack incorporates into her own catalogue of feminine spaces in Cassatt's and Morisot's work—spaces that are often closed and compressed and always separate from masculine spheres of action.[8] Certainly, in Morisot's *On the Balcony,* the distance and height of the female viewers' vantage point, along with the absence of a distinct middle, transitional ground and, especially, the presence of the balustrade bars as a barrier, serve to render Paris remote, inaccessible—physically, if not visually.[9] However, approaching each viewer separately allows the spectator perhaps to differentiate between them. The woman, her eyes fixed on her young daughter (presumably), may suggest the more traditional woman's role within the family structure, underscored by the conservative dark dress. On the other hand, the daughter's gaze may represent the more open perspective of the younger generation, turned away from the family and toward the lure of the big city. The daughter, rendered in lighter value, looks beyond the bars that would imprison her, toward the distant space of future adventure.

While one must be wary of "reading too much" into a painting, it is undeniable that the contours of the image are dictated by thematic as well as visual forces and that the writing process causes amorphous feelings to be articulated with a precision that the painter does not require to execute an image. Worse yet would be not "reading enough" into a painting, even if this means rejecting preconceived hypotheses should they fail the tests of consistency and versimilitude that govern criticism of any art form. Moreover, whatever "interpretation" is proposed here is based on salient visual data—the form (dramatized), distance, height, and angle of the viewpoint, along with compositional elements, like the interposed railing, the contrast between light and dark values, and the absence of a distinct middle ground.

In applying Mitterand's set of questions to Morisot's painting, one might conclude that a woman looks at a child, who looks at Paris from a vantage point whose height and distance suggest visual fascination as much as physical separation. The choice of viewpoint underscores, even generates, thematic concerns, while suggesting ideological positions— Marxist for T. J. Clark, feminist for Griselda Pollack. The visual "view-

8. See *Vision and Difference: Femininity, Feminism, and the Histories of Art* (London: Routledge, 1988), especially chapter 3, "Modernity and the Spaces of Femininity," where Pollack discusses Morisot and Cassatt.

9. In analyzing Morisot's painting, Pollack concludes that "what Morisot's ballustrades demarcate is not the boundary between public and private but between the spaces of masculinity and femininity inscribed at the level of both what spaces are open to men and women and what relation a man or woman has to that space and its occupants" (ibid., p. 62).

point" determines ideological "points of view," as it will be seen to do throughout *Les Rougon-Macquart.*

I shall now turn to Zola's novels to examine viewpoints that are 1) elevated or otherwise innovative, 2) fixed or mobile, and 3) dramatized and/or multiple, in order to assess their thematic consequences and their role in Zola's narrational program. Since most of the early examples involve explicit dramatized observers, where the viewpoint is attributed to the character, the distinction between narrator's space and character's space will be suspended momentarily before returning as a major issue in the final sections of this chapter.

Bird's-Eye / Worm's-Eye

If the act of viewing is called to the reader's attention in *Les Rougon-Macquart* by the extraordinary number and salient use of perception verbs, the viewer's vantage point is often identified with equal explicitness and specificity. The term "viewpoint" (*point de vue*) itself occurs twice in the opening scene of *La Curée,* where Renée and Maxime tour the Bois de Boulogne in their carriage (322 and 326), and again in the first chapter of *Le Ventre de Paris,* where Claude and Florent observe a street scene. In this latter example, cited at the head of this chapter, Zola underscores the linking of viewpoint and composition that governs the overall structure of his descriptive passages, as shall be seen in Chapter 4.

The effect of the viewpoint can often surprise the character, as it does in *L'Oeuvre* to both Christine, who doesn't recognize Notre-Dame Cathedral seen from behind (101), and Claude—"la Femme, vue ainsi d'en bas, avec quelques pas de recul, l'emplissait de stupeur" ("the Woman, seen thus from below, from a few steps away, filled him with amazement," 347)—when angle (behind), level (below), or distance (away) alter the appearance of highly familiar objects.

Zola, like Degas and other impressionists, shows a penchant for unorthodox angles of vision.[10] In *Le Ventre,* for example, Claude is struck by both distance and angle: "Au loin, les Halles, vues de biais, l'enthousiasmaient" ("From afar, the Halles, seen diagonally, enthused him," 781). This type of oblique perspective is adopted and signaled with some regular-

10. Edmond Duranty was among the first to describe this aspect of the "new painting" (he alludes to Degas here): "Views of people and things have a thousand ways of being unexpected in reality" (*La Nouvelle Peinture: A propos du groupe d'artistes qui expose dans les galeries Durand-Ruel* [Paris: Marcel Guérin, 1876], repr. in *Impressionism and Post-Impressionism,* ed. Linda Nochlin [Englewood Cliffs, N.J.: Prentice-Hall, 1966], 6).

ity in the Rougon-Macquart novels, as, for example, with "the Arc de Triomphe posed at an angle" in *La Curée* (329) or when Jacques is repeatedly struck by a house that "rose up diagonally" in *La Bête humaine* (1180).

However, by far the most recurrent and consistent area of innovation for Zola involves the use of elevated viewpoint. Such views from above occur at crucial moments in virtually every novel, and Zola even uses the rather technical term for them, "bird's-eye view" (*à vol d'oiseau*), in both *Une Page d'amour* (1084) and *L'Argent* (43).

The elevated vantage point is often used for informational ("expository") purposes, since it allows the character to see with sufficient breadth to situate even a vast setting for the reader. Thus, in the first part of *La Faute de l'abbé Mouret*, Serge surveys the countryside of his parish; in *L'Assommoir*, Gervaise looks down from her hotel window to scan the working-class neighborhood and identify its major reference points;[11] in *La Bête humaine*, Roubaud sits at the window as his "eye plunges" (997) down on the Gare Saint-Lazare, the Pont de l'Europe, and the rails that lead to Le Havre, thereby circumscribing the novel's main lines of action. In both of the latter cases, the window serves to frame the scene and call attention to the vantage point, thus justifying the description.[12]

In some cases the elevated viewpoint simply serves as a source of visual entertainment, of panoramic pleasure. Nana's view of the countryside from the roof of her chateau elicits the cry "it's a fairyland" (1234), while in *L'Assommoir*, the Lantier wedding party's view of Paris from atop the Vendôme column evokes reactions of awesome terror (449).

Nonetheless, in the vast majority of cases, the elevated viewpoint does not just fulfill expository or entertainment purposes, but has a definite thematic value. Although in scenes such as Silvère and Miette peering down at their images in the well, dizziness and depth are suggested by the vantage point (184), the elevated vantage points of interest here are the panoramic views of landscapes or cityscapes. Basically, the elevated viewpoint is used to underscore one of two recurrent themes in *Les Rougon-Macquart*—escape or domination.[13]

11. See Joy Newton and Basil Jackson, "Gervaise Macquart's Vision: A Closer Look at Zola's Use of 'Point of View' in *L'Assommoir*," *Nineteenth-Century French Studies* 11, nos. 3–4 (Spring–Summer 1983): 313–20.
12. Concerning the function of the window, see Naomi Schor, "Zola: From Window to Window," *Yale French Studies* 42 (June 1969): 38–51, and Philip Walker, "The Mirror, the Window, and the Eye in Zola's Fiction," *Yale French Studies* 42 (June 1969): 52–67.
13. Naomi Schor describes the thematic function of the elevated viewpoint from a slightly different though complementary perspective: "Vertical distance combines feelings of superiority with those of detachment. The greater the height, the further removed one is from the suffering below" ("From Window to Window," 44).

"Dreamers" frequently rise from the entrapment of their claustro-
phobic milieu to look down on, or out and away from, their situation.
Florent's motivation in *Le Ventre de Paris*—"Que de rêves il avait faits, à
cette hauteur, les yeux perdus sur les toitures élargies des pavillons"
("How many dreams he had had, from this height, his eyes absorbed in
the enlarged roofs of the pavilions," 867; see also 713)—could well be
extended to any number of Zola characters, including Renée when she
returns to the "children's room" of her family home and gazes down at
the Seine (*La Curée*, 402, 598), Silvère and Miette hiding in the hills
awaiting the inevitable arrival of the government troups, or Gervaise and
Goujet as they look over Paris from the heights of Montmartre (613).

In *Une Page d'amour* the thematic value of the elevated viewpoint (not far
from the vantage point in Morisot's painting) is more complicated. Hélène
herself has a certain "aloofness" (1084) and "distance" (1083) from others,
which is initially reflected in her view of Paris from above and afar. She
remains separated, distant, in fact, so removed from the city that its monu-
ments, sights, and scenes remain unknown to her throughout the novel.
She initially seeks to escape from her emotions in the visual pleasure of the
ever-changing panorama outside her window. However, the cityscape
soon becomes a vast screen for the projection of fantasies, desires, and
fears, as she plays out her emotional drama on the decor. When she views
Paris in the final chapter, again from on high, again from afar—but this
time from the cemetery (Père-Lachaise) where her daughter Jeanne is
buried—distance and height once again reflect her character, as does her
separation from the city, which she will never come to know (1091–92).
Her estrangement is mirrored by the elevation and distance of her vantage
point, much as with the mother and child in Morisot's painting.

Opposite escape, dominance is also associated frequently with the ele-
vated viewpoint: the placement of the battle scene "at King William's feet"
(*La Débâcle*, 584) suggests Prussian dominance of the French army; Nana,
after climbing atop the seat of her landau in order to view the horse races,
"dominated the plain" (1398);[14] and the speculator Saccard traces the strate-
gic paths of Haussmann's renovations of Paris, calculating profits to be
had, as he looks down on Paris from the heights of Montmartre (*La Curée*,
387–90). The same Saccard occupies a similar vantage point, looking
down on la Bourse, the seat of commerce, at the beginning of *L'Argent*:

> Jamais, en effet, il ne l'avait vue sous un si singulier aspect, à vol
> d'oiseau. . . . Et le monument lui-même n'était plus qu'un cube

14. The verb "dominer" occurs elsewhere in describing the elevated viewpoint (see
L'Argent, 343, and *La Débâcle*, 897).

de pierre, strié regulièrement par les colonnes, un cube d'un gris sale, nu et laid, planté d'un drapeau en loques. Mais surtout, les marches et le péristyle l'étonnaient, piquetés de fourmis noires, toute une fourmilière en révolution, s'agitant, se donnant un mouvement énorme, qu'on ne s'expliquait plus, de si haut, et qu'on prenait en pitié.

(Never, in fact, had he seen it from such a unique perspective, a bird's-eye view. . . . And the monument itself was no more than a cube of stone, streaked regularly by its columns, a dirty gray cube, naked and ugly, topped by a ragged flag. But, especially, the steps and peristyle astounded him, dotted with black ants, a whole anthill in revolt, agitated, frought with a great movement that was no longer intelligible, from so high, and on which one took pity. 43)

Here the elevated viewpoint leads to a startling perspective that reduces la Bourse in size and complexity by simplifying it to an elementary geometric form. The very height of the vantage point reduces the crowd in size and stature ("ants") and transforms the stock exchange into a manageable system ("anthill") that one dominates emotionally ("pity") as well as physically. Saccard has used a visual vantage point to the same purposes that Florent used Lisa's reflection in the mirror (*Le Ventre,* 667)—to manage, manipulate, and control a phenomenon with which he is obsessed to the point of timidity in a direct view.

In both cases the victory is short-lived, a notion that the narrator of *L'Argent* underscores near the end of the penultimate chapter (a particularly pregnant position in Zola's novels) in the final view of la Bourse, seen from below:

Mme Caroline leva les yeux. Elle était arrivée sur la place, et elle vit, devant elle, la Bourse. Le crépuscule tombait, le ciel d'hiver, chargé de brume, mettait derrière le monument comme une fumée d'incendie, une nuée d'un rouge sombre, qu'on aurait crue faite des flammes et des poussières d'une ville prise d'assaut. Et la Bourse, grise et morne, se détachait, dans la mélancolie de la catastrophe.

(Mme Caroline raised her eyes. She had arrived at the square, and she saw before her la Bourse. Night was falling, [and] the winter sky, filled with fog, placed a sort of smoke behind the monument, a dark red cloud that seemed made of the flames and dust of a city under attack. And la Bourse, gray and sad, detached itself, in the melancholy of the catastrophe. 360–61)

If the market itself is threatened by financial ruin, it still looms over the minuscule spectators/speculators, its dominance heightened by the choice of the vantage point below it.

This "worms-eye" view, a striking viewpoint directed up at the subject, can also be found in impressionist paintings, such as Degas's *Mlle Lala au Cirque Fernando,* where, appropriately enough, the spectator looks up at a high-wire walker. Zola's use of this technique, as Laurey K. Martin has convincingly shown,[15] is consistently aimed at demonstrating the domination of the individual by the encompassing, threatening milieu. In *L'Assommoir,* for example, in examining the "grande Maison," Gervaise repeatedly raises her eyes (414, 422), leading to an impression of the house's increasing size (431) and ultimately to a feeling of complete domination by it: "Alors il sembla à Gervaise que la maison était sur elle, écrasante, glaciale à ses épaules" ("Then it seemed to Gervaise that the house was on top of her, crushing, ice-cold on her shoulders," 431). In fact, Zola uses the worm's-eye viewpoint almost exclusively in cases where he intends to suggest the overwhelming impact of the milieu on the individual. In *Germinal,* for example, Etienne's perception of the mine ("he looked into the air," 1152) leads to a reaction of fear: "le vol géant sur sa tête l'ahurissait" ("the gigantic flight over his head panicked him," 1153). In the opening chapter of *Le Ventre de Paris,* as Florent wanders aimlessly through the gigantic marketplace, dwarfed by the modern metal structures, he repeatedly returns to the pointe Saint-Eustache and looks up at the church (609, 611, 621). The recurrence of this same act enables Zola to centralize the sense of space in the chapter and measure the passage of time, while showing the dominance of Florent by the milieu in which he has been inserted. This final example, from *Le Ventre,* suggests another characteristic of Zola's handling of viewpoint—mobility and movement.

The Mobile Viewpoint

In traditional painting, viewpoint is not only at ground level, it is fixed and static. The single immobile point from which the scene is viewed dictates the perspective lines and unified composition of the scene. The impressionists began to experiment with modulating viewpoints, as if one were seeing from two or more contiguous vantage points, or looking

15. "L'Elaboration de l'espace fictif dans *L'Assommoir,*" *Cahiers naturalistes* (forthcoming).

from two levels at once,[16] while Cézanne, and later the cubists, attempted to depict an object simultaneously from two radically separated vantage points.[17] However, their experiments run up against the nature of the art form, which is spatial and static. The nature of literature, on the other hand, is temporal and sequential, and Zola experiments with these properties, expressing and exploiting them through several forms of mobile viewpoint.

Guy Gauthier has noted of Zola's descriptions that "he likes viewpoints that are fixed but privileged, panoramic views, vast perspectives."[18] While we have certainly witnessed Zola's penchant for panoramic scenes, the issue of fixity/mobility warrants further discussion. I would contend that, throughout *Les Rougon-Macquart,* we find a dialectical interplay of modes within an overall evolution where the dominant mode goes from (1) the fixed viewpoint, to (2) scanning (eye movement), to (3) tracking (moving viewer), to (4) recurrence and (5) reversal of viewpoint, and finally to (6) the multiplication of simultaneous viewpoints that characterizes later novels like *La Bête humaine* and *La Débâcle.*

Certainly the stationary viewpoint, often framed by the window,[19] is the dominant mode in several novels, particularly earlier ones. From *Le Ventre de Paris* (where Florent gazes out his window at the Halles) to *La Conquête de Plassans* (where l'abbé Faujas observes the different political factions in their gardens), to *L'Assommoir* (where Gervaise looks futilely for Lantier in the streets below her hotel room), to *Une Page d'amour* (where Hélène and Jeanne fix their gazes on the distant Paris), to *La Joie de vivre* (where Pauline observes the sea), to *Le Rêve* (where Angélique watches the Cathedral), the window frames a scene for the stationary

16. See, for example, the disproportionately large size of foreground figures in relation to mid-ground figures in Manet's *Road Menders, rue de Berne* (formerly rue Mosnier), suggesting two views, one looking down, the other out. Anne Coffin Hanson has commented on the "visual truth" of this aspect of Manet's art: "It is extremely difficult, even experimentally, to stabilize the human eye, but recent experiments confirm what medieval opticians asserted, that the eye is literally blind when not in motion. It cannot take the static position of the camera or mathematical theory and still function" (*Manet and the Modern Tradition* [New Haven: Yale University Press, 1977], 202).

17. See, for example, John P. Richardson, "Georges Braque," in *Impressionist and Post-Impressionist Paintings from the U.S.S.R.* (Washington: National Gallery of Art; and New York: Knoedler and Co., 1973): ". . . they [Braque and Picasso during their cubist period] renounced traditional perspective with its single viewpoint, and represented objects from all sides, or at least from more than one side simultaneously" (11).

18. "Il affectionne les points de vue fixes, mais privilégiés, les vues panoramiques, les grandes perspectives." "Zola et les images," *Europe* 46, nos. 468–69 (April–May 1968): 405.

19. See Schor, "Zola: From Window to Window" and Walker, "The Mirror, the Window, and the Eye."

observer. However, in all these cases, movement occurs and is even highlighted, through scanning (eye movement).

Scanning occurs sporadically in several novels: eye movement dictates spatial form in *La Curée*—"A mesure que l'oeil montait l'hôtel fleurissait davantage" ("As the eye rose the hotel flourished even more," 331)— encompasses vast space in *Nana*—"d'un regard circulaire, elle embrassait l'horizon immense" ("with a circular look, she embraced the immense horizon," 1398)—and expresses a certain freedom in the otherwise oppressive milieu of *La Terre*—"le regard allait librement d'un bout à l'autre de l'horizon" ("[Jean's] look moved freely from one end of the horizon to the other," 797).

In some novels, including several of the middle ones, scanning assumes a sustained and dominant role. The beginning of *L'Assommoir* displays the systematic movement of Gervaise's surveillance: "elle regardait à droite . . . elle regardait à gauche . . . lentement, d'un bout à l'autre de l'horizon, elle suivait le mur d'octroi" ("she looked to the right . . . she looked to the left . . . slowly, from one end of the horizon to the other, she followed the city wall," 376). The use of the motion verb "follow" in the latter part of the passage stresses the movement of Gervaise's eye, which contrasts ironically with her immobility and entrapment in the hotel room. In *Une Page d'amour,* "le regard de la jeune femme [Hélène] rencontrait d'abord le pont des Invalides, puis le pont de la Concorde, puis le pont Royal; les ponts continuaient, semblaient se rapprocher, se superposaient" ("the young woman's [Hélène's] gaze encountered first the bridge of les Invalides, then the bridge of la Concorde, then the Royal Bridge; the bridges continued, seemed to approach each other, to become superimposed," 851). Through the effects of scanning, time is embedded in the spatial description, both by the temporal adverbs and by the metonymic device where action verbs are attributed to the inanimate bridges. Obviously the movement is due not to the bridges but to the eye; visual effects replace their unstated causes. In another example, Hélène undermines her voluntary withdrawal from the city through her liberal gaze: "Maintenant, Hélène, d'un coup d'oeil paresseusement promené, embrassait Paris entier" ("Now, Hélène, with a lazily strolling glance, embraced all of Paris," 852). Again, the choice of expressions is interesting: her gaze overcomes her fear of walking in Paris ("strolling"), while manifesting the repressed sexual desires that progressively emerge through visual contact with the city ("embraced").

In the final pages of part I in *Germinal,* as Etienne, posted at the door of Rasseneur's bar, decides whether to stay in Montsou, his mobile gaze confronts, grasps, and records the decor that darkness had previously masked from him: "Pendant qu'Etienne se débattait ainsi, ses yeux, qui

erraient sur la plaine immense, peu à peu l'aperçurent. . . . les regards
d'Etienne remontaient du canal au coron . . . puis, ils revenaient vers le
Voreux, s'arrêtaient" ("While Etienne continued to question himself, his
eyes, which were wandering over the immense plain, gradually per-
ceived it. . . . Etienne's gaze rose from the canal to the compound . . .
then, it came back toward the Voreux, stopped," 1192). Just as Gervaise's
ocular tour of the neighborhood at the beginning of *L'Assommoir* will
later be played out on foot as she walks the streets, so it would seem that
Etienne's visual promenade, where his gaze stops at le Voreux, seals his
decision to stay and, with it, his fate.

The use of scanning to replace actual movement might lend credence
to Gauthier's judgment concerning Zola—"sometimes, as if regretfully,
he accompanies his characters. . . . [He is] seldom inclined to move in his
role as observer"[20]—were it not for the frequent use of mobile viewpoint
or "tracking," often in crucial positions such as the beginning and ending
scenes of his novels.[21] *La Curée,* for example, begins with Renée's and
Maxime's tour of the Bois de Boulogne by carriage, while *Le Ventre de
Paris* features Florent's approach to Paris in Mme François's wagon, fol-
lowed by his wandering through the Halles on foot. If scanning the
faubourg Poissonnière opens *L'Assommoir,* then walking the same route
closes it. In all cases, the narrator's/reader's gaze accompanies the charac-
ters on their journey, tracking them in movement and filtering the scene
through them rather than remaining removed and observing them from
afar. It is true that, in the early novels, such movement is sporadic and
discontinuous; the viewpoint does not remain in motion for long; the
carriage stops, as does Florent (at the Saint-Eustache point) and Gervaise
(to observe her shadow).

With the middle novels, however, a continuous mobile viewpoint be-
comes a more prevalent mode of registering a scene. In the chapter
beginning *Germinal,* Etienne's slow walk from Marchiennes to Montsou
at night causes him to perceive his surroundings progressively: the dis-
tance, darkness, and incompleteness of his perception enable him to regis-
ter only vague impressions ("a vision of a village," 1134) before eventu-
ally recognizing what he is seeing ("then the man recognized a mine"
1134) and, finally, completing the scene: "Etienne . . . regardait, retrou-
vait chaque partie de la fosse" ("Etienne looked . . . identified each part

20. "quelque fois, mais comme à regret, il accompagne les personnages. . . . Peu enclin
à bouger en tant qu'observateur." "Zola et les images," 405.

21. As Philippe Hamon has noted, "Enfin la 'description ambulatoire' sera un procédé
de choix que Zola emploiera pour passer en revue les diverses parties d'un milieu complexe
et differencié" (*Le Personnel du roman: Le Système des personnages dans les "Rougon-Macquart"
d'Emile Zola* [Geneva: Droz, 1983], 72).

of the mine," 1135). The progressive perception fostered by the mobile viewpoint has allowed the object, complete with its associations and impacts, to form gradually and Etienne's thoughts about it to grow; in the most concrete sense, he is determined by his milieu. At no point, and in no way, does the narrator/reader fail to accompany Etienne and share in the progressive nature of his experience.

La Terre also opens with a mobile viewer, Jean seeing and sowing, which enables Zola to set the scene of the immense countryside: "Jean . . . remontait la pièce du midi au nord. . . . Mais Jean se retourna, et il repartit, du nord au midi ("Jean . . . walked up the field from south to north. . . . But Jean turned around, and he took off again, from north to south," 368–69). Presumably, Zola could have had Jean stop somewhere between the north and south boundaries of the field and turn around in order to encompass the scene, but the moving perspective clearly attracts him. Perception, like literature, is a temporal medium; time controls and defines space.

Time accelerates with the appearance of the locomotive in *La Bête humaine,* and Zola's fascination with the perceptual possibilities of rapid movement is evident in his notes for that novel, particularly those he took during a ride (in the cab!) from Paris to Mantes: "Mon impression sur la locomotive. D'abord une grande trépidation. . . . La tête semble se vider. A droite et à gauche, les champs ne défilent pas plus vite que vus d'une portière de wagon. Il y a seulement plus d'air, plus d'espace, le vaste ciel sur la tête, la campagne vue d'un coup. . . . L'impression des longues lignes droites" ("My impression on the locomotive. First, great trepidation. . . . One's head seems to empty. On the right and on the left, the fields don't pass more quickly than seen from a [railway] car window. There is only more air, more space, the vast sky over one's head, the countryside seen at a glance. . . . The impression of long straight lines").[22] The example demonstrates clearly Zola's concurrent interest in movement, relativity (comparison of this view with that from inside the train), the deformation entailed by speed (twice termed "impression"), and their effect on spatial perception ("more space").

Not surprisingly, given the presence of the artist/*flâneur* Claude Lantier, *L'Oeuvre* is dominated by the moving viewpoint. In addition to several scenes involving the wandering group of young artists, the novel features a long, key scene, in chapter IV, depicting the habitual walk of Claude and Christine from the Ile Saint-Louis, where Claude lives, to Passy, where Christine resides. As the characters advance, objects and their relationships are defined, space itself takes form: "à mesure qu'ils avançaient, d'autres quais sortaient de la brume" ("as they advanced,

22. In Mitterand's notes for *La Bête humaine,* IV, 1775.

other quais emerged from the fog," 103); "Tandis qu'ils avançaient, la braise ardente du couchant s'empourprait à leur gauche" ("While they advanced, the fiery embers of the setting sun grew purple on their left," 104). The same walk, the same spatial trajectory, recurs later in the novel: "ils refirent leur ancienne course . . . voyant à chaque pas se lever le passé; et tout se déroulait . . . l'astre à son déclin les suivait" ("They retraced their former path . . . seeing the past rise with each step; and everything unfolded . . . the setting sun followed them," 211). But this time the scene fails to move them, and as Claude turns back to look on the scene from its reverse perspective, he chooses it for his final, obsessive painting. Clearly, the space, formed as time passes, becomes a symbol of time lost, and Claude attempts to recuperate it by arresting it in the work of art. Here "retourner" (212) expresses both the physical act of "turning around" to reverse the viewpoint and the desire to "return" to the past and recapture lost time. The main thematic concern of the novel, the relationship of present to past, is mirrored by the evolution of the mobile viewpoint into a pattern of repetition and reversal, a pattern by no means limited to *L'Oeuvre*.

Repetition and Reversal

The use of several viewpoints on the same scene, whether from the same character at different times or from different characters at the same time, marks a major structuring principle of Zola's novels.[23] The carriage tour of the Bois de Boulogne in *La Curée* is repeated in the final chapter, as Renée, alone, sees Maxime and Saccard walking together. Gervaise's initial visual tour of her area is repeated physically in the streetwalking scene near the end of *L'Assommoir*. In *La Terre*, Jean is motivated by "le désir de revoir une fois encore se dérouler la plaine immense" ("the desire to see the immense plain unfold one more time," 797), and he watches sowers from the church that he had seen while sowing in the first chapter (368). In all of these cases, the recurrence is used primarily for its closure value. The novel comes full cycle while highlighting the changes (all negative!) that have occurred in the interim.

In other novels, especially later ones, repetition of a viewpoint provides a different perspective on the same scene. In *Germinal*, for example,

23. Philip Walker concludes that Zola's use of multiple converging viewpoints contributes to the sense of relativity and the "cosmic vision" that characterize Zola's work (see "The Mirror, the Window, and the Eye," 64–65).

the progressive, partial perception of the mine in the opening chapter of part I is completed by Etienne's scanning the same scene in reverse from the barroom door in the final chapter of part I: "Il s'étonna, il ne s'était pas figuré l'horizon de la sorte, lorsque le vieux Bonnemort le lui avait indiqué du geste, au fond des ténèbres" ("He was amazed; he hadn't imagined the horizon that way, when old Bonnemort had pointed it out, in the depth of the darkness," 1192). The narrator continues to record Etienne's surprise at seeing the scene from this perspective and distance, in daylight: "Mais, autour des bâtiments, le carreau s'étendait, et il ne se l'imaginait pas si large. . . . Etienne regardait, et ce qui le surprenait surtout, c'était un canal" ("But around the buildings the pavement stretched out, and he hadn't imagined it so wide. . . . Etienne looked, and what surprised him most was a canal," 1192–93). This use of reprise allows Zola to capture the initial impact of the scene (chapter I) but also to convey complete information within an appropriate expositional unit (part I). He seems at once convinced of the partial, incomplete nature of perception and determined to complete it. In fact, the reader will no doubt recognize again the process by which hazy impression becomes detailed image. At the end of *Germinal,* Zola again describes this scene from Etienne's perspective: "et, quand il jetait les yeux autour de lui, il reconnaissait des coins du pays" ("and, when he cast his eyes around him, he recognized parts of the countryside," 1589). But with this repetition and recognition is a reversal of direction, as Etienne now takes the route from Montsou to Marchiennes; the sun is rising this time, and a rare note of hope is struck and signaled by the reversal of perspectives.

In *La Bête humaine,* the repetition of the same scene at different moments, from different angles, and with different perspectives leads to a sense of the relativity and uncertainty of human perceptual experience that augments the aura of mystery at the core of the novel. Jacques, from his position in the countryside near the Croix-de-Maufras, a signal station on the Paris–Le Havre line, thinks he sees a murder on a train passing

dans un tel vertige de vitesse, que l'oeil doutait ensuite des images entrevues. Et Jacques, très distinctement, à ce quart précis de seconde, aperçut, par les glaces flambantes d'un coupé, un homme qui en tenait un autre renversé sur la banquette et qui lui plantait un couteau dans la gorge, tandis qu'une masse noire, peut-être une troisième personne, peut-être un écroulement de bagages, pesait de tout son poids sur les jambes convulsives de l'assassiné.

(with such dizzying speed that one's eye later doubted the images glimpsed. And Jacques, very distinctly, in that precise quarter of a

second, saw, through the lit up panes of a passenger car, one man holding another overturned on a seat and sticking a knife in his neck, while a black mass, perhaps a third person, perhaps a pile of luggage, pressed with all its weight on the convulsing legs of the murdered man. 1047)

Despite the precision of the scene, the speed of the train and resulting brevity of the image cause Jacques to question immediately the validity of his perception—"Avait-il bien vu?" ("Had he seen correctly?" 1047)—then to doubt its reality—"il finissait par admettre une hallucination" ("he ended up admitting an hallucination," 1047). When called to testify at a preliminary hearing, he repeats that the murder scene was a momentary vision, an image so rapid as to lose form and meaning (1094).

Later, while on that very train, Jacques looks out and recognizes his former vantage point: "Comme, à la sortie du tunnel de Malaunay, il jetait un coup d'oeil, inquiet de l'ombre portée d'un grand arbre barrant la voie, il reconnut le coin reculé, le champ de broussailles, d'où il avait vu le meurtre" ("At the exit of the Malaunay tunnel, as he cast his eyes about, bothered by the shadow of a large tree blocking the railway, he recognized the remote spot, the underbrush, from which he had seen the murder," 1133). Still later, Séverine recounts her role in the murder, describing the scene from her vantage point on the train (thus not only repeating what Jacques saw from the outside, but adding what she saw from the inside while looking toward the countryside where he had been):

> Mais le bruit tomba, le train sortait du tunnel, la campagne pâle reparut, avec les arbres noirs qui défilaient . . . et le train courait, nous emportait à toute vitesse, pendant que la machine sifflait, à l'approche du passage à niveaux de la Croix-de-Maufras. . . . Comme je me relevais, nous passions à toute vapeur devant la Croix-de-Maufras. J'ai aperçu distinctement la façade close de la maison, puis le poste du garde-barrière.

> (But the noise fell off, the train came out of the tunnel, the pale countryside reappeared, with the black trees flashing by . . . and the train ran on, carrying us at full speed, while the engine whistled in approaching the Croix-de-Maufras crossing. . . . As I got up, we passed the Croix-de-Maupas at full steam. I distinctly perceived the closed-up house front, then the crossing guard's post. 1202)

The mobile viewpoint is highlighted by the forceful adverbs and the effect of the stationary trees seen as moving, an impression of perceptual

relativity that underscores the broader relativity of the entire scene, seen from several angles at different moments. Ironically, we have a clearer perception of the murder from Jacques's vantage point than from Sévé-rine's, and a more detailed description of Jacques's vantage point from Sévérine's perspective than from his. Each perspective is necessary to complement and complete the other. When Jacques finally succumbs to his hereditary murderous impulses and kills Sévérine, his memory provides yet another perspective, dredged up from the visual past: "Et un souvenir aigu lui revenait, celui de l'autre assassiné, le cadavre du prési-dent Grandmorin, qu'il avait vu, par la nuit terrible, à cinq cents mètres de là" ("And a sharp memory came back to him, that of the other murder victim, President Grandmorin's body, which he had seen that terrible night, five hundred meters away," 1298).[24]

Separated by the space of the text, these scenes are resurrected, recon-structed, and reassembled by the reader to form a total view encompass-ing the entire scene, viewed from several vantage points, by different viewers, at different moments. While the subsequent viewpoints enable the reader to "solve" the mystery of the murder by accumulating perspec-tives on it, the necessity of doing so in this manner attests the relativity, incompleteness, and uncertainty of perceptual evidence. In solving the murder mystery, a new one is written involving the mystery of percep-tion itself.

If the shifting viewpoints are well suited to enhancing, then solving, the mysteries of *La Bête humaine,* they are equally appropriate for under-scoring the unfolding military strategies of *La Débâcle.* The combination of optical instruments and elevated viewpoints examined earlier enables Zola to bring elements of the battle into visual range and focus, as when Weiss looks out from his house in Bazeilles: "à l'angle d'un petit bois de la Marfée, il retrouva le groupe d'uniformes, plus nombreux, d'un tel éclat au grand soleil, qu'en mettant son binocle par-dessus ses lunettes, il

24. The novel is replete with such reversals. The passengers whom Phasie sees from afar are later deposited in her house by the snowstorm (1188). Sévérine revisits the room where her husband had beaten her (1190), just as Jacques later sees the room where Sévérine had been seduced by the président Grandmorin, whose murder he had witnessed (1275). Jacques finds himself inside the house whose appearance he remembers from another vantage point: "Cette maison, il la sentait à son entour, telle qu'il l'avait vue si souvent, lorsque lui-même passait là, emporté sur sa machine. Il la revoyait, plantée de biais au bord de la voie, dans sa détresse et dans l'abandon de ses volets clos" (1275–76). And, in the space of two para-graphs, Flora's view of the oncoming train, as she rushes to her death ("un oeil énorme, toujours grandissant, jaillissant comme de l'orbite des ténèbres," 1273) is completed by the mechanic's viewpoint from the train: "Le mécanicien avait bien vu cette grande figure pâle marcher contre la machine, d'une étrangeté effrayante d'apparition, sous le jet de clarté vive qui l'inondait" (1274).

distinguait l'or des épaulettes et des casques" ("at the edge of a small
wood in la Marfée, he relocated the group of uniforms, larger, with such
brilliance in the full sun that, by putting his pince-nez over his glasses, he
could distinguish the gold of the epaulettes and helmets," 583). But, in
order to complete the scene, to capture it in its totality and increase its
informational content, Zola shows it from another perspective, that of
Delaherche in Sedan, armed with a telescope: "il tomba . . . sur le groupe
d'uniformes que Weiss avait deviné de Bazeilles, à l'angle d'un bois de
pins. Mais lui, grâce au grandissement, aurait compté les officiers de cet
état-major, tellement il les voyait avec netteté" ("he fell . . . upon the
group of uniforms that Weiss had glimpsed from Bazeilles, at the edge of
a small pine wood. But, thanks to the magnification, he could have
counted the officers in this escort, so clearly did he see them," 623).
Among this group is King William, who is also designated as a viewer of
the scene (623), allowing him to see the battle from on high, as though it
were a chessboard. These views are later complemented by those of Jean
and Maurice from the Plateau d'Algérie (ch. V, 642 ff.), who watch the
battery unit of Honoré (651) and the cavalry unit of Prosper (658), whose
point of view is also given (660).[25]

Unlike the previous examples, most of which involved the repetition
and reversal of viewpoints over time,[26] the vantage points given here are
meant to constitute a nearly simultaneous vision of the same scene, the
battle, in order to render it in its totality with full complexity. This is not
far from the efforts of Cézanne and, later, the cubists to depict a phenome-
non from several angles in order to capture it in its entirety, to remove it
from the contingencies of relative perception.

Of course, Zola could have simply described the battle from a general
"overview," as had his predecessors Voltaire (in *Candide*) and Hugo (in
L'Expiation). Indeed, he might have presented the scene as if he were
consulting one of the overall maps that are invariably found in his prepara-
tory dossiers. However, Zola's preference for the dramatized, personal
viewpoint prevails, and he adopts the technique for battle depiction pio-

25. See also Hamon's analysis of *La Débâcle* in terms of "une sorte de quadrillage intense
de regards qui se croisent, se répondent, s'alternent, prennent le relais les uns des autres à
partir de 'postes' privilégiés" (*Le Personnel du roman,* 80); David Baguley's conclusion that
"si, dans la deuxième partie du roman, Zola multiplie les 'points de vue' . . . il tient à
montrer divers aspects de la bataille dans une variété de perspectives" ("Le Récit de guerre:
Narration et focalisation dans *La Débâcle,*" *Littérature* 50 [May 1983]: 84); and Philip
Walker's suggestive remarks on multiple viewpoint in *La Débâcle* ("The Mirror, the Win-
dow, and the Eye," 62).

26. This recurrence of viewpoints involves both the story time (when the events are
meant to occur) and the narrative time (when they are recounted to the reader).

neered by Stendhal in the famous scene from *La Chartreuse de Parme,* where the battle of Waterloo is filtered through Fabrice's eyes.[27] By combining the viewpoint of the soldier in the battle with that of the general from his observation post, Zola is able to capture at once the impact of the fighting on the individual and the global sense of the battle. Instead of depicting the scene as on a general map, he does so through a series of overlapping grids, each one representing a segment of the scene registered through a personal viewpoint.

The Dramatized Viewpoint

In the vast majority of the examples discussed above, the viewpoint is attributed to one of the novel's characters, who observes a scene, registering impressions of it, much as the woman and child ostensibly view Paris from the terrace in Morisot's painting. Many of Zola's novels establish the central character as "register" or "reflector"[28] from the opening chapter, even from the opening sentences, as with Gervaise's frustrated search for Lantier from the hotel room in *L'Assommoir,* Etienne's piecemeal perception of the mine in *Germinal,* or Jean's seeing while sowing in *La Terre.* The initial viewpoint may be shared, as with Renée and Maxime touring the Bois de Boulogne from their carriage in *La Curée,* Florent and

27. This technique drew the following commentary from a contemporary of Zola's: "Stendhal ne regarde que par les yeux de Fabrice: son Waterloo est fait d'une série d'épisodes animés par les impressions tout individuelles d'un témoin dans la foule. Ainsi le réalisme au lieu de chercher à se rendre compte des ensembles se contente d'études fragmentaires. Une bataille, peinte telle qu'un Fabrice peut l'apercevoir de son coin ou même un général de son observatoire, remplit souvent fort mal l'idée que nous nous en faisons par avance" (A. David-Sauvageot, *Le Réalisme et le naturalisme dans la littérature et dans l'art* [Paris: Calmann Lévy, 1890], 9). In fact, Emile Faguet, reviewing *La Débâcle* in the *Revue politique et littéraire* of 25 June 1892 compares Zola's technique to that of Stendhal: "Il est entendu que c'est pour que nous eussions la marche au moins générale des choses sous les yeux que l'auteur a permis que ses soldats fussent de si bons stratégistes. Il est clair que M. Zola ne pouvait pas nous écrire toute la campagne de 1870 jusqu'à Sedan comme Stendhal a écrit la bataille de Waterloo. Cette façon 'd'assister sans rien comprendre' n'est de mise que pour un récit relativement court" (in *R-M,* v, 1433). For an excellent recent discussion of Zola's handling of the problem of battle depiction (and, indeed, of the representation of history in fiction), see Baguley, "Le Récit de guerre," in which he concludes: "Ainsi, *La Débâcle* se caractérise par un double mouvement centripète et centrifuge qui, par le moyen des changements de narration et de focalisation, fragmente et reconstitue constamment l'histoire" (88).

28. The terms are from Henry James. See especially his preface to *The Wings of the Dove,* included in *The Art of the Novel: Critical Prefaces,* ed. R. P. Blackmur (New York: Charles Scribner's Sons, 1934), 300.

Claude Lantier wandering through the Halles in *Le Ventre de Paris,* or Claude and Christine experiencing a thunderstorm in *L'Oeuvre.* The presence of one character may justify the description of the other, or a single character may see himself in a mirror to preserve the integrity of the "register." The high incidence of "voyeurism," of characters spying on each other, can also be attributed to Zola's preference for having characters (rather than a neutral narrator) view a scene.

The central character is the central viewer, and, if visual limitations cause the viewpoint to stray momentarily, or even progressively (as when Claude's madness diminishes his reliability, indeed his viability, as a viewer in *L'Oeuvre*), another character is usually designated to pick up the viewpoint, as are Christine and then Sandoz, in the final chapters of *L'Oeuvre.*[29] If no character is available, Zola is prepared to call upon a vast array of animals and entities on whom he will momentarily graft the viewpoint. An (admittedly alliterative) assemblage of animals—*chien* (dog), *chat* (cat), *cheval* (horse), and *chèvre* (goat)—momentarily control the visual center in *La Joie de vivre* (819, 950), *Germinal* (1182), and *L'Assommoir* (615). In addition to animal, viewpoints can be vegetable or mineral, including a garden (*La Faute de l'abbé Mouret,* 1403), a railway station (*La Bête humaine,* 1130), and la Cité (*L'Oeuvre,* 101).[30]

Zola states his defense of dramatized viewpoint clearly in a remark concerning the characters in *L'Assommoir*—"Il ne faut pas que l'atmosphère qui les entoure soit telle que je la vois, mais bien telle qu'ils la voient eux-mêmes" ("The atmosphere surrounding them must not be as I see it, but just as they see it themselves")[31]—and illustrates it throughout his preliminary notes with comments such as "Delaherche giving me the city."[32]

The logic behind Zola's commitment to the dramatized viewpoint is complex and involves at least the following objectives: (1) increasing the vivacity, credibility, and coherence of the literary work; (2) illustrating the naturalist doctrine positing the determinism of the individual by the milieu; (3) underscoring the thematic value of viewpoint and visuality;

29. As Lubbock, defender of James and the technique of center of vision, has noted: "If the spell is weakened at any moment, the listener is recalled from the scene before him, and the story rests only upon the author's direct assertion. Is it not possible, then, to introduce another point of view, to set up a fresh narrator to bear the brunt of the reader's scrutiny?" (*The Craft of Fiction,* 251).

30. More on allegations of Zola's abuse of privileged viewpoint by Wayne Booth and others elsewhere in this chapter. See, for example, note 43.

31. In F.W.J. Hemmings, *Emile Zola,* 2nd ed. (Oxford: The Clarendon Press, 1966), 120.

32. "Delaherche me donnant la ville." From the notes for *La Débâcle,* in *R-M,* v, 1406.

and (4) minimizing the visibility of the narrator's space, thereby promoting impartiality, as in the experimental sciences.[33] The first three goals will be discussed with relative rapidity so that the last can be expanded in some detail, since it directly involves the relationship of narrator, story, and reader space, a relationship outlined at the start of this chapter.

(1) The gain in vivacity accomplished by the dramatized viewer hardly needs to be justified, explained, or illustrated at this late date in literary history. The impact of events filtered through the character, and hence the interaction between the individual and the world, is perhaps the key factor in the development of the novel as the predominant literary genre of the nineteenth century. The gain in credibility and coherence has been articulated by "Anglo-American" authors like Henry James and critics like Percy Lubbock, among many others. Lubbock, for example, exhorts the novelist to "dramatize the seeing eye," contending that "there is an inherent weakness in [the story] if the mind that knows the story and the eye that sees it remain unaccountable. At any moment they may be questioned, and the only way to silence the question is somehow to make the mind and the eye objective, to make them facts in the story. When the point of view is definitely included in the book, when it can be recognized and verified there, then every side of the book is equally wrought and fashioned."[34] Despite commonplace accusations of Zola's lack of interest in aesthetic concerns, his sensitivity to the work's artistic coherence is evident in pronouncements such as the following:

> Quant au romancier, il se tient à l'écart, surtout par un motif d'art, pour laisser à son oeuvre son unité impersonnelle, son caractère de procès-verbal écrit à jamais sur le marbre. Il pense que sa propre émotion gênerait celle de ses personnages, que son jugement atténuerait la hautaine leçon des faits. C'est là toute une poétique nouvelle dont l'application change la face du roman.

> (As for the novelist, he stays to the side, especially for artistic motives, in order to lend his work its impersonal unity, its legal-like character forever written in stone. He believes that his own emotions would interfere with his characters', that his opinions would weaken the high lesson of the facts. This involves a completely new poetics whose application is changing the face of the novel).[35]

33. Hamon suggests another objective, not dealt with here—the use of *le regard* as "mise en scène" for the "documentation" of naturalism (see *Le Personnel du roman*, 69).

34. *The Craft of Fiction*, 117 and 116.

35. Quoted by Hemmings, *Emile Zola*, 120.

This impersonal unity, which he attributes to the narrator's absence, is strictly related to the use of the character's viewpoint, as demonstrated in the fourth part of the present argument.

(2) Zola's doctrine of determinism has often been interpreted in the broadest sense—the individual is formed by historical forces from without and hereditary forces from within. The influence of the milieu is usually treated generally, as when miners are formed by the mine or workers drink too much because of their working-class neighborhood. Often neglected is concrete determinism by the physical milieu—represented by Zola's descriptions (to be discussed in Chapter 4) and transmitted by the senses. Zola could hardly have been more explicit:

> Notre héros n'est plus le pur esprit, l'homme abstrait du XVIIIe siècle; il est le sujet physiologique de notre science actuelle, un être qui est composé d'organes et qui trempe dans un milieu dont il est pénétré à chaque heure. Dès lors, il nous faut bien tenir compte de toute la machine et du monde extérieur. La description n'est qu'un complément nécessaire de l'analyse. Tous les sens vont agir sur l'âme. Dans chacun des ses mouvements, l'âme sera précipitée ou ralentie par la vue, l'odorat, l'ouïe, le goût, le toucher. La conception d'une âme isolée, fonctionnant toute seule dans le vide, devient fausse. C'est de la mécanique psychologique, ce n'est plus de la vie.

> (Our hero is no longer the pure mind, the abstract entity of the eighteenth century; he is the physiological subject of contemporary science, a being composed of organs and bathed in a milieu that penetrates him at every moment. Henceforth, we must take into account the whole machine and the exterior world. Description is only a necessary complement of analysis. All the senses will act on the soul. In each of its movements the soul will be speeded up or slowed down by sight, smell, sound, taste, touch. The conception of an isolated soul, functioning alone in a void, becomes false. That's psychological mechanics, it's no longer life. *Les Romanciers naturalistes,* 77–78)

The senses, vision chief among them, provide the firm causal contact between man and milieu that illustrates determinism on the most concrete level, that of immediate experience, or, in literature, that of subject, verb, and object. Zola's style is transitive and causal, with vision serving as the chief intermediary between character and world; the following sentence can serve as an example, prior to our detailed analysis of style in

Chapter 4: "ce qu'il aperçut l'immobilisa, grave, extasié, murmurant" ("what he saw paralyzed him, grave, enrapt, murmuring," *L'Oeuvre,* 19). What the character sees determines what he or she thinks and how he or she reacts. The characters must see the atmosphere that surrounds them in order for Zola to show its effect on them.

(3) The thematic purposes of dramatized viewpoint are by now obvious, particularly in terms of character representation and development. Indeed, the entire preceding chapter (on the thematics of vision) can be seen in this light, as could most of the previous discussion in this chapter. Nana's narcissism as she studies herself in the mirror, Gervaise's despair and entrapment while looking for Lantier, Etienne's fear in perceiving the monstrous mine, King William's domination, Claude's exuberance in *Le Ventre* and madness in *L'Oeuvre,* numerous cases of voyeurism, and several notable instances of visual pleasure, play, and communication are all rendered through the dramatized viewpoint. Hélène's separation from Paris, like that of Morisot's mother and child, is reflected in the distance, level, and angle of her vantage point. Viewpoint can also be used to frame ideological positions, as in the following passage from *La Conquête de Plassans,* where l'abbé Faujas surveys the gardens of the two opposing political factions he is meant to unify in order to achieve the political conquest alluded to in the title: "Puis, après avoir lentement promené son regard, à droite et à gauche, sur les deux sociétés, il quitta la fenêtre, il ferma ses rideaux blancs d'une discrétion religieuse" ("Then, after having slowly cast his glance, to the right and to the left, onto both groups, he left the window and closed his white curtains with religious discretion," 988). This hidden, elevated vantage point from behind the curtains of his third-floor room suggests Faujas's surveillance and power, while the direction of his look attains a clearly ideological meaning, by the double value (physical and political) of the "left" and the "right," brought to the reader's attention by the word "*sociétés*" in the French text.

In other cases, the viewpoint does not merely reflect or underscore the ideological "message" or "point of view," but determines it, generates it for the reader, as in the following passage from *Germinal,* where the rampaging miners are watched by a bourgeois party from a hidden vantage point in a barn:

> Et les autres, malgré leur désir de détourner les yeux, ne le pouvaient pas, regardaient quand même.
>
> C'était la vision rouge de la révolution qui les emporterait tous, fatalement, par une soirée sanglante de cette fin de siècle. Oui, un soir, le peuple lâché, débridé, galoperait ainsi sur les chemins; et il ruissellerait du sang des bourgeois. Il promènerait des têtes, il

sèmerait l'or des coffres éventrés. Les femmes hurleraient, les
hommes auraient ces mâchoires de loups, ouvertes pour mordre.
Oui, ce seraient les mêmes guenilles, le même tonnerre de gros
sabots, la même cohue effroyable, de peau sale, d'haleine empes-
tée, balayant le vieux monde, sous leur poussée débordante de
barbares. Des incendies flamberaient, on ne laisserait pas debout
une pierre des villes, on retournerait à la vie sauvage dans les bois,
après le grand rut, la grande ripaille, où les pauvres, en une nuit,
efflanqueraient les femmes et videraient les caves des riches. Il n'y
aurait plus rien, plus un sou des fortunes, plus un titre des situa-
tions acquises, jusqu'au jour où une nouvelle terre repousserait
peut-être. Oui, c'étaient ces choses qui passaient sur la route,
comme une force de la nature, et ils en recevaient le vent terrible
au visage.
 Un grand cri s'éleva, domina la *Marseillaise:*—Du pain! du pain!
du pain!

(And the others, despite their desire to turn their eyes away, could
not, watched just the same.
 It was the red vision of the revolution that would sweep them
all away, inevitably, one bloody evening at this century's end. Yes,
one evening, the unleashed, unbridled people would gallop like
this along the roads; and they would drip with bourgeois blood.
They would carry [severed] heads; they would scatter gold from
ripped open coffers. The women would yell; the men would have
these same wolflike jaws, ready to bite. Yes, there would be the
same rags, the same thunder of heavy clogs, the same frightening
rabble, with dirty skin, stinking breath, sweeping away the old
world, with their overflowing barbaric thrust. Fires would flame;
no stone would remain unturned; one would return to primitive
life in the woods, after the great orgy, the grand feast, where the
poor, in one night, would ravage the women and empty the cel-
lars of the rich. There would no longer by anything, not a sou of
wealth, not a title of property, until the day when a new world
would grow again, perhaps. Yes, these were the things that were
passing on the road, like a force of nature, and they could feel the
deadly wind blowing in their faces.
 A great cry went up, drowning the *Marseillaise:*—Bread! bread!
bread! 1436–37)

 The viewpoint is clearly that of the bourgeois party hiding in the barn
as the miners pass, as we see in the first sentence quoted here. Thus the

paragraph that follows, in the conditional mode, is not a description of actual events, nor a prediction of future ones by the narrator, but a projection of the viewers' fears. Here the viewpoint does not underscore a subject but forms a new one—the scene is less a description of workers than the perception of the working class by the beleaguered bourgeoisie, a visual confrontation of classes, an example of growing class awareness.[36] Even when the strike fails, this germination of class consciousness creates a positive note at novel's end and constitutes an essential component of the ideological message in *Germinal,* which is directed, after all, at a bourgeois reading public by a "bourgeois intellectual," not directly at the working class. Furthermore, the viewers stand in, as intermediaries and interpreters, for the reader—the viewpoint constitutes a *mise en abyme,* a projection of the reader into the space of the novel through the mediation of vision. Without the bourgeois viewpoint, the passage becomes purely descriptive and the ideological intent, implications, and impact are lost, unless Zola is willing to let the narrator make ideological statements, which contravenes the most sacred canons of his narrational program.

(4) For Zola, one of the principal attractions of Bernard's experimental method was its impersonal nature (see, for example, *Le Roman expérimental,* 41), which the novelist incorporated into his literary theories as the keystone of his narrational program: "Je passe à un autre caractère du roman naturaliste. Il est impersonnel, je veux dire que le romancier n'est plus qu'un greffier qui se défend de juger et de conclure" ("I come to another characteristic of the naturalist novel. It is impersonal; I mean that the novelist is only a clerk of courts who refrains from judging and concluding," *Roman ex.,* 103). Zola stresses that the novelist must efface himself, erase himself from the work: "Le romancier naturaliste affecte de disparaître complètement derrière l'action qu'il raconte. Il est le metteur en scène caché du drame. Jamais il ne se montre au bout d'une phrase. On ne l'entend ni rire ni pleurer avec ses personnages, pas plus qu'il ne se permet de juger leurs actes" ("The naturalist novelist pretends to disappear completely behind the action he recounts. He is the hidden director of the scene. Never does he show himself at the end of a sentence. One doesn't hear him laughing or crying with his characters, any more than he allows himself to judge their actions," *Les Romanciers naturalistes,* 109). Stated in

36. See both Philippe Hamon, *Texte et idéologie* (Paris: PUF, écriture, 1984), 115–16, and Henri Mitterand, "Poétique et idéologie: La Dérivation figurale dans *Germinal,*" in *Fiction, Form, Experience: The French Novel from Naturalism to the Present / Fiction, forme, expérience: Le Roman français depuis le naturalisme,* ed. Grant Kaiser (Montréal: Editions France-Québec, 1976), 44–52, for detailed analyses of the ideological dimensions of this scene.

our terms, Zola seeks to neutralize narrator space, to render it transparent; he attempts to do so by manipulating both *voice* and *viewpoint*.

If the narrator is to remain inconspicuous, his *voice* should adopt the neutral tone of legal and scientific documents, while avoiding manifestations of artistic language such as flamboyant rhetoric (see *Roman ex.,* 45). Furthermore, the novelist must not be content with merely disguising his voice, as was Flaubert,[37] but must work to silence it, by allowing the characters to assume as much of the narration as possible. Consequently, Zola's novels are distinguished by a large amount of dialogue and by a high incidence of free indirect discourse,[38] techniques that situate the voice within the characters' space rather than in the narrator's.

By the same token, and of greater relevance to this study of vision, Zola reduces the role of the narrator by systematically adopting the character's *viewpoint,* by "dramatizing the seeing eye."[39] By causing the reader to perceive a scene through the character, Zola creates the illusion of bypassing the narrator, just as the spectator seems to bypass the implied viewer by identifying with the dramatized observer(s) in Morisot's *On the Balcony.* In Zola's case, making phenomena visible to the characters, thus "showing" them to the reader, absolves the narrator from the necessity of "telling" them.[40]

Of course, the problem with such a program is that not all phenomena are inherently visible: some are abstract; some are "internal"; others constitute processes, systems, or structures too vast to be "visualized." Zola's solution is to translate such phenomena—psychological, ideological, structural—into visual images, so that they can be perceived by the character (and thus the reader) through dramatized viewpoint, rather than be summarized by the narrator (thereby breaking the illusion of impersonality).

37. Among the numerous examples from his correspondence where Flaubert stresses the importance of the narrator's invisibility yet omnipresence in the text, the best-known is no doubt the following: "L'Artiste doit être dans son oeuvre comme Dieu dans la Création, invisible et tout-puissant; qu'on le sente partout, mais qu'on ne le voie pas" (18 March 1857, *Correspondance,* nouvelle édition augmentée [Paris: Conard, 1926–33], IV, 164).

38. Guy Robert describes the narrational effect of free indirect discourse in noting "la fréquence très caractéristique du style indirect libre; à chaque instant le narrateur s'efface pour restituer dans ses termes mêmes la pensée de ses personnages et la mieux imposer" (*Emile Zola: Principes et caractères généraux de son oeuvre* [Paris: Société d'Editions, Les Belles Lettres, 1952], 127).

39. The expression (indeed exhortation!) is by Lubbock, *The Craft of Fiction,* 117.

40. Although examples of the distinction between telling and showing are frequent in the prefaces of Henry James (see *The Art of the Novel*), Lubbock (*The Craft of Fiction*) was the first to clearly formulate it and use it to point out the advantages of "scene" and "drama" over more traditional means of narrating the novel.

In *L'Oeuvre,* for example, three seemingly abstract relationships inform the novel's structure: the progressive genesis of the created work, the contrast between past and present, and the conflict between art and reality. All are converted into visual form by the use of Claude's final painting, his masterpiece (*l'oeuvre*).

Zola's preliminary notes for the novel reveal his intentions to illustrate the stages of the creative process through alterations in the painting: "Comment pousse une oeuvre, l'idée première née d'un ensemble de travaux acquis et de sensations. Peu à peu l'idée prend corps, et dès lors la lutte commence. . . . Cela pourra m'être donné par le tableau du port Saint-Nicolas. . . . Premier état de l'oeuvre, changement de détail, recommencements: enfin tout le drame" ("How a work evolves, the initial idea stemming from a combination of experiences and previous works. Gradually the idea takes form, and henceforth the struggle begins. . . . I can get this by using the painting of the Saint-Nicolas port. . . . The first stage of the work, changes in detail, starting over: in short the whole drama").[41] As the conception of the novel evolves, so do Zola's intentions for using the final masterpiece. By including Christine in the painting, he will be able to "externalize" a series of "inner" conflicts: "jalousie de Christine dédoublée, jalouse de son image peinte, de la femme faite avec elle par Claude, interprétée par lui selon son idée de peintre, son tempérament, qui n'est plus elle, qui est elle arrangée, et qu'il aime davantage" ("jealousy of Christine doubled, jealous of her painted image, of the woman made from her by Claude—interpreted by him according to his artistic conception, his temperament—who is no longer her, but her rearranged, and whom he loves more").[42]

This doubling of Christine's image allows Zola to dramatize two major conflicts in *L'Oeuvre*—between past and present on the one hand (252–55) and between art and reality on the other (342–52). Zola further underscores the contrast between past and present by resurrecting Christine's image from Claude's early painting ("Plein Air") and juxtaposing it with her present image in the "Port Saint-Nicolas" painting. This juxtaposition of images allows Zola to dramatize the ravages of time through both Christine's loss of beauty—"voilà qu'elle devenait sa propre rivale, qu'elle ne pouvait plus regarder son ancienne image, sans être mordue au coeur" ("here she was becoming her own rival, no longer able to look at her former image without being bitten to the quick," 254)—and Claude's loss of talent—"Continuellement, il la consultait, il la comparait, désespéré et fouetté par la peur de ne l'égaler jamais plus" ("Continually he

41. No. 10.316, fol. 285, N.A.F., B.N.
42. Included in *R-M,* IV, 1461.

studied it, compared it, distraught and tortured by the fear of never again equaling it," 253). In both cases the images are "externalized," then perceived through the viewpoint of the characters, who can verbalize and interpret them. The narrator has neither to probe the privileged inner space of the characters nor to formulate and analyze what resides therein.[43]

Zola's notes for *L'Oeuvre* again reveal his clear intentions regarding the purpose(s) of Claude's painting(s):

> . . . lier les deux tableaux l'un à l'autre. Il a gardé Plein Air, il a pu couper la figure posée par Christine et ne gardera qu'elle. Alors cela pesant sur toute sa vie, il veut l'égaler, il le copie, n'arrive pas, la femme jeune et la femme vieillie se battant, se détruisant. Enfin, le lien est là, il n'y a plus qu'une oeuvre.
>
> (. . . link the two paintings to each other. He kept *Plein Air;* he was able to cut out the figure posed for by Christine and keep only it. Then it weighs on his entire life, he wants to equal it, he copies it, doesn't succeed, the young woman and the aging woman at odds, destroying each other. Finally, the link is there; henceforth there is only one work.)[44]

Here we confirm the role of the two painted images to dramatize inherently interior conflicts for Christine (the struggle with her former self) and Claude (the desire to equal his former talent). Furthermore, the two images, seen as juxtaposed for the purpose of illustrating the conflict between past and present, can also be seen as joined (forming one work) to illustrate yet another antithesis—between art (the two painted images of Christine becoming a single "masterpiece") and reality (to be represented by Christine herself, who "was reality," *L'Oeuvre*, 243).

In the novel itself, this conflict between art and reality is perceived and formulated in turn by Sandoz (236), by Claude (243), and especially by Christine: "Le tableau immense se dressait entre eux, les séparait d'une muraille infranchissable . . . elle sentait bien qu'il préférait sa copie à elle-

43. As Wayne Booth states, "the most important single privilege is that of obtaining an inside view of another character, because of the rhetorical power that such a privilege conveys upon a narrator" (*The Rhetoric of Fiction*, 160–61). I should note that Booth defines "privilege" as "what could not be learned by strictly natural means or limited to realistic vision and inference" (160). Booth contends that "one of the most artificial devices of the storyteller is the trick of going beneath the surface of the action to obtain a reliable view of the character's mind and heart" (3).

44. Included in Patrick Brady, *"L'Oeuvre" de Emile Zola: Roman sur les arts, manifeste, autobiographie, roman à clef* (Geneva: Droz, 1967), 192.

même. . . . Et ce fut dès lors que Christine, décidément battue, sentit peser sur elle toute la souveraineté de l'art" ("The huge painting rose up between them, separating them with an impassable wall . . . she could really feel that he preferred the copy to herself. . . . And from then on Christine, clearly beaten, felt the whole sovereignty of art weigh upon her," 244).

In this case an abstract relationship of an aesthetic nature is visualized (through the painting), dramatized (through the characters' viewpoint), and articulated (through their voices), absolving the narrator from the necessity of intervening to make a didactic statement. This task Zola habitually leaves to a *porte-parole* (spokesman),[45] who must, nonetheless, serve a prior apprenticeship as *porte-perception*.[46]

Zola's use of Claude's "masterpiece" not only demonstrates his propensity for dramatized viewpoint and his tendency to "visualize" inherently abstract concepts but also serves to embody the undeniably dialectical nature of Zola's creative process. The "Port Saint-Nicolas" painting is first used to illustrate a "thesis" (the evolution of the created work over time), then is juxtaposed with a former painting ("Plein Air") to produce an "antithesis" between present and past. In another context this conflict is resolved or "synthesized" through a trait common to the two paintings (their status as "art"), which then becomes the thesis that dialectically begets its own antithesis (reality), when "art" is juxtaposed with Christine herself. This dialectical process can be "visualized" (Diagram 10). It will be left to Sandoz, premier *porte-parole* of *L'Oeuvre,* to continue the dialectical process by synthesizing the conflict between art and reality in subordinating the former to the latter: "Seule, la vérité, la nature, est la base possible, la police nécessaire, en dehors de laquelle la folie commence" ("Truth, nature, is the only possible basis, the necessary police, outside of which madness begins," 358).

Thus Zola uses a visual image, the painting, coupled with the characters' viewpoint, not only to dramatize a vast array of psychological problems and ideological positions (points of view), but to control the very evolution of the novel and to concretize a complex dialectical process, which we have in turn translated into a graphic image.

Zola himself utilizes an actual graphic image in conjunction with two

45. J. H. Matthews assesses the role of this verbal technique for implementing Zola's program of impersonal narration: "L'étude de l'emploi par Zola de porte-parole a démontré que l'auteur s'est vu obligé de recourir à ce procédé par la nécessité d'insister sur l'importance du milieu dans le roman expérimental-naturaliste sans cesser de rester le greffier, le metteur en scène caché du drame" (*Les Deux Zola: Science et personnalité dans l'expression* [Geneva: Droz, 1957], 50).

46. Hamon uses the term "porte-regard" in a similar context (*Le Personnel du roman,* 82).

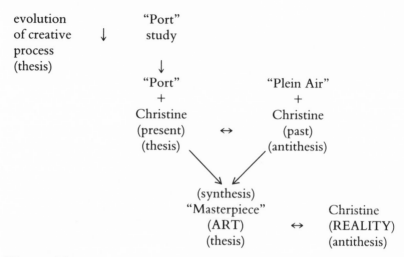

Diagram 10.

novels—*Une Page d'amour* and *Le Docteur Pascal*—by publishing with
them facsimiles of the genealogical tree that is meant to represent the
roots of the Rougon-Macquart family. The tree itself is a "network,"[47]
which visualizes the overall system of family relationships over time and,
in fact, constitutes a structural diagram of the entire Rougon-Macquart
series. As such, it is an undeniably metaliterary document, and its inclu-
sion with *Une Page d'amour,* the only novel to incorporate a literary term
into its title, seems appropriate. In this instance, the tree is "grafted" onto
the preface of the novel, a privileged communication between author and
reader that bypasses, surpasses, subordinates, even subverts the charac-
ters' space, since the tree maps out their genetic destiny before the fact (of
the story). With *Le Docteur Pascal,* the final novel in the series, the tree is
again appended to the beginning of the novel, but it also invades the story
space, where it is continually perceived by the characters and comes to
constitute a major element of the novel's plot. Pascal conceives it to
explain the hereditary traits of the family; his mother, the conniving
Félicité Rougon, attempts to destroy it, in order to bury the family
secrets; Clotilde, Pascal's niece, ward, and lover, preserves it, so as to
perpetuate the scientific discoveries it represents.[48] Moreover, in chapter
V (1004–25), with the tree before their eyes, Pascal not only explains the
hereditary relationships to Clotilde but, in doing so, gives a summary of

47. See Jacques Bertin, *Semiology of Graphics,* trans. William J. Berg (Madison: Univer-
sity of Wisconsin Press, 1983), 269–83.
48. See *Le Docteur Pascal,* 929, 1034, 1140, 1181, 1197, 1203, 1216, and 1219.

every novel in the series. These pages are like a critical companion to the Rougon-Macquart cycle, complete with a structural diagram, a *mise en abyme,* located in the characters' space, registered through their viewpoint, and elucidated by their commentary. Consequently, the graphic accompanying the novel appears less as a manifestation of the narrator's space, proof of the novel's fictionality, than as a document that issues from the story space and thus supports its veracity.

In the immediate context of this study, both the painting in *L'Oeuvre* and the genealogical tree in *Le Docteur Pascal* illustrate the importance of dramatized viewpoint for Zola's communication of ideological (psychological, aesthetic, structural) points of view. In the broader context of this book, the process of visualization, whereby abstract concepts, in fact entire systems, are translated into visual images and implanted in the novels, sustains the contention that Zola's work must indeed be approached as a visual novel.

The Narrator as Overseer: From Separation to Synthesis

While examples of the narrator's *vocal* intrusions are relatively rare in Zola's novels and diminish progressively throughout the Rougon-Macquart series,[49] instances of the narrator's *visual* intrusions are quite another matter.

49. In the early novels, the time frame of the characters' story is occasionally interrupted by references to the narrator's time (the present), such as "today" (*La Fortune,* 9, 36, 73) and "still" (*La Fortune,* 6, 9, 276), not to mention predictions of the future, such as "later" (*La Fortune,* 288). The narrator makes overt judgments—"ce grotesque, ce bourgeois ventru, mou et blême" ("this grotesque person, this potbellied, flabby, pale bourgeois," *La Fortune,* 289)—and generalizations—"La population de Plassans se divise en trois groupes; autant de quartiers, autant de petits mondes à part" ("The population of Plassans is divided into three groups; that many neighborhoods, that many separate worlds," *La Fortune,* 39). Comparisons sometimes exceed the scope of the characters' knowledge and expression—"the primitive love of old Greek stories" (*La Fortune,* 170)—often with obvious irony—"One might think he was an old Roman sacrificing his family on the altar of his country" (228). The narrator may provide information despite the characters ("the truth was," *Le Ventre,* 662) or unbeknownst to them ("she was mistaken," *Le Ventre,* 807). The chronology of the story may be broken by flashback, often to provide information about the characters' backgrounds (see, for example, chapter II of *La Fortune, Le Ventre,* and *La Conquête*). In *La Fortune* and *La Conquête* it is the narrator, not the character, who provides the information; there is even an occasional first-person pronoun designating the narrator—"I" (*La Fortune,* 38), "we" (73), and "our" (185).

The middle novels still contain some vestiges of the narrator's voice. The following example (from *L'Assommoir*) is at once a judgment and a prediction: "Mais ce fut là le dernier beau jour du ménage" ("But that was the last good day of their marriage," 682). In

In certain cases, instead of masking the narrator's viewpoint by hiding it behind the characters', Zola points out the illusion by insisting on the separation, even the opposition, of two conflicting viewpoints emanating from separate fictional spaces. In other cases, Zola may go so far as to exploit such situations of dual viewpoint to achieve a wealth of perspectives, culminating in an "overview," or visual synthesis.

It must be recognized that, however "invisible" the narrator may become, he remains the principal purveyor of viewpoint, the implied viewer, in third-person narration. The reader may appear to *see through* the character, but the reader also *sees* the character; a character is no more than a mask or a lens through which the narrator may choose at times to see, but the narrator is the true seer, the overseer. However neutral or transparent the narrator's space may be portrayed, it is always interposed between that of reader and character, like the camera's lens. Rather than minimizing mediation, the dramatized viewpoint doubles it, even though that viewpoint may create an illusion of directness because the reader may project himself/herself into the character, temporarily entertaining the fantasy of bypassing the narrator to join the character in the space of the story. Consequently, the author committed to third-person narration and to dramatized viewpoint invariably establishes a situation of dual viewpoint, not unlike that in Monet's *Seine at Bennecourt* or Morisot's *Balcony*. This coexistence of narrator's and character's viewpoint—whether through conflict or collusion, through separation, simultaneity or superimposition—will furnish the focus of this final section.

Separation of the narrator's and character's viewpoints is especially

Une Page d'amour, a comment pointing to the characters' ignorance, stresses the narrator's awareness: "Malgré eux, sans qu'ils en eussent conscience, leur familiarité devenait alors plus grande" ("Despite themselves, without realizing it, their familiarity was increasing," 883). Comparisons from *Nana* ("like those legendary monsters," 1470), *La Joie de vivre* ("stupid mollusk-like stubbornness," 810), and *Germinal* ("animal trainer," 1223) exceed the characters' capacities of expression while constituting judgments about them. *Au Bonheur des Dames* has a prediction of a future event ("later," 581), even one reaching beyond the narrator's time ("it was the embryo of the vast workers' associations of the twentieth century," 728). [However, this latter example may be an instance of *style indirect libre* reflecting Denise's point of view, rather than the narrator's.]

Even the later novels display isolated lapses of the narrator's overt presence, in offering information—"the truth" (*L'Oeuvre,* 227, and *L'Argent,* 338)—predicting the future— "later" (*L'Argent,* 202, and *La Débâcle,* 840–41)—and expressing things that exceed the characters' intent—"what he didn't say" (*La Terre,* 383)—and ken—"unconscious passion" (*L'Oeuvre,* 99). Instances of the first person ("our," *La Terre,* 811) and the second person ("you," *L'Oeuvre,* 292) in these later novels, however, are clearly examples of free indirect discourse implicating the characters, rather than the narrator and the reader.

evident in the early novels. The beginning words of the first novel, *La Fortune des Rougon,* are as follows: "Lorsqu'on sort de Plassans par la porte de Rome, située au sud de la ville, on trouve, à droite de la route de Nice, après avoir dépassé les premières maisons du faubourg, un terrain vague désigné dans le pays sous le nom d'aire Saint-Mittre" ("When one leaves Plassans, by the Roman gate, located on the south side of the city, one finds, after having gone beyond the first houses of the suburb, a vacant area known throughout the area by the name of the Saint-Mittre lot," 5). No character is as yet present; the narrator serves an expositional function, providing the reader with essential information and displaying considerable precision, as seen in the proper names, compass points, and spatial orientation. It is not for several pages that a character ("a young man") is introduced, and his most immediate task is to assume the viewpoint ("looking before him," 9), which will then be alternated compatibly with that of the narrator throughout the novel. Later novels, like *Le Rêve* and *La Débâcle,* follow this same pattern of a general viewpoint at the beginning, followed shortly by that of a character as the scene shifts and becomes more precise.

La *Curée* shows the same combination of general (narrator) and particular (character) viewpoints, but in reverse order. Renée and Maxime are introduced as centers of vision from the first page, during the carriage ride through the Bois de Boulogne (319), and are replaced by a more general viewpoint ("one perceived," 330; "the eye rose," 331) when the description of the *hôtel* requires greater precision. Likewise, the perceptive Florent and the artist Claude Lantier share the viewpoint in the opening chapter of *Le Ventre de Paris* but give way in chapter II to a general viewpoint, including a summarized presentation of Florent's life through flashback. The practice of alternating the viewpoint from personal to general, often from chapter to chapter, is quite common in Zola's novels, as evidenced in *Germinal,* where chapter I is seen from Etienne's perspective, chapter II from the narrator's, and chapter III from Etienne's again. In all of the above cases, the viewpoints are complementary, the shifts imperceptible, but this is not always the case.

Dual viewpoints can coexist in shorter segments, often reflecting a pattern of conflicting perspectives. Usually the narrator intervenes in order to see and report what the character cannot,[50] a situation that always occurs when perception verbs are used with negative constructions. In *Germinal,* for example, Etienne sees a couple pass by: "C'étaient Catherine et le grand Chaval. Mais Etienne ne les avait pas reconnus au passage, et il les suivait des yeux" ("It was Catherine and big Chaval. But

50. This kind of narrative situation is typical of Flaubert (see the Conclusion).

Etienne hadn't recognized them in passing, and he followed them with his eyes," 1242). Although Etienne is the viewer, he cannot identify what he sees, and it is thus the implied viewer, the narrator, who must intervene to name the passersby. Highlighting the character's limitations necessarily implies adopting the narrator's viewpoint, a situation Zola sustains for several pages, before bringing it directly to the reader's attention by noting the moment when Etienne does recognize the couple (1245).

Perception verbs coupled with negative constructions imply rather blatantly that the scene is being registered by eyes other than those of the character, that there is a dual viewpoint. In *L'Oeuvre,* the narrator must step in when Claude begins to lose visual contact with the world about him. After a lengthy description of statuary at the Salon, the narrator notes: "Mais Claude ne voyait rien, ce n'étaient que des taches grises dans le jour brouillé et verdi" ("But Claude could see nothing, there were only gray spots in the murky, greenish daylight," 299; see also 264, 300, 307, 318, 319, and 351). Though a shift in viewpoint is a narrative necessity due to the character's limitations, Zola seems to go out of his way to insist on the situation, thereby pointing out the duality of perception and the narrator's primacy. In effect, narrative space becomes an observatory from which the reader joins the narrator in watching the more distant characters.

Such use of negative constructions with perception verbs signals situations that are momentary (as in *Germinal*) or temporary (as in *L'Oeuvre*) but not sustained throughout either novel. In *Une Page d'amour,* however, Zola establishes a situation of conflicting viewpoints from the outset, points it out blatantly and repeatedly, and extends it throughout the novel, using it to underscore a metaphysical problem, even a metaliterary one.

In the culminating chapter of part I, highlighting the first of the five lengthy descriptions of Paris that will dominate the novel, Hélène and her daughter Jeanne look out over Paris from their apartment in Passy:

> Longtemps, elles ne parlèrent pas. Jeanne, sans bouger, demanda enfin à voix basse:
> —Maman, tu vois, là-bas, près de la rivière, ce dôme qui est tout rose. Qu'est-ce donc?
> C'était le dôme de l'Institut. Hélène, un instant, regarda, parut se consulter. Et, doucement:
> —Je ne sais pas, mon enfant.
>
> (For a long time, they didn't speak. Jeanne, motionless, finally asked in a low voice:—Mama, you see, over there, near the river,

that dome that's all pink. What is it? It was the dome of the
Institute. Hélène, for an instant, looked, appeared to reflect. And,
softly:—I don't know, child. 853)

Although there are two characters looking, it is ultimately the narrator's
viewpoint that prevails, since he is the only one who fully sees, who
knows and names the monument—just as in Morisot's painting, only the
implied viewer can simultaneously see both Paris and the woman and
child looking. Zola underscores the arrangement by continuing the dia-
logue in similar fashion:

> La petite se contenta de cette réponse, le silence recommença.
> Mais elle posa bientôt une autre question.
> —Et là, tout près, ces beaux arbres? reprit-elle, en montrant du
> doigt une échappée du jardin des Tuileries.
> —Ces beaux arbres? murmura la mère. A gauche, n'est-ce pas? . . .
> Je ne sais pas mon enfant.
> —Ah! dit Jeanne.
> Puis, après une courte rêverie, elle ajouta, avec une moue grave:
> —Nous ne savons rien.

> (The little girl was satisfied with the answer, the silence started
> over. But soon she asked another question. —And there, nearby,
> those beautiful trees? she continued, pointing at a vista of the
> Tuileries garden. —Those beautiful trees? murmured the mother.
> On the left, you mean? . . . I don't know, child. —Ah! said
> Jeanne. Then, after a short daydream, she added, with a serious
> pout: —We don't know anything. 853–54)

The narrator then adds, "Elles ne savaient rien de Paris, en effet. Depuis
dix-huit mois qu'elles l'avaient sous les yeux à toute heure, elles n'en
connaissaient pas une pierre" ("They knew nothing of Paris, in fact. For
eighteen months they had had it before their eyes at all hours, and they
didn't know a single stone," 854), a rather startling statement considering
the reader has just absorbed one of the lengthiest cityscapes in the history
of the French novel, replete with numerous references to monuments, for
which Hélène was ostensibly the viewer—"il fallait qu'elle se penchât
pour apercevoir" ("she had to lean over in order to see," 851). Zola's
disclaimer undermines not only the autonomy of the dramatized viewer
but the very tenets of dramatized viewing that he had only recently
outlined during the preparation of the previous novel, *L'Assommoir* ("the
atmosphere surrounding them mustn't be as I see it but just as they see it

themselves").[51] Rarely content with simple repetition, Zola denies his characters' viewpoint yet a third time:

> Jeanne, pourtant, s'entêtait parfois.
> —Ah! tu vas me dire! demanda-t-elle. Ces vitres toutes blanches. . . ? C'est trop gros, tu dois savior.
> Elle désignait le Palais de l'Industrie. Hélène hésitait.
> —C'est une gare. . . . Non, je crois que c'est un théâtre.
> Elle eut un sourire, elle baisa les cheveux de Jeanne, en répétant sa réponse habituelle:
> —Je ne sais pas, mon enfant.

> (Jeanne, however, was sometimes stubborn. —Ah! you have to tell me! she demanded. Those white windows. . . ? It's too big, you must know. She pointed out the Palais de l'Industrie. Hélène hesitated. —It's a railway station. . . . No, I think it's a theater. A smile came over her, as she kissed Jeanne on the hair, repeating her usual answer: —I don't know, child. 854)

The same scenerio is repeated in strictly similar terms in the culminating chapter of part III. Here Hélène and l'abbé Jouve watch Paris at night, under a sky filled with constellations whose luminous qualities are matched metaphorically by the lights of Paris, compared to constellations. Yet, in the middle of this lengthy description, with two characters stationed as observers, Zola undermines their visual credibility: "A deux reprises, elle questionna sur des noms d'étoiles; toujours la vue du ciel l'avait tourmentée. Mais il hésitait, il ne savait pas" ("On two occasions, she asked questions about the names of the stars; the sight of the sky had always bothered her. But he hesitated; he didn't know," 966).

In the final chapter of part IV, Jeanne looks out over Paris, as the narrator takes pains to point out the limitations of her knowledge of the scene— "Elle avait fini par connaître trois monuments, les Invalides, le Panthéon, la tour Saint-Jacques" ("She had ended up knowing three monuments, the Invalides, the Panthéon, the Saint-Jacques tower," 1029)—limitations repeated explicitly on two other occasions (1030 and 1070). This does not prevent the narrator from then going on to describe Notre-Dame, Saint-Vincent-de-Paul, le Palais de l'Industrie, Saint-Augustin, l'Opéra, and a whole host of other monuments and buildings that lie beyond the character's knowledge. In fact, Saint-Augustin and the Opéra did not even exist at the time of the character's story (the time frame of the early fifties

51. See note 31 in this chapter.

within which the action is meant to occur), although they were in place by the time the novel was researched and published (1877). This anachronism clearly wrests the reader from the story space and installs him/her in the narrator's space, from which, alone, the buildings could be seen. Another perceptual ambiguity arises from the difference between the "referential" denotation of the narrator's space and the "signified" denotation of the characters'; that is, the narrator, who knows Paris, refers to the "rive gauche" (left bank), although it is to the characters' right, and the "rive droite," although it is to their left (see 852 and 1032).[52]

Of course, Zola insists on the characters' limitations to underscore several of the novel's themes. The characters do not know Paris, any more than they know themselves or others. Hélène willingly embraces a state of ignorance concerning Henri—"Qu'avait-elle besoin de connaître Henri? Il lui semblait plus doux de l'ignorer" ("What did she need to know about Henri? It seemed nicer to not know about him," 911)—and, especially, concerning Paris: "Alors, elles continuèrent à regarder Paris, sans chercher davantage à le connaître. Cela était très doux, de l'avoir là et de l'ignorer. Il restait l'infini et l'inconnu. C'était comme si elles se fussent arrêtées au seuil d'un monde dont elles avaient l'éternel spectacle, en refusant d'y descendre" ("Then, [Hélène and Jeanne] continued to look out at Paris, without seeking further to know about it. It was very nice, to have it there and not know about it. It remained infinite and unknown. It was as if they had stopped at the threshold of a world whose eternal spectacle they had, while refusing to step down into it," 854). Not knowing, not naming, enables the characters to enjoy an exclusively visual experience, a preintellectual and prelinguistic state recalling the innocence of Eden or the pure impression described by Laforgue and the painters of his time. But Zola is not content to duplicate this state for the reader. Narrating is naming, and throughout the novel Zola creates, develops, and repeats situations where the character's position is undermined, the narrator's authority underscored. Not only does *Une Page d'amour* prove Zola to be well aware of the illusory nature of dramatized viewpoint, but it shows that he is willing to point out the illusion, to make a metaliterary statement concerning the nature of fiction.

If the dual perspective stemming from the sometimes conflicting demands of viewing (the character's prerogative) and naming (the narrator's necessity) occasionally leads to hesitation, ambivalence, and ambiguity—traits exploited at times in *Une Page d'amour*—the character's and narrator's

52. Both of the above examples, involving anachronism and ambiguous designation, will be discussed in Chapter 4 (description).

viewpoints can, at other times, coordinate. I have traced a pattern of compatibility in alternating viewpoints from section to section or from chapter to chapter (particularly prevalent in the early novels), but dual perspectives can also operate simultaneously within the most minute textual segments.

In the following sentence fragment from *L'Oeuvre*—"c'était elle qui le sentait timide, qui le regardait fixement parfois, avec le vacillement des yeux, le trouble étonné de la passion qui s'ignore" ("it was she who found him timid, who sometimes stared at him, with wavering eyes, [with] the astonished disturbance of unconscious passion," 99)—the reader passes from the viewpoint of the character, Christine, to the narrator's as he describes her from both outside ("wavering eyes") and inside ("unconscious passion"). In effect, the rather short clause affords the reader two perspectives: one of Christine looking at Claude; the other of the narrator looking at Christine. Either perspective could exist separately: the first half of the clause would limit the reader to the character's perspective; the second half to the narrator's; what would be gained in simplicity, economy, and focus, would be lost in the multiplicity, dynamism, magnification, and merging of visual spaces provided by Zola's doubling of perspectives.

The next example, from *La Conquête de Plassans,* involves several shifts within the same short sentence: "Il parut très contrarié en apercevant le visiteur, qu'il feignit d'abord de ne pas reconnaître" ("He appeared quite annoyed in seeing the visitor, whom he pretended at first not to recognize," 1014). We begin by seeing the abbé Faujas from the outside, through the narrator (verbs like "appeared" and "seemed" are the narrator's province, as are judgments such as "annoyed"), before passing to the abbé's viewpoint ("seeing the visitor"), then we shift back to the narrator for a judgment ("he pretended"), followed finally by the abbé's perspective ("not to recognize"). The shifts occur so rapidly as to imply two simultaneous perspectives on the same event, either capable of being sustained independently, but both profiting by their collusion. In the following sentence from *Une Page d'amour*—"Quand il vit que tout le monde le regardait en souriant, il s'arrêta; et, de ses yeux bleus étonnés, il examinait Jeanne" ("When he saw that everyone was looking at him and smiling, he stopped; and, with his astonished blue eyes, he examined Jeanne," 819)—the viewpoint is primarily that of Henri's young son Lucien, but superimposed are those of the entire gathering ("everyone"), as well as that of the narrator ("astonished").

This interaction of viewpoints often occurs over entire chapters; unlike the clear separation of narrator and character discussed earlier, the viewpoints can shift frequently and imperceptibly to create an effect of inter-

weaving, even simultaneity. In the beginning scene from *L'Oeuvre,* for example, which depicts Christine's encounter with Claude during a rainstorm, each character, along with the narrator, adds a different but complementary perspective on the scene, thereby adding to its texture for the reader. "Claude" is the first word in the novel, and the character bearing that name dominates the viewpoint, marking no doubt the closest alliance with the narrator in all of the Rougon-Macquart novels, due to his visual acuity (as a painter) and to his familiarity with the milieu. Nonetheless, it is necessary for the narrator to provide certain judgments (such as "wandering artist") and descriptions (like "he galoped in a gangly way," 11), as well as the perception of the décor. If Claude's viewpoint is designated for immediate effects—"A la brusque lueur d'un second éclair il aperçut . . ." ("In the sharp light of a second flash he saw . . . ," 11)— the interjection of the more general pronoun *on* (one) for certain types of perception, especially those involving detail—"on vit le grand air triste des antiques façades, avec des détails très nets" ("one saw the sadly grand air of the old façades, with very clear details," 11)—suggests a broader perspective, at once more encompassing and more precise. This "supervision" surpasses the characters and suggests a viewpoint from the privileged space of the narrator, much as a motion picture camera might recede behind the character's viewpoint to capture an overview of the scene or focus in on minute details. In other instances, unattributed visual expressions, passive constructions without a specific agent, such as "le quai entrevu" ("the quai glimpsed," 11), seem to suggest a superimposed perspective, where both narrator and character share the viewpoint.

The introduction of Christine's viewpoint adds yet another dimension, that of a supernatural vision nurtured by fear of the unknown: "Un éclair éblouissant lui coupa la parole; et ses yeux dilatés parcoururent avec effarement ce coin de ville inconnue, l'apparition violâtre d'une cité fantastique . . . un nouvel éclair l'avait aveuglé; et, cette fois, elle venait de revoir la ville tragique dans un éclaboussement de sang" ("A dazzling flash cut her short; and her dilated eyes wandered fearfully over this unknown urban area, this violet apparition of a dreamlike city . . . another flash had blinded her; and, this time, she had just seen again the tragic city in a spattering of blood," 12–13). Again Zola adds a complementary perception of the scene suggesting the narrator's space, signaled by the general pronoun "on" appearing three times:

Les plus minces détails apparurent, on distingua les petites persiennes fermées du quai des Ormes, les deux fentes des rues de la Masure et du Paon-Blanc, coupant la ligne des façades; près du pont Marie, on aurait compté les feuilles des grands platanes. . . .

Et l'on vit encore les remous de l'eau, la cheminée haute du
bateau-lavoir, la chaîne immobile de la dragueuse.

(The slightest details appeared, one could distinguish the small
closed blinds on the quai des Ormes, the two openings of la
Masure and le Paon-Blanc streets, breaking the line of façades;
near the Marie Bridge, one could have counted the leaves on the
plane trees. . . . And one could also see the eddies in the water, the
tall chimney of the washhouse boat, the motionless chain of the
dredger. 13)

The narrator assumes the viewpoint for descriptions involving details,
reference points, linear precision, and mathematical accuracy. The three
viewpoints add slightly different perspectives to the same scene—the
impressionistic sensitivity of Claude, the emotive exaggeration of Chris-
tine, the precision of the narrator—resulting in a global perception by the
reader, who simulates the situation of the narrator as overseer or synthe-
sizer of the scene. We may represent the viewpoint graphically (Diagram
11). The scene is mediated[53] for the reader either by one or another

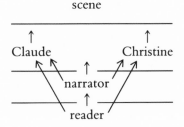

Diagram 11.

53. Hamon also discusses mediation, but among the characters and within the story
space. When he speaks, for example, of the character as "médiatiseur entre deux espaces," it
is between the space of a room and the space of the décor, both on the story level (see *Le
Personnel du roman,* 71), which he represents schematically (Diagram 12). The narrator,
whose presence Hamon discusses in a later book, appears as an equal perceptual alternative
to the characters within the story, not as their mediator (see *Texte et idéologie*). The concept
of different spaces on different levels and their relationships does not enter into his other-
wise excellent argument, which he represents graphically (Diagram 13) (116).

lieu clos	fenêtre	paysage
B	A	C
	(personnage)	

Diagram 12.

character, or by the narrator, who, while retaining a situation of domi-
nance, occasionally appears to step aside so that the reader ostensibly
perceives the setting through the characters' eyes. This creates the illusion
of simple mediation,[54] although the viewpoint is meant to alternate
among three mediational options. The visual interaction between char-
acter and narrator, between particular and general viewpoints, is comple-
mentary. The value of the character's viewpoint, for reasons ranging
from vivacity to determinism, has already been discussed. The use of the
general pronoun *on* warrants further amplification.

Throughout the Rougon-Macquart series, the pronoun *on* is used as the
subject of perception verbs, thus constituting a "viewpoint" in descriptive
passages. Rejecting the clear and consistent option to continue the char-
acter's viewpoint—*il* or *elle*—Zola frequently chooses the broader pro-
noun *on*. Because of its general quality, *on* can involve the narrator's view-
point (registering effects that are uncharacteristic of the characters or
impossible for them),[55] the characters' viewpoint (often in a collective

Narrateur
↓
spectacle

(légumes)
↑ ↑
(dégoût) (plaisir)

P1 Spectateur—Florent Claude—P2 Spectateur

Diagram 13.

54. Even an invisible narrator always remains interposed between the reader and the
character, despite the "illusion" of direct identification.

55. Cases featuring a viewpoint broader than that of the characters and thus attributable
to the narrator, such as the one in the immediately preceding example from *L'Oeuvre,*
frequently involve the perception of sharp detail, lines, organizational principles, and over-
all composition, usually not typical of even the more acute observers, like Claude—whose
vision is characterized by "impressions," dominated by effects of light and color and by
emotional reactions. Near the end of *L'Oeuvre,* for example, we read: "on distingua
nettement, comme sur un transparent d'ombres chinoises, les découpures des wagons. . . .
Et la ligne redevint nette, un simple trait à l'encre coupant l'horizon" ("one distinguished
clearly, as on a Chinese shadowgraph, the silhouettes of the railway cars. . . . And the line
became clear again, a simple stroke of ink cutting the horizon," 361). The precise perception
of detail accompanies the use of *on* in numerous examples from other novels: "on y
distinguait jusqu'à la découpure fine des feuilles de saule" ("one could even distinguish the
indented outlines of the willow leaves," *Le Rêve,* 872); "On distinguait les moindres détails
avec une précision singulière . . . si nets, qu'on aurait compté les pierres" ("One distin-
guished the slightest details with unique precision . . . so clear that one could have counted

sense),[56] or a superimposition of narrator's and character's viewpoints, where the novelist profits by the lack of specific attribution inherent in *on* to solve a narrative dilemma or augment the range of perspectives on the scene.

This latter case is most frequent, with *on* representing both character and narrator, mutually reinforcing each other's perceptual qualities: the precision of the narrator and the vivacity of the character merging in the same perception. In *Une Page d'amour,* for example, where the characters' ignorance and the narrator's need to name occasionally lead to a divergence of viewpoints underscored by the novelist, another strategy often appears—that of superimposing the two viewpoints, blending them through the general pronoun *on.* Jeanne, remember, knows only three monuments ("les Invalides, le Panthéon, la tour Saint-Jacques," 1029; confirmed on 1030 and 1070), while the narrator feels compelled to name a dozen others in the same scene. By using the pronoun *on*—"on apercevait le dôme des Invalides, les flèches de Sainte-Clotilde, les tours de Saint-Sulpice mollissant, se fondant dans l'air trempé d'humidité" ("one perceived the Invalides dome, the steeples of Sainte-Clotilde, the

the stones," *La Débâcle,* 894); "On distinguait nettement les plus petits détails, tant la lumière était pure" ("The light was so pure that one could clearly distinguish the smallest details," *Une Page d'amour,* 850; see also 851, 1055, and 1091). Even when "clearly" is replaced by "vaguely," the view retains a general quality that exceeds the characters—"on distinguait vaguement des façades brouillées, des coins d'arbres, d'un vert cru de décor" ("one vaguely distinguished murky façades, parts of trees, with a raw green like scenery," *Une Page,* 972)—and often a geometric aspect that serves to organize the scene for the reader: "On distinguait vaguement les quatre immenses corps de petites maisons adossées, des corps de caserne ou d'hôpital, géométriques, parallèles, que séparaient les trois larges avenues, divisées en jardins égaux" ("One vaguely distinguished the four immense masses of small attached houses, the geometric, parallel masses of barracks or a hospital, separated by the three wide avenues, divided into equal lots," *Germinal,* 1142).

56. Zola uses *on* to represent the characters' viewpoint, particularly in situations involving a sense of collectivity, as with the theme of class solidarity in *Germinal:* "Et, au fond de sa chambre éventrée, on apercevait la machine. . . . Et l'on vit alors une effrayante chose, on vit la machine, disloquée sur son massif. . . . Au fond, on ne distinguait plus qu'un gâchis de poutres" ("And, at the back of the ripped open room, one perceived the machine. . . . And then one saw a frightening thing; one saw the machine, detached from its base. . . . Beyond, one distinguished no more than a mess of beams," 1546–47). Here the limited perception and the emotional reactions signal the characters' viewpoint, which Zola can render as a collective perception through repetition of the general pronoun *on.* A similar usage occurs in *La Débâcle,* underscoring the confusion of battle as well as the mutual plight of the common soldier: "et l'on ne voyait plus le pont. . . . Et l'on aurait cru des cavaliers fantômes allant à la guerre des ténèbres, avec des chevelures de flammes" ("and one could no longer see the bridge. . . . And one might have believed [one saw] phantom horsemen, with flaming hair, going off to battle in the underworld," 526–27).

towers of Saint-Sulpice softening, dissolving in the humidity-bathed air," 1032)—Zola combines the two viewpoints. He begins with a monument known to Jeanne, then introduces two others that require his knowledge. He retains the immediacy of her perception ("softening, dissolving") along with the precision of the narrator's. Rather than oppose the two viewpoints antithetically, as he did in other cases, Zola synthesizes them, superimposes them in a perception that benefits from both perspectives. Rather than name the monuments without their "perception," or insist on Jeanne's perception of monuments without naming them, he avoids a conflict of viewpoints by using the encompassing pronoun *on*.[57]

This combination of narrator's and character's viewpoints in a single perception, where the individual components are indistinguishable, constitutes a visual equivalent of free indirect discourse, where the characters' expressions are mediated by the narrator's voice. Zola's novels are rife with examples of the latter technique, as in *La Curée*, when Renée meets Maxime for the first time: "Mais comme il était fagoté, grand Dieu!" ("But, my God, what a get up he had on!" 404). The expressions are clearly Renée's, highlighted by the expletive and the exclamation point, but the narration remains the narrator's: there are no quotation marks or present tenses signaling direct discourse, nor main clauses, such as "she said that" marking indirect speech. In effect, the character's *voice* is mediated by that of the narrator in much the same way as the pronoun *on* allows the narrator to mediate the character's *vision*. In fact, examples abound where free indirect discourse is used to capture a visual effect, where its verbal use augments the visual mixture of character and narrator. In *Une Page*, for example: "My God! what a stubborn rain . . ." (877); "My God! she was seeing her child eat!" (939); "How thin they appeared! how transparent they were!" (956; for a sustained example see 1029–30). The reader will no doubt have recognized the overly solicitous nature of Hélène in all three examples, although she is not quoted directly. With free indirect discourse, the characters' voices, along with their vision, is mediated by the narrator.

This situation involving mediation of character by narrator—whether visually by the use of *on* or verbally by free indirect discourse—merely highlights a system that is inherent in third-person narration. Although the narrator may momentarily step aside to allow his characters to see or to speak, his is the primary view and voice in the novel, the main mediational medium between the reader and the space of the story. When the narrator does not step aside, he creates a schema of double mediation: the

57. For further examples of this synthetic use of the pronoun *on* in *Une Page d'amour* alone, see 846, 850–51, 908, 1024, 1032, and 1090.

narrator, already interposed between the reader and the scene, interposes a character between himself and the scene, making the reader's perception twice removed, as in Diagram 14. The narrator always sees more than the character (since he can see the character, as well as what the character is seeing); the reader can never see more than the narrator,[58] whose position duplicates that of the hypothetical viewer(s) in a painting or the camera(s) in a motion picture.

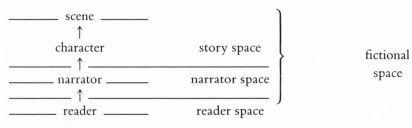

Diagram 14.

Zola frequently complicates this already intricate system by tripling mediation, as in the final pages of the penultimate chapter (always a significant position) from *L'Oeuvre* (338–41). The narrator observes Christine, who secretly observes Claude, who stares at the invisible Cité, while contemplating suicide (Diagram 15). Christine's viewpoint is uti-

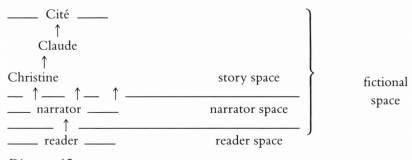

Diagram 15.

lized to dramatize her anxiety about Claude and, in fact, to articulate fears of suicide, since Claude is barely conscious throughout most of the final pages: "le surveillant dans un vertige d'inquiétude, le voyant toujours faire le terrible saut" ("watching him with vertiginous worry, seeing him

58. Although the reader can occasionally interpret what is seen better than the narrator; this is the case with an "unreliable narrator."

make the terrifying leap," 339). Claude's viewpoint is utilized to register the effects of the eerie light reflected off the river and thus lend the scene its lugubrious impact: "Lui, debout, très grand, ne bougeait pas, regardait dans la nuit. . . . Une lanterne rouge, au ras du barrage de la Monnaie, jetait dans l'eau un filet de sang. Quelque chose d'énorme et de lugubre, un corps à la dérive, une péniche détachée sans doute, descendait avec lenteur au milieu des reflets, parfois entrevue, et reprise aussitôt par l'ombre" ("Upright, quite large, he was still, looking into the night. . . . A red lantern, at the level of the Monnaie Dam, cast a streak of blood on the water. Something enormous and lugubrious, a drifting body, a barge adrift no doubt, was moving along slowly amidst the reflections, sometimes glimpsed, then quickly recaptured by the shadows," 340). But the narrator must reinforce the marred vision of both Christine ("her eyes filled with tears," 340) and Claude ("He had come, called by [the Cité], and he couldn't see it," 340). The narrator thus remains the ultimate source, retains the ultimate viewpoint.

Whether alternating (as in the opening scene from *L'Oeuvre*) or superimposed (as in this penultimate scene), whether conflicting (as in the scene from *Une Page* where Jeanne questions Hélène about the monuments) or synthesized (as in the scenes where Jeanne's limited knowledge of three monuments is supplemented by the narrator through the pronoun *on*), this combination of character's and narrator's viewpoints confers a wealth of perspectives on the scenes of Zola's novels. Clearly, the prospect of increasing the range of perspectives, of expanding the visual field by multiplying viewpoints and merging visual spaces, supercedes Zola's principles of narrational silence, invisibility, and impartiality. This proliferation of viewpoints reinforces the evolution of Zola's novels toward a cubistlike multiplicity, which recognizes the relativity of human perception while attempting to surpass it through synthesis.[59] Furthermore, the merging of viewpoints—narrator's and character's—allows Zola to combine general and particular perspectives in order to create a text that is at once document and impression. Zola acknowledges the importance of this combination in his notes for *La Débâcle:* "Faire la scène historique telle quelle. Mais la faire surtout passer par les impressions et les explications de Maurice" ("Do the historical scene as it was. But, especially, make it pass through the impressions and explanations of Maurice").[60] In any given description, the narra-

59. This progression in Zola's novels is not unlike the analytic and synthetic stages of the cubist movement.

60. In *R-M*, v, 1404. Henri Mitterand comments on this dual aspect of Zola's style in his notes for *La Bête humaine:* "Il semble avoir réussi à amalgamer et à concilier les deux points de vue, celui de la technicité et celui de l'impressionnisme, parce que le personnage qui sert

tor may be the source of historical facts, geographical reference points, sharp lines, precise detail, and overall compositional organization, while the character may be used to register "impressionist" effects of atmosphere, light, color, and movement. The relationship of these two aspects of description—"naturalist" and "impressionist"—whether as components of simultaneous perception or as parts of a visual process, will be a main topic of discussion in the following chapter, concerning description.

de relais à la description a lui-même, momentanément, un double rôle: homme de métier, et voyageur; ce qu'il sait peut compléter et corriger ce qu'il voit, sans cependant dissiper tout l'inconnu et toute la poésie du spectacle" (IV, 1761–62). As we have seen, when a character possessing such a combination of perceptual qualities (like Jacques Lantier alluded to here) lacks (as in *Une Page*), or fails (as in *L'Oeuvre*), Zola achieves the same amalgamation of "technicality" and impressionism by combining the narrator's viewpoint with that of the characters.

4 Vision and Description: Beyond the Impression

Décrire n'est plus notre but; nous voulons simplement compléter et déterminer. (Describing is no longer our goal; we simply want to complete and determine.)
—Le Roman expérimental (186)

Nos descriptions n'ont plus un rôle purement pittoresque, elles sont là pour donner le drame entier, les personnages avec l'entourage qui agit sur eux. (Our descriptions no longer play a purely picturesque role; they are there to provide the whole drama, the characters with the milieu that acts on them.)
—Nos auteurs dramatiques (67)

Dans ce qu'on nomme notre fureur de description, nous ne cédons presque jamais au seul besoin de décrire; cela se complique toujours en nous d'intentions symphoniques et humaines. (In what is called our mania for description, we hardly ever yield solely to the need for describing; for us, it's always complicated by symphonic and human intentions.)
—Letter/Preface to the first illustrated edition of *Une Page d'amour*[1]

No aspect of Zola's novels has generated more commentary and controversy—from detractors, from defenders, and from Zola himself—than his descriptions. The three quotes above suggest the importance of descriptive passages in Zola's novels and the variety of functions ascribed to them, from the implementation of determinism, to the development of plot and character, to the creation of structural and symbolic patterns. All of these purposes will be examined here, from the special perspective that Zola's visual properties, preferences, and peculiarities afford the reader.

Vision is of particular importance in description, as Barthes reminds us in *S/Z:* "every literary description is a *view.*"[2] His suggestion that paint-

1. Included in *R-M*, ii, 1605.
2. His emphasis. *S/Z,* trans. Richard Miller (New York: Hill and Wang, 1974), 54.

ing served the writer as a model for such descriptions[3] is confirmed in Zola's case, with evidence ranging from the systematic demarcation and organization of space (composition) to the interplay of visual elements like light and line within that space. Since Zola's novels are literally laden with descriptive passages, this study will be limited, for the most part, to those involving panoramic cityscapes, whose link with innovative viewpoint has already been examined in relation to Berthe Morisot's *On the Balcony, Meudon* (Figure 2, page 103).

More Morisot: The Panoramic Cityscape

If the artist's choice of the panoramic cityscape entails innovations in viewpoint—namely, elevation and distance—by its very scope it involves an attention to composition not always attributed to impressionist art.[4] The broader the scope, the more that compositional concerns come into play. The greater the space depicted, the greater the need to demark and delineate it clearly. The fewer the details, the more that broad lines, bands, and blocks characterize the canvas, the more that shape, design, and volume prevail.

In painting, the spatial organization of cityscapes is often achieved through the deployment of landmarks. Domes, for example, often used to "center" or "balance" the composition, can further solidify space by their referential value; that is, the domes provide a known reference point that "orients" the spectator and allows him or her to "superimpose" on the depicted space the topographical disposition of the area, its grid of streets and sites, its geographical coordinates: N-S-E-W. The dome serves to organize, even represent the entire surrounding area (often left vague), a salient detail standing for the absent whole, a visual synecdoche for an entire quarter. Occasionally the dome may even add a "symbolic" dimension to the painting, as does the Institut de France, representing the artistic establishment, or the Invalides, suggesting military sacrifice and glory.

Manet's *L'Exposition universelle de 1867* (1867), viewed from the butte de Chaillot, is centered on the dome of the Invalides, which protrudes above the distant horizon line and stabilizes the bustle of city life in the

3. Ibid., 54–58.

4. Ruth Moser's judgment that "les Impressionnistes ne 'composent' plus; ils choisissent, tout au plus le site qui fera le sujet de leur toile" (*L'Impressionnisme français* [Geneva: Droz, 1952], 54) is echoed by Yvon Taillandier's claim about Monet that "composition was no longer of any importance" (*Claude Monet,* trans. A.P.H. Hamilton [New York: Crown Publishers, 1967], 88).

foreground and the clutter of the world's fair in the middle ground.[5] In Renoir's *Pont des Arts* (also 1867), the roofs of various buildings and monuments rise progressively from left to right toward the dome of the Institut de France, which towers above them, its prominence reinforced by the horizontal line of the Pont des Arts, the diagonal of the quai, and the curve of the staircase, all of which intersect at the Institut's base.

The concern for composition is especially striking in Monet's earliest efforts at panoramic views of Paris. In the *Quai du Louvre* (1867), the Panthéon looms near the center of the composition, flanked symmetrically by the Val-de-Grâce and the Collège Henri IV. The horizontal lines of the Quai des Grands Augustins, the regular vertical lines of trees and lampposts (one occupying the exact center of the foreground), the shapes of the kiosks (matching those of the domes), all lend a strong sense of order to a scene of broad scope and great activity. The companion painting, *Le Jardin de l'Infante* (also 1867), has the same dimensions (36" × 24¼") but is turned vertically, the blocking itself indicative of the importance of composition to Monet in these canvases. Here the dome of the Panthéon occupies the exact center of the painting, again flanked by the two other domes, which dominate the horizon. In the foreground, the garden itself, with its symmetrical paths and borders in the French style, framed by a fence, further highlights the importance of line and design, qualities enhanced by the intense green at the bottom, set in contrast with the gray sky at the top of the canvas.

Berthe Morisot, whose rustic cityscape *La Seine en aval du Pont d'Iéna* (1866) was exhibited in the Salon and influenced Manet's *Exposition universelle,* turned to broader panoramas of city life in 1872. Her *Vue de Paris des hauteurs du Trocadéro* is composed of unified bands of color that run progressively from a terrace in the foreground to a park whose striking green dominates the middle ground, to roads, the river, the city, and finally to the horizon and the sky. The horizon line is punctuated vertically by the towers of Saint Clotilde, Notre-Dame, and Saint Sulpice to the left, counterbalancing the dominant golden dome of the Invalides flanked by that of the Panthéon to the right. Her frequent featuring of the Invalides in various cityscapes, even fans (where design is a paramount concern), illustrates its importance as a compositional factor in her depictions of Paris.[6] Such is also the case in *On the Balcony, Meudon* (1874; see

5. See T. J. Clark, *The Painting of Modern Life: Paris in the Art of Manet and His Followers* (Princeton: Princeton University Press, 1984), 60–78, for an analysis of this painting, although Clark fails to mention the use of the dome, which is even cut off from the cover reproduction of the painting.

6. See Marie-Louise Bataille and Georges Wildenstein, *Berthe Morisot: Catalogue des peintures, pastels et aquarelles* (Paris: Les Beaux Arts, 1961), figs. 720, 721, 729, and 730.

Fig. 2). Here the vertical blocking of the canvas reduces the scope of the painting in order to emphasize the human dimensions discussed in the previous chapter. The dome of the Invalides is set in opposition to the woman's head on the horizon line, while the steeples diminish in compositional status. The incorporation of the large baluster on the right serves as a counterpoint to the dark mass of the woman's dress and a counterweight to the strong diagonal lines of the balcony and railing. The baluster, whose vertical lines are repeated regularly by the bars of the bannister, lends a cantilevered solidity to the composition by anchoring the lower right corner of the canvas.

In all these canvases, a major concern is the composition—the organization of space by overall lines (both orthogonal and diagonal), the relationship of forms and volumes (by progression, as in the *Pont des Arts;* symmetry, as in the *Quai de Louvre;* or contrast, as in *On the Balcony*), and even the emphasis on design (rarely attributed to impressionists other than Degas and Cassatt). The same concern with composition—the demarcation of space, the disposition of broad lines, and the organization of forms within that space—characterizes Zola's depiction of Paris in the panoramic cityscapes of *Les Rougon-Macquart.* In the visual novel "composition" becomes a spatial as well a temporal matter. The novelist is careful to describe elements in terms of their location in three-dimensional space—along the horizontal and vertical dimensions as well as in planes suggesting depth—in addition to situating them along the fourth dimension, time (a given in literature).

Composition and the Representation of Space

In no novel does Zola more consistently depict Paris from a distant, elevated vantage point than in *Une Page d'amour,* and in no novel does his depiction of the decor display more concern with the overall demarcation of space and the systematic organization of elements within that space, in short, with composition.[7]

7. There have been numerous studies on Zola's handling of space, among them the following, listed chronologically: Roland Bourneuf, "L'Organisation de l'espace dans le roman," *Etudes littéraires* 3, no. 1 (April 1970): 77–94; Chantal Jennings, "La Symbolique de l'espace dans *Nana,*" *Modern Language Notes* 88, no. 4 (May 1973): 764–74; Lewis Kamm, "The Structural and Functional Manifestations of Space in Zola's *Rougon-Macquart,*" *Nineteenth-Century French Studies* 3, nos. 3–4 (1975): 224–36; Jacques Allard, *Zola: Le Chiffre du texte: Lecture de "L'Assommoir"* (Grenoble: Presses Universitaires de Grenoble, 1978);

Zola's compositional concerns are evident in the novel's preparatory dossier, whose variety of visual materials is striking, even given Zola's penchant for them. These documentary materials include, for example, a panoramic photograph of Paris, taken from the towers of Saint-Gervais, behind the Hôtel-de-Ville, looking toward the Arc de Triomphe. This viewpoint of Paris (looking west) is the direct opposite of the one chosen for the novel (looking east), the very difference suggesting the importance of organizing a vast space, regardless of its specific elements or orientation. The most cursory glance at the photo shows the dominance of the swath cut by the Seine through the middle of the scene and the importance of visual reference points provided by monuments dotting the horizon as they emerge from the fairly uniform height of the Paris skyline (where buildings of six to seven floors are the rule). Zola also consulted a panoramic engraving of Paris executed from a hypothetical position looking down on the city from west of the Arc de Triomphe toward the eastern horizon behind the Ile de la Cité. The vantage point is near to that chosen for the novel and produces a similar arrangement of landmarks.[8] Again, the monuments clearly stand out above the horizon, while the Seine, cut by its numerous bridges and split by the Ile de la Cité, constitutes the main line of vertical continuity as it extends toward the horizon line.

The importance of spatial composition is further reflected by the maps that Zola drew while preparing *Une Page d'amour.* The ultimate in visual organization, the maps involve spaces of varying scopes, including the Passy area (*R-M,* II, 1604), the dwellings involved in the novel (1614), Deberle's pavillion (1616), the garden (1617), and Hélène's apartment (1618).

The written notes for the novel also include numerous pages betraying compositional concerns, particularly those which Zola labeled as "topo-

David Baguley, "Les Paradis perdus: Espace et regard dans *La Conquête de Plassans* de Zola," *Nineteenth-Century French Studies* 9, nos. 1–2 (Fall–Winter, 1980–81): 80–92; Anne Belgrand, "Espace clos, espace ouvert dans *L'Assommoir,*" in *Espaces romanesques,* ed. Michel Crouzet (Paris: PUF, 1982), 5–14; Mary Jane Evans Moore, "The Spatial Dynamics of *L'Assommoir,*" *Kentucky Romance Quarterly* 29, no. 1 (1982): 3–14; Denis Bertrand, *L'Espace et le sens: "Germinal" d'Emile Zola* (Paris: Hadès-Benjamins, 1985); Chantal Bertrand-Jennings, *Espaces romanesques: Zola* (Sherbrooke, Québec: Editions Naaman, 1987); Laurey K. Martin, "L'Elaboration de l'espace fictif dans *L'Assommoir,*" *Cahiers naturalistes* (forthcoming). Only the latter study primarily relates Zola's representation of space to painting.

8. Mitterand adds this engraving to the dossier for *La Curée,* and even though it would appear more directly related to *Une Page d'amour,* it is clear that, either way, Zola saw it and had it in his possession at the time of composing the latter novel.

graphical."[9] These notes are dominated by the panoramic view of Paris, chosen as the point of departure for the novel long before plot and characters: "dès ma vingtième année, j'avais rêvé d'écrire un roman dont Paris, avec l'océan de ses toitures, serait un personnage" ("from the time I was twenty, I had dreamed of writing a novel in which Paris, with its ocean of rooftops, would be a character").[10] The first page of the section titled "Vue de Paris"[11] shows clearly the extent to which Zola is preoccupied with the overall composition of the vast scene:

Vue de Paris.

Les deux bonnets pointus de Sainte Clotilde un peu à gauche du dôme des Invalides.

Les quais indiqués par la ligne des arbres. Berges et parapets gris.

Les 2 tours de Saint-Sulpice derrière les Invalides.

Notre-Dame au fond de la Seine.

Au premier plan, dans la Seine, des grues, des bateaux déchargés.

Des fumées grises s'envolant de Paris, par un temps couvert.

Les Tuileries et le Louvre en face, avec des arbres.

Les passants et les voitures (omnibus jaunes), des fourmis en bas sur le quai; puis, au loin, on ne les distingue même plus.

Par un temps gris, les maisons sont toutes petites et se perdent au loin, tout est noir.

On voit l'Opéra à l'extrême-gauche, au dessus du Palais de l'Industrie.

Paris ramassé, la vallée de la Seine au milieu—Le Mont Valérien derrière Passy (on le voit du cimetière).

(View of Paris. The two pointed caps of Saint Clotilde a little to the left of the Invalides dome. The quais shown by the lines of trees. Gray banks and parapets. The 2 towers of Saint-Sulpice behind the Invalides. Notre-Dame at the end of the Seine. In the foreground, in the Seine, cranes, unloaded boats. Gray smoke blowing away from Paris, in overcast weather. The Tuileries and the Louvre opposite, with trees. Passersby and vehicles (yellow busses), ants below on the quai; then, in the distance, one can no longer even see them. On a gray day, the buildings are very small and are lost in the distance, everything is black. One can see the

9. See especially no. 10.318, fols. 514–25, Département des Manuscrits, Nouvelles Acquisitions Françaises, Bibliothèque Nationale; see also 462–66, and no. 10.345, fols. 128, 158, 174–75, and 178.

10. Included in *R-M*, II, 1605; see also 1608.

11. No. 10.318, fol. 521, N.A.F., B.N.

Opéra on the far left, above the Palais de l'Industrie. Paris gathered up, the Seine valley in the middle—Mount Valérien behind Passy (one can see it from the cemetery).

Although the description is divided into paragraphs, which suggest blocks or moments of vision, there is only one temporal indication ("then"). All except the second paragraph are characterized by an adverbial expression indicating spatial position: some suggesting horizontal relationships; others vertical ones; several delineating the planes of the scene, which lend it depth. Zola also notes the broad lines of the scene created by the row of trees, indicating the quais, which in turn denote the Seine. Indeed, the river and its quais constitute the major compositional feature, mentioned in five paragraphs, but the scene is dominated by the vertical lines of spires and domes, which, along with the rising smoke, dwarf both residences and residents. While the broad lines of the scene are set by the natural topographical features, this vast space is organized by the various monuments, each of which characterizes a particular visual segment of the scene, denoted by the separate paragraphs in the French text: Sainte-Clotilde and the Invalides, Saint-Sulpice, Notre-Dame, the Tuileries and the Louvre, the Opéra and the Palais de l'Industrie. Along with a few others mentioned in the following pages of notes (Saint-Augustin, Saint Vincent de Paul, la Tour Saint Jacques, le Panthéon), these monuments are the reference points that define the "base map" on which the variables of atmosphere, light, color, and temperament will be inscribed and compared over the five vast descriptions whose spatial configurations dominate the novel and constitute its main structuring principle.

So important was the organization of space in these descriptions that Zola was willing to contravene two of the main tenets of his artistic canon in order to ensure spatial solidity. First, he violated the principle of historical accuracy by including in the novel two monuments (the Opéra and Saint-Augustin) that, although they figure prominently in the notes for the novel (February and April 1877), did not exist at the time of the novel's setting (1860). Zola defends this clear anachronism in a letter accompanying an illustrated edition of *Une Page d'amour* in 1884:

J'avoue la faute, je livre ma tête. Lorsque, en avril 1877, je montai sur les hauteurs de Passy pour prendre mes notes, à un moment où les échafaudages du futur palais du Trocadéro me gênaient déjà beaucoup, je fus très ennuyé de ne trouver, au nord, aucun repère qui pût m'aider à fixer mes descriptions. Seuls, le nouvel Opéra et Saint Augustin émergeaient au-dessus de la mer confuse des

cheminées. Je luttai d'abord pour l'amour des dates, mais ces masses étaient trop tentantes, allumées sur le ciel, me facilitant la besogne en personnifiant de leurs hautes découpures tout un coin de Paris, vide d'autres édifices; et j'ai succombé et mon oeuvre ne vaut certainement rien si les lecteurs ne peuvent se résoudre à accepter cette erreur volontaire de quelques années dans les âges des deux monuments.

(I admit the sin, I surrender. When, in April 1877, I went up to the heights of Passy to take my notes, at a time when the scaffolding for the future Trocodero palace was already bothering me considerably, I was very disturbed not to find, in the north, any reference point that could help me to fix my descriptions. The new Opéra and Saint Augustin alone emerged above the confused sea of chimneys. I resisted at first through love of dates, but these masses were too tempting, highlighted on the sky, facilitating my task by embodying with their high silhouettes an entire area of Paris, devoid of other edifices; and I succumbed, and my work is certainly worth nothing if its readers are not prepared to accept this voluntary error of several years in the ages of the two monuments. 1606)

Whether Zola is being truthful or simply justifying an oversight, his argument is clearly based on compositional concerns, which we can identify as the overall stability of the description ("fix my descriptions"), the reference points provided by the monuments, and the visual shorthand by which the monument serves to stand for and even "embody" the entire area.

Chronological accuracy yields to anachronism for reasons of composition, just as Zola's principle of narrative neutrality occasionally gives way to the blatant contradiction between the narrator's and character's perspectives, as seen in the previous chapter, when the narrator systematically names monuments that go beyond the knowledge of the characters, especially Hélène and Jeanne in *Une Page d'amour*.[12] The referential and compositional value of the monument for the reader's perception of the visual description clearly supersedes here the program of narrational silence to which Zola rigidly adheres in general. The exception proves the rule and points out the extreme importance that Zola accorded the organization of both visual space and the narrative.

Yet another unique feature of *Une Page d'amour* signaling the impor-

12. See *Une Page d'amour*, 853 ff. and my discussion in Chapter 3, pages 136–39.

tance of visual organization attending this novel is the inclusion of the first genealogical tree. The tree transposes relations of kinship and periods of time (generations) into spatial form and, in so doing, affords them the power of visual processing.[13] A genealogical tree or network is no less than a family map, and, like the map, it accomplishes a visual overview, establishes a reference system, simplifies the complex, and spatializes the temporal. The genealogical tree of *Les Rougon-Macquart,* included with *Une Page d'amour* (and later with *Le Docteur Pascal*), summarizes the entire series, enabling us to grasp it as a vast "ensemble."[14]

Numerous further examples of compositional concerns occur within *Une Page d'amour,* as well as in the other novels of the series.[15] The ubiquitous windows, pointed out by Philip Walker,[16] serve to block and frame scenes, whether characters look out, as in *Une Page*—"Les deux fenêtres de la chambre étaient grandes ouvertes, et Paris, dans l'abîme qui se creusait au pied de la maison, bâtie à pic sur la hauteur, déroulait sa plaine immense" ("The two bedroom windows were wide open, and Paris, in the abyss dug out at the foot of the building, built vertically on the heights, unfurled its immense plain," 845)—or look in, as in *La Bête humaine*— "Jacques, les yeux levés vers la fenêtre, avait regardé défiler les petites vitres carrées, où apparaissaient des profils de voyageurs" ("Jacques, his eyes raised toward the window, had watched the small square panes pass by, where travelers' profiles appeared," 1031).[17]

Commonly known reference points, such as monuments or the Seine, are the major organizing principles of descriptions of Paris, as evidenced by the examples in the notes to *Une Page d'amour* and by Claude's determined search for objects to anchor his composition (in the examples referred to in note 15). However, when the space depicted is at once vast and

13. See Jacques Bertin, *Graphics and Graphic Information-Processing,* trans. William J. Berg and Paul Scott (Berlin: Walter de Gruyter, 1981).

14. In fact, Zola uses the word "ensemble" twice in the final paragraph of his "Note" of 2 April 1878 preceding *Une Page d'amour,* indicating the significance he attached to the overall scope of the series and to the genealogical tree that represents that scope. See *R-M,* II, 800.

15. The word "composition" is itself used with some frequency, particularly by the painter Claude Lantier, in *Le Ventre* (624 and 800), and later in *L'Oeuvre* (216 and 234). This preoccupation is not limited to the painter but extends to more unlikely characters, such as the department store owner and arch-capitalist Octave Mouret, who closes the doors of his store in *Au Bonheur des Dames* because of an arrangement of umbrellas that "was killing his composition" (617).

16. See Walker's "The Mirror, the Window, and the Eye in Zola's Fiction," *Yale French Studies* 42 (June 1969): 52–67.

17. There are, in fact, two sets of framing windows–those of Phasie's home ("la fenêtre") and those of the passing train ("les petites vitres carrées").

less familiar, solidity of composition is assured by the compass points (N-S-E-W) and the metric measuring system, as in the opening description from *La Terre*—"Jean, qui remontait la pièce du midi au nord, avait justement devant lui, à deux kilomètres, les bâtiments de la ferme" ("Jean, who walked up the field from south to north, indeed had before him, two kilometers away, the farm buildings," 367)—or *La Débâcle,* where spatial precision is necessary for understanding military movement—"des forêts montent à l'ouest et au nord, une côte s'élève jusqu'au village de Belleville; tandis que, vers Buzancy, à l'est, de vastes terrains plats s'étendent" ("forests rose to the west and the north, a hill sloped up to the village of Belleville; while, toward Buzancy, in the east, vast flat areas stretched out," 504; see also 594).

Time, the very fiber of literary composition, is often rendered by spatial means. In *Une Page d'amour,* for example, Hélène marks the march of time toward the upcoming rendezvous between Juliette and Malignon (see 1008–11), not by listening to the clock tick, but by watching its face, which is a spatial organization of the day's time, much as a calendar is the transcription of a month, or a genealogical tree, of generations.[18]

Spatial configurations are not always fixed, however; they often display an elastic quality, with elements shifting in relation to each other. In *Une Page d'amour,* as light changes, "the Seine grew larger" (851), while, with alterations in atmosphere, "Paris escaped from the fog, expanded" (1087; see also 834, 912, 1031, and 1091). This expansion of space ("a sudden enlarging of the horizon," *Eugène Rougon,* 85) can depend on the quality of light ("the beautiful evening enlarged the horizon," *L'Oeuvre,* 214; see also 232), or atmosphere ("the background grew misty, which enlarged the plain," *La Terre,* 797), or surrounding spatial patterns ("an enlarging of the valley opening up on the immensity of the plain," *Nana,* 1238).

Spatial elasticity can also be attributed to the viewer's psychological state, as in *Une Page d'amour,* where the proximity of Dr. Deberle causes Hélène's sense of space to be altered: "But this space, immense a short while ago, seemed to narrow" (810). Later, with l'abbé Jouve, "the vast horizon of Paris, in the evening, touched her with a profound religious impression. The plain seemed to grow larger" (967–68). She is particularly sensitive to the spatial impact of the steep staircase of the Passage des Eaux: "Quand elle arrivait, elle avait, d'en haut, une étrange sensation, en regardant s'enfoncer la pente raide du passage le plus souvent désert. . . . le passage s'ouvrait sous ses pieds comme un trou noir" ("When she

18. Similar examples are found in *Le Docteur Pascal*: "Les yeux ne quittaient pas la pendule," 1153; see also 939, 1175, and 1179.

arrived, she had, from above, a strange sensation, in watching the steep slope of the usually deserted passage sink. . . . the passage opened up under her feet like a black hole," 829 and 995). This rush of space (reminiscent of the pulling power of the slope in Cézanne's *Maison du pendu*) reflects Hélène's fears and desires, as it leads down to another level of Paris, another life, and, eventually, to the depths of adultery.

Zola also utilizes the three spatial dimensions systematically to reflect characters' temperaments or situations, as has been demonstrated by Laurey K. Martin.[19] Depth, as in the preceding example, suggests fear and/or desire; the vertical dimension, the domination and determination of the characters by the milieu (the *grande maison* in *L'Assommoir* overwhelms Gervaise); the horizontal dimension, escape (Gervaise and Goujet look beyond their entrapment in the Faubourg Poissonnière toward the distant horizon). Indeed, Gervaise's entrapment is underscored by the spatial limitations imposed by the boulevards and buildings that surround her and delimit her space: "et elle enfila d'un regard les boulevards extérieurs, à droite, à gauche, s'arrêtant aux deux bouts, prise d'une épouvante sourde, comme si sa vie, désormais, allait tenir là, entre un abattoir et un hôpital" ("and her eyes ran along the outside boulevards, to the right, to the left, stopping at both ends, seized with muted terror, as if her life, henceforth, were stuck there, between a slaughterhouse and a hospital," 403).

Spatial configurations can also be used to suggest social or political patterns, which are nowhere more evident than in the two novels of provincial political dealings, *La Fortune des Rougon* and *La Conquête de Plassans*. On the first page of *La Fortune* l'aire Saint-Mittre, the empty lot where Silvère and Miette meet, is depicted "closed by two sections of wall . . . closed in on three sides the lot is like a square leading nowhere" (5). It is a replica of the city that contains it, as the narrator points out in a rather rare burst of subjective presence: "There is no [other] city, I believe, that has been determined for so long to shut itself in like a nun" (38). The city's reaction to the counterrevolution of 1851 is, of course, to close its city doors at midday and, as the narrator disdainfully adds, "in mid-nineteenth century" (253). If its closed space reflects its general political attitude, the spatial divisions of the city subdivide it neatly into three social groups: "so many neighborhoods, so many separate worlds" (39). Even in public places, when the groups appear simultaneously, as during Sunday walks, they remain rigidly (and spatially) separated: "six to eight meters separate them, and they remain a thousand leagues from

19. "L'Elaboration de l'espace fictif dans *L'Assommoir*," *Cahiers naturalistes* (forthcoming).

each other, scrupulously following two parallel lines, as if not destined to meet in this world" (40–41). The narrator's subsequent description of Plassans in social terms—"this closed city where the division of classes was so clearly marked in 1849" (73)—has already been demonstrated by spatial demarcation and division, that is, by composition, harnessed here to achieve sociological ends. In *La Conquête,* the narrator reminds the reader that "Plassans is divided into three absolutely distinct neighborhoods" (954)[20] and goes on to find another way to socially subdivide space into political factions. Mouret's house, as the owner describes it to l'abbé Faujas, is in the middle, with the legitimists on the right and the Bonapartists on the left (933). When the *abbé* accomplishes his mission by bringing together the two antirepublican factions, their reunion occurs in the middle, in "his paradise" (formerly known as Mouret's garden), where the political roles are now ironically reversed, with the Bonapartist deputy-prefect seated on the *abbé's* right and the legitimist president on his left (1061).[21] Again, Zola has used the organization of space to underscore social and political relationships, much as he used the dimensions of space to dramatize psychological conditions in the examples cited earlier.

However, the primary purpose of composition in the Rougon-Macquart novels is visual. Space is blocked out, much as on a base map set up for the inscription of data, or on a canvas waiting to be filled in with lines and colors, as when light spills over the vast space occupied by Paris in *Une Page d'amour:* "Une clarté blonde, du blond vague de l'enfance, se brisait en pluie, emplissait l'espace de son frisson tiède" ("A blond light, a vague youthful blond, broke up like rain, filled up the space with its warm shiver," 846). But what are the predominant visual elements that Zola uses to fill the space whose composition clearly preoccupies him in the initial stages of description? What relationship do they bear to each other? In what ways do they reflect the peculiarities of Zola's vision or the innovations in painting that characterize Zola's times? How do they inform the debate regarding the curious relationship between impressionism and naturalism in Zola's critical and fictional works? These questions will be dealt with in the subsequent sections of this chapter.

20. The same reminder will be repeated in *Le Docteur Pascal:* "Ah! ce Plassans, avec le cours Sauvaire, la rue de Rome et la rue de la Banne qui le partageaient en trois quartiers, ce Plassans aux fenêtres closes" (1125).

21. For a comprehensive discussion of the political ramifications of Zola's handling of space in *La Conquête,* see David Baguley, "Les Paradis perdus: Espace et regard dans *La Conquête de Plassans.*"

Impressionism: *"Light Motifs" in Monet's* Impression: Sunrise

Light is the characteristic most often cited by critics in defining the innovative impact of impressionism. For John Rewald, the impressionists "had selected one element from reality—light—to interpret all of nature,"[22] while for Phoebe Pool "light had become the great unifying factor of figure and landscape."[23] Such was also a prominent assessment of the "new painters" from the outset, as we note in the work of Edmond Duranty, contemporary of Zola and author of *La Nouvelle Peinture* (1876): "Their discovery actually consists in having recognized that full light *de-colors* tones, that the sun reflected by objects tends (because of its brightness) to bring them back to that luminous unity which melds its seven prismatic rays into a single colorless radiance: light."[24]

The rendering of light recurs frequently in Zola's descriptions of contemporary experiments in painting:

> Aujourd'hui nos jeunes artistes ont fait un nouveau pas vers le vrai, en voulant que les sujets baignassent dans la lumière réelle du soleil, et non dans le jour faux de l'atelier; c'est comme le chimiste, comme le physicien qui retournent aux sources, en se plaçant dans les conditions mêmes des phénomènes. Du moment qu'on veut faire de la vie, il faut prendre la vie avec son mécanisme complet. De là, en peinture, la nécessité du plein air, de la lumière étudiée dans ses causes et ses effets.

> (Today our young artists have taken a new step toward truth, in wanting their subjects to bathe in the real light of the sun, and not in the false light of the studio; it's like the chemist and the physicist returning to their sources, placing themselves within the very conditions of phenomena. From the moment that one wants to represent life, one has to take life with its complete mechanism.

22. *The History of Impressionism*, 4th rev. ed. (New York: MOMA, 1973), 338.

23. *Impressionism* (New York: Praeger, 1967), 56.

24. From *La Nouvelle Peinture: A propos du groupe d'artistes qui expose dans les Galeries Durand-Ruel* (Paris: Marcel Guérin, 1876), repr. in *Impressionism and Post-Impressionism 1874–1904*, ed. Linda Nochlin (Englewood Cliffs, N.J.: Prentice-Hall, 1966), 4. Although Duranty's hand-annotated copy may seem to suggest that he alludes to painters other than the mainstream impressionists, the title and general scope of the essay indicate otherwise. See *The New Painting: Impressionism, 1874–1886*, ed. Charles S. Moffett (San Francisco: The Fine Arts Museums of San Francisco, 1986), 37–49.

Whence, in painting, the necessity of open air, of light studied in its causes and its effects. ("Le Naturalisme au salon," *Salons,* 241)

If light is a central factor in the "mechanism," the "milieu," governing the experience of reality, it is no less important as an artistic technique unifying the canvas: "Voilà donc ce qu'apportent les peintres impressionnistes: une recherche plus exacte des causes et des effets de la lumière, influant aussi bien sur le dessin que sur la couleur" ("Here is therefore what the impressionist painters bring: a more accurate study of the causes and effects of light, influencing drawing as well as color," *Salons,* 261). Light is, in short, a central factor in Zola's conception and definition of impressionism.

As both of the above judgments indicate, it is not merely the "presence" of light that would link a given painter or the novelist himself with impressionism but the study of "the causes and effects of light," not only on the phenomena being represented but on the means of representation.

Claude Lantier's pronouncements in *L'Oeuvre* also insist on the effects of light: "les choses et les êtres tels qu'ils se comportent dans de la vraie lumière" ("things and beings as they behave in real light," 45; see also 155). Claude (like his eponym Monet) strives to dissect and depict the conditions governing the light and its effect on the perception of reality, an effort that separates him from his forerunners.

Chief among these conditions, as Zola was quick to perceive, is the movement out of doors, into the "open air." This step itself entails numerous consequences, several of which are described in a remark by Yvon Taillandier: "Monet was drawn to realize that the three principal elements in daylight as against light in a studio or within a room are—intensity, diffusion and mobility."[25]

In Monet's *Impression: Sunrise* (see Fig. 3),[26] all three elements are clearly present and are enhanced by further conditions governing the light in the painting. The time of day (here dawn, but with dusk as well) allows the sun to be perceived directly, without eyestrain, and in relation to the foreground and the horizon. The direction of the viewpoint, facing the sun (against all laws of amateur photography, not to mention military strategy), also adds to the intensity of the light and color depicted in the scene. The choice of a waterscape, among the hallmarks of impressionist painting, entails the depiction of reflected light and doubles the image of the solar disk, while disaggregating it from its clear, spherical form into a

25. *Monet,* 68.

26. This painting, housed in the Musée Marmottan in Paris, was among those stolen on 27 October 1985 and was only recently recovered.

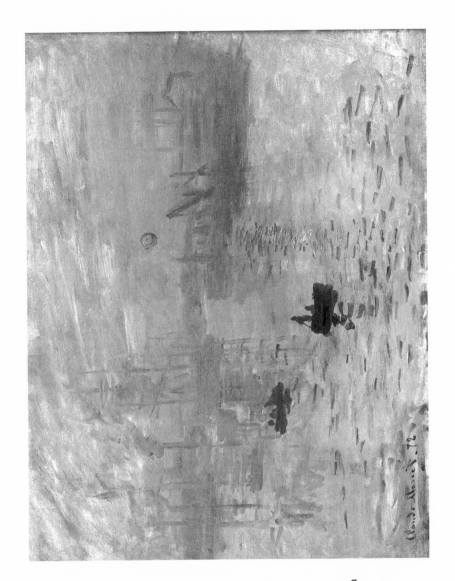

FIG. 3. Claude Monet, *Impression: Sunrise*. Oil on canvas, 1872. Courtesy Musée Marmottan, Paris. (Photo: Giraudon. Courtesy Art Resource, New York)

series of increasingly separate lines; the flat, slashing orange strokes streaked with white suggest the different planes formed by the movement of the waves and thus portray the mobility of light. The dynamic dissolution of this reflected image contrasts markedly with the clear image formed by the reflection (suggesting mental "reflection") in Monet's *La Seine à Bennecourt,* but the "impression," articulated by William Seitz, remains similar in its impact and implications: ". . . reflections become a means of shaking off the world assembled by memory in favour of the world perceived momentarily by the senses. In reflections the artifices so important to workaday life are transformed into abstract elements in a world of pure vision."[27]

Perhaps paramount among the conditions governing light is the atmosphere: here, a predawn haze emanating from the water and thickened by the smoke from a stack to the left. By distorting the three distance gradients of aerial perspective—detail, sharpness, and color—Monet creates the effect of volume and renders the atmosphere tangible, palpable. This favors the diffusion of light over the entire scene and thus imparts an overall luminosity to all of the canvas. Monet enhances this effect by using a high (light) value for all of the phenomena depicted, including the forms of the masts and the boats, as well as the shadows cast by these objects and by the waves, all of which might usually be rendered at a much lower (darker) value. This "light palette" or *coup de clarté* (burst of light) characterized Zola's understanding of impressionist innovation, as witnessed in his description of the Salon des Refusés in *L'Oeuvre:* "quel joli ton général, quel coup de lumière apporté, une lumière gris d'argent, fine, diffuse, égayée de tous les reflets dansants du plein air! . . . La note claire de son tableau, ce bleuissement dont on se moquait, éclatait parmi les autres" ("what a lovely overall tone, what a ray of light, a silver gray light, fine, diffuse, brightened by all the dancing reflections in the open air! . . . The light note of his painting, this bluishness that aroused mockery, stood out among the others," *L'Oeuvre,* 130; see also 296).

Monet achieved this lightness by the use of a pale ground, particularly gray, but often cream or beige, "whose luminosity," as Waldemar Januszczak notes, "plays a crucial role in creating the illusion of light and sun."[28] By mixing his colors with lead white to create a pastel effect reflecting luminosity, by scumbling (dragging paint across the surface), by slurring (pulling two wet colors together with a single stroke), and by scratching through built-up layers of paint back to the pale ground or

27. Quoted by Pool, *Impressionism,* 86–87.
28. See "Claude Monet," in *Techniques of the World's Great Painters,* ed. Waldemar Januszczak (Secaucus, N.J.: Chartwell Books, 1980), 103.

even the white canvas, Monet emphasizes not only the "lightness" and luminosity of light, but suggests the interplay of various light effects by the dynamic nature of the brushwork.[29]

The diffusion of light in *Impression: Sunrise* has, in turn, an effect on the color, which is also diffused. The orange emanating from the disk of the sun reflects off the moving water and resonates in the hazy atmosphere, allowing it to impart its color to sky, water, and land (to the extent that solid objects are recognizable). By the same token, the "bluishness" mentioned by Zola in the above passage from *L'Oeuvre* and often associated with Monet[30] is certainly applicable to this canvas. Blue characterizes not only the sky and the water, where we would "expect" to find it, but the masts, boats and even shadows, where we might not. In short, there is no "local" color or "proper" color attributed exclusively to given aspects of reality, but "color effects," caused by the light, atmosphere, and neighboring colors.

Furthermore, these two principal colors—orange and blue—are complementary; that is, the primary color (blue) does not enter into the composition of the binary color (orange, formed of yellow and red). Since each color tends to project its complementary into the space surrounding it (especially shadows), the effect is to *intensify* the complementary color already occupying that space and create a visual vibration that enhances the dynamic play of light.[31]

Although the impressionists did not apply color theory as systematically as the some of the "neo-impressionists" (Seurat, Signac, and Pissarro, for example), they were well aware of the notion of color interplay through the writings of the chemists Chevreul, Maxwell, and Rood, the discoveries of the physiologists Young and Helmholz, and the paintings

29. Increasing the value both "lightens" the colors and causes a certain amount of illuminating light to reflect off the surface of the canvas, as noted by Richard Brown: "Hovering over objects in strong illumination, this reflectance contributes very strongly to our realization of the presence of both the envelope of atmosphere around objects and the dominating light source itself" ("Impressionist Technique: Pissarro's Optical Mixture," in *Impressionism in Perspective,* ed. Barbara Ehrlich White [Englewood Cliffs, N.J.: Prentice-Hall, A Spectrum Book, 1978], 118).

30. In fact, Zola's literary disciple and fellow art critic J.-K. Huysmans spoke of the impressionists' "indigomania" in his "L'Exposition des indépendants en 1880," cited in Rewald's *The History of Impressionism,* 441.

31. Another example of color interplay often associated with impressionism is the famous and oft-disputed notion of optical mixture ("mélange optique"), whereby two juxtaposed primaries (say red and blue) will be perceived in combination as their binary (violet). Certainly Monet, tabbed with "indigomania" by Huysmans, has also been accused of "violettomania." See, for example, Oscar Reutersvärd, "The 'Violettomania' of the Impressionists," *Journal of Aesthetics and Art Criticism* 9, no. 2 (December 1950): 106–10.

of, among others, Delacroix, whose juxtaposition of the complementaries red and green was renowned.

Whatever (if any) the theoretical source, whatever the effect (whether intensifying or graying), whatever the mechanism (whether mixing or vibrating), color and light become active entities on the canvases of Claude Monet and the impressionists. Color and light are part of a chain of "causes" (atmosphere, time of day, point of view, etc.); not the least among them is questioning the identity of the very objects of which they had previously been assumed to be merely qualities.

"The causes and effects of light . . ." in Zola's Descriptive Passages

Among the "impressionist" effects at play in Zola's novels, I shall examine the action and interaction of light: (1) with its sources, particularly the sun; (2) with other luminous phenomena, like color; and (3) with the objects of the physical world—before describing the impact of light on the observer in a later section of this chapter (causality).

(1) Sun and sunlight. Many of the major scenes described in the Rougon-Macquart novels take place in the "open air," and Zola took excruciating pains to ensure that his verbal tableaux embodied the elements and innovations of the visual artists he admired. The preparatory notes for the open-air scenes in *L'Oeuvre,* for example, comprise fifty pages of a dossier entitled "Paris," which Zola based on several long walks in April and May of 1885, during which he noted the topography, the reference points furnished by bridges and monuments, and, more than in any other novel, the position of the sun, atmospheric conditions, and the resultant effects of light and color.[32] Indeed, the word *soleil* (sun) occurs 93 times in the novel itself, along with *lumière* (light) and *clarté* (brightness), mentioned 37 and 17 times, respectively.

The sun's progressive rising is drawn out over the entire opening chapter of *Le Ventre de Paris,* where it provides the very organizing principle for the text, governing the gradual emergence of forms (the décor, reality), dictating the characters' movements, and creating space and time.

The sun occasionally symbolizes life in novels such as *La Faute de l'abbé*

32. See Henri Mitterand's description of Zola's preparation for the novel and comparison of it with that of "landscape artists," *R-M,* IV, 1377.

Mouret or *Le Docteur Pascal,* but, as in the following passage from *La Faute,* that value is nonetheless rendered in visual terms:

> Le soleil avait grandi, et les moineaux s'enhardissaient. Pendant que le prêtre lisait . . . le soleil enflammait l'autel, blanchissait les panneaux de faux marbre, mangeait les clartés des deux cierges, dont les courtes mèches ne faisaient plus que deux taches sombres. L'astre triomphant mettait dans sa gloire la croix, les chandeliers, la chasuble, le voile du calice, tout cet or pâlissant sous ses rayons . . . l'astre demeura seul maître de l'église. Il s'était posé à son tour sur la nappe, allumant d'une splendeur la porte du tabernacle, célébrant les fécondités de mai. Une chaleur montait des dalles. Les murailles badigeonnées, la grande Vierge, le grand Christ lui-même, prenaient un frisson de sève, comme si la mort était vaincue par l'éternelle jeunesse de la terre.

> (The sun had risen, and the sparrows grew bolder. While the priest read . . . the sun lit up the altar, whitened the panels of artificial marble, overcame the brightness of the two candles, whose short wicks were no more than two dark spots. The triumphant star cast its radiance on the cross, the chandeliers, the chasuble, the chalice veil, all their gold paling under its rays . . . the star remained sole master of the church. It had landed in turn on the altar cloth, lighting with splendor the tabernacle door, celebrating the fertility of May. A warmth rose from the tiles. The whitewashed walls, the large [statue of the] Virgin, the large Christ itself, shivered with vigor, as if death were vanquished by the eternal youth of nature. 1226)

If the sun becomes master of the church, vainquisher of darkness (death), and a symbol of eternal youth, that value is acquired progressively and visually, as the narrator notes the sun's movement, its luminous effects, its interaction with other luminous entities (candles, chandeliers), its alteration of colors, and its transformational impact on the objects of material reality.

Paragraphs frequently begin, as did the example from *La Faute,* with a notation indicating the sun's position, often coupled with the time of day and the season. The second paragraph in *La Curée* provides another such example:

> Le soleil se couchait dans un ciel d'octobre, d'un gris clair, strié à l'horizon de minces nuages. Un dernier rayon, qui tombait des

massifs lointains de la cascade, enfilait la chaussée, baignant d'une lumière rousse et pâlie la longue suite des voitures devenues immobiles. Les lueurs d'or, les éclairs vifs que jetaient les roues semblaient s'être fixés le long des rechampis jaune paille de la calèche, dont les panneaux gros bleu reflétaient des coins du paysage environnant. Et, plus haut, en plein dans la clarté rousse qui les éclairait par derrière, et qui faisait luire les boutons de cuivre de leurs capotes à demi pliées, retombant du siège, le cocher et le valet de pied, avec leur livrée bleu sombre, leurs culottes mastic et leurs gilets rayés noir et jaune, se tenaient raides, graves et patients.

(The sun was setting in an October sky of light gray, streaked with thin clouds on the horizon. A final ray, falling from the distant banks of the cascade, ran up the road, bathing in pale reddish light the long line of immobilized vehicles. The golden glimmers, the vivid flashes cast by the wheels seemed fixed along the straw yellow ornaments of the carriage, whose large blue panels reflected parts of the surrounding landscape. And higher, right in the reddish light that lit them from behind and that made the copper buttons of their half-folded greatcoats glow, as they hung from the seat, the coachman and footman, with their dark blue livery, their beige pants and their black and yellow striped vests, remained rigid, serious and patient. 319)

Zola begins by noting the sun's position, suggesting the time of day, then the month, the type of sky, and the atmospheric conditions. A luminous entity ("a final ray") is then depicted in terms of its action ("falling"), interaction ("ran up the road"), and effect on objects ("bathing the long line of vehicles"), both in color ("reddish") and value ("pale"). These objects then produce additional effects of reflected light ("the golden glimmers, the vivid flashes"), which are at once active ("cast") and palpable ("fixed"). The process is duplicated by the reddish light acting on the coachman and valet, whose position at the end of the sentence, preceded and dominated by the luminous effects, further reinforces their respective roles in the chain of causes and effects of light that characterizes the scene. Light is seen not as a dependent quality, but as an active entity that transforms reality and achieves a certain autonomy, which is fixed and depicted in terms of another state of matter, liquidity ("bathing").

Indeed, comparisons of light with states of matter occur frequently in Zola's novels, conferring on light the tangible status, the "texture," it appears to attain in impressionist canvases. From the opening pages of

the first novel, *La Fortune,* light is described as liquid: "the moonlight was flowing" (12) and "sheets of blue light were flowing" (25).[33] In *L'Oeuvre,* Zola compares light to a golden liquid: "Et, au travers de la vaste pièce, la nappe de brûlant soleil, tombée des vitres, voyageait, sans être tempérée par le moindre store, coulant ainsi qu'un or liquide sur tous ces débris de meuble dont elle accentuait l'insoucieuse misère" ("And, across the vast room, the sheet of burning sunlight, falling from the windows, traveled, unmitigated by any blinds, flowing like liquid gold on this debris of furniture, accentuating its careless poverty," 23). He also compares light several times to dust (as in "golden dust," 102, 117, 135), and even manages to combine these two tangible qualities of light— liquid and dust—in a double (some might say mixed) metaphor: "cette poussière d'eau" ("this watery dust," 105).

(2) Light and color. The intense activity of light, its interaction with other luminous phenomena, evident throughout, is typified by the short phrase from *Une Page d'amour*—"une flamme jaillit, un rayon tomba" ("a flame shot up, a ray fell," 1029)—where the simultaneous movements upward and downward suggest the pervasiveness of light, its mobility, its power (reinforced by the metaphor "flame"), and its rapidity (suggested by the use of the simple past tense for both verbs). Another example, from *L'Oeuvre*—"une telle poussée de lumière que des traits d'étincelles jaillissaient, partaient d'un bout du ciel à l'autre, visibles, ainsi qu'une volée de flèches d'or" ("such a surge of light that traces of sparks shot forth, went from one end of the sky to the other, visible, like a flight of golden arrows," 104–5)—shows a similar effect of light's intensity ("surge"), mobility ("shot forth, went"), and diffusion ("one end to the other").

Luminosity is also captured by the term *ton,* which Zola uses frequently to characterize the degrees of color intensity, the modulations in power that depend on the "saturation" and "value" of a "hue."[34] In *Le Ventre de Paris,* for example, the narrator speaks of Cadine's bouquets, where "les rouges y dominaient, coupés de tons violents, de bleus, de jaunes, de violets, d'un charme de barbare" ("the reds dominated, cut by violent tones, of blues, yellows, violets, with barbaric charm," 769),

33. The qualities of liquidity ("coulaient") and texture ("nappes") occur frequently, as in "pluie de rayons" (*Une Page,* 834) and "la lumière descendait les gradins en une large nappe rougie" (*Son Excellence Eugène Rougon,* 13).
34. For a discussion of the relationship between saturation, value, and hue, see Jacques Bertin, *Semiology of Graphics,* trans. William J. Berg (Madison: University of Wisconsin Press, 1983), 85.

while Claude describes a delicatessen display with "tous les tons vigou-
reux, le rouge des langues fourrées, le jaune des jambonneaux, le bleu des
rognures de papier, le rose des pièces entamées, le vert des feuilles de
bruyère, surtout le noir des boudins" ("all the vigorous tones, the red of
the stuffed tongues, the yellow of the ham knuckles, the blue of the
scraps of paper, the pink of the cut pieces, the green of the heather leaves,
especially the black of the blood sausages," 800). In both examples the
intensity ("violent," "vigorous") would seem to suggest "pure tones,"
colors that are fully "saturated" so that neither other colors nor dark or
light values are perceptible.[35] In the following example from *Au Bonheur
des Dames,* on the other hand, the word *ton* seems to connote the colors'
value (degree of light and dark): "Une exposition de soies, de satins et de
velours, y épanouissait, dans une gamme souple et vibrante, les tons les
plus délicats des fleurs: au sommet, les velours d'un noir profond, d'un
blanc de lait caillé; plus bas, les satins, les roses, les bleus, aux cassures
vives, se décolorant en pâleurs d'une tendresse infinie" ("An exhibition of
silk, satin, and velvet spread out, in a supple and vibrant range, the most
delicate tones of flowers: at the top, the velvets in deep black, in milky
white; lower, the satins, the pinks, the blues, in lively folds, faded into
paleness with infinite tenderness," 391). The decoloring effect of light,
mentioned by Duranty as an innovation of the impressionists, leads to an
overall paleness or light value, apparent elsewhere in Zola's descriptions.
In *Une Page d'amour,* for example, "l'immense tableau avait une simpli-
cité, deux tons seulement, le bleu pâle de l'air et le reflet doré des toits"
("the immense painting had a [certain] simplicity, only two tones, the
pale blue of the air and the golden reflection of the roofs," 850). Indeed
the reduction in the number of tones is characteristic of Zola, who notes
in the same novel the "uniform tone, the bluish gray of slate" (904) and "a
single tone of gold more and more dazzling" (908; see also *La Terre,* 531).
The single tone, especially at a high value or degree of brightness, is also
characteristic of Monet, the impressionists, and their fictional representa-
tive, Claude Lantier.[36]

35. For a definition of "pure tone," see Bertin, *Semiology,* 85.
36. As André Fontainas, *Histoire de le peinture française au XIXe et au XXe siècles* (Paris:
Mercure de France, 1922), 218, notes: "Les impressionnistes érigèrent en méthode efficace le
procédé empirique, si bien que désormais les parties claires d'un paysage ne furent pas
claires uniquement par rapport à des parties sombres, dont le contraste seul leur assurait le
bénéfice de cette clarté, mais des tableaux tout entiers furent clairs, ensoleillés, chatoyants,
en fête, sans le secours d'aucun artifice, d'aucune opposition si tranchée. Une joie lumineuse
et fraîche s'installa dans l'art, un frémissement de l'air mouvementé, la palpitation unanime
de la vie." Claude Lantier reflects this preference for "la gamme claire de l'école nouvelle"
(*L'Oeuvre,* 184), which comes to characterize his painting and which is described by the

The most striking luminous entity, for Zola, as for other authors, is, of course, color, "this ardent life of colors" (*L'Oeuvre*, 33).[37] Like tonality, coloration is often unified, generalized, reduced to a single hue, as with the bluish effect that accompanies the light value of Lantier's landscapes, as well as those of Zola that we have just examined. Several novels include scenes where the dominant color is white—the spectral combination of all colors perceived as one. The most famous of these is in the final chapter of *Au Bonheur des Dames,* where the description of the white goods displayed in the department store occupies a full thirty pages (768–97). Typical of Zola's color technique is the following passage:

> . . . la grande exposition de blanc prenait une splendeur féerique d'apothéose, sous cet éclairage nouveau. Il sembla que cette colossale débauche de blanc brûlait elle aussi, devenait de la lumière. La chanson du blanc s'envolait dans la blancheur enflammée d'une aurore. Une lueur blanche jaillissait des toiles et des calicots de la galerie Montsigny, pareille à la bande vive qui blanchit le ciel première du côté de l'Orient.

> (. . . the great exhibition of white goods took on an epic splendor, under the new lighting. It seemed as if this colossal debauchery of white were also burning, becoming light. The white song rose up in the ignited whiteness of dawn. A white gleam shot out from the canvas and calico of the Montsigny gallery, like the intense band that first whitens the sky in the east. 796–97)

In seeking to apply marks of the same color, Zola faces a problem that does not confront the painter: the redundancy evident in the literary text, where the words must be repeated over time, unlike spots of color in a

narrator in words much like those of Fontainas: "Certes, il y avait là bien des maladresses, bien des efforts puérils, mais quel joli ton général, quel coup de lumière gris d'argent, fine, diffuse, égayée de tous les reflets dansants du plein air! C'était comme une fenêtre brusquement ouverte dans la vieille cuisine au bitume, dans les jus recuits de la tradition, et le soleil entrait, et les murs riaient de cette matinée de printemps! La note claire de son tableau, ce bleuissement dont on se moquait, éclatait parmi les autres" (130).

37. The use of color is a progressively increasing literary phenomenon that reaches its summit in Zola's works. Georges Matoré ("A propos du vocabulaire des couleurs," *Annales de l'Université de Paris* 28 no. 2 [April–June 1958]: 137–50) has counted 814 color words in *Germinal* (as compared, for example, with 20 in *Manon Lescaut*). Other studies concerning color in *Germinal* are those of Marcel Girard, "L'Univers de *Germinal,*" *Revue des sciences humaines* 69 (January–March 1953): 59–76; Philip Walker, "Zola's Use of Color Imagery in *Germinal,*" *PMLA* 77, no. 4, pt. 1 (September 1962): 442–49; and David Baguley, "Image et symbole: La Tache rouge dans l'oeuvre de Zola," *Cahiers naturalistes,* no. 39 (1970): 36–46.

painting, which, despite their number, are perceived simultaneously. Zola deals with the problem by varying the grammatical form and function of the various words denoting white. He uses both the masculine and feminine forms of the adjective (*"blanc"* and *"blanche"*), two forms of the noun ("white" and "whiteness"), as well as the verb "whiten." He varies the metaphors qualifying white several times in the same sentence ("song . . . ignited . . . dawn"), while he modulates the effects of light accompanying the color white ("lighting . . . light . . . gleam"). As with light, color is active, and Zola achieves further variety in his "brushwork" by varying the type of action conveyed by the verbs ("took on . . . burning . . . becoming . . . rose up . . . shot out . . . whitens"). The variety reaches its apex in the final sentence of the paragraph: "Il n'y avait plus que cet aveuglement, un blanc de lumière où tous les blancs se fondaient, une poussière d'étoiles neigeant dans la clarté blanche" ("There was nothing more than this blinding [effect], a whiteness of light where all the whites melded, stardust snowing in the white brightness," 797). Here the many whites, in the plural, merge to form a single white, rendered by a metaphor combining both singular and plural (*"une poussière d'étoiles"*). Similar resolutions of the problem of literary repetitiveness, all involving the color white, occur in *Le Rêve* (966–67), as well as in the striking snow scenes from *Germinal* (1467), *La Bête humaine* (1162), and *Une Page d'amour,* where the general whiteness takes on the bluish cast noted earlier as typical of Monet, Lantier, and the impressionists: "c'était un bleu livide, très pâle, à peine un reflet bleu dans la blancheur du soleil" ("it was a livid blue, very pale, scarcely a blue reflection in the sun's whiteness," 1091).

Another painterly technique exploited by Zola is that of describing a *gamme,* a range within the same color, where differences in value or combinations with other colors create modulations or nuances of the principal color, thus achieving variety within unity. In *Le Ventre de Paris,* for example,

> les paquets d'épinards, les paquets d'oseille, les bouquets d'artichauts, les entassements de haricots et de pois, les empilements de romaines, liées d'un brin de paille, chantaient toute la gamme du vert, de la laque verte des cosses au gros vert des feuilles; gamme soutenue qui allait en se mourant, jusqu'aux panachures des pieds de céleris et des bottes de poireaux.

> (the packages of spinach, the packages of sorrel, the bouquets of artichokes, the piles of beans and peas, the stacks of romaine lettuce, held together with a piece of straw, sang the entire scale of

green, from the lacquered green of the pods to the deep green of
the leaves; a gradual scale descending to the motley colors of
celery stalks and bundles of leeks. 627; see also 801)

Here the range of greens seems based on value (light to dark) and inten-
sity (weak to strong), combined with texture (fine to coarse). In the
following passage from *La Faute de l'abbé Mouret,* where Serge studies the
different blues in the sky, differences are discernible due to the presence of
other hues within the blue: "ce n'était pas tout du bleu, mais du bleu rose,
du bleu lilas, du bleu jaune" ("it wasn't all blue, but pinkish blue, lilac
blue, yellow blue," 1324). In *La Terre,* a similar modulation of color
combination characterizes Buteau's perception of La Beauce: "chaque
plante prit sa nuance, il distingua de loin le vert jaune du blé, le vert bleu
de l'avoine, le vert gris du seigle" ("each plant had its nuance, he distin-
guished from afar the yellow green of the wheat, the blue green of the
oats, the gray green of the rye," 531).

However, in addition to the unity and modulation of color, Zola's
palette has a special affinity for juxtapositions of colors. In *Une Page
d'amour,* for example, a description of the sky is characterized by contrast-
ing colors: "dans le vaste ciel d'un gris de perle, derrière les brumes qui se
fondaient, le ton d'or du soleil allumait une clarté rose. Une seule bande
de bleu, sur Montmartre, bordait l'horizon d'un bleu si lavé et si tendre,
qu'on aurait dit l'ombre d'un satin blanc" ("in the vast, pearl gray sky,
behind the dissipating mist, the golden tone of the sun lit up a pink
brightness. A single band of blue, over Montmartre, rimmed the horizon
with a blue so diluted and tender that it appeared to be a shadow of white
satin," 1087). Here, in rapid succession, appear the colors gray, gold,
pink, blue, and white, accompanied by effects of the atmosphere, the
sun, tone, light, value ("washed out"), and texture ("satin").

Of the numerous color contrasts to be found in Zola's descriptive
passages, it is the combination of red (or pink) with blue that is the most
recurrent, as in the above example and in the following one, from
L'Oeuvre: "un château du rêve, bleuâtre, léger et tremblant, au milieu des
fumées roses de l'horizon" ("a dream castle, bluish, light and trembling,
amidst the pink mists of the horizon," 101–2; see also 214).[38]

38. See also *Le Docteur Pascal,* 920, and Zola's note in *R-M,* v, 1641. The combination of
red (or pink) and blue is typical of Monet, as the painter himself noted in a letter of 1884 to
the art collector and dealer Durand-Ruel: "cela fera peut-être un peu crier les ennemis du
bleu et du rose, car c'est justement cet éclat, cette lumière féerique que je m'attache à
rendre" (in Lionello Venturi, *Les Archives de l'impressionnisme* [Paris: Durand-Ruel, 1939], i,
273).

The combination of blue and pink can be used to organize entire scenes, as in *Une Page d'amour,* where the left bank is painted in blue, in contrast with the right bank in pink (849; see also 893 and 900). Pink (or red) and blue combine with other colors ("pinkish gray, bluish gray," *L'Assommoir,* 391) and lights ("blue and pink flames," *Le Ventre,* 620; see also 622), and are even "mixed" to produce violet ("the reds, the blues, the violets," *Le Ventre,* 782). In fact, Zola depicts what might be termed a systematic "study" of optical mixture and of its effects on external phenomena in the following passage from *L'Oeuvre* describing Claude's and Christine's many walks along the Seine:

> A chacune de leurs promenades, l'incendie changeait, des fournaises nouvelles ajoutaient leurs brasiers à cette couronne de flammes. Un soir qu'une averse venait de les surprendre, le soleil, reparaissant derrière la pluie, alluma la nuée tout entière, et il n'y eut plus sur leurs têtes que cette poussière d'eau embrasée, qui s'irisait de bleu et de rose. Les jours de ciel pur, au contraire, le soleil, pareil à une boule de feu, descendait majestueusement dans un lac de saphir tranquille; un instant, la coupole noire de l'Institut l'écornait, comme une lune à son déclin; puis, la boule se violaçait, se noyait au fond du lac devenu sanglant. Dès février elle agrandit sa courbe, elle tomba droit dans la Seine, qui semblait bouillonner à l'horizon, sous l'approche de ce fer rouge.

> (With each of their walks, the fire changed, new furnaces added their blazes to this crown of flames. One evening, when a sprinkle surprised them, the sun, reappearing behind the rain, lit up the whole cloud, and above them there was nothing but this blazing watery dust, that glowed with blue and pink. On clear days, however, the sun, like a ball of fire, descended majestically into a calm sapphire lake; for an instant, the black dome of the Institute blocked part of it, like the moon when it's not full; then, the ball grew violet, drowned in the depths of the now bloody lake. From February on its curve increased, it fell straight into the Seine, which seemed to boil on the horizon, at the approach of this burning iron. 104–5)

In this passage Zola initially emphasizes the colors blue and pink; then, as one primary color, red ("ball of fire"), approaches another, blue ("sapphire lake"), their optical mixture produces their binary, violet ("the ball grew violet"). Indeed, the effects are reciprocal, since both the red sun and the blue lake alter their colors in contact with each other, the red sun becoming violet and the blue lake taking on the purple cast of blood. In

fact, Zola's awareness of the interaction of colors is demonstrable, since, in the same novel, Gagnière postulates the theory of complementary colors—"Le rouge du drapeau s'eteint et jaunit parce qu'il se détache sur le bleu du ciel, dont la couleur complémentaire, l'orangé, se combine avec le bleu" ("The red of the flag fades and yellows because it stands out against the blue of the sky, whose complementary color, orange, combines with the blue," 191)—while Claude's later work displays a similar effect—"un rouge se transformant en un jaune près d'un bleu" ("a red transforming into a yellow in proximity with a blue," 248).

Whatever the specific effect he seeks, Zola often captures the impact of color linguistically by the extensive use of the nominal form—in the opening chapter of *Le Ventre de Paris,* for example, as Florent wanders through the Halles: "On ne voyait encore, dans la clarté brusque et tournante des lanternes, que l'épanouissement charnu d'un paquet d'artichauts, les verts délicats des salades, le corail rose des carottes, l'ivoire mat des navets; et ces éclairs de couleurs intenses filaient le long des tas, avec les lanternes" ("One could still see, in the harsh, turning light of the lanterns, only the fleshy spread of a package of artichokes, the delicate greens of the lettuces, the pink coral of the carrots, the flat ivory of the turnips; and these flashes of intense colors were moving along the piles, with the lanterns," 614; see also 622). To capture the intensity of the colors Zola promotes them grammatically (from adjective to noun) and syntactically (from after the object, where a color adjective appears in French, to before the object). He can then modify the colors, not the objects, with adjectives suggesting value ("delicate") or texture ("flat"), qualities that characterize the colors more than the objects with which those colors might be affiliated. In a sense, the color, the quality, detaches itself from the object and dominates it as the focal point of the experience, a technique often associated with literary impressionism[39] and which will be analyzed further as an example of synecdoche (part for whole) in the following chapter. Thus, when Zola utilizes the nominal form to highlight effects of light and color, it is not to divorce them from the objects of material reality, but, on the contrary, to stress their power, impact, and dominance. In exploring the interaction of luminous entities (sun, light, color), Zola also seeks to underscore their influence on material objects, their transformative effect on the physical milieu.

39. See, for example, Charles Bally, "Impressionnisme et grammaire," in *Mélanges Bernard Bouvier* (Geneva: Sonor, 1920), 261–79; Beverley Gibbs, "Impressionism as a Literary Movement," *Modern Language Journal* 36, no. 4 (April 1952): 175–83; and Helmut Hatzfeld, *Literature Through Art: A New Approach to French Literature* (New York: Oxford University Press, 1952), esp. 173.

(3) Transformation.[40] The sun can transfigure the appearance of objects to the point of suggesting a change in state, from solid to liquid, as in *La Curée:* "Le soleil, haut sur l'horizon, coulait, emplissait d'une poussière d'or les creux des feuillages, allumait les branches hautes, changeait cet océan de feuilles en un océan de lumière" ("The sun, high on the horizon, was flowing, filling the openings in the greenery with golden dust, lighting the top branches, changing this sea of leaves into an ocean of light," 592).

Transformation by coloration is particularly noticeable; it may even be said that in Zola's descriptive passages objects have no definitive, local, or proper color, but assume that imparted by their surroundings. Indeed, the narrator confirms Claude's opinion that objects have no fixed color: "il en tirait cette conclusion vraie, que les objets n'ont pas de couleur fixe, qu'ils se colorent suivant les circonstances ambiantes" ("he drew this true conclusion that objects have no fixed color, that they assume their colors according to ambiant circumstances," *L'Oeuvre,* 248). This principle is further demonstrated in numerous passages; Claude says of Christine, for example: "tu es toute grise, ce matin. Et l'autre jour, tu étais rose" ("you're completely gray this morning. And the other day you were pink," 241; see also 103, 113, 138, and 233).

Similar effects are noted throughout *Les Rougon-Macquart.* In *Une Page d'amour,* the dome of the Invalides, usually seen as golden, becomes "completely pink" (853), while elsewhere "the trees turned red" (834). In *La Conquête de Plassans,* the black garment of the abbé Faujas becomes "completely red" (907), while in *Son Excellence Eugène Rougon,* red vests are transformed into violet through the effect of green light: "ces hautes flammes vertes dansaient en l'air, comme flottantes et suspendues, tachant la nuit sans l'éclairer, ne tirant du noir que la double rangée des gilets écarlates qu'elles rendaient violâtres" ("these high green flames danced in the air, as if floating and suspended, dotting the night without lighting it, only pulling out of the black the double row of scarlet vests that they turned into violet," 183).

The transformations brought on by changes in light and atmosphere were studied systematically by the impressionists—especially by Monet in his series paintings of the 1890s, which feature repeated views under varying conditions of the Rouen cathedral, poplars, and haystacks, among other motifs.[41] Zola undertakes the same type of experiment as

40. For a thorough study of the various types of transformation of Paris throughout Zola's novels, see Stefan Max, *Les Métamorphoses de la grande ville dans "Les Rougon-Macquart"* (Paris: Nizet, 1966).

41. See especially Paul H. Tucker, *Monet in the '90s: The Series Paintings* (Boston: Museum of Fine Arts; and New Haven: Yale University Press), 1989.

early as the 1870s (as evidenced by the five long descriptions of Paris under different conditions of light and atmosphere terminating each section of *Une Page d'amour*), and as late as the late 1880s (as we see in the different tableaux of La Beauce opening parts I, III, IV, and V of *La Terre;* see 367, 531, 564, 608, 709, and 1575).

However, changes in light and atmosphere are not always confined to separate passages, but are often brought together, juxtaposed, to stress their transformative effects. In *Le Ventre de Paris,* the young Claude Lantier's sensitivity to "the same horizon offering itself continuously under different conditions" (781) is echoed by Florent's fascination with the everchanging vista seen from his elevated vantage point overlooking the Halles: "A chaque heure, les jeux de lumière changeaient ainsi les profils des Halles, depuis les bleuissements du matin et les ombres noires de midi, jusqu'à l'incendie du soleil couchant, s'éteignant dans la cendre grise du crépuscule" ("With each hour, the play of light thus changed the profiles of the Halles, from the bluishness of the morning and the black shadows of midday to the flames of the setting sun, extinguished in the gray cinders of twilight," 730). This play of light in turn creates emotive effects on him (as it does for Hélène in *Une Page d'amour*): "Et lui, à chaque aspect de cet horizon changeant, s'abandonnait à des songeries tendres ou cruelles" ("And, with each aspect of this changing horizon, he succumbed to daydreams [ranging from] tender to cruel," 867). Serge and Albine in *La Faute de l'abbé Mouret,* experience a similar pleasure (with their own particular brand of sensuality) in watching the sky: "il les ravissait à toutes les minutes de la journée, changeant comme une chair vivante, plus blanc au matin qu'une fille à son lever, doré à midi d'un désir de fécondité, pâmé le soir dans la lassitude heureuse des tendresses" ("it delighted them at every moment of the day, changing like living flesh, whiter in the morning than a waking girl, golden at noon with a desire of fertility, swooning in the evening with the happy weariness of its tenderness," 1391; see also 1484).

The older Claude Lantier (of *L'Oeuvre*) becomes obsessed with the transformative effects of light (caused by variations in time and atmosphere) on the Cité, the site of his ultimate "masterpiece":

A toutes les heures, par tous les temps, la Cité se leva devant lui, entre les deux trouées du fleuve. Sous une tombée de neige tardive, il la vit fourée d'hermine, au-dessus de l'eau couleur de boue, se détachant sur un ciel d'ardoise claire. Il la vit aux premiers soleils, s'essuyer de l'hiver, retrouver une enfance, avec les pousses vertes des grands arbres du terre-plein. Il la vit, un jour de fin brouillard, se reculer, s'évaporer, légère et tremblante comme un

palais des songes. . . . D'autres fois encore, quand le soleil se
brisait en poussière parmi les vapeurs de la Seine, elle baignait au
fond de cette clarté diffuse, sans une ombre, également éclairée
partout, d'une délicatesse charmante de bijou taillé en plein or fin.

(At all hours, in all weather, the Cité rose before him, between the
two branches of the river. Under a late snowfall, he saw her clad in
ermine, above the mud-colored water, standing out on a clear slate
sky. He saw her on the first sunny days, shaking off winter, redis-
covering youth, with the green buds of the large trees on the
terrace. He saw her, on a fine foggy day, retreat, evaporate, light
and trembling like a dream palace. . . . Still other times, when the
sunlight broke up into dust in the mist of the Seine, she bathed in
the depths of this diffuse brightness, without a shadow, lit equally
all over, with the charming delicacy of a jewel set in fine gold. 231)

The ultimate impressionist effect (i.e., the cumulative effect of light
and color on the objects of physical reality) is the reduction of the de-
picted object's status as a material entity. As Ruth Moser concludes, "In
the end, there is in impressionist painting no more line, almost no more
shape, no more volume, no more matter. There is only the image of a
world stripped of weight and consistency, vibrating in an intense and
dazzling light."[42] Moser's description certainly suits a painting like
Monet's *Impression: Sunrise,* and, indeed, it applies to many of the exam-
ples from Zola's novels that we have examined in this section—but does
it fit the main lines of Zola's descriptive passages, or even their overall
impact?

Naturalism: From Detail to Definition

Zola's affiliations with the visual arts, whether concerning his techniques
or his manner of seeing, are by no means limited to impressionist charac-
teristics. On the contrary, his descriptive passages ultimately embody a
sense of solidity and materiality achieved by an insistence on (1) the
precise detail of specific objects, rendered through (2) line and form, as
well as through (3) contrasts in values (particularly light and shadow).

42. "A la fin, il n'y a dans la peinture impressionniste plue de ligne, presque plus de
forme, plus de volume, plus de matière. Il n'y a plus que l'image d'un monde privé de poids
et de consistance, vibrant dans une lumière intense et éblouissante." *L'Impressionnisme fran-
çais,* 74.

(1) Detail. In preparing his descriptive passages, Zola frequently notes the importance of detail, as in the following example from the notes for *L'Oeuvre:* "beaucoup de netteté dans les détails" ("a great deal of clarity in the details," 1459).[43] The reader will also recall from the discussion of viewpoint, that the character's "impressionist" vision is often supplemented by the narrator's perception of detail, conveyed especially through the pronoun *on,* as in the opening scene from *L'Oeuvre:* "on vit le grand air triste des antiques façades, avec des détails très nets" ("one saw the sadly grand air of the old façades, with very clear details," 11; see also 13, 213, 214, etc.).[44] Again, in *La Bête humaine,* the narrator observes a morning sky where "l'horizon entier devenait rose, d'une netteté vive de détails, dans cet air pur d'un beau matin d'hiver" ("the entire horizon became pink, with a striking clarity of details, in the pure air of this beautiful winter morning," 1058). Monet and the impressionists, on the other hand, usually sacrificed precise detail to overall impression, as a quick glance at *Impression: Sunrise* amply illustrates.

(2) Line. Line, also downplayed in impressionism, as Moser notes above, figures frequently in Zola's descriptions, as in *La Fortune des Rougon,* where "the moon cut out clearly the lines of the wall" (194; see also 28 and 153). In *La Curée,* two islands "aligned the theatrical lines of their fir trees against the pale sky" (322), while in *La Débâcle,* "Sedan stood out with its geometric lines" (583).

The use of line gives a strong quality of "design" to Zola's tableaux, often captured by the verb *dessiner* (to draw)—"other sparks drew a double line" (*Une Page d'amour,* 969)[45]—or by that verb coupled with a reference to those visual art forms where line and design are paramount—in *La Fortune des Rougon,* for example: "Au milieu de l'aire, sur un morceau du sol gris et nu, les tréteaux des scieurs de long se dessinaient allongés, étroits, bizarres, pareils à une monstrueuse figure géométrique tracée à l'encre sur du papier" ("In the middle of the lot, on a piece of naked, gray land, the sawyers' trestles were drawn, lengthened, narrow, bizarre, like a monstrous geometric figure traced on paper with ink," 10). Here the clearly drawn lines lead to the perception of forms comparable to those of drawings. In *Le Ventre de Paris,* it is Florent, the would-be revolutionary, not Claude, the

43. Patrick Brady finds that the importance of detail and the strength of line in *L'Oeuvre* are precisely the qualities that separate Zola from the impressionists and link him with "naturalist painters" like Courbet and Manet. See *"L'Oeuvre" de Emile Zola: Roman sur les arts, manifeste, autobiographie, roman à clef* (Geneva: Droz, 1967), 353–61.

44. For further examples, see the discussion in Chapter 3, pages 143–45.

45. See also *La Fortune,* 156; *La Faute,* 1320, 1363; *Une Page,* 952, 953, 954, 973; *Nana,* 1325; *La Bête,* 1050; and *La Terre,* 438.

young painter, who observes a scene in the following terms: "Il se plaisait aussi le soir, aux beaux couchers de soleil qui découpaient en noir les fines dentelles des Halles, sur les lueurs rouges du ciel . . . c'était comme un transparent lumineux et dépoli, où se dessinaient les arêtes minces des piliers, les courbes élégantes des charpentes, les figures géométriques des toitures. Il s'emplissait les yeux de cette immense épure lavée à l'encre de Chine" ("He also liked evening, with its beautiful sunsets that silhouetted the fine lacework of the Halles against the red glow of the sky . . . it was like a luminous, tarnished transparency, where the sharp edges of the pillars, the elegant curves of the framework, the geometric lines of the rooftops were drawn. He filled his eyes with this immense drawing washed in India ink," 730). Again, the definition of lines leads to a perception of geometrical shapes that elicits a comparison with an art form where line and design, not color and light, predominate. In *Une Page d'amour,* even distant forms, often transformed by the gradients of light, color, and atmosphere, display the solidity of the Japanese print, noted for its design qualities: "les lointains eux-mêmes prenaient une netteté d'image japonaise" ("the background itself took on the clarity of a Japanese print," 1088).

(3) Contrast. Zola's descriptive techniques differ most sharply from those of impressionism, however, in the frequency with which they insist on a vivid contrast between values, usually rendered through a strong juxtaposition of light and shadow. Whereas the impressionists often attempted to create an effect of extreme luminosity by eliminating shadow, dark colors, and heavy tones from their canvases, Zola's descriptions are distinguished by their frequent use of these very effects. In the following passage from *L'Oeuvre,* for example, the novelist Sandoz, not the painter Claude, sees the entire scene in terms of its oppositions:

> En effet, sous le ciel gris de cette matinée de novembre, dans le frisson pénétrant de la bise, les tombes basses, chargées de guirlandes et de couronnes de perles, prenaient des tons très fins, d'une délicatesse charmante. Il y en avait de toutes blanches, il y en avait de toutes noires, selon les perles; et cette opposition luisait doucement, au milieu de la verdure pâlie des arbres nains.

> (In effect, under the gray sky of this November morning, in the penetrating shiver of the breeze, the low tombs, loaded with garlands and crowns of beads, took on very fine tones, charming in their delicacy. Some were completely white, some were completely black, depending on the beads; and this contrast was glowing softly, amidst the pale greenery of the dwarf trees. 357)

Numerous examples of contrasts in value characterize the descriptive passages of *Les Rougon-Macquart,* such as "a black mass against the whiteness of a pillar" (*La Conquête,* 1063) and "the brightness . . . pierced the shadow with a train of intense sparks" (*Son Excellence Eugène Rougon,* 85).

The contrast between light and shadow becomes the ordering principle for entire chapters. Such is the case for the first chapter of the first novel in the series, *La Fortune des Rougon,* where expressions like "white and black, in light and shadow" (10) and "alive with shadows and lights" (25) echo throughout the opening scene. The same is true for part IV, chapter VII of *Germinal,* where Etienne's speech to the striking miners in the forest is marked by the progress of the moon, leading to the stark contrast between the crowd and Etienne: "Lorsque la foule, encore dans l'ombre, l'aperçut ainsi, blanc de lumière, distribuant la fortune des ses mains ouvertes, elle applaudit de nouveau, d'un battement prolongé" ("When the crowd, still in the shadows, saw him that way, white with light, distributing money with his open hands, it clapped again, with prolonged applause," 1379).

Zola's perception of value, unlike that of the impressionists, often derives from a contrast with other values, which lends his descriptive passages a large measure of their overall sense of solidity. Specific objects, perceived in terms of their value, need the background of other objects from which they can detach and define themselves. The following scene, mediated through the eyes of Sandoz in the last pages of *L'Oeuvre,* is particularly revealing and contains many of the nonimpressionist traits that abound in Zola's descriptions:

> Le pente gazonnée montait, et des lignes géométriques se détachaient en noir sur le gris du ciel, les poteaux télégraphiques reliés par les minces fils, une guérite de surveillant, la plaque d'un signal, la seule tache rouge et vibrante. Quand le train roula, avec son fracas de tonnerre, on distingua nettement, comme sur un transparent d'ombres chinoises, les découpures des wagons, jusqu'aux gens assis dans les trous clairs des fenêtres. Et la ligne redevint nette, un simple trait à l'encre coupant l'horizon.

> (The grassy slope rose, and geometric lines stood out in black against the gray of the sky, the telegraph poles joined by thin wires, a guard's hut, a signal plate, the lone mark, red and vibrating. When the train moved, with its thundery noise, one could distinguish clearly, as on a Chinese shadowgram, the silhouettes of the cars, even the passengers seated in the light holes of the

windows. And the line became straight again, a simple stroke of
ink cutting the horizon. 361)

Here again a contrast in values (black against gray) leads to more specific
definition ("stood out" and "silhouettes"), followed by the perception of
a clear line, expressed in terms of two art forms, a shadowgram and an
ink drawing, neither typical of impressionism.

This visual process of definition by contrast sometimes involves the
horizontal plane, the juxtaposition of objects or elements side by side, as
in "the moon, very light, cut out the shadows clearly" (*La Faute*, 1444) or
"between this bright border and this dark border, the spangled Seine was
glowing" (*L'Oeuvre*, 102). Definition can also occur on a vertical plane,
as certain phenomena detach themselves from others by moving upward,
as in "the dark rocks, here and there, made islands, spits of land, emerg-
ing from the luminous sea" (*La Fortune*, 249) or "higher up, domes and
steeples ripped through the fog" (*Une Page d'amour*, 846). The two types
of contrast can be represented graphically (Diagram 16).

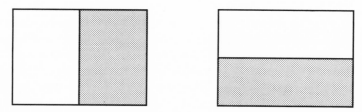

Diagram 16.

However, in Zola's descriptive passages, the most common source of
contrast is depth, the third dimension, where an object defines itself
against a background, from which it detaches itself (Diagram 17). The
verbs *découper* and *se découper* (cut out, outline) are particularly suited for
depicting this sense of contrasting planes, of relief, as in the following

Diagram 17.

example from *L'Oeuvre:* "les grandes ombres se découpaient bizarrement contre les murs peints en gris" ("the large shadows were cut out bizarrely against the gray-painted walls," 15).[46] However, it is especially the verbs *détacher* and *se détacher* (detach, stand out) that capture this visual process of definition in depth and represent it verbally, as in the initial description of Miette in *La Fortune:* "sa tête . . . se détachait vigoureusement sur la muraille blanchie par la lune" ("her head . . . stood out vigorously against the wall whitened by the moon," 15). Throughout the pages of *Les Rougon-Macquart,* a multitude of objects, characters, and scenes surge forth from a hazy, vague, or dark background: "The Halles stood out in black against the auburn mist of the sky" (*Le Ventre,* 865); "the Emperor stood out in black against the blaze" (*Eugène Rougon,* 102); "the Panthéon stood out against the sky" (*Une Page,* 908); "the line stood out in black on a red cloud" (*La Débâcle,* 486).[47] These occurrences mark an aspect of Zola's vision pointed out by J. H. Matthews, that "Zola's eye notes a color bursting forth against a neutral background,"[48] although, as seen in the above examples, it is perhaps more often that the neutral object defines itself against a background of color. In either case, this visual process of definition by contrast marks a salient and significant characteristic of Zola's style.

In all of the above examples, from those involving detail and line to those involving design and definition, the object is represented, not merely as a hazy impression formed amorphously by color, light, and atmosphere, but as a well-defined, solid, material entity. It is, of course, this latter conception of reality that generally characterizes Zola's work[49] and that of the painters he most admired, including Manet, Cézanne, and Degas.[50] Indeed, Zola lends several of these nonimpressionist traits to the painter Claude Lantier—"J'en fais naturellement un naturaliste" ("Naturally I'll

46. See also 12, 211, 300, 318; *Le Ventre,* 730; *La Faute,* 1285, 1369; *L'Assommoir,* 422, 482; *La Joie,* 816; *Le Rêve,* 872, 922–23; *Une Page,* 1085; *Germinal,* 1376, 1491; *La Bête,* 1019, 1189; and *La Débâcle,* 687.

47. The verb *se détacher,* signaling visual definition, occurs with great frequency in Zola's novels. See, for example, *L'Assommoir,* 732; *Une Page,* 846, 850, 954, 1084; *Nana,* 1099, 1221, 1398; *Au Bonheur,* 627; *La Joie,* 980; *Germinal,* 1161; *L'Oeuvre,* 92, 139, 205, 231, 299, 323–24, 327, 340, 361; *La Terre,* 438, 459; *Le Rêve,* 863, 905, 922; *La Bête,* 1037, 1057, 1133, 1147, 1319; and *L'Argent,* 361.

48. "l'oeil de Zola note la couleur qui éclate sur un fond neutre," *Les Deux Zola: Science et personnalité dans l'expression* (Geneva: Droz, 1957), 66.

49. See, for example, Pool, *Impressionism,* 72; Elliott Grant, *Emile Zola* (New York: Twayne, TWAS, 1966), 129; and Antoinette Jagmetti, *"La Bête humaine" d'Emile Zola* (Geneva: Droz, 1955), 13.

50. The latter had, in fact, expressed his intent as follows: "I should like to restore to every subject its weight and volume, and not only paint the appearance" (in Pool, *Impressionism,* 72).

make him a naturalist")[51]—who does not, for example, abandon line and design, and even admires the work of their archproponent, Ingres, whose "drawing was like thunder and damnation" (*L'Oeuvre*, 45). Claude also displays a solidity of composition not necessarily true of the impressionists as Zola understood them: "Quelques études, incomplètes, mais d'une notation charmante dans la vigueur de leur facture, furent sauvées du couteau à palette et pendues aux murs de la salle à manger" ("A few studies, incomplete, but charming in notation and vigorous in construction, were saved from the palette knife and hung on the dining room walls," *L'Oeuvre*, 154).[52]

The combination of impressionist features (light and color) and naturalist traits (line and composition) that defines Claude's canvases is precisely what characterizes Zola's descriptive passages. Zola is at once an impressionist and a naturalist; his novels reflect both modes of vision. In some instances, light and line coexist simultaneously in space—side by side, one atop the other, or interposed in depth.[53] In other cases, far more frequent, light and line are components, even stages, of the dynamic, dialectical process that constitutes visual perception. Their relationship is not only spatial, but temporal.

Focusing: From Impressionism to Naturalism

The following passage from *L'Oeuvre*, describing Claude's and Christine's walks along the Seine, is a lengthy but laden example of the fusion

51. No. 10.316, fol. 276, N.A.F., B.N.

52. Patrick Brady, the premier analyst of Claude as painter, finds in him these same "caractéristiques non-impressionnistes—facture solide, emploi du noir et des contrastes fortement marqués" ("*L'Oeuvre*" de Emile Zola, 293). Henri Mitterand, who quotes Brady at length, sums up Brady's view, to which I also subscribe: "Il faut souligner, au-delà de tout rapprochement, que la peinture de Claude Lantier, si elle retient les éléments caractéristiques de l'Impressionnisme (le plein air, la décomposition de la lumière, la clarté des couleurs), n'est pas conçue par Zola comme une pure et simple transposition des toiles impressionnistes, telles que Monet par exemple peut en fournir le type. Dans la mesure même où Claude est inspiré de Cézanne et de Manet, il est normal que les plans et les structures de ses toiles soient plus fortement marquées et contrastées que ceux d'une toile d'académisme—La lecture des *Salons* montre d'ailleurs, que Zola savait distinguer les traits originaux de Manet—qu'il préférait entre tous—de Monet et de Cézanne, pour ne citer que ces trois peintres, de même qu'il savait opposer les talents neufs à l'exploitation des procédés traditionnels" (*R-M*, IV, 1457).

53. Perhaps their coexistence involves two types of perception, as suggested in Rudolf Arnheim's description of the relationship between line and form: "Broadly speaking, in color vision action issues from the object and affects the person; but for the perception of shape the organizing mind goes out to the object" (*Art and Visual Perception*, rev. ed. [Berkeley and Los Angeles: University of California Press, 1974], 336).

of impressionist effects (light, color, atmosphere, transformation) and naturalist traits (line, contrasts, definition, composition) that characterizes Zola's descriptive passages:

> D'un bout à l'autre, le soleil oblique chauffait d'une poussière d'or les maisons de la rive droite; tandis que la rive gauche, les îles, les édifices se découpaient en une ligne noire, sur la gloire enflammée du couchant. Entre cette marge éclatante et cette marge sombre, la Seine pailletée luisait, coupée des barres minces de ses ponts, les cinq arches du pont Notre-Dame sous l'arche unique du pont d'Arcole, puis le pont au Change, puis le Pont-Neuf, de plus en plus fins, montrant chacun, au-delà de son ombre, un vif coup de lumière, une eau de satin bleu, blanchissant dans un reflet de miroir; et, pendant que les découpures crépusculaires de gauche se terminaient par la silhouette des tours pointues du Palais de Justice, charbonnées durement sur le vide, une courbe molle s'arrondissait à droite dans la clarté, si allongée et si perdue, que le pavillon de Flore, tout là-bas, qui s'avançait comme une citadelle, à l'extrême pointe, semblait un château du rêve, bleuâtre, léger et tremblant, au milieu des fumées roses de l'horizon. Mais eux, baignés de soleil sous les platanes sans feuilles, détournaient les yeux de cet éblouissement. . . . puis, à mesure qu'ils avançaient, d'autres quais sortaient de la brume, très loin, le quai Voltaire, le quai Malaquais, la coupole de l'Institut, le bâtiment carré de la Monnaie, une longue barre grise de façades dont on ne distinguait même pas les fenêtres, un promontoire de toitures que les poteries des cheminées faisaient ressembler à une falaise rocheuse, s'enfonçant au milieu d'une mer phosphorescente. En face, au contraire, le pavillon de Flore sortait du rêve, se solidifiait dans la flambée dernière de l'astre.

(From one end to the other, the oblique sun warmed the houses on the right bank with golden dust; while the left bank, the islands, the buildings were outlined in black against the flaming halo of the setting sun. Between this bright border and this dark border, the spangled Seine was glowing, cut by the thin strokes of its bridges, the five arches of the Notre-Dame bridge below the single arch of the Arcole bridge, then the Change bridge, then the Pont-Neuf, progressively thinner, each showing, beyond its shadow, an intense burst of light, blue satin water, whitening in a mirrorlike reflection; and, while the twilight cutouts on the left ended up with the silhouette of the pointed towers of the Palace of Justice, drawn strongly in charcoal against the void, a soft curve was

rounding to the right in the brightness, so lengthened and lost that
the pavillon de Flore, very distant, which was advancing like a
citadel, at the far tip, seemed like a dream castle, bluish, light and
trembling, amidst the pink mists of the horizon. But, bathed in
sunlight under the leafless plane trees, they averted their eyes from
this dazzling sight. . . . then, as they advanced, other quais
emerged from the fog, far away, the quai Voltaire, the quai
Malaquais, the dome of the Institute, the square building of the
Monnaie, a long gray stroke of façades whose windows one
couldn't even distinguish, a promontory of rooftops that the chim-
ney pottery transformed into a rocky cliff, sinking into the middle
of a phosphorescent sea. Opposite, on the other hand, the pavillon
de Flore was emerging from the dream, was solidifying in the
final blaze of the sun. 102–3)

The entire scene is obviously constructed according to the opposition of
light and shadow, which is referred to frequently and which gives the
passage its strength and solidity of composition. Zola's use of stark con-
trast is evident in the juxtapositions of "a black line" and "flaming halo,"
"this bright border" and "this dark border," "shadow" and "intense burst
of light," "whitening" and "silhouette," and finally "charcoal" and
"brightness." In short, space is organized by contrasts in light and value.

Less evident, perhaps, yet ultimately more imporant in Zola's effort to
go beyond impressionism toward the solidity and definition inherent in
naturalism, is the use of time in this passage. The eye analyzes the numer-
ous steps in the act of seeing and passes beyond the sensation, or general
impression (hastily sketched in the early moments of this scene), to arrive
eventually at a more solid perception of specific, precisely defined, well-
focused objects.

In accordance with his understanding of the order of sensation, Zola
first notes the angle of the sun, next the sun's light, and then the objects
struck by that light (especially the houses on the right bank). At this point
in perception, the objects are still quite general and expressed in the plural
(houses, islands, buildings), and, in fact, they merge into one overall line.
These objects begin to define themselves against the background of light
provided by the sun, and, between the contrasting banks, several specific
objects, primarily the bridges that constitute known reference points,
begin to emerge from the backdrop of the Seine. Finally, as the process of
definition continues ("twilight cutouts"), the buildings and monuments
mentioned generally become specific objects ("the pointed towers of the
Palace of Justice"), again through contrast in depth ("drawn strongly in
charcoal against the void"). At this moment, these objects, although

identified specifically, can hardly be called well defined and solid (the pavillon de Flore, in particular, is transformed into a dream castle through "impressionist" effects of light, color, and atmosphere). However, through movement in space ("they advanced") and time ("then"), a novelistic advantage that Zola can claim over painting, the scene accumulates more and more specific details and objects (particularly the quais and the Institute dome) until, finally, the pavillon de Flore is rescued from its hazy, dreamy appearance and receives the weight and volume ("was solidifying")—again by contrast with a background of light ("in the final blaze of the sun")—that ultimately characterizes Zola's perception and representation of reality.

By exploiting the temporal advantages of his medium, Zola exceeds what might be termed an "impression" (the transformation of the pavillon de Flore into a dream castle)—especially since the metamorphosis is triggered by effects of light and color—and identifies the solid, material status he found this object to possess in reality. His use of time, therefore, and of the temporal sequence he found in the very act of seeing, allows him to identify the luminous shimmering effects of color and value that characterize impressionism, and yet advance beyond that impression to the solidity and the definition of specific objects that distinguishes naturalism from the art of Monet and his followers.

Zola's conscious use of temporal sequence to structure his descriptive passages is evident throughout his preparatory notes, as demonstrated by the following example from the dossier for *Germinal*:

> Comme distribution de la description, il ne faut d'abord qu'une masse presque informe, une vision fantastique de la fosse aperçue dans la nuit. Les quelques lanternes accrochées aux tréteaux, la porte des générateurs, les trois ou quatre fenêtres éclairées, et surtout les feux du terri. Etienne monte sur le terri et là trouve Bonnemort. Leur conversation s'engage. Bonnemort lui nomme le Voreux. Et reprise de la description précisée, les choses sortant du rêve . . . ce qu'on voit du haut du terri, les forges lointaines, Montsou caché dans la nuit. Le vieux désigne les lieux du doigt, dans le noir.

> (For distribution of the description, initially one only needs an almost amorphous mass, a fantastic vision of the mine perceived in the night. The few lanterns attached to the trestles, the generator door, the three or four lit windows, and especially the fires on the slag heap. Etienne walks up there and finds Bonnemort. Their conversation begins. Bonnemort names the Voreux for him. And

return to the description in more precision, things emerging from
the dream . . . what one sees from atop the slag heap, the distant
forges, Montsou hidden in the night. The old man points out the
places in the darkness.)[54]

Here we find this same technique whereby Zola represents the initial
impression ("an almost amorphous mass") and yet, through his use of
elapsed time, goes beyond this hazy, ill-defined state ("things emerging
from the dream") to achieve a more precise description and a sharper
focus on individual objects. This temporal process of visual perception
does, in fact, constitute the ordering principle for the opening scene in
Germinal (see 1133–35). Etienne is struck first by lights ("he saw red
lights," "the lights reappeared near him, though he understood nothing
more"), then by masses ("a heavy mass; a flattened pile"), then by forms
("the silhouette," "profiles"), which generate images ("this fantastic appa-
rition") and metaphors ("smoky moons"), before he finally situates him-
self ("then the man recognized a mine")—which is only identified several
pages later ("the Voreux, at present, emerged from the dream"), when
Etienne begins to recognize precise details and shapes ("Etienne . . . lo-
cated each part of the mine"). In fact, the process of description extends
over the entire first part of *Germinal,* some six chapters, because it is only
in the final pages of part I that Etienne is able to firm up the definition of
the mine and rectify previous impressions. As Etienne, pondering
whether to stay in Montsou, looks out the door of Rasseneur's café, he
completes the description of the mine with a broader view of its surround-
ings: "Mais autour des bâtiments le carreau s'étendait, et il ne se
l'imaginait pas si large, changé en un lac d'encre par les vagues montantes
du stock de charbon . . . et ce qui le surprenait surtout, c'était un canal, la
rivière de la Scarpe canalisée, qu'il n'avait pas vu dans la nuit" ("But
around the buildings the pavement stretched out, and he hadn't imagined
it so wide, changed into an inky lake by the rising waves of the coal
stock . . . and what surprised him most was a canal, the channeled
Scarpe river, which he hadn't seen in the night," 1192–93). For Zola,
description is ultimately a temporal matter. The milieu, the mine, defines
itself through the visual process; space is generated by time.

 This dynamic technique, so widespread in Zola's work that it becomes
perhaps the major organizing principle of his descriptive passages, is by
no means confined to his construction of extended scenes and whole
sections of a novel. Zola orders his paragraphs and even his sentences to
capture first the general impression, governed by color and light, then

54. In *R-M,* III, 1855.

more precise detail and specific objects. The same syntax of solidification, definition, and description over time, involving many of the same terms as in the above examples from *L'Oeuvre* and *Germinal,* occurs in *Le Ventre de Paris,* again in the opening chapter: "Et Florent regardait les grandes Halles sortir de l'ombre, sortir du rêve, où il les avait vues, allongeant à l'infini leurs palais à jour. Elles se solidifiaient, d'un gris verdâtre, plus géantes encore, avec leur mâture prodigieuse, supportant les nappes sans fin de leurs toits" ("And Florent watched the large Halles emerge from the shadows, emerge from the dream, where he had seen them, extending their open-work palaces infinitely. They were solidifying, with a greenish gray, even more gigantic with their prodigious mastwork, supporting the endless sheets of their roofs," 626).[55]

In its most extreme form, this process of definition and focusing becomes a matter of recognition and identification of visual phenomena that were previously shapeless and nameless, as in the following passage from *L'Oeuvre:*

> Claude resta un moment immobile. L'ombre avait envahi l'atelier, une ombre violâtre qui pleuvait de la baie vitrée en un mélancolique crépuscule, noyant les choses. Il ne voyait plus nettement le parquet, où les meubles, les toiles, tout ce qui traînait vaguement, semblait se fondre, comme dans l'eau dormante d'une mare. Mais assise au bord du divan, se détachait une forme sombre, raidie par l'attente, anxieuse et désespérée an milieu de cette agonie du jour. C'était Christine, il l'avait reconnue.

> (Claude remained motionless for a moment. Darkness had invaded the studio, a violetlike darkness that rained from the bay window in a melancholy twilight, drowning things. He could no longer clearly see the floor, where the furniture, the canvasses, everything lying around vaguely, seemed to liquify, as in the stagnant water of a pond. But seated on the edge of the sofa, a dark form was standing out, stiffened by waiting, anxious and distraught amidst this death of daylight. It was Christine, he had recognized her. 139)

55. Strictly similar scenes are found in *Le Rêve* ("Peu à peu, en effet, le Clos-Marie sortait de l'obscurité. . . . Ce qui venait du rêve finit par prendre l'ombre d'un corps," 871) and in *Une Page d'amour* ("Paris se dégageait des fumées, s'élargissait avec ses champs de neige, sa débâcle qui le figeait dans une immobilité de mort. . . . Les maisons sortaient toutes noires des masses blanches où elles dormaient, comme moisies par des siècles d'humidité. . . . Mais, à mesure que la bande bleue grandissait du côté de Montmartre, une lumière coulait, limpide et froide comme une eau de source, mettant Paris sous une glace où les lointains eux-mêmes prenaient une netteté d'image japonaise," 1088).

Claude notices first the overall impression, the violet darkness whose color has penetrated the entire scene, rendering even the most prominent object no more than a vague shape whose only recognizable quality is its dark value. But the form begins, near the end of the paragraph, to define itself ("was standing out") in more physical detail ("stiffened") and emotive impact ("anxious and distraught") until finally, in the last sentence, Claude is able to recognize and identify the form as Christine. Zola thus uses the suggestion and vague nuance of the impressionists as only a step in a dynamic process eventually leading to detailed recognition, which more nearly suits the naturalist's aims of materiality and solidity.[56]

Amorphous masses take shape, then name, in numerous examples throughout *Les Rougon-Macquart.* In *L'Assommoir,* when Gervaise visits Goujet's machine shop: "De larges ombres flottaient. Et il y avait par moments des masses noires passant devant le feu, bouchant cette dernière tache de clarté, des hommes" ("Large shadows were floating. And at times there were black masses passing before the fire, blocking out this last spot of light, men," 528). In the opening scene from *Le Ventre de Paris,* Mme François, from her wagon, "s'était penchée, elle avait aperçu, à droite, presque sous les pieds du cheval, une masse noire qui barrait la route. . . . C'était un homme" ("had leaned over, she had perceived, on the right, almost under the horse's hoofs, a black mass blocking the road. . . . It was a man," 604). That man turns out to be Florent, whose eventual importance is portended, as is that of the mine in *Germinal,* by the progressive presentation.[57] Later in *Germinal,* Etienne and Catherine, lost in the mine, "virent une masse géante, blanchâtre, sortir de l'ombre et lutter pour les rejoindre, entre les boisages trop étroits, où elle s'écrasait. C'était Bataille" ("saw a large mass, whitish, emerge from the darkness and struggle to join them, between the too narrow wooden beams, where it was crushed. It was Bataille," 1564). Here a shapeless form, identifiable only by its vague color, emerges from obscurity and is finally identified. Zola puts the identification into a separate sentence (in fact a separate paragraph) to further emphasize the dissection of the perceptual act into its stages.

The syntax of individual sentences often displays the same process of

56. For identical examples of this process, in *L'Oeuvre* alone, see 90, 126, 270, 286, 293, and 358.

57. In *La Fortune des Rougon,* Rougon perceives "une forme noire qu'il reconnut pour être sa femme" (222). For additional scenes involving the emergence of forms, then detail, from shadows, see *La Fortune,* 17, 26, 222; *La Curée,* 596; *Le Ventre,* 894; *Une Page,* 995; *Nana,* 1329, 1235; *Au Bonheur des Dames,* 417, 434, 685; *Germinal,* 1173, 1472, 1567; *L'Oeuvre,* 82; *La Terre,* 420; *Le Rêve,* 815; *La Bête,* 1024; *L'Argent,* 14; and *La Débâcle,* 419, 883.

progressive focusing, as Zola postpones the appearance of the object in order to explore its effects or the impressions it produces. In the following sentence from *La Débâcle,* for example—"elle resta stupéfaite, en apercevant, étendue sur la chaise longue, son amie en larmes, bouleversée par une émotion extraordinaire" ("she remained stupefied, at seeing, lying on the chaise longue, her friend in tears, overwhelmed by an extraordinary emotion," 851)—the reader is first given the effect (stupefaction), then a situation ("lying on the chaise longue"), before arriving at the object ("her friend"), which is in turn qualified by an effect ("in tears") preceding its cause, an "extraordinary emotion," whose specific cause is not yet given.

This postponement of identification and deferral of cause is a hallmark of Zola's style on all levels and characterizes another form of sentence structure, identifiable in the following example from *L'Oeuvre:* "Mais ce qui tenait le centre de l'immense tableau, ce qui montait du fleuve, se haussait, occupait le ciel, c'était la Cité" ("But what was holding the center of the immense painting, what was coming out of the Seine, was rising, was occupying the sky, it was the Cité," 213). Here the repeated use of the impersonal pronoun structure *ce qui* (what) avoids the use of a specific antecedent, allowing Zola to explore aspects of position, composition, and movement, before identifying the object in question—the Cité.[58]

Finally, traces of Zola's progressive style can be detected in even the smallest of linguistic units, as in the following adjectival phrase coupled with a relative clause, "peuplé de points noirs, qui étaient des hommes" ("populated with black dots, which were men," *L'Oeuvre,* 75). Here Zola gives first the impression, based on form ("dots") and value ("black"), then the identification, rather than the reverse order, as he occasionally does, as in similar examples from *La Curée*—"des promeneurs attardés, des groupes de points noirs" ("lingering walkers, groups of black dots," 329)—and *Une Page d'amour*—"elle distinguait les passants, une foule active de points noirs" ("she distinguished the passersby, an active crowd of black dots," 851). This latter option mirrors traditional French sentence structure, where the cause or source normally precedes the effect or quality.[59] Another example, again involving "black dots," occurs in *Son Excellence Eugène Rougon:* "le pont Louis-Philippe s'animait d'un

58. The same impersonal structure, promoting the deferral of identity and cause, occurs with great frequency in Zola's novels. In *L'Oeuvre* alone see also 12, 19, 21, 176, 245, 298, 305, 314, 325, and 331.

59. See the discussion of traditional versus sensorial sentence structure among the authors of Zola's generation in the Conclusion of this book.

grouillement de points noirs" ("the Louis-Philippe bridge bustled with a swarming of black dots," 86). Here the impression remains vague and undefined, befitting, perhaps, the bustle and visual confusion of what is surely a crowd scene, much as Monet's figures in *Boulevard des Capucines* remain "black tongue-lickings," according to the critic Louis Leroy.[60] It is, however, the first example of "black dots," the phrase from *L'Oeuvre,* which is truest to Zola's manner: the impression is given initially, at the stage where it occurs in vision, then is rectified by the more detailed perception, as with the temporal ordering that underlies visual perception. Temporal order is, in short, the main organizing principle of Zola's descriptions, whatever the length of the linguistic or literary unit.

The impressionists, on the other hand, often attempted to minimize the sense of temporal sequence in their work in order to emphasize the transitory, fleeting qualities of reality, more specifically those of light. The hasty *ébauche* and the unfinished sketches that Zola found characteristic of the impressionists were hardly due to sloppiness on their part, but to a conscious program that sometimes involved eliminating manifestations of temporality from their art. Monet, in particular, struggled against the changes wrought by time in an effort to portray the momentary effects of light and color on a landscape. One of his American friends recounted of him: "He told me that in one of his 'Peupliers' the effect lasted only seven minutes, or until the sunlight left a certain leaf, when he took out the next canvas and worked on that. He always insisted on the great importance of a painter noticing when the effect changed, so as to get a true impression of a certain aspect of nature and not a composite picture, as too many paintings were, and are. He admitted that it was difficult to stop in time because one got carried away, and then added: 'J'ai cette force-là, c'est la seule force que j'ai!' "[61]

Monet's goal has been described as an attempt to achieve "the fleeting momentary impression—the visual equivalent of Bergson's *instantané,*"[62] and he wrote to his friend Gustave Geffroy in 1890: "I am working at a desperately slow pace, but the further I go, the more I see that I have to work a lot in order to manage to convey what I am seeking: 'instantaneity', above all, the envelopment, the same light spread over everywhere."[63]

60. Leroy's review, "L'Exposition des impressionnistes," is reprinted in Rewald's *The History of Impressionism,* 318–24.

61. Lilla Cabot Perry, "Reminiscences of Claude Monet from 1889 to 1909," *The American Magazine of Art* 17 (March 1927): 119–25, in *Impressionism and Post-Impressionism,* ed. Linda Nochlin, 36.

62. Nochlin, ibid., 29.

63. From Geffroy's *Claude Monet: Sa vie, son temps, son oeuvre* (Paris: Les Editions G. Crès et Cie., 1922), 188–89, in *Impressionism and Post-Impressionism,* ed. Linda Nochlin, 34.

His denial of the temporal sequence and his insistence on the instantaneous enabled Monet to emphasize the luminous and colored effects of reality at the expense of the more solid and palpable aspects of external phenomena that ultimately characterize Zola's perception and representation of reality.[64]

Henri Mitterand asserts that Zola's notes for *L'Oeuvre* have an instantaneous quality that makes them highly "impressionistic," a quality he does not find in the finished text, polished as it is by "rhetoric" and "écriture artiste."[65] While it is quite true that the pages in Zola's finished novels are more rigid and solid than the notes from which they were constructed, this is more than a question of stylistic polishing. In fact, it is precisely Zola's goal to construct, through a text "meditated at length," the solid and material aspects of reality that coexist with the fleeting and transitory. Indeed, it was the solidity of construction, form, volume, and matter in Manet's work that ultimately led Zola to prefer him to the impressionists and to attempt to incorporate these same qualities in the painting of Claude Lantier. It is hardly surprising, then, that Zola denies (or, rather, rectifies) the instantaneous and spontaneous impression, which he saw as working against the very principles of naturalism and materialism.

Zola did feel that there was a moment, in the act of seeing, when the eye perceives only an amorphous mass of light, a patch of color or value, and he felt that the impressionists had made great strides in representing scientifically the light effects governing that moment. But it was only a moment, only a step in the visual act, an instant of raw sensation that the creative eye must transform into a complete perception of reality—solid and well defined. Zola saw that the task of naturalism was to recognize this momentary impression, since it was scientifically "true," and then focus it, through a dynamic representation of the temporal sequence in the visual act, into a more solid and detailed perception of reality. In order to portray the light-governed impression and still retain sharpness of

64. It would be a gross oversimplification, however, to claim that author and painter simply succumbed to the destiny prescribed by their respective media: temporality on the one hand, instantaneity on the other. Above all, the impressionists' struggle for instantaneity should not be understood as a denial of time, an attempt to negate or arrest movement, an affirmation of the permanent, eternal, static moment. The impressionist "instant" embodies time in two important ways: 1) externally, as an implied part of the temporal continuum, whose trails are often traceable within the canvas and which makes of it an emblem of the contingent, the fleeting, the transitory; and 2) internally, as an example of dynamic interplay and mobility. The impressionist image is a "snapshot," which is "snapped" precisely because things move and change so rapidly; it is not a composite, not an album, not a montage, nor even a time-lapse.

65. In *R-M,* IV, 1349.

detail and line, he called upon the distinctive property inherent in
literature—the ability to represent time—and it is ultimately the depic-
tion of the temporal sequence he found to constitute the visual act that
separates Zola from the impressionists and restores to his passages, para-
graphs, and sentences the full strength of matter that characterizes his
vision of reality.

The Visual Act: From Impression to Identification

In addition to using the process of progressive definition to lend solidity
and identity to his objects, Zola achieved, by representing this temporal
sequence, what he felt was a scientifically accurate analysis of the visual act.
While attention was focused on the status of the *object* in the preceding
section of this chapter and on the *observer* in the chapters on looking and
viewpoint, here the focus is on *observation,* on the act of seeing, on visual
perception.

As we recall from the Introduction, for Zola and some present-day
psychologists, vision may be described as a three-part process, composed
of observation (looking), sensation (input), and perception (definition
and identification). In the Rougon-Macquart novels, an astonishing num-
ber of passages detail all three steps of the perceptual process, with a clear
insistence on the appropriate visual term distinguishing each step and on
its precise position within the entire sequence. The following example
from *La Fortune des Rougon* depicts Silvère being watched by tante Dide,
"qui le regardait alors dans les yeux, comme prise d'inquiétude à les voir
si clairs et si profonds d'une joie qu'elle croyait reconnaître" ("who
looked into his eyes, as if stricken by fear in seeing them so clear and deep
with a joy that she thought she recognized," 186). Here the steps of
looking (*regardait*), seeing (*voir*), and perceiving (*reconnaître*) are marked
with the appropriate perception verb and presented in the order of their
occurrence, which then becomes the organizing principle of the sentence.
The same visual syntax prevails in the following passage from *Le Ventre
de Paris:* "Comme il levait les yeux, il aperçut le cadran lumineux de
Saint-Eustache, avec la masse grise de l'église. Cela l'étonna profondé-
ment. Il était à la pointe Saint-Eustache" ("As he raised his eyes, he
perceived the luminous face of Saint-Eustache, with the gray mass of the
church. That astounded him deeply. He was at the Saint-Eustache point,"
609). Again looking ("he raised his eyes") is followed by seeing ("he
perceived"), a stage characterized by sensations and impressions ("lumi-
nous . . . gray mass") as well as by definition ("the church"), before

identification and recognition occur ("he was at the Saint-Eustache point"), provoking a reaction of astonishment on Florent's part.

In the following passage from *L'Oeuvre*—"Et, l'ayant regardée à ce moment, il la vit qui éclatait d'un joli rire. C'était l'échappée joueuse d'une grande fille encore gamine" ("And, having watched her at that moment, he saw her burst out in lovely laughter. It was the joyous escape of a still girlish young woman," 23)—first Claude looks, then sees, and finally is able to identify the phenomenon before him. In another example, also from *L'Oeuvre*—"et il promenait ses yeux, encore troubles de sommeil, quand il aperçut, à motié caché par le paravent, un paquet de jupes. Ah! oui, cette fille, il se souvenait!" ("and he was casting his eyes about, still full of sleep, when he perceived, half-hidden by the screen, a pile of skirts. Ah! yes, that girl, he remembered!" 18)—Zola again breaks down the visual act into observation, perception, and recognition, which depends on memory ("he remembered"), while representing these stages in what he felt to be their temporal order.

Strictly similar structures recur throughout Zola's descriptive passages, as evidenced by the following examples from *Germinal*—"Pendant qu'Etienne se débattait ainsi, ses yeux qui erraient sur la plaine immense, peu à peu l'aperçurent. . . . Devant lui, il retrouvait bien le Voreux" ("While Etienne debated with himself, his eyes straying across the vast plain, little by little he perceived it. . . . Before him, indeed he recognized the Voreux," 1192)—and from *La Débâcle*—"En levant les yeux Jean lut sur une plaque: Avenue de la Sous-Préfecture. Au bout il y avait un monument dans un jardin. Et, au coin de l'avenue, il aperçut un cavalier, un chasseur d'Afrique, qu'il crut reconnaître. N'était-ce pas Prosper" ("In raising his eyes Jean read on a sign: Avenue de la Sous-Préfecture. At the end there was a monument in a garden. And, at the corner of the avenue, he perceived a horseman, from the Africa Cavalry, whom he thought he recognized. Wasn't it Prosper," 544).[66] What for some authors might be depicted as an instantaneous visual event is represented as a process with three distinct steps—looking, seeing, recognizing—each embodying its own particular traits.

Furthermore, Zola often explores the dynamics of each particular step in the visual process. Step one, observation, for example, is the area where both watching (the theme of *le regard*) and viewpoint are applicable. Zola uses a variety of perception verbs to trace the processes of visual scanning—"les regards remontaient . . . revenaient . . . s'arrêtaient" ("the eyes rose . . . returned . . . stopped," *Germinal*, 1193)—

66. See also *L'Assommoir*, 376–77; *Une Page*, 802, 811; *L'Oeuvre*, 126–27; *La Terre*, 420; and *La Débâcle*, 697.

accommodation—"Puis, ses yeux s'habituèrent. . . . Déjà, elle s'orientait, cherchait sur le buffet les allumettes, dans un coin où elle se souvenait de les avoir vues" ("Then, her eyes adjusted. . . . Already, she was orienting herself, was looking for the matches on the buffet, in a corner where she remembered having seen them," *La Bête humaine*, 1189)—or discovery—"elle rouvrit les yeux, elle s'approcha, se regarda, s'examina" ("she reopened her eyes, approached, looked at herself, examined herself," *La Curée*, 576).

Step two, the stage of input and sensation, is perhaps the most dynamic, and the one most frequently explored by Zola, since this is the stage where the tension between light and line occurs; where the process of temporal focusing takes place; where the hazy impression begins to define itself before becoming the solid, identified object of perception. This is, in fact, the stage just examined in the previous section of this chapter.

Perception itself, step three, is also seen by Zola as dynamic, since identification invariably involves the intervention of memory. In *L'Oeuvre*, for example, Claude scans the scene of the second Salon: "Enfin, à force de se hausser sur la pointe des pieds, il aperçut la merveille, il reconnut le sujet, d'après ce qu'on lui en avait dit. C'était le tableau de Fagerolles" ("Finally, by standing on tiptoes, he perceived the marvel, he recognized the subject, based on what he had already heard about it. It was Fagerolles's painting," 286). Here perception occurs through recognition and memory ("what he had heard") before leading to identification ("It was"), highlighted in a separate sentence. In an example from *La Débâcle*—"brusquement, à quatre cents mètres devant eux, ils aperçurent une dizaine d'hommes, vêtus d'uniformes sombres, sortant d'un petit bois. C'étaient enfin des Prussiens, dont ils reconnaissaient les casques à pointe" ("abruptly, four hundred meters in front of them, they perceived some ten men, wearing dark uniforms. Finally, it was the Prussians, whose pointed helmets he recognized," 603)—the stage of observation is suggested by the viewpoint ("four hundred meters"), which in turn yields to seeing ("they perceived") a series of impressions ("some ten men, wearing dark uniforms"), which are then identified as Prussians through the intervention of memory ("they recognized"). The process of visual identification—which most authors would ignore, take for granted, compress (in order to arrive at the object of perception), or convert (by promoting that object to grammatical subject)—is stretched out and dissected by Zola to the point that it becomes the organizing principle, indeed, the very topic of the text. Observer and object are subordinated to the process of observation.

Even when vision fails, when perception does not occur, Zola points

that out and pinpoints the stage at which the failure takes place. A block at stage one, not looking, obviously eliminates perception entirely, but one can also look without seeing. In *L'Oeuvre*, for example, as Christine escapes from the storm to Claude's room, Zola writes: "Elle entra, regarda sans voir. . . . Elle ne reconnut rien" ("She entered, looked without seeing. . . . She recognized nothing," 15). Here all three steps are present, although the block at step two ("without seeing") obviously prohibits recognition as well. Zola nonetheless insists on the obvious in order to highlight perception, albeit aborted, and locate the stage of a breakdown in the visual system.[67] In other cases, both looking and seeing can be completed but fail to produce recognition, as in *Une Page d'amour*—"en levant la tête, elle aperçut Zépherin . . . elle ne l'avait pas sans doute reconnu tout de suite" ("in raising her head, she perceived Zépherin . . . no doubt she hadn't recognized him immediately," 860; see also *La Curée*, 576).

However, the visual steps most often lead to the final stage of recognition, even though that process may be halting and extended over a considerable amount of time, as in the scene where Saccard discovers Renée with Maxime and begins to understand, through perception of a series of details, that she has signed a paper of substantial benefit to his financial future:

> Alors Saccard . . . jeta un coup d'oeil rapide autour de lui . . . il aperçut l'acte de cession. . . . Il regarda l'acte, regarda les coupables. Puis se penchant, il vit que l'acte était signé. Ses yeux allèrent de l'encrier ouvert à la plume encore humide. . . . Il regarda encore sa femme et son fils. . . . Puis il plia lentement l'acte, le mit dans la poche de son habit. Ses joues étaient devenues toutes pâles.
>
> (Then Saccard . . . cast a rapid glance around him . . . he perceived the transfer document. . . . He looked at the document, looked at the guilty [lovers]. Then leaning over, he saw that the document was signed. His eyes roamed from the open inkwell to the still moist pen. . . . He looked again at his wife and his son. . . . Then he slowly folded the document, put it in the pocket of his coat. His cheeks had become pale. 571)

The entire scene (only portions of which are given here) takes place over two paragraphs, thirteen sentences, punctuated, linked, indeed structured, by the perception verbs.

67. See also *La Faute*, 1320, 1329, 1330, 1334; *L'Argent*, 342; and *La Débâcle*, 606.

It is clear, then, that the strict chronological sequence, the temporal and sensorial order of events that Zola found in the visual act, characterizes the presentation of events in his descriptive passages. Often, however, this order is not merely temporal, but causal as well, so that visual events become necessarily linked over time.

Vision and Causality

Zola's analysis of visual perception often leads him to examine the role of vision in the causal sequence by which thought and feeling are determined by external reality. Zola frequently uses verbs of perception in sentences where transitive structure along with causal conjunctions and prepositions link seeing to material phonomena (especially light effects), on the one hand, and to thinking and feeling, on the other, thus illustrating concretely, by the use of vision in a mediative role, his materialist premise that man is determined by his milieu. In effect, Zola establishes a determinist equation that we can represent graphically (Diagram 18).

light → object → seeing: seeing → feeling ∴ objects → feeling
(i.e., stimulus) → (action) → (reaction) ∴ (stimulus → reaction)
(i.e., external) → (mediative) → (internal) ∴ (external → internal)

Diagram 18.

Seeing is causally determined by certain light effects in many of Zola's passages. In the opening scene from *L'Oeuvre,* for example, where Claude and Christine are beleaguered by the storm, this determinism is illustrated in several instances: "la réverbération alluma les vitres des hautes fenêtres sans persiennes, on vit le grand air triste des antiques façades" ("the reverberation lit up the panes of the high blindless windows, one saw the sadly grand air of the old façades," 11); "à la brusque lueur d'un second éclair, il aperçut une grande jeune fille" ("in the harsh light of a second flash, he perceived a tall young woman," 11); "à la clarté vague du bec de gaz scellé au coin de la rue de la Femme-sans-Tête, il la voyait ruisseler, la robe collée à la peau" ("in the vague light of the gaslamp on the corner of the rue de la Femme-sans-Tête, he saw her dripping, her dress stuck to her skin," 13). In the initial example, the juxtaposition of clauses—the first involving light ("lit up") in the form of a transitive verb acting on objects ("the panes"), the second, seeing ("one saw")—implies a causal link, tightened by the use of causal prepositional

phrases in the next examples ("in the harsh light," "in the vague light") and rendered explicit several pages later when Christine speaks of "ces éclairs tout bleus, tout rouges, qui me montraient des choses à faire trembler!" ("these blue and red flashes that showed me such frightening things!" 26). Here Zola constructs a causal syntax, where light ("flashes") is the subject of a transitive verb ("showed"), which acts on material reality in the form of a direct object ("things") and on the observer as indirect object ("me"), provoking an emotional reaction ("frightening"). In all of the above examples, chosen from a passage rather typical of Zola's style, physical phenomena, particularly light, are causally linked to visual perception.

The next step in the determinist equation is to causally link the act of seeing to feeling and thinking, and this is another common trait of Zola's style. Borrowing again from *L'Oeuvre,* we note a deluge of sentences linking vision to emotion, thought, and action, and Zola achieves this causal connection through a variety of grammatical structures. He often makes the object of perception the subject of his sentence, by converting the visual action (*voir:* "see") into a nominal form (*la vue:* "seeing" or "sight"), as in "une pareille vue arracha une exclamation à Claude" ("such a sight drew an exclamation from Claude," 310; see also 66, 93, 101, and 132). In this sentence, the temporal sequence—vision preceding reaction—further contributes to the sense of determinism, an effect that Zola also achieves by making a clause involving vision the subject of a sentence, as in "ce qu'elle vit la bouleversa, la planta sur le carreau, pieds nus, dans une telle surprise, qu'elle n'osa d'abord se montrer" ("what she saw overwhelmed her, stopped her dead in her tracks, barefooted, so surprised that at first she didn't dare show herself," 342; see also 19 and 314).

All of these sentences insist on a causal relationship that most authors would treat as either redundant or uninteresting and that, in any case, few authors would bother to represent so explicitly and consistently as Zola. He further emphasizes the link between what is seen and what is felt or thought by his causal use of temporal conjunctions such as *quand* or *lorsque* ("when") in passages such as the following from *L'Oeuvre:* "Et, quand il constata que tout se trouvait rangé, très propre, la cuvette, la serviette, le savon, il s'emporta" ("And, when he confirmed that everything was in order, very clean, the basin, the towel, the soap, he got mad," 32).[68] Zola also uses the gerundive *en* followed by the present participle to reinforce the relationship between vision and thought, as in

68. In *L'Oeuvre* alone, see also 73, 125, 137, 166, 173, 253, 268, 279, 295, 338, 353, and 361.

"une pitié lui serra le coeur, en le voyant si las" ("pity gripped his heart, at seeing him so weary," 306) and "à ce moment, Dubuche, ayant jeté un coup d'oeil sur Gaston, s'affola, en remarquant que la couverture avait glissé et que les jambes de l'enfant se trouvaient découvertes" ("at that moment, Dubuche, having cast a glance at Gaston, panicked, in noticing that the cover had slipped and that the child's legs were uncovered," 316).[69] Causality is also captured by numerous phrases where human reactions are tied to perception verbs by prepositions, as in "désespéré de voir" ("distraught at seeing," 60) and "la honte d'être vu" ("the shame in being seen," 100).[70] Often Zola merely places his perception verbs in such close contact with the thoughts and feelings of his characters that the reader makes the causal connection the novelist wants to suggest, as in "Claude le regardait, étonné de le retrouver si vieux" ("Claude watched him, astounded at finding him so old," 315) and "Claude, qui regardait et écoutait, sentit alors la tristesse lui noyer le coeur" ("Claude, who watched and listened, then felt sadness drown his heart," 292).[71] Chapter 2 contains numerous examples where vision itself is the cause of characters' reactions, such as "s'il la regardait, elle croyait se sentir déshabiller par son regard" (" if he looked at her, she felt herself undressed by his gaze," 113) and "le peintre . . . lui jeta des coups d'oeil qui la sabraient des épaules aux genoux" ("the painter . . . cast glances her way that cut her from the shoulders to the knees," 240). Zola often doubles this effect, as in "elle-même le regardait avec un sourire gêné, quand elle le voyait n'emporter ni toile ni couleurs" ("she herself looked at him with an embarrassed smile, when she saw he was taking neither canvas nor colors with him," 147), where looking ("looked at him") is the result of a visual cause ("she saw"), which also produces an emotive effect ("an embarrassed smile").[72]

69. See also 219, 229, 238, 289, 301, 304, and 312.
70. See also 64, 85, 98, 138, 144, 174, 214, 223, 224, 246, 263, 279, 286, 332, and 333.
71. See also 98, 170, 183, and 352.
72. See also 289. While the density of such examples of visual causality is no doubt slightly greater in *L'Oeuvre*—due to the presence of the artist Claude Lantier and the thematic importance of vision and loss of vision—examples abound in all of Zola's novels. The perception of others' looking causes reactions in the following two examples from *Une Page d'amour:* "Quand il aperçut ce regard . . . il murmura" (804) and "quand il vit que tout le monde le regardait en souriant, il s'arrêtait; et, de ses yeux bleus étonnés, il examinait Jeanne" (819; see also 810). Separate visual causes, highlighted by two perception verbs, combine to produce a single effect in an example from *Au Bonheur des Dames:* "Quand il la vit sourire, au fond du grand salon, et qu'il aperçut deux autres dames prêtant l'oreille, il s'égaya le premier de ses phrases" (450–51; see also 417). Other instances of visual causality involve the same variety of grammatical forms as those described in the examples from *L'Oeuvre.* Vision can be represented by a nominal form followed by a transitive verb and

In short, Zola illustrates the influence of the milieu on human thought, feeling, and behavior by having vision (causally linked to the physical world of the object, often through light, on the one hand, and to the mental world of the observer, on the other) assume the place of mediation between matter and mind that he felt it to hold in human perceptual experience.

As noted throughout this chapter, causality operates in several areas of description, from the "causes and effects of light," which act upon other luminous entities, to the effect of light on the appearance of objects, to the effect of objects on observers. Causality is transmitted through the visual process, itself characterized by a series of steps that are related not just temporally, but causally. Zola sees all phenomena as parts of a vast causal chain, which might be reduced and expressed graphically (Diagram 19). The process is complicated by the fact that any element within a given level (external, mediative, internal) can affect any other element on its own level and any process on the subsequent level. The diagram is, of course, nothing more (nor less) that the representation of determinism on the most concrete level of optical perception.

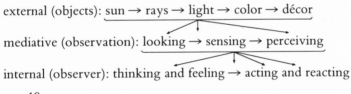

external (objects): sun → rays → light → color → décor

mediative (observation): looking → sensing → perceiving

internal (observer): thinking and feeling → acting and reacting

Diagram 19.

In one sense, the notion of determinism has a broad meaning (well documented by critics and by Zola himself), expressed by Taine's formula of "race, moment, et milieu," which might be modified in Zola's case to "heredity, history, and environment."[73] Certainly Gervaise (in *L'Assommoir*) and her son Etienne (in *Germinal*) are victims of their hereditary tendency to drink alcohol, brought out by accidents and reinforced by the poverty of their working-class milieu, itself perpetuated by the

direct object—"la vue les clouait d'admiration et d'envie" (*La Curée*, 332)—subordinate clauses introduced by temporal-causal conjunctions—"lorsqu'il la vit . . . il se radoucit" (*La Conquête de Plassans*, 985)—or by the gerundive *en*, followed by a present participle— "Gervaise devint toute pâle en reconnaissant" (*L'Assommoir*, 604).

73. For a recent discussion of the modes and levels of determinism operative in Zola's novels, see William J. Berg and Laurey K. Martin, *Emile Zola Revisited* (Boston: G. K. Hall, Twayne's World Authors Series, 1992).

policies of the Second Empire. In a broad sense, Jeanlin (in *Germinal*) is also a victim of heredity and milieu (in his case, the mine): "avec son museau, ses yeux verts, ses grandes oreilles, dans sa dégénérescence d'avorton à l'intelligence obscure et d'une ruse de sauvage, lentement repris par l'animalité ancienne. La mine, qui l'avait fait, venait de l'achever, en lui cassant les jambes" ("with his muzzle, his green eyes, his big ears, in his degeneration as a puny specimen with the obscure intelligence and the trickery of a savage, slowly recaptured by his animal heritage. The mine, which had made him, had just finished him off, by breaking his legs," 1370). Claude Lantier in *L'Oeuvre* is "determined" by the collusion of numerous forces, such as Paris (202), work (262), and heredity (245), not to mention money and art—"les défaites de l'argent étaient donc aussi lourdes que celles de l'art" ("thus economic defeats were as telling as artistic ones," 315)—history—"il a éte la victime d'une époque" ("he was the victim of an era," 357)—and especially himself–"elle le voyait se dévorer lui-même" ("she saw him devouring himself," 244–45).[74] All of the above examples can be characterized as ultimate causes or final causes, and, while they depict powerful forces at play, they do so at a somewhat abstract and remote level, which is not the only one on which causality operates in the theory of determinism.

Determinism also (perhaps especially) involves immediate causes ("*causes prochaines*"), whose incidence and influence Zola, after Claude Bernard, seeks to track:

> Il y a un déterminisme absolu dans les conditions d'existence des phénomènes naturels, aussi bien pour les corps vivants que pour les corps bruts. Il [Bernard] appelle 'déterminisme' la cause qui détermine l'apparition des phénomènes. Cette cause prochaine, comme il la nomme, n'est rien autre chose que la condition physique et matérielle de l'existence ou de la manifestation des phénomènes. Le but de la méthode expérimentale, le terme de toute recherche scientifique, est donc identique pour les corps vivants et pour les corps bruts: il consiste à trouver les relations qui rattachent un phénomène quelconque à sa cause prochaine, ou autrement dit, à déterminer les conditions nécessaires à la manifestation de ce phénomène.
>
> (There is an absolute determinism in the existential conditions of natural phenomena, for living bodies as well as for inert bodies.

74. For similar use of "se dévorer" as sign of self-destruction, see also 207; *Germinal*, 1520, 1583; *La Bête*, 1327, 1330; *L'Argent*, 262; and *La Débâcle*, 887.

He [Bernard] calls 'determinism' the cause that determines the appearance of phenomena. This immediate cause, as he terms it, is nothing other than the physical and material condition of the existence or manifestation of phenomena. The goal of the experimental method, the objective of all scientific research, is thus identical for living bodies and inert bodies: it consists of finding the relations that link a given phenomenon to its immediate cause, or stated otherwise, in determining the conditions necessary for the manifestation of this phenomenon. *Le Roman expérimental,* 13)

Determining these immediate causes is essentially a matter of vision, of direct observation, as Hippolyte Taine, whose "humble disciple" Zola declares himself to be, notes in the Preface to *De l'intelligence:* ". . . psychology becomes a science of facts; because our knowledge amounts to facts; one can speak with precision and in detail of a sensation, an idea, a memory, a vision, just as [one can] of a vibration, a physical movement; in both cases, it's a fact that emerges; one can reproduce it, observe it, describe it."[75] Taine finds also that the explanation of these facts depends on the observer's ability to analyze them into distinct elements and then distinguish the order in which these elements combine: "To explain one of these actions is to break down its elements, show their order, define the conditions of their occurrence and their combination."[76] In examples cited in Chapter 1 of this book Taine illustrates this breaking down of actions into a visual sequence by describing the painters of his time. It is clear from our discussion of Zola's descriptive passages that the analysis of the visual components of reality and of the visual act itself, in order to uncover the causal chains operative in human experience, is a primary characteristic of Zola's style.

Determinism is embedded in vision and embodied in linguistic representation, as Zola acknowledges explicitly on numerous occasions. He suggests of modern style that it is basically an attempt to capture the impact of sensation, contending that "l'évolution moderne, en matière de style, cet enrichissement considérable de la langue, ce flot d'images nouvelles, cette couleur et je dirai cette odeur introduites dans la phrase" ("the

75. ". . . la psychologie devient une science de faits; car ce sont des faits que nos connaissances; on peut parler avec précision et détails d'une sensation, d'une idée, d'un souvenir, d'une prévision, aussi bien que d'une vibration, d'un mouvement physique; dans l'un comme dans l'autre cas, c'est un fait qui surgit; on peut le reproduire, l'observer, le décrire." *De l'intelligence,* 8th ed. (Paris: Hachette, 1897), I, 1–2.

76. "Expliquer une de ces actions, c'est en démêler les éléments, montrer leur ordre, fixer les conditions de leur naissance et de leur combinaison." Ibid., II, 6.

modern evolution, when it comes to style, [is] this considerable enrich-
ment of language, this wave of new images, this color and I'd say this
odor introduced into the sentence," *Le Roman expérimental,* 268). He
asserts that his respect for the Goncourts derives in large measure from
their ability to capture the initial impact of the sensation: "Tous leurs
efforts tendent à faire de la phrase comme l'image instantanée de leur
sensation. Rendre ce qu'ils sentent, et le rendre avec le frémissement, le
premier heurt de la vision, violà leur but" ("All their efforts tend to make
of the sentence the instantaneous image of their sensation. Render what
they feel, and render it with the quiver, the first shock of vision, that's
their goal," *Romanciers naturalistes,* 160). Zola finds that the representation
of events in the order of their perception is essential to style as well as to
scientific accuracy:

> Le romancier analyste, debout et attentif, note les plus minces dé-
> tails. Il se produit sous ses yeux une suite de faits qu'il enregistre
> avec soin . . . et peu à peu l'observateur réunit un ensemble consi-
> dérable de petites remarques qui toutes sont dépendantes les unes
> des autres; cet ensemble est le procès-verbal même de la vie, il
> contient tout un traité de psychologie et de physiologie expérimen-
> tale.
>
> (The analytic novelist, upright and attentive, notes the smallest
> details. Under his eye there occurs a series of facts that he records
> carefully . . . and little by little the observer gathers a considerable
> set of small notations that are all interdependent; this set is the
> very court record of life, it contains an entire treatise of psychol-
> ogy and experimental physiology.)[77]

For Zola, style is the linguistic crystallization of the principle of deter-
minism, the textual representation of the experimental human sciences.
Such a conclusion on my part is by no means new, nor even necessary,
since Zola enunciates it so explicitly. What is perhaps revealing about this
analysis is the crucial role of vision in converting physiology to psychol-
ogy, in linking matter to mind. To the above categorizations it can justifi-
ably be added that Zola's style, particularly as it pertains to description, is
essentially a matter of vision, through which the causal chains determin-
ing human experience are revealed. It is through the representation of
vision and visual effects that Zola's descriptive style illustrates his conten-

77. From *Le Figaro,* 18 December 1866, in Fernand Doucet, *L'Esthétique d'Emile Zola et
son application à la critique* (The Hague: Smith, 1923), 139.

tion in the epigraph beginning this chapter that "describing is no longer our goal; we simply want to complete and determine" (*Le Roman expéri-mental,* 186). However, in stressing the importance of determinism, Zola's additional contentions regarding description, cited in the two other quotes heading this chapter, must not be forgotten.

Object and Observer: From Determinism to Projection

In addition to concretizing the principles of determinism, Zola's descriptive style also involves dramatic concerns ("the whole drama") as well as structural and psychological dimensions ("symphonic and human intentions").[78] Through visual perception one can trace the many modalities of interaction between object and observer, ranging from determinism to projection. Visual interaction occurs in several modes, often simultaneously, thus fostering numerous types of relationships of varying degrees of complexity between object and observer, *paysage* and *personnage*.

It would be unwise to end this chapter with a monolithic and rather traditional conclusion that the exclusive, even primary mode in Zola's novels is deterministic, especially in preparation for a chapter on vision and imagination. Thus I will chart here the various patterns and shifts in *Une Page d'amour*—about whose descriptive passages Zola had acknowledged his "symphonic and human intentions"—through the modes of visual interaction between the characters and their milieu, Paris in particular.

Deterministic patterns are certainly prevalent and often take the form of a communication system.[79] From the first page of the novel, Paris is described as an active sender of sensations, though there is no implied receiver: "Paris envoyait seul son lointain ronflement" ("Paris was sending only its distant humming," 801), a pattern that may be depicted graphically as follows: P →. Similarly, the characters are often described as receivers, without an explicit sender, as in "Hélène resta . . . regardant" ("Hélène remained . . . looking," 850), which may be characterized thus: H ←. The completion of the perceptual message, where both sender and receiver are present in the same transitive sentence, occurs especially in the final chapters (always the fifth) of each of the five sections of the novel—chapters in which character and milieu are particularly interactive and visual activity especially intense. The last sentence from the concluding chapter of part I stands as a typical exam-

78. See the second and third epigraphs heading this chapter.
79. See the discussion of Roman Jakobson's schema of communication in Chapter 2.

ple: "Cette matinée de printemps, cette grande ville si douce, ces pre-
mières giroflées qui lui parfumaient les genoux, avaient peu à peu fondu
son coeur" ("This spring morning, this great city so soft, these first
wallflowers scenting her knees, had gradually melted her heart," 855).
This communicative structure, which also appears as "Paris lui en-
voyait . . ." ("Paris sent her . . . ," 903; see also 967 and 973) can be
represented accordingly: P → H. A parallel determinist structure—"elle
croyait sentir toutes ces flammes brûler dans son coeur" ("she thought
she felt all these flames burn in her heart," 907) or "Hélène . . . soulagée
par cette mer" ("Hélène . . . relieved by this sea," 964), where the
recipient, though determined by the actions of the decor, is highlighted
syntactically (head of sentence), gramatically (pronoun or noun), and
thus semantically—can be represented as follows: H ← P.

Visual communication can also operate in the opposite direction: the
character can become the sender and Paris the receiver. Such is the case in
the following example from the final chapter of part II—"elle y apportait
le souffle court et ardent de l'émotion qui l'agitait" ("she brought to
[Paris] the short, ardent breath of the emotion that agitated her," 902)—
which can be represented as: H → P. A related example, from the final
page of the novel—"témoin muet des rires et des larmes dont la Seine
semblait rouler le flot" ("mute witness of the laughter and tears whose
waves seemed to flow from the Seine," 1092)—shows Paris as a passive
(even silent) receiver of emotions projected by Hélène: P ← H.

The most striking examples of this relationship occur in scenes where
Hélène "projects" images from her imagination or memory onto Paris,
which becomes no more than a screen for her visual fantasies. In the final
chapter of part II, for example, Hélène looks out her window at the city:
"Sur le fond d'un noir d'encre, Henri apparaissait avec une netteté
singulière. . . . Puis, lorsque d'un suprême effort elle avait chassé la vi-
sion, elle la voyait se reformer plus lointaine, lentement grossie" ("Against
the inky black backdrop, Henri appeared with singular clarity. . . . Then,
when she had chased away the vision with a supreme effort, she saw it
reform farther away, gradually enlarged," 903). Paris never totally disap-
pears, but is subordinated to the images projected by Hélène—"pourtant,
dans cette évocation, elle gardait la conscience des vastes étendues qui se
déroulaient sous elle" ("however, in this evocation, she remained con-
scious of the vast spaces unfolding below her," 904)—and even manages to
reassert itself in the visual relationship: "Par moments, de brusques lueurs
semblaient percer ses paupières closes; et, dans ces lueurs, elle croyait voir
les monuments, les flèches et les dômes se détacher sur le jour diffus du
rêve. Alors, elle écarta les mains, elle ouvrit les yeux et demeura éblouie.
Le ciel se creusait. Henri avait disparu" ("At times, harsh lights seemed to

pierce her closed eyelids; and, in these lights, she thought she saw the monuments, the steeples and the domes stand out against the diffuse daylight of the dream. Then, she lifted her hands, opened her eyes, and remained dazzled. The sky was before her. Henri had disappeared," 904).

The above example demonstrates that the visual link is rarely unidirectional and static; rather, it constitutes a dynamic interplay between character and milieu. This reciprocal relationship is repeated in the following example, from several pages later in the same chapter of *Une Page*: "Hélène, baignée par ces flammes, se livrant à cette passion qui la consumait, regardait flamber Paris" ("Hélène, bathed by these flames, yielding to this passion that consumed her, watched Paris blaze," 909). Though Hélène is seen as a receiver—"bathed by these flames" (H ← P)—she is also consumed by her own passion (H ← H), which she then projects onto Paris—"watched Paris blaze" (H → P). The sentence describes in rapid succession a series of relationships whose representation would have to be rather complicated in order to suggest the interplay and dynamics of the visual relationships: H ← H ⇄ P; or: P → H ← H → P. Similarly, the description of Paris as "un ami qui s'imposait" ("a friend imposing himself," 965) contains elements of projection ("friend") and reception ("imposing"), and, since Hélène's presence in the sentence is merely implied (by the human connotations of both noun and verb), it might be represented as: P ⇄ (H).

These shifting modalities of vision can be traced in the final pages of part IV of the novel (which explore the circumstances leading to Jeanne's death), by detailing her changing relationship with the decor, again Paris seen from the window. On the opening page of the final chapter, this relationship is depicted as negative or nonexistent—"la ville elle-même n'était pas là pour tenir compagnie à l'enfant" ("the city itself wasn't there to keep the child company," 1024)—which may be translated graphically as: J ≠ P. Her visual relationship with Paris alternates between projection—"Un tel désespoir emplissait son coeur d'enfant qu'il faisait noir autour d'elle" ("Such despair filled the child's heart that around her it was dark," 1033), J → P—and determinism—"puis, en laissant retomber la tête, elle en emportait l'image, il lui semblait qu'il s'étalait sur elle et l'écrasait" ("then, letting her head fall, she retained its image, which seemed to spread over her and crush her"), P → J. The chapter ends, appropriately, with separate but parallel sentences, detailing first Jeanne's loss of consciousness—"Il n'y avait plus rien, elle dormait dans le noir" ("there was nothing more, she was sleeping in the darkness")—followed by the disappearance of Paris—"A l'horizon, Paris s'était évanoui" ("On the horizon, Paris had vanished," 1034)—suggesting the graphic formula: Paris = Jeanne (P = J). Indeed,

in many cases, both character and milieu are present, but no influence, no determinism or projection, is implied, as in "Paris, justement, ce matin-là, avait la joie et le trouble vague de son coeur" ("Precisely, Paris, that morning, had the joy and vague disturbance of her heart," 847). This type of relationship, based on harmony, parallel, analogy, similarity, or coincidence, rather than on influence, may be represented graphically as: $P = H$; or $P \mid H$.[80]

A striking example of this parallel relationship between character and décor, occurs in the final chapter of the novel, where the reader, without the aid of the narrator's judgment, perceives a resemblance between Hélène and the décor, the cemetery where she has come to visit the grave of her daughter Jeanne, who expired in the previous chapter. Elements of the description of the cemetery—"La neige se durcissait déjà, une haute *fourrure* de cygne *bordait* le parapet de la terrasse. Au delà de cette ligne blanche, dans la pâleur brouillée de l'horizon, Paris s'étendait" ("The snow was already hardening, a lofty *fur* of swans' down *bordered* the parapet of the terrace. Beyond this white line, in the murky paleness of the horizon, Paris stretched out," 1083 [my emphasis])—are picked up in the description of Hélène on the following page—"Enveloppée d'un large manteau sombre, *bordé* de *fourrure*" ("Wrapped up in a large dark coat, *bordered* in *fur*," 1084). In fact several additional qualities attributed to Hélène—her "*pâleur*" (paleness), "*hauteur*" (loftiness), and "*dents blanches*" (white teeth, 1084)—stem directly from the semantic units (*sèmes*) of the earlier description—"*haute*" (lofty) . . . "*blanche*" (white) . . . "*pâleur*" (paleness). Coupled with her "*douleur muette*" ("mute suffering," 1083), which reflects the location of the cemetery on the Rue de la Muette (see 1081 and 1089), this is a fascinating example of the simultaneous genesis of two parallel textual entities, character and decor ($H = P$ and $P = H$). This analogous relationship in turn provides an intimate glimpse into the workings of the visual imagination, a rarely discussed aspect of Zola's creative process, which forms the core of the following chapter.

80. Indeed, from the first page the narrator identifies a "harmonie bourgeoise," which he then illustrates: "La veilleuse dormait, les meubles dormaient; sur le guéridon, près d'une lampe éteinte, un ouvrage de femme dormait. Hélène, endormie, gardait son air grave et bon" (801). No determinism is implied; Hélène and her apartment simply share the same characteristics, especially drowsiness.

5 The Visual Imagination: Figuration, Hallucination, and Creation

Je ne sais pas inventer. (I don't know how to invent.)
— Edouard Manet (interview with Zola)
— Emile Zola (interview with De Amicis)[1]

Zola's doctrine of naturalism, based on observation, documentation, and experimentation, stressing the "objective" if not "photographic" representation of reality, would appear to leave little room for imagination. Indeed, Zola distinguishes himself clearly from philosophical positions and literary movements that privilege the imagination. He notes of "idealism" that "notre querelle avec les idéalistes est uniquement dans ce fait que nous partons de l'observation et de l'expérience, tandis qu'ils partent d'un absolu" ("our quarrel with the idealists is solely in the fact that we start from observation and experimentation, while they start from an absolute," *Roman ex.,* 76). Elsewhere he identifies the differences be-

1. Manet's statement, as reported by Zola, is in *Salons,* ed. F.W.J. Hemmings and R. J. Niess (Geneva: Droz, 1959), 125. Zola's identical statement to De Amicis can be found in the latter's *Studies of Paris,* trans. W. W. Cady (New York: G. P. Putnam's Sons, 1887), 211.

tween naturalism and romanticism, the latter relying on "les types, les abstractions généralisées de la formule classique" ("types, generalized abstractions based on the classic formula," *Une Campagne,* 102). He asserts that only novelists with defective vision could exhibit epic traits: "Ils pourront peut-être écrire des poëmes épiques, mais jamais ils ne mettront debout une oeuvre vraie, parce que la lésion de leurs yeux s'y oppose, parce que, lorsqu'on n'a pas le sens du réel, on ne saurait l'acquérir" ("They might be able to write epic poems, but they'll never construct a true work, because the lesion in their eyes is against it, because when one doesn't have a sense of reality, one could never acquire it," *Roman ex.,* 168). Indeed Claude Lantier's madness and loss of talent near the end of *L'Oeuvre* are due to "le tourment d'un symbolisme secret, ce vieux regain de romantisme" ("the torment of a secret symbolism, this old renewal of romanticism," 236).

Yet, despite Zola's disclaimers, critics have tended to stress his "poetic" and "imaginative" qualities (no doubt in reaction to his known penchant for polemic exaggeration), citing the very movements Zola disdains. Edouard Herriot pays homage to Zola by saluting his "multi-faceted work, where naturalism, romanticism, idealism, even symbolism each has a part, a work gorged with life that started like a chronicle and ended like a poem."[2] Indeed, all the traits Herriot sketches have received considerable and convincing attention by Zola's critics, who have examined his romanticism,[3] his epic and mythic qualities,[4] his symbolism,[5] his poetry,[6] and even his mystic aspects.[7] Other critics have cast similar doubts on

2. "je salue ce grand coeur triste, cette âme hautaine, une oeuvre multiforme, où le naturalisme, le romantisme, l'idéalisme, le symbolisme même ont chacun leur part, une oeuvre gorgée de vie qui débuta comme une chronique et s'acheva comme un poème." "Hommage à Zola," *Equisses* (Paris: Hachette, 1928), 52.

3. For Zola's romanticism, see, for example, Pierre Citron, "Quelques aspects romantiques du Paris de Zola," *Cahiers naturalistes* 24–25 (1963): 47–54, and Patrick Brady, *"L'Oeuvre" de Emile Zola: Roman sur les arts, manifeste, autobiographie, roman à clef* (Geneva: Droz, 1967), 361–66.

4. See especially Alfred Proulx, *Aspects épiques des "Rougon-Macquart" de Zola* (The Hague: Mouton, 1966); Jean Borie, *Zola et les mythes, ou: De la nausée au salut* (Paris: Seuil, 1971); and Roger Ripoll, *Réalité et mythe chez Zola,* 2 vols. (Paris: Champion, 1981).

5. Philip Walker, for example, in "Zola's Use of Color Imagery in *Germinal,*" *PMLA* 77 (September 1962), 442–49, speaks of Zola's "strongly symbolic and subjective presentation of reality." See also David Baguley, "Image et symbole: La Tache rouge dans l'oeuvre de Zola," *Cahiers naturalistes* 39 (1970): 36–46, and Chantal Jennings, "La Symbolique de l'espace dans *Nana,*" *Modern Language Notes* 88 (1973): 764–74.

6. See, for example, Jean Cocteau, "Zola, le poète," *Cahiers naturalistes* 1 (1955–56): 442–43, and Neide de Faria, *Structure et unité dans "Les Rougon-Macquart": La Poétique du cycle* (Paris: Nizet, 1977).

7. For Zola's mystic tendencies see Ernest Seillière, *Emile Zola* (Paris: B. Grasset, 1923).

Zola's objectivity, impartiality, and fidelity to reality by stressing his distortion and manipulation of documentary materials for artistic and imaginative ends.[8]

Clearly, Zola's conception of imagination must be reevaluated in order to reconcile his imaginative tendencies with his rejection of the idealist, romantic, and symbolic approaches to poetic invention. Zola outlines the terms for such a reevaluation in the letter to Henry Céard cited in the Preface to this book.[9] In that letter Zola not only acknowledges the importance of imagination in his art ("I enlarge," "our Lie"), while distinguishing his imagination from that of other writers, like Balzac, but he also asserts that the most fruitful approach to his imagination is through a close examination of his visual perception ("I would only have liked to see you take apart the mechanism of my eye") and, in essence, invites such a study ("I'd like to see you study the problem one day").

In this final chapter, I plan to follow Zola's advice to Céard by exploring the relationship between vision and imagination in creation. The predominance of imagination in Zola's works is by no means a new assertion, as the legions of critics cited above demonstrates; however, identifying imagination as a visual mechanism, locating the areas of distortion and manipulation within the visual, constitutes a unique perspective on this question and leads to new insights regarding creativity in Zola's works. Like memory for Proust, the image marks a point of intersection between reality and imagination, an area of artistic distillation and creation. I shall explore two of the most obvious manifestations of the visual imagination—figuration and hallucination—in order to describe the role of vision in the creative process and, indeed, in Zola's fundamental (phenomenological) relationship with reality.

Visual Figuration

In the broadest sense a "figure," like the term "image" (or "imagery"), betrays the presence of the visual in language, as implied by Lyotard's invitation in Discours/Figure: "let's trace the routes of the eye in the field of language, let's seize the fixed movement, let's espouse the undulations of metaphor, which is the fulfilment of desire, and then, we shall see how

8. See especially Laurey K. Martin, "L'Elaboration de l'espace fictif dans L'Assommoir," Cahiers naturalistes (forthcoming).

9. See page 3 of the Preface.

exteriority, power, organized space, can be present within interiority, within closed meaning."[10]

In the stricter sense of the term "figure" used here, designating one of the major tropes—metaphor, metonymy, synecdoche—Zola's figuration displays decidedly visual contents, mechanisms, and relationships, thus leading naturally to an exploration of the workings of the visual imagination.

Naturalism, like its predecessor realism, is marked by the effort to eliminate overly "literary" effects such as the narrator's overt presence, artificial plot devices, and an ornamental style—all of which would call attention to the text as literature, not as life. Consequently, one might expect to find in Zola's novels (as well as in those of Flaubert, Maupassant, and other French "realists") a great reduction in the number of rhetorical figures, since these devices appear to be ultraliterary, blatantly artificial, highly ornamental.[11]

Indeed, this seeming incompatibility between realism/naturalism and rhetoric has fostered two important but equally erroneous assumptions. The first and most traditional of these is characterized by the tendency of the critic, upon discovering tropes in realist texts, to attribute this aspect of the author's art to his failure to outgrow romanticism (with which, apparently, rhetorical figures are not incompatible); thus, Pierre Citron refers to Zola's metaphors as "several romantic aspects"[12] of his art, and Ferdinand Brunetière, having acknowledged the importance of synecdoche in Flaubert's novels, concludes that he had "studied Chateaubriand a great deal."[13] A second direction is to reduce realist rhetoric to one form as does Roman Jakobson in his famous article on two aspects of lan-

10. "traçons les parcours de l'oeil dans le champ du langage, saisissons le bougé-fixe, épousons les vallonnements de la métaphore, qui est l'accomplissement du désir, et alors, on verra comment l'extériorité, la force, l'espace formé, peuvent être présents dans l'intériorité, dans la signification fermée." *Discours/Figures* (Paris: Klincksieck, 1974), 15. Lyotard adds later that "cette extériorité, c'est le voir et le désirer qui l'ouvrent" (50), que "La figure-forme est la présence du non-langage dans le langage" (51), and que "la figure est une déformation qui impose à la disposition des unités linguistiques une autre forme" (61).

11. In *Sémantique de la métaphore et de la métonymie* (Paris: Larousse, 1973), 73, Michel LeGuern notes that "les métaphores sont des images, et toute une tradition rhétorique et littéraire a voulu voir dans l'image un 'ornement' du style," and he quotes from Cicero, *De Oratore*: "C'est pour orner que l'on met un mot propre à la place d'un autre mot propre." LeGuern states further that "il est certain que l'écart par rapport au fonctionnement normal de la référence diminue l'attention portée aux choses, au profit d'une attention plus vive aux mots: il en résulte un renforcement de la fonction poétique" (78). This stressing of the poetic function comes, of course, at the expense of the mimetic or realist function of words.

12. "quelques aspects romantiques" (see note 3 of this chapter).

13. "Flaubert avait beaucoup étudié Chateaubriand." In *Le Roman naturaliste* (Paris: Calmann Lévy, 1892), 156.

guage,[14] where he suggests that romanticism is characterized by the importance of metaphor, realism by the predominance of metonymy. In criticizing Jakobson's position, Michel LeGuern displays the same reductionist approach in attempting to prove that synecdoche (of the part for the whole) is the most characteristic form of realist figure.[15]

My contentions are as follows: instead of the expected reduction of rhetorical figures, one finds in Zola's works a profusion of tropes such as the novel has never seen; all three basic types of figure—metaphor, metonymy, and synecdoche—characterize Zola's art (as well as that of the other major French realist novelists); realist figures assume a particular form, based precisely on their *visual* qualities, which distinguishes them from those that dominate other literary movements, such as romanticism; figures play a highly functional (not ornamental) role in Zola's novels.

Emblematic of the profusion and variety of figures found in Zola's novels is the following phrase, describing a sunset, from Zola's *Une Page d'amour* (907)—"une gloire enflamma l'azur" ("a glory enflamed the azure")—a phrase in which the literal sense—"the sun lit up the sky"—has been modified by the substitution, in sequence, of a metonymy, a metaphor, and a synecdoche. Zola has replaced the sun, the actual subject of this description, by the term "a glory," which refers to the effect produced by the sun on its observers.[16] This procedure, in which an effect is substituted for its cause, an impression for the object producing it, is a form of *metonymy*. The verb "enflamed" also involves a substitution—of flames for the sun's rays—but here the basis is the similarity (of light and heat) between the two things (flames and rays), rather than causality, and thus the figure is a *metaphor*. Finally, "the azure" has replaced the sky that encompasses it (the color) among many other qualities. The quality stands for the object itself, the salient detail for the entire phenomenon, the part for the whole, and thereby constitutes a *synecdoche,* a figure whose process of substitution is based on a relationship of inclusion, rather than on causal-

14. "Deux aspects du langage et deux types d'aphasie," in *Essais de linguistique générale,* trans. Nicholas Ruwet (Paris: Editions de Minuit, 1963), 43–67. Jakobson says clearly that "on n'a pas encore suffisamment compris que c'est la prédominance de la métonymie qui gouverne et définit effectivement le courant littéraire qu'on appelle 'réaliste' " (p. 62).

15. While noting that "un relevé systématique des métonymies dans les textes français relevant de diverses esthétiques oblige à admettre qu'il n'existe pas de corrélation entre la littérature réaliste et la métonymie en général," LeGuern goes on to claim that "il est absolument évident qu'un type particulier de métonymie, la synecdoche de la partie pour le tout, tient une place privilégiée dans les textes réalistes" (*Sémantique,* 104).

16. In French, the word "gloire" also carries the sense of "halo," particularly in religious art, but this doesn't alter my conclusion, since a halo is itself an effect of the sun.

ity or similarity.[17] Throughout Zola's novels, all three figures are found frequently, and, for each, a particular form dominates, thus distinguishing Zola's rhetoric from that of other literary movements. A further distinctive feature resides in the very visuality of Zola's figures and figurative operations.

Illustrative of the properties peculiar to Zola's *metaphors* is this example taken from *L'Oeuvre:* "une courbe molle s'arrondissait à droite dans la clarté, si allongée et si perdue, que le pavillon de Flore, tout là-bas, qui s'avançait comme une citadelle, à l'extrême pointe, semblait un château du rêve, bleuâtre, léger et tremblant, au milieu des fumées roses de l'horizon" ("a soft curve was rounding to the right in the brightness, so lengthened and lost, that the pavillon de Flore, very distant, which was advancing like a citadel, at the far tip, seemed like a dream castle, bluish, light, and trembling, amidst the pink mists of the horizon," 103). This passage, where the pavillon de Flore (a real building that terminates the Seine-side wing of the Louvre) is compared to a dream castle, contains no fewer than seven properties that distinguish Zola's metaphors from other types:

1. Both terms, the pavillon de Flore and the "dream castle," are given in the text, as is the comparing expression "seemed like." Therefore, this is comparison rather than an identification, where there is no comparing expression, or a pure metaphor, where one of the terms is absent, to use the distinctions drawn by Gérard Genette, perhaps the most influential of his generation of French rhetoricians.[18]
2. Both terms are physical, material objects, as opposed, for example, to the type of metaphor more typical of the romantic text, where a physical object is often compared to an abstract idea or an emotional state, as in the following example from Chateaubriand's *René:* "Quelquefois une haute colonne se montrait seule debout dans un désert,

17. My definitions of these tropes are based on the distinctions drawn by Donald Rice and Peter Schofer in *Rhetorical Poetics* (Madison: University of Wisconsin Press, 1983). In addition to reevaluating the major trends in French studies of rhetoric, they are the first to radically and effectively limit metonymy to a relationship of *causality* rather than the broader and vaguer term "contiguity." Also of interest is "Synecdoques et métonymies," *Poétique* 23 (1975): 371–88, in which Nicholas Ruwet reacts against the *Rhétorique générale* (Paris, 1970) of J. Dubois and the Liège group, who attempt to reduce all figures to types of synecdoche.

18. In "La Rhétorique restreinte," from *Figures III* (Paris: Seuil, 1972), 21–40, Genette distinguishes three kinds of figures based on analogy—the comparison, the identification, and the metaphor—and avoids using the term "metaphor" to encompass all of these varieties. However, most French works on rhetoric use the term "metaphor" in the more general sense, as a I do here. For further clarification and illustration of Genette's terminology, see note 21 below.

comme une grande pensée s'élève, par intervalles, dans une âme que le temps et le malheur ont dévastée" ("Sometimes a tall column stood alone and erect in a deserted spot, like a great thought rises, at intervals, in a soul that time and misfortune have devastated").[19]

3. The comparing or "imaginary" term, "dream castle," although not physically present in this scene near the Louvre, is generated by the circumstances of the novel, appears in other metaphors, and reflects the childlike qualities of the observer, Claude Lantier. Thus, although the comparing term is not drawn from the immediate context of the scene, it is true to the general context of the novel.[20] In this respect it differs greatly from the mythological or artistic allusions that come from a context that is outside the novel, that bypasses and surpasses the characters and thereby betrays the narrator's presence, as in so many of Balzac's comparisons, to cite only one prenaturalist writer who displays this trait.

4. The motivating causes for the comparison are also given in the text; that is, the causal expressions "so lengthened and lost" and the adjectives "bluish, light, and trembling" together explain why the pavillon de Flore looks like a dream castle. To borrow from Genette's terms once again, Zola's comparison is "motivated."[21]

5. Furthermore, these causes themselves, like the objects compared, are visual phenomena, involving a variety of properties, including shape ("rounding"), line ("lengthened"), distance ("lost"), color ("bluish"), volume ("light"), and stability ("trembling"), all of which conspire to open up the space of imagination and figuration. This exterior visual motivation differs substantially from the abstract or emotive interior

19. *René* (Paris: Garnier Frères, 1962), 194.

20. Brunetière was perhaps the first to describe and evaluate this type of figure, in examining Flaubert's comparisons: "Elle [la comparaison] ne sert plus d'une distraction pour l'oeil ou pour l'imagination du lecteur; elle n'est pas davantage offerte à sa curiosité comme un souvenir des lointains voyages ou comme témoin des infinies lectures de l'auteur; elle devient l'expression d'une correspondance intime entre les sentiments et les sensations des personnages qui sont en scène" (*Le Roman naturaliste,* 158). Jacques Neefs ("La Figuration réaliste: L'Exemple de *Madame Bovary,*" *Poétique* 16 [1973], 466–76) also examines this type of comparison, which he calls "intra-diégétique" (after Genette). While Neefs limits his examples to *Madame Bovary,* he does extend his conclusions to the entire realist movement: "la frontière diégétique apparaît bien comme le principe d'ordre réaliste par excellence" (472).

21. Genette (*Figures III,* 30) lists ten types of figures based on analogy, ranging from: pure metaphor (my flame), unmotivated identification (my love, flame), motivated identification (my love, ardent flame), and unmotivated comparison (my love is like a flame), to motivated comparison (my love burns like a flame), the last of which I claim here to be the most typical of Zola's figures.

qualities that generally motivate the metaphors of Chateaubriand (see the above quotation) or, say, Proust.[22]

6. Zola's metaphor is presented from the viewpoint of the novel's characters, whose presence and precise angle of vision is clearly indicated at the beginning of the paragraph in which the figure appears. By way of contrast, those of Balzac are more frequently presented from the narrator's viewpoint, and, even in the Chateaubriand text, where the first-person form makes a distinction between character (the younger René) and narrator (the older Réne who is telling the story) difficult, the shift in verb tense (past to present) seems to indicate a change in perspective from the character's experience to the older narrator's judgment.

7. In fact, Zola's comparison is presented as a sort of visual distortion or momentary hallucination ("seemed like"), and, indeed, this and other terms like *apparaissait* ("appeared") and *ressemblait* ("looked like") are usually found in Zola's novels in place of the more traditional *ainsi* or *comme* ("like" or "as").

Certainly it would be foolhardy to claim that this type of metaphor, with all seven of these traits, is typical of Zola's style; rather it is archetypal, quintessential, a model or master trope that combines many of the qualities found to one degree or another in his novels. For example, the more simple comparison (simile) in the above example, "the pavillon de Flore . . . advancing like a citadel" again involves two concrete objects, motivated from the exterior ("advancing") and presented as a visual phenomenon from the characters' viewpoint.[23]

Examples of *metonymy* in Zola's novels reveal many of these same properties. Unlike metaphor, which is clearly marked for the reader by the intrusion of an alien context (the comparing term comes from outside the scene itself), metonymy merely involves a displacement of attention within the components of the scene and thus remains relatively unobtrusive, difficult to discern and define. The following example taken from Zola's *Nana*—"de grosses voix se querellaient dans les couloirs" ("loud voices were quarreling in the corridors")[24]—also involves a nearly imperceptible shift from cause to effect, since, strictly speaking, it is the men

22. See the discussion of Proust's metaphors in the Conclusion.

23. For discussions of Zola's metaphors from different perspectives, see especially Maarten Van Buuren, "La Métaphore filée chez Zola," *Poétique,* 57 (1984): 53–63, and "*Les Rougon-Macquart*" *d'Emile Zola: De la métaphore au mythe* (Paris: Corti, 1986). See also William J. Berg, "A Note on Imagery as Ideology in Zola's *Germinal, Clio* 2 (Fall 1972): 43–45, and Allan H. Pasco, "Myth, Metaphor, and Meaning in *Germinal,*" *French Review* 46 (1973): 739–49.

24. LeGuern (*Sémantique,* 14) uses this example to illustrate the process of metonymy.

who are quarreling, not the loud voices, which merely mark the effect produced on the listener. A clearer and more sustained example can be found in *L'Oeuvre:* "Dans l'atelier, de gros pas marchaient, des mains frôlaient, il y eut une dégringolade de choses, accompagnée d'une sourde exclamation. La porte s'éclaira" ("In the studio, heavy steps were walking, hands were rubbing, there was a falling of things, accompanied by a muted exclamation. The doorway lit up," 15). In the first sentence, a series of auditory effects suggests their absent cause, someone groping around in a dark room. The impression produced on a listener, rather than the actual event, is described. A similar operation occurs in the second sentence, where "the doorway lit up" lays emphasis on the visual effect rather than on the cause, someone's lighting a lamp.

In each of the above examples of metonymy, the same particular form of the figure emerges—that of an effect being substituted for its cause. This form, however, represents only one type of metonymy among nine identified by Fontanier in *Les Figures du discours,* the most often cited of the traditional French works on rhetoric.[25] More prevalent forms, according to Fontanier, include substituting a cause for an effect (Bacchus, the God, for the wine which he symbolizes), an artist for his work (a Manet), or a place for its product (a Burgundy for the wine produced there). All of these forms display the tendency to seek the origin of a phenomenon instead of remaining absorbed in its effect, as in the examples from Zola's novels. In this sense, it may be possible to link the use of this trope, where the effect replaces the cause, where an impression displaces the thing producing it, to the rise of impressionism. One must be careful, however, after having dispelled the fallacy of attributing a realist's rhetoric to his "romantic origins," to avoid the pitfall of attributing his tropes to "latent impressionism." Rather, these figures, in their particular forms, are inherent to Zola's work, which shares several points with impressionism, among them the use of certain types of metonymy.

While allowing us to distinguish a particular form of metonymy prevalent in realism—effect for cause—the above examples also enable us to draw a series of parallels with Zola's metaphors. Again, the figure is presented from a character's viewpoint and constitutes, in fact, an exploration of perceptual phenomena, where concrete physical objects or occurrences ("the doorway lit up") are related through a motivation that is present in the text and is itself a physical phenomenon (the darkness of the room, the distance of the observers).

Synecdoche of the part for the whole is the most prevalent type of this

25. Fontanier's work, dating from the early nineteenth century, has been reedited with an introduction by Genette (Paris: Garnier Flammarion, 1977).

figure in Zola's novels, as in the following example taken from *Le Ventre de Paris:* "On ne voyait encore, dans la clarté brusque et tournante des lanternes, que l'épanouissement charnu d'un paquet d'artichauts, les verts délicats des salades, le corail rose des carottes, l'ivoire mat des navets; et ces éclairs de couleurs intenses filaient le long des tas, avec les lanternes" ("One could still see, in the harsh, turning light of the lanterns, only the fleshy spread of a package of artichokes, the delicate greens of the lettuces, the pink coral of the carrots, the flat ivory of the turnips; and these flashes of intense colors were moving along the piles, with the lanterns," 614) The use of the nominal form ("the greens of the lettuces" rather than "the green lettuces") enables Zola to detach the colors (green, pink, and ivory) from the objects (lettuces, carrots, and turnips) and to modify these colors (which become "delicate," "coral," and "flat"), rather than the objects themselves, while imparting an independent movement to the colors ("these flashes of intense colors were moving along the piles").[26] In this way the salient detail (the quality, the part) precedes the object and predominates, but does not replace it; both terms, the part and the whole are present in the text. In other cases, the whole entity may be displaced by a part or quality, as in the following example from *L'Argent*—"les marches et le péristyle étaient noirs d'un fourmillement de redingotes" ("the steps and peristyle were black with a swarming of frock coats," 23)—where the visual focusing on "frock coats" also serves as social designation, since the garments suggest men of prominence, as befits the novel's title.

Again, it is important to situate the predominance of this particular type of synecdoche (part for whole) by noting that Fontanier classifies eight different forms of this figure, most of a more abstract kind, such as the singular for the plural (the Frenchman for all Frenchmen), the particular for the general (daily bread for all food), and genus for species (animal for lion). However, while this one property (the fact that it is usually a part for a whole) distinguishes it from other forms of this figure, other properties present in the examples studied clearly link it to Zola's preferred forms of both metaphor and metonymy: it is a physical, concrete part that replaces or complements a physical, concrete whole, a relationship motivated by the physical properties of the scene (the moving light of the lantern in the example taken from *Le Ventre de Paris*), and, in fact, the figure is presented as a perceptual experience from the characters' viewpoint.

26. Again we might note, in passing, that the use of the "nominal form," where the quality is presented as a substance in its own right, is often identified by critics as one of the distinguishing features of literary impressionism. See Chapter 4, note 36.

So long, then, as the figures are functional, not ornamental, phenomenal, not static; so long as they emerge from the fabric of the text, motivated by the milieu and mediated by the character, not the narrator; so long as they are physical and immanent, not abstract and transcendent, there is no incompatibility between realism/naturalism and rhetoric. On the contrary, figures are an integral part of the late nineteenth-century novel; they point to its essential, most creative aspect—its phenomenality, not its photography.

If the key to naturalist thought as well as style is in "causality," as was stressed in the preceding chapter (description), that "causality" emerges here through the notion of "motivation." The "causes" of figures are within the exterior space of the milieu, on the one hand, and the interior space of desire, on the other, their relationship mediated by the role of vision.

Exterior Motivation: Light and Color

Many of the traits of figuration described in the previous section— particularly sensorial figures motivated by exterior phenomena—characterize the realist/naturalist movement in general, as well as the Rougon-Macquart novels. However, Zola's figures are distinct, in fact, unique, in the role of light and color as motivators for (1) comparisons, (2) synecdoches, and (3) metonymies.

(1) Comparisons in Zola's novels may often resemble those of the romantics, particularly in the choice of themes, but his point of departure is generally quite different from theirs. Balzac, for example, compares Paris to an ocean in the following manner:

> Mais Paris est un véritable océan. Jetez-y la sonde, vous n'en connaîtrez jamais la profondeur. Parcourez-le, décrivez-le! quelque soin que vous mettiez à le parcourir, à le décrire; quelque nombreux et intéressés que soient les explorateurs de cette mer, il s'y recontrera toujours un lieu vierge, un antre inconnu, des fleurs, des perles, des monstres, quelque chose d'inouï, oublié par les plongeurs littéraires.

> (But Paris is a veritable ocean. Sound it out, you'll never know its depth. Explore it, describe it! whatever care you take in exploring it and describing it; however numerous and dedicated are the

explorers of this sea, there will always be an untouched place, an
unknown cove, flowers, pearls, monsters, something unexpected,
forgotten by literary divers.)[27]

Zola uses a similar comparison in *La Curée:*

> Ce jour-là ils dînèrent au sommet des buttes dans un restaurant
> dont les fenêtres s'ouvraient sur Paris, sur cet océan de maisons
> aux toits bleuâtres pareils à des flots pressés emplissant l'immense
> horizon.

> (That day they dined atop the hills in a restaurant whose windows
> opened up onto Paris, onto this ocean of houses with bluish roofs
> like compressed waves filling the immense horizon. 387)

Both authors compare Paris to an ocean; however, whereas Balzac's sense
of mystery leads him to establish an emotive or abstract comparison
between Paris and the seething subterranean existence in the sea, Zola is
moved only by what he sees, by the visible qualities of a specific scene.
Balzac's metaphor arises from the observer's mind and is imposed on
reality; Zola's seems to arise from the objects themselves, from the roofs
of Paris whose blue color and staggered arrangement make them resem-
ble the movement of waves on the surface of the ocean. Balzac's imagina-
tion runs free and unchecked; Zola attempts to wrest from the observable
properties of reality a poetry that is visible to the creative eye.
A similar comparison of Paris to an ocean recurs in *Une Page d'amour:*

> Hélène, depuis huit jours, avait cette distraction du grand Paris
> élargi devant elle. Jamais elle ne s'en lassait. Il était insondable et
> changeant comme un océan, candide le matin et incendié le soir,
> prenant les joies et les tristesses des cieux qu'il reflétait. Un coup
> de soleil lui faisait rouler des flots d'or, un nuage l'assombrissait et
> soulevait en lui des tempêtes. Toujours, il se renouvelait.

> (For eight days, Hélène had had this distraction of Paris looming
> large before her. Never did she tire of it. It was unfathomable and
> changing like an ocean, candid in the morning and lit up in the
> evening, taking on the joys and sorrows of the skies it reflected. A
> burst of sunlight gave it waves of gold, a cloud darkened it and
> stirred up its storms. Always, it renewed itself. 846)

27. *Le Père Goriot* (Paris: Garnier Frères, 1963), 20.

Of the two motivations for the comparison—"unfathomable and changing"—Balzac would surely enlarge on the first, whereas Zola explores the second; and the causes of change in every case are visual phenomena, especially ones involving the type of sky, atmospheric conditions, sunlight, and colors.

Light is, in fact, the prime motivator of comparisons throughout the Rougon-Macquart series, not just in the novels usually described as "impressionist." In the opening chapter of *La Fortune,* moonlight transforms the aire Saint-Mittre into "un vaste lit où la clarté dormait" ("a vast bed where light was sleeping," 10); while later "la lune faisait de chaque rocher un fût de colonne tronqué, un chapiteau écroulé, une muraille trouée de mystérieux portiques" ("the moon changed each rock into a truncated column, a crumbled capital, a wall pierced by mysterious porticos," 162); and again "des taches rouges apparurent . . . la lune . . . les faisait étaler comme des mares de sang" ("red spots appeared . . . the moon . . . made them spread out like pools of blood," 251). In all these cases, and frequently elsewhere in this novel, moonlight triggers and justifies a comparison. The same is true in the following example from *La Joie de vivre:* "au bord d'un chemin désert, un grand peuplier isolé et noir, que la lune à son lever surmontait d'une flamme jaune; et l'on aurait dit un grand cierge brûlant dans le crépuscule, au chevet de quelque grande morte, couchée en travers de la campagne" ("beside a deserted path, [there was] a large poplar, alone and black, that the rising moon covered with a yellow flame; and one would have said a large candle burning in the twilight, at the bedside of a large corpse, lying across the countryside," 977–78).

Artificial light may also motivate comparisons, as in *Germinal:* "la clarté rougeâtre des trois lampes . . . donnait à cette salle souterraine un air de caverne scélérate, quelque forge de bandits" ("the reddish light from the three lamps . . . lent this subterranean room the air of a wicked cavern, some bandits' forge," 1181). However, the most frequent and noticeable motivator of metaphoric transformation is sunlight, particularly in novels considered "impressionist," as in the following example from *L'Oeuvre:*

Un double courant de foule, un double fleuve y roulait, avec les remous vivants des attelages, les vagues fuyantes des voitures, que le reflet d'un panneau, l'étincelle d'une vitre de lanterne semblaient blanchir d'une écume. En bas, la place, aux trottoirs immenses, aux chaussées larges comme des lacs, s'emplissait de ce flot continuel.

(A double stream of humanity, a double river was flowing, with the living eddies of harnesses, the fleeing waves of coaches, which

a panel's reflection, a lantern glass's spark, seemed to whiten with foam. Below, the square, with its immense sidewalks, its lanes large like lakes, was filling up with this continual flow. 74–75)

Here reflections and sparks of light take on the watery appearance of foam, thus unifying and justifying the use of liquid imagery throughout the scene. The point of departure for the imagery, and the point of resemblance between the observed and imagined objects, is the liquid quality visually suggested by the effects of light. In essence, light not only triggers the image, it serves subsequently as a sort of "fixative" that holds the extended metaphor together.

Zola clearly found in light immense sources of metaphor and poetry: light was physical yet ethereal, visible yet malleable; light possessed its own particular properties of color, tone, and reflection, yet was by nature fleeting, nuanced, and suggestive; light was, in fact, *observable* and yet *poetic,* and thus fulfilled the conditions of Zola's theory of imagination. In Zola's claim that his imagination expressed both visual and poetic qualities—"leaping toward the stars on the springboard of precise observation"—light itself is the stuff these stars are made of.[28]

Zola's comparisons occasionally involve synesthesia, where the comparing term pertains to a different sense from that of the compared. No doubt the most famous of these involves the "symphony of cheeses" from *Le Ventre de Paris,* where odors are compared to musical sounds (see 357 and 830–33). Another such example, from *La Faute de l'abbé Mouret,* involves the same transposition from smell to sound: "she listened to the odors" (1515). Several examples—lesser known, perhaps, but every bit as striking—involve the transposition from vision to music, and the point of departure, the compared term, is, in every case, either light or color. In *La Curée,* for instance, "les clartés du lustre, très délicatement

28. Effects of light had always held great fascination and potential for poetic expression for Zola. He had written to Cézanne as early as 1860 that "c'est joli, c'est frais, c'est bien brossé; mais tout cela n'est qu'un tour de métier. . . . L'art est plus sublime que cela; l'art ne s'arrête pas aux plis d'une étoffe, aux teintes rosées d'une vierge. Voir Rembrandt, avec un rayon du lumière, tous ses personnages, même les plus laids, deviennent poétiques" (in *R-M,* IV, 1344). In another early letter, after describing a rather flat, "photographed" scene, Zola adds, "mais qu'il vienne un rayon de soleil qui fasse scintiller la paille jaune d'or, miroiter les flaques d'eau, qui glisse dans les feuilles de l'arbre, s'y brise, en ressorte en gerbes de lumière . . . dès ce moment, ce tableau n'aura-t-il pas, lui aussi, sa poésie?" (In Antonio De Carli, *En relisant Zola* [Torino, 1932].) In an article for *La Cloche,* written in 1872 while he was composing *Le Ventre de Paris,* he noted that "et selon qu'un rayon de soleil égaie Paris, ou qu'un ciel sombre la fasse rêver, la ville a des émotions diverses, devient un poème de joie ou de mélancolie" (in Patrick Brady, *"L'Oeuvre" de Emile Zola,* 95).

fouillé, chantaient une symphonie en jaune mineur, au milieu de toutes ces étoffes couleur de soleil" ("the lights from the finely detailed chandelier sang a symphony in yellow minor, amidst all these sun-colored fabrics," 350). In *Le Ventre de Paris,* the vegetables "chantaient toute la gamme du vert . . . gamme soutenue qui allait en se mourant . . . mais les notes aigues, ce qui chantait plus haut, c'étaient toujours les taches vives des carottes, les taches pures des navets, semées en quantité prodigieuse le long du marché, l'éclairant du bariolage de leurs deux couleurs" ("sang the entire scale of green . . . an elevated scale . . . but the sharp notes, singing higher, were still the intense spots of the carrots, the pure spots of the turnips, sown in great number along the market, lighting it with the medley of their two colors," 627). In *Une Page d'amour,* at Jeanne's funeral, with the description of the children's clothes, "tout ce blanc chantait" ("all this white was singing," 1077).

In addition to light and color, several other types of visual effect can also motivate metaphors, as in the following example from *L'Oeuvre,* where Christine sees "Notre-Dame qu'elle ne reconnaissait pas, vue ainsi du chevet, colossale et accroupie entre ses arcs-boutants pareils à des pattes au repos, dominée par la double tête de ses tours, au-dessus de sa longue échine de monstre" ("Notre-Dame, which she didn't recognize, seen thus from the rear, colossal and squatting between its flying buttresses, like resting paws, dwarfed by the twin heads of its towers, above its long monsterlike spine," 101). Here viewpoint ("seen thus") combines with the shape of the towers and the relative spatial position ("above") to motivate the comparison of Notre Dame to a monster. In most cases, light and color are combined with these other visual effects: with *space*— "les terres du Jas-Meiffran, plates et sans arbres, s'étendaient sous la lune comme une immense pièce de linge" ("the lands of Jas-Meiffran, flat and treeless, spread out under the moon like a vast piece of linen," *La Fortune,* 11)—with *shape*—"d'étranges rayons se jouaient, éclairant des formes vagues, des masses glauques, pareilles à des ébauches de monstres" ("strange rays were at play, lighting vague forms, watery masses, resembling the outlines of monsters," *La Curée,* 356)—with *line*—"tout ce fer mettait là, sous la lumière blanche des vitrages, une architecture légère, une dentelle compliquée où passait le jour, la réalisation moderne d'un palais du rêve" ("all this steel, in the white light of the windows, created a light architecture, a complicated lattice through which daylight passed, the modern fulfillment of a dream castle," *Au Bonheur des Dames,* 626)— and with *viewpoint*—"Le lac, vu de face, dans le jour pâle qui traînait encore sur l'eau, s'arrondissait, pareil à une immense plaque d'étain" ("The lake, seen opposite, in the pale daylight that still lingered on the water, grew rounder, like an immense pewter plate," *La Curée,* 325).

In the following sentence from *La Joie de vivre*—"Lazare restait une minute immobile, à regarder un bateau pêcheur de Port-en-Bassin, dont la voile grise rasait l'eau comme l'aile d'une mouette" ("Lazare remained motionless for a minute, watching a fishing boat from Port-en-Bassin, whose gray sail skimmed the water like a gull's wing," 973)—the reader witnesses the same operation, as the color gray combines with the shape of the sail to trigger the comparison with a gull's wing. However, it is not the shape of the boat, but of a part of the boat, its most salient visual feature, its sail (which, technically speaking, does not itself skim the water), that catches Lazare's eye, signaling the process of focusing not on the whole entity, but on qualities, segments, details, parts, which is a mark of visual synecdoche.

(2) Synecdoche of the part for the whole dominates Zola's novels, as in the example from *Le Ventre de Paris* cited earlier ("the delicate greens of the lettuces," 614), where a quality (color) is brought to the fore by promoting it grammatically (from the usual adjective to the more dominant noun) and syntactically (the color noun precedes the object, whereas the adjective would follow it in French). In fact, Zola's reputed "myopic" or "telescopic" vision often leads to a doubled effect of focusing, as in *La Curée*—"Les verdures étaient d'un vert tendre et délicat" ("The greens were a tender and delicate green," 585)—where the color green is twice nominalized and twice modified. As in the earlier example from *Le Ventre,* the synecdoche is an entirely visual process, often involving the displacement toward light or color.

In the following example, from *Germinal,* light is the motivator of the figure: "Des formes spectrales s'y agitaient, les lueurs perdues laissaient entrevoir une rondeur de hanche, un bras noueux, une tête violente, barbouillée comme pour un crime. Parfois, en se détachant, luisaient des blocs de houille, des pans et des arêtes, brusquement allumés d'un reflet de cristal" ("Ghostly forms were stirring, isolated lights left partially visible the roundness of a thigh, a sinewy arm, a violent head, blackened as for a crime. Sometimes, emerging, were blocks of coal, flat sections and edges, suddenly lit with a crystalline reflection," 1165). Here parts of the miners and the mine are highlighted (literally) with no perception of the whole entities to which they belong. Furthermore, in the case of "the roundness of a thigh," one quality of one body part is nominalized, thus achieving a double synecdoche where a part of a part replaces the whole. Such examples are surprisingly frequent in Zola's novels, as in the opening paragraph of *Le Ventre de Paris:* "Un bec de gaz, au sortir d'une nappe d'ombre, éclairait les clous d'un soulier, la manche bleue d'une blouse, le bout d'une casquette, entrevus dans cette floraison énorme" ("A gaslight,

at the edge of a sheet of darkness, lit up the nails of a shoe, the blue sleeve
of a shirt, the brim of a hat, glimpsed in this enormous flowering," 603).
Again the synecdoche is presented as a visual effect ("glimpsed") trig-
gered by an effect of lighting, which reduces the obfuscated entities
(men) to parts (a shoe, a shirt, a hat), which are further reduced to their
parts (nails, a sleeve, a brim). The relationship of inclusion inherent in
synecdoche takes the form of a visual *mise en abyme* or *emboîtement*
("bracketing" or "boxing"), which appears again in the following exam-
ple from *La Curée:* "il apercevait des coins de redingote qui fuyaient
effarouchés" ("he saw corners of frock coats fleeing in fright," 466). Here
the men are reduced to parts of a garment to which are then attributed the
movement ("fleeing") and emotions ("fright") that belong, in fact, to the
whole (the men) not the parts (of their clothing). Another such example
is found in *Nana:* "Dans une loge, un coin d'épaule nue avait une
blancheur de soie" ("In a box, a corner of naked shoulder had a whiteness
of silk," 1102). Here the part ("corner") of the part ("shoulder") is then
defined by a quality in the nominal form ("a whiteness"). This fragmenta-
tion (here focusing on body parts) is particularly appropriate to the super-
ficial, precarious, and ultimately dehumanized sensuality of *Nana,* and
the technique can be found deployed in numerous other examples, such
as "Le long du couloir, par les fentes, on apercevait des coins de nudité,
des blancheurs de peau, des pâleurs de linge" ("Along the corridor,
through the cracks, one could see corners of nudity, whiteness of skin,
paleness of linen," 1222). It is encountered in novels as disparate as *Au
Bonheur des Dames*—"des moitiés d'épaules et de bras" ("halves of shoul-
ders and arms," 627)—and *La Terre*—"Parmi la masse des blouses, con-
fuse et de tous les bleus, depuis le bleu dur de la toile neuve, jusqu'au bleu
pâle des toiles déteintes par vingt lavages, on ne voyait que les taches
rondes et blanches des petits bonnets" ("Amidst the mass of shirts, mud-
dled and of many blues, from the hard blue of new cloth, to the pale blue
of cloth faded by twenty washings, one could only see the round white
spots of the small bonnets," 508). Again one finds the process of double
focusing, where the workers and women are represented first by particu-
lar items of clothing, which are then seen in terms of their colors. Here
the visual process serves a definite social function, situating the class and
economic standing of the obscured people.[29]

29. The same social use of visual synecdoche occurs in further examples from *La Terre*
("le bleu des blouses se fonçait," 510; "des blouses bleues se gonflaient au vent," 514) and
elsewhere ("la foule des bonnets blancs, des caracos noirs, des blouses bleues," *Le Ventre,*
628; "Pauline, absorbée, suivait jusqu'au soir, à l'horizon, la robe bleue de Louise et le
veston blanc de Lazare, au milieu des taches sombres des ouvriers," *La Joie de vivre,* 938).

As the above examples suggest, synecdoche not only functions as social designator, identifying class by clothing and color, but also constitutes one of the primary techniques or modes of seeing in Zola's renowned depiction of crowds. Individuals are reduced to a common, generalized denominator, which serves as visual shorthand for the entire group, thus simplifying and unifying the description. That denominator is often clothing color, as in the above examples and another cited earlier from *L'Argent:* "les marches et le péristyle étaient noirs d'un fourmillement de redingotes" ("the steps and peristyle were black with a swarming of frock coats,"23). Zola's notes for the latter novel, based on his own observations of activity at the Bourse, clearly reveal this process of visual generalization: "Dans cette foule, c'est le noir des redingotes qui domine, et le noir luisant des chapeaux. Pas une note claire" ("In this crowd, it's the black of the frock coats that dominates, and the shining black of the hats. Not a single light note," 1338). Crowds can also be depicted by focusing on specific body parts, as in *L'Argent*—"il y avait là . . . de grasses faces luisantes, des profils desséchés d'oiseaux voraces, une extraordinaire réunion de nez" ("there were . . . fat shiny faces, dried up profiles of birds of prey, an extraordinary collection of noses," 24; see also 310 and 325)—*Nana*—"une confusion, un fouillis de têtes, de bras, qui s'agitaient, les uns s'asseyant" ("a muddle, a jumble of heads, of arms, which were stirring, some seating themselves," 1104)—and *L'Oeuvre*—"tous les nez, le nez magistrat, le nez industriel, le nez décoré" ("all sorts of noses, the magistrate's nose, the industrialist's nose, the decorated nose," 299; see also 127, 250, 287, and 299). The above examples point to a relatively unnoticed aspect of Zola's style, again linked to the process of visual synecdoche: namely, his social satire, where a comic effect is achieved by attributing a verb ("seating themselves") or an adjective ("decorated") that pertains to the whole to a part with which it is incompatible (arms and noses).

This use of synecdoche, not just as social shorthand, but as social satire, can be found in numerous examples, some sustained over entire novels. In *La Fortune des Rougon* the individuals composing Félicité Rougon's reactionary group are repeatedly referred to by the room they occupy, the renowned and redoubtable "yellow salon."30 Satire is enhanced by the comic effect of attributing characteristics of the individuals (human traits) to the room that encompasses them, as in "the yellow

30. It can be argued that this synecdoche involves the transfer from part (individuals) to whole (the group, indeed, the room where they are found), or from whole (the individual) to part (reduced to one's milieu). The point is, as Rice and Schofer wisely argue, that the process is based on inclusion (*Rhetorical Poetics,* 28–30). In Zola's case, we might add that his is a *visual* process of *spatial* inclusion.

salon was master of Plassans" (99), "the opinion of the yellow salon" (104), along with verbs such as "gossip" (103), "agitate" (108) and "consternate" (109).[31]

Synecdoche serves more serious purpose in several novels. It underscores confusion in crowd scenes in *Eugène Rougon* ("a forest of arms," 98) and *Germinal* ("a mixture of arms," 1268). It creates a sense of fragmentation and disintegration in *La Bête humaine,* where the passing train produces visions of "faces glimpsed in a flash" (1175–76), and especially in *La Débâcle,* where the dismemberment in a hospital scene underscores the destruction and dehumanization of war: "il y avait des mains cassées, des doigts qui tombaient, retenus à peine par un fil de peau. Les jambes et les bras fracturés semblaient les plus nombreux, raidis de douleur, d'une pesanteur de plomb" ("there were broken hands, fingers falling off, barely attached by a strip of skin. Fractured legs and arms seemed most numerous, stiffened in pain, heavy like lead," 671).

In *L'Oeuvre,* synecdoche serves to stress the incompleteness of Claude's work, the disintegration of his talent, and finally the fragmentation of his personality as he slips into madness (represented also by his loss of visual contact with reality). From the outset Claude's work is limited to "d'admirables morceaux, des pieds de fillette, exquis de vérité délicate, un ventre de femme surtout" ("admirable parts, a young girl's feet, exquisite in delicate truth, a woman's belly especially," 44), a limitation often expressed as a double reduction: "un ton de la gorge . . . une ligne du ventre" ("a tone of the chest . . . a line of the belly," 242). The fragmentary aspect of Claude's work, mirroring that of his psyche and vision, is depicted at different moments of the novel by the insistence on parts and fragments. The disintegration of Mahoudeau's statue on Claude's wedding day (224), the disappearance of his painting bit by bit as night falls (265), his son's grotesque head (258), his eyes bulging out of their sockets before his uncompleted masterpiece (352), the finality of his funeral, represented by the disappearing cassocks of the priest and altar boy (362), all are rendered by the insistence on parts whose whole entity is never to be restored, recaptured.

Interestingly, Claude's tendency to focus on parts or fragments, captured by Zola's use of synecdoche—"en croyant distinguer quelque dos de sa connaissance" ("believing he recognized some back that he knew," 105); "on voyait le dos de Bongrand s'irriter" ("one could see Bongrand's back get angry," 187)—constitutes a major tenet of realism for Duranty: "By means of a back, we want a temperament, an age, a social condition

31. Other humorous examples of social satire involve "habits noirs" (*La Curée,* 350, 439, 558, 561, 563) and "redingotes" (*Son Excellence Eugène Rougon,* 86, 97, 109, 257).

to be revealed."[32] Synecdoche also figures heavily in Monet's appreciation of Japanese prints: "Their refinement of taste has always pleased me, and I approve of the suggestions of their aesthetic code, which evokes presence by means of a shadow, the whole by means of a fragment."[33] Monet's judgment is echoed curiously by the painter and would-be musician Gagnière's definition of the "impression" in *L'Oeuvre:* "une impression. . . . Pour moi, d'abord, c'est un paysage qui fuit, un coin de route mélancolique, avec l'ombre d'un arbre qu'on ne voit pas" ("an impression. . . . For me, first of all, it's a fleeing landscape, a melancholy roadside, with the shadow of an unseen tree," 84). In both cases, synecdoche (Monet's fragment that evokes the whole, Gagnière's "roadside") is identified with the impressionist aesthetic. Both examples also involve effects that suggest absent causes—for Monet, presence by means of a shadow, for Gagnière, the unseen tree by its shadow. The suggestion of a cause by means of an effect constitutes another figure found frequently in Zola's novels, metonymy.

(3) Metonymy involves the transposition from one form of expression (literal) to another (figurative), on the basis of their causal relationship. For example, an effect can replace its hidden cause, as in the example cited earlier from the opening chapter of *L'Oeuvre:* "La porte s'éclaira" ("The doorway lit up," 15). The reflexive verb with an inanimate subject—"la porte s'était ouverte" ("the door had opened," 70)—or an impersonal subject—"il se fit un grand silence" ("there fell a great silence," 16)—seem ideally designed to exclude the cause, the subject acting to open the door or to create silence. A personal subject can also involve metonymy: "Et Dubuche s'en alla vers la Richaudière, et Claude le regarda qui se rapetissait au milieu des cultures, avec la soie luisante de son chapeau et la tache noire de sa redingote" ("And Dubuche went off toward la Richaudière, and Claude watched him grow smaller amidst the gardens, with the shiny silk of his hat and the black spot of his frockcoat," 158). Here Dubuche's decreasing size suggests the visual effect on the observer, Claude, as Dubuche walks away; a more literal rendering would have been "Dubuche s'éloigna" ("Dubuche grew more distant"; see, for example, 304).

The most frequent and consistent use of active verbs to produce visual

32. *La Nouvelle Peinture: A propos du groupe d'artistes qui expose dans les galeries Durand-Ruel* (Paris: Marcel Guérin, 1876), repr. in *Impressionism and Post-Impressionism: 1874–1904,* ed. Linda Nochlin (Englewood Cliffs, N.J.: Prentice-Hall, 1966), 5.

33. In John Rewald's *The History of Impressionism,* 4th rev. ed. (New York: MOMA, 1973), 209.

effects involves elements of the decor: "des lignes d'édifices filaient" ("lines of buildings filed by," 74); "le pavillon de Flore . . . s'avançait" ("the pavillon de Flore . . . was advancing," 103), "deux flèches s'élançaient" ("two steeples thrust upward," 213); "les ponts jetaient des barres de lumières" ("the bridges cast bars of light," 339). Obviously the pavillon de Flore, the building terminating the Seine-side wing of the Louvre, is no more capable of "advancing" than bridges are of "casting bars of light"; again, the real causes of these appearances, viewer eye movement or atmospheric conditions (both prime attributes of impressionism), have been suppressed in favor of the visual effects or impressions. The net effect is to activate Paris and demonstrate the interaction of object and observer. As in Gagnière's description of impressionism, the reader often sees only shadows—"il fut étonné de cette ombre immobile" ("he was astounded by this motionless shadow," 243)—and sometimes nothing at all—"pas une lueur de lanterne ne luisait" ("not a lantern light was glowing," 12). In this final example from L'Oeuvre, enhanced by alliteration, once the reader deduces the absent cause (a cab), it turns out not to be there after all.

The main motivators of metonymy in Zola's novels are effects of light and color and, especially, movement, also at the core of impressionist innovation.[34] In the following example, from the opening scene in La Curée—"le lac et les petits bois évanouis dans l'ombre ne furent plus, au ras du ciel, qu'une barre noire" ("the lake and small woods vanishing in the darkness were no more on the skyline than a black bar," 326)—the transformation of the woods into a black bar is due to the stated light condition (darkness) and the unstated movement of the carriage through the Bois de Boulogne, away from the woods, which then appear to recede ("vanishing"). The same conditions of light and movement concur in Le Ventre de Paris, again in the opening scene. As Florent approaches Paris in Mme François's wagon, it stops momentarily, thus producing the effect, the illusion, of Paris receding—"Florent n'avançait plus, l'avenue s'allongeait toujours, reculait Paris au fond de la nuit" ("Florent was no longer advancing, the avenue was still growing longer, pushing Paris back into the depths of the night," 607). In the same scene, Zola had originally described, in the serial version published in L'Etat "des becs de gaz qui allaient tout là-haut" ("gaslights going up"),[35] which

34. As Arnold Hauser has noted, "Modern technology thus introduces an unprecedented dynamism in the whole attitude to life and it is above all this new feeling of speed and change that finds expression in impressionism" (Naturalism, Impressionism, the Film Age, vol. 4 of The Social History of Art [New York: Vintage Books, 1951], 168).

35. In R-M, I, 1624.

became "des becs de gaz qui se rapprochaient et se confondaient" ("gas-lights growing nearer and more confusing," 605) in the definitive version of the novel. The change bears direct (albeit limited) testimony of Zola's efforts to capture the effects produced on the observer, effects triggered again by conditions of light and movement. Such effects replace absent, unseen causes in numerous passages, from *Le Ventre*—"des lanternes, autour de lui, filaient doucement, s'arrêtaient dans les ténèbres" ("lanterns around him moved softly, stopping in the shadows," 608)—to *Germinal*—"il aperçut la chandelle qui filait" ("he saw the moving candle," 1368)—to *La Débâcle*—"tout à coup, près des cantines, une grande lueur éclata" ("suddenly, near the canteens, a great light struck," 417). Not unexpectedly, the rapid movement of the train in *La Bête humaine* accelerates and accentuates such effects of movement, and Zola mentions them frequently, as when Séverine recounts to Jean her experience on the train while she and Roubaud killed Grandmorin: "des arbres défilaient furieusement" ("trees flashed by furiously," 1200); "les arbres noirs qui défilaient" ("the black trees flashing by," 1202); "Derrière mon dos, la campagne fuyait, les arbres me suivaient d'un galop enragé, tournant sur eux-mêmes, tordus, jetant chacun une plainte brève, au passage" ("Behind my back, the landscape was flying by, the trees were following me at a furious gallop, turning on themselves, twisted, each one uttering a brief moan, in passing," 1203). Here, of course, the visual effects are heightened by the psychological state of Séverine, which leads to another dimension of Zola's figures, to another, more interior, more private space.

The Space of Fear and Desire

Zola's figures—metaphor, synecdoche, and metonymy—thus reveal a dominant form for each: motivated comparisons, part for the whole, and effect for the cause, respectively. These forms prevail throughout the entire Rougon-Macquart series, and the exterior motivation is also consistent throughout his novels—light and color on the one hand, viewpoint and movement on the other, trigger the comparisons, focus attention on a particular part of an object, or emphasize the effect of an event. This emphasis coincides with the major innovations of impressionism. Indeed, figures are impressions. Light and color, through their elastic, formless properties, trigger the figures, open the space of impression and imagination. Movement, through its transience, stretches that space.

But what factors dominate that space, form the images, shape the

figures, give contours to the comparisons, focus on particular parts, select the effects that will emerge and dominate? What makes the viewer see a "dream castle" or an "ocean" of rooftops, focus on a back or a shoulder, perceive stationary objects as approaching or receding? As early as the second novel of the Rougon-Macquart series, *La Curée,* the narrator provides the reader with the elements of an answer. As Renée and Maxime make incestuous love in the greenhouse, visions occur: "C'était alors, au milieu de la lueur pâle, que des visions les hébétaient, des cauchemars dans lesquels ils assistaient longuement aux amours des Palmiers et des Fougères; les feuillages prenaient des apparences confuses et équivoques, que leurs désirs fixaient en images sensuelles" ("It was then, in the middle of the pale light, that the visions dazed them, nightmares where they watched at length the love-making of Palms and Ferns; the foliage assumed confused and ambiguous appearances, which their desires fixed into sensual images," 487). These visions form in ways similar to Zola's figures. An effect of light or color ("the pale light") opens the space of impression and imagination ("visions" and "nightmares") and breaks down the material form of objects into "confused and ambiguous appearances," which their desires then shape ("fixed") into specific figures ("sensual images").

The fixative of the figure is desire, along with, as shall be seen, its partners, fear and guilt. In fact, desire and fear often direct the viewer toward the space of the impression, that of the absent object, that of the shadow: "Et, les yeux errants, il s'efforçait de percer les ombres, tourmenté du désir et de la peur de voir" ("And, his eyes wandering, he forced himself to pierce the shadows, tormented by the desire and the fear to see," *Germinal,* 1137). And it is from the shadow, from the space of imagination that the image emerges: "l'image était ressortie de l'ombre, en se précisant, en s'accentuant, jusqu'à devenir l'obsession de toutes ses heures" ("the image had emerged from the shadow, defining itself, accentuating itself, until it became the obsession of all his hours," *L'Oeuvre,* 91). The sense of process, of the image forming through the action of desire, fear, or guilt, is represented frequently in Zola's novels, as in *La Joie de vivre*—"Du trouble de son cerveau, des images se précisaient, se dressaient" ("From his troubled mind, images were taking shape, rising up," 1043)—and *La Faute de l'Abbé Mouret*—"la faute se précisait avec une effrayante netteté" ("the sin was taking shape with frightening clarity," 1483). The process of imagination is identical for hallucination (which will be examined in some detail later) and figuration. In fact, Zola's depiction of the role of desire in forming the image within the hazy space of imagination corresponds remarkably with Lyotard's description of figuration in *Discours/Figures:* "the sensory forms at the same time as desire, from which

it receives its depth, its hidden side"; "A scene without backdrop is an open space on which desire and anguish represent their offshoots endlessly and freely."[36] For Zola, all types of figures are formed through a dialectical interplay involving the reception of light (impression) and the projection of desire (expression).

Traces of this interplay can be found in the figures themselves. Zola's comparisons, for example, while true to the milieu (since they are spawned by effects of color and light), are also true to the personality or mental state of the character observing that milieu. It is hardly surprising that Rougon's band of fear-stricken reactionaries in *La Fortune des Rougon,* waiting in the darkness for the arrival of the counterrevolutionary army, would see the scene in terms of the following images: "ils interrogeaient les blancheurs vagues. Et, dans l'ombre indécise ils entrevoyaient des profils monstrueux, la plaine se changeait en lac de sang, les rochers en cadavres flottant à la surface, les bouquets d'arbres en bataillons encore menaçants et debout" ("they peered into the vague whiteness. And in the uncertain darkness they glimpsed monstrous profiles, the plain changing into a lake of blood, the rocks into cadavers floating on the surface, tufts of trees into battalions still standing and threatening," 252). Here the conditions of light ("vague whiteness") and shadow ("uncertain darkness") open the space of imagination, which is then filled with images formed by the reactionaries' fears. (Note also the fine line between what is figure or comparison for the reader and hallucination for the characters, a line I intend to explore later.)

It is also understandable that the luxury-minded Renée (*La Curée*) and her sister would be struck by light effects that then transform the Seine into visions of beautiful gowns (403). Similarly, the child Jeanne (*Une Page d'amour*) sees Paris as a "childish watercolor" (1029), and, abandoned by her mother, sees the sun through the rain as a "smile through the tears" (1029). In addition, the five major descriptions in *Une Page d'amour,* show Paris transformed by changes in lighting and atmosphere into images of transparency, fire, constellations, flood, and purity, but each scene is also patently linked to the observer's state of mind, as Hélène's awakened love turns to passion, mystery, disaster, and oblivion. The metaphors reflect the milieu, on the one hand, and the "human dimensions" of description alluded to by Zola in the novel's preface, on the other.[37]

One can often follow the modulations and progressions from color to

36. "le sensible se constitue en même temps que le désir et reçoit de lui son épaisseur, sa face cachée"; "Une scène sans toile de fond, c'est un espace ouvert pour que le désir et l'angoisse y représentent sans fin et sans loi leurs rejetons." *Discours/Figures,* 51 and 198.

37. See the third epigraph heading Chapter 4.

emotion, as in the scene where the bourgeois watch the marching miners in *Germinal:*

> A ce moment, le soleil se couchait, les derniers rayons, d'un pourpre sombre, ensanglantaient la plaine. Alors la route sembla charrier du sang. Les femmes, les hommes continuaient à galoper, saignants comme des bouchers en pleine tuerie. —Oh! superbe dirent à demi-voix Lucie et Jeanne, remuées dans leur goût d'artistes par cette belle horreur. Elles s'effrayaient pourtant. . . . C'était la vision rouge de la révolution.

> (At that moment the sun was setting, the last rays of deep purple bathed the plain in blood. Then the road seemed to sweep the blood along. The women, the men continued to gallop, bloodied like butchers in the midst of slaughtering. —Oh! superb murmured Lucie and Jeanne, their artists' taste stirred by this beautiful horror. They became frightened, however. . . . It was the red vision of the revolution. 1436)

Here the light from the setting sun creates a purple color, transformed by fear into a metaphor of blood, which increases in precision and intensity, then covers the miners, generating a further and more specific comparison with butchers. The initial admiration of Lucie and Jeanne becomes outright fear, which leads to the more pervasive metaphor of the red revolution, still as true to the color that spawned it as to the fears that shaped it.

A single visual effect can engender more than one comparison, as in the following description of Paris seen jointly by Jeanne and Hélène in *Une Page d'amour:* "éclairé par les nuées saignantes, pareil à quelque ville des légendes expiant sa passion sous une pluie de feu" ("lit up by the bloodied clouds, like some legendary city expiating its passion under a rain of fire," 911). Here the light produces metaphors common to both characters ("bloodied . . . rain of fire") in addition to ones reflecting the child Jeanne's readings ("legendary city") and her mother Hélène's guilt ("expiating its passion"). The same invariant conditions of light can produce metaphoric modulations through the variable of desire. Similarly, the sun's rays often produce comparisons with gold, which can vary with the character. In *La Curée,* the greedy Aristide sees the sun as a "gold ingot" (388) and later in *L'Argent* as "golden music" (108), while in *La Faute* the religious but prideful Serge sees his church as "gilded" (1484 and 1296), and the charitable Angélique in *Le Rêve* sees the sun's gold as "alms" (988).

A variety of comparisons can be used to suggest the many facets of a character's personality without Zola's having recourse to the narrator's commentary or analysis. Thus, in *L'Oeuvre,* when Claude Lantier observes the Cité "at all hours and in all weather" (231), the variety of comparisons reflects the various conflicting aspects of his personality. Referred to by Sandoz as a "grand coeur d'enfant" ("big child at heart," 361), he sees the Cité "retrouver une enfance" ("rediscover childhood"); the dreamer who saw the pavillon de Flore as a "château du rêve" ("dream castle," 103) here sees a "palais des songes" ("dream palace"); the violence that leads him to destroy paintings with a knife produces "une lumière louche de coupe-gorge" ("a shady cutthroat light"); and his timidity with nudity and repressed sexuality (see 243) lead him to see the Cité "nue et flagellée" ("nude and scourged").

One can trace the progress, the modulations, and crystallizations of desire as it cathects objects or seeks its real object through the comparisons attributed to the characters. This is particularly true in novels like *La Curée, Une Page d'amour,* or, especially, *La Faute de l'abbé Mouret,* where sexual desire, repression, and contravention are more overtly central to the thematic content than in novels of broader social scope, like *Germinal* or *La Débâcle.*

In part II of *La Faute,* as Serge emerges from his coma to be reborn in le Paradou, the comparisons engendered by the sky reflect conflicting sides of his personality: "Ce n'était pas tout du bleu, mais du bleu rose, du bleu lilas, du bleu jaune, une chair vivante, une vaste nudité immaculée qu'un souffle faisait battre comme une poitrine de femme" ("It wasn't all blue, but pink blue, lilac blue, yellow blue, living flesh, a vast, immaculate nudity that a breath [of air] made beat like a woman's breast," 1324). The colors produce the oxymoronic comparison with an immaculate nudity, reflecting the religious and the sensual sides of Serge, with the dominant, though repressed, sexuality leading to the comparison with a woman's breast. The comparisons both reflect desire and allow it an avenue of expression around the barriers of repression into the sanctioned domain of the imagination.

In a later sortie into the garden, colors again trigger comparisons embodying the same contradiction:

> La vie rieuse du rose s'épanouissait ensuite: le blanc rose, à peine teinté d'une pointe de laque, neige d'un pied de vierge qui tâte l'eau d'une source; le rose pâle plus discret que la blancheur chaude d'un genou entrevu, que la lueur dont un jeune bras éclaire une large manche; le rose franc, du sang sous du satin, des épaules nues, des hanches nues, tout le nu de la femme, caressé de lumière.

(Then the laughing life of pink opened up: pink-white, barely tinted with a touch of lacquer, snow of a virgin's foot testing springwater; pale pink more discreet than the warm whiteness of a glimpsed knee, than the light that a young arm shines on a wide sleeve; pure pink, blood beneath satin, naked shoulders, naked thighs, all the nakedness of a woman, caressed by light. 1340)

Here the description follows a progression from the virgin, to the child revealing glimpses of the body, to the outright nudity of the woman, "caressed" by light.

In the systematic search by Serge and Albine for the "immense tree," the comparisons attributed to the trees in the garden tell the tale of evolving desire. In chapter XI, for example, the trees are compared to a church:

Ils entrèrent enfin sous les futaies, religieusement, avec une pointe de terreur sacrée, comme on entre sous la voûte d'une église. Les troncs droits, blanchis de lichens d'un gris blafard de vieille pierre montaient démesurément, alignaient à l'infini des enfoncements de colonnes. Au loin, des nefs se creusaient.

(They finally entered the cluster of high trees, religiously, with a touch of sacred fear, as when entering a church's vault. The straight trunks, lightened with lichens to a pale gray like old stone, rose inordinately, aligning endless recesses of columns. In the distance, naves were forming. 1378)

Once again the comparisons are triggered by visual effects of light, color, and line, but are formed into religious images (vault, stone, columns, nave) by the characters' mental disposition ("religiously," "sacred").

In the following paragraph, however, the repressed side of sensuality emerges through the comparisons, as the trees are compared to bodies:

Les ormes avaient des corps énormes, des membres gonflés, engorgés de sève, à peine cachés par les bouquets légers de leurs petites feuilles. Les bouleaux, les aunes, avec leurs blancheurs de fille, cambraient des tailles minces, abandonnaient au vent des chevelures de grandes déesses, déjà à moitié métamorphosées en arbres.

(The elms had enormous bodies, swollen extremities, gorged with sap, barely hidden by the light tufts of their small leaves. The birches, the alders, with their girlish whiteness, arched their thin

waists, abandoned to the wind their tresses of great goddesses,
already half-changed into trees. 1378)

Again, visual effects of size, color, and shape spawn the images, which
are shaped by growing sexuality into parts of the human anatomy.

This contradiction of repression (religion) and desire (sexuality) is re-
solved later in the chapter, first on the level of the comparisons, as the
trees form bodies that enter a church: "Au loin, le long des colonnades, il
y avait des coups de soleil couchant, pareils à un défilé de filles en robes
blanches, entrant dans l'église, pour des fiançailles, au sourd ronflement
des orgues" ("In the distance, along the colonnades, there were shafts of
setting sunlight, resembling a line of girls in white dresses, entering a
church, for engagement ceremonies, to the muted roar of the organ,"
1381). Here the formerly conflicting desires cooperate as the church sanc-
tions sexuality in the sanctity of future marriage. This resolution on the
level of the comparisons (that is, one might say, on the level of uncon-
scious desire) is followed closely by a promise of resolution on the level of
action, when the characters kiss and admit their love as the chapter ends.

There follow several chapters (12–14) of embarrassment, repentance,
fear, guilt, and resultant repression, leading back to the oblique expression
of desire through the comparisons, as Serge sees various states of the sky:

> Il les ravissait à toutes les minutes de la journée, changeant comme
> une chair vivante, plus blanc au matin qu'une fille à son lever, doré
> à midi d'un désir de fécondité, pâmé le soir dans la lassitude
> heureuse de ses tendresses. . . . ou encore un coucher passionné,
> des blancheurs renversées, peu à peu saignantes sous le disque
> embrasé qui les mordait, finissant par rouler avec lui derrière
> l'horizon, au milieu d'un chaos de membres tordus qui s'écrou-
> laient dans de la lumière.

> (It delighted them at every moment of the day, changing like
> living flesh, whiter in the morning than a waking girl, golden at
> noon with a desire of fertility, swooning in the evening in the
> happy weariness of its tenderness. . . . or yet a passionate sunset,
> whiteness leaning back, gradually bleeding under the glowing
> disk that bit it, ending up by tumbling with it behind the horizon,
> amidst the chaos of twisted extremities that crumbled in the light.
> 1391)

Here the comparisons, engendered again by effects of light and color, are
unilaterally sensual. Desire is unattenuated by repression; its realization

will follow shortly in chapter XV, as the characters find the big tree and reenact the seduction of Adam by Eve. The tree itself, because of its size and shape, is depicted as an overt symbol of male virility:

> Il avait une taille géante, un tronc qui respirait comme une poitrine, des branches qu'il étendait au loin, pareilles à des membres protecteurs. Il semblait bon, robuste, puissant, fécond; il était le doyen du jardin, le père de la forêt. . . . Sa sève avait une telle force, qu'elle coulait de son écorce; elle le baignait d'une buée de fécondation; elle faisait de lui la virilité même de la terre.

> (It had gigantic size, a trunk that breathed like a chest, branches that it extended afar, resembling protective extremities. It seemed good, robust, powerful, fertile; it was the dean of the garden, the father of the forest. . . . Its sap had such force that it ran from its bark, bathing the tree in a mist of fertility, making it the very virility of the earth. 1404)

As Serge comes to grips with his own sexuality, the comparisons are unequivocally sexual, the desire unattenuated and undisguised, the motivations more and more internal. In a state of pure "impression"—"Couleurs, parfums, sonorités, frissons, tout restait vague, transparent, innommé, pâmé d'un bonheur allant jusqu'à l'évanouissement des choses" ("Colors, odors, sounds, shivers, everything remained vague, transparent, unnamed, swooning with a happiness leading to the vanishing of things")—the tree exhales "la mollesse d'un désir. . . . Il n'était plus qu'une volupté" ("the softness of desire. . . . It was nothing more than voluptuousness" 1405). In this state of pure desire, untempered by reality, the characters make love, as matter itself "turned the park into a great fornication" (1409), and the chapter ends. In the final chapter of part II, however, reality reasserts itself in the vision of the village des Artaud, the person of the Frère Archangias, and the law of the Father—"In the name of God" (1417)—which conspire to call Serge back to his role as abbé, back to the rule of repression.

Very rarely is it the narrator's concerns, not the characters', that guide the impression toward the image, that form its light and color into contour and shape. *Une Page d'amour* is the only novel in the series whose title points to its literariness, and this concern with the text as text emerges through comparisons formulated by the narrator. In the final chapter (1083), for example, the words *page, plume* (pen), and *ligne* (line) recall the writing process, as do comparisons using *encre* (ink) and the verb *dessiner* (draw) throughout the novel.

The narrator (however rarely he appears) is, like the characters, simply another manifestation of the author, who becomes absorbed in his literary creations and assumes their desires, just as they reflect his—much as a comparison expresses the repressed desire of a character, so that character can express the repressed desire of the author.[38] (This complex relationship is examined further in a visual context in the section of this chapter on creative hallucination.)

Like comparison, synecdoche and metonymy, triggered by effects of light and movement, are often focused and formed by fear and desire. Reduction of human entities to "corners of naked shoulders" points to the prevalence of sensual desire in *Nana,* while the "frock coats" in *Son Excellence Eugène Rougon* suggest the importance of status and power. In *La Joie de vivre,* as Pauline singles out certain colors—"Pauline, absorbée, suivait jusqu'au soir, à l'horizon, la robe bleue de Louise et le veston blanc de Lazare, au milieu des taches sombres des ouvriers" ("Pauline, absorbed, followed into the evening, on the horizon, the blue dress of Louise and the white jacket of Lazare, amidst the dark spots of the workers," 938)—the synecdoches reveal at once her desire and her jealousy.

The movements inherent in the forms of metonymy rendered through active verbs attributed to inanimate objects can also reflect the characters' emotional states. Just as the viewpoint can function to suggest domination by the milieu or the desire to escape, verbs such as *dominer* (dominate) or *s'enfoncer* (sink) mirror the characters' frame of mind, while remaining true to the visual circumstances of light, color, and movement that trigger the figure. In a passage cited earlier from *Le Ventre de Paris,* for example—"Florent was no longer advancing, the avenue was still growing longer, pushing Paris back into the depths of the night," 607)— the recession lends Paris a sense of inaccessibility, underscoring the mixture of fear and desire that characterizes Florent's concept of the city.

Figures occasionally arise internally, stimulated and formed by the imagination, without the motivation of the milieu. Jacques Lantier, for example, is subject to inner visions: "En lui, l'inconnu se réveillait, une onde farouche montait des entrailles, envahissait la tête d'une vision rouge. Il était repris de la curiosité du meurtre" ("Within him, the unknown was awakening, a savage wave arose from his innards, invaded his head with a red vision. He was consumed again by a curiosity about murder," *La Bête humaine,* 1204). Unlike the "red vision" of the revolu-

38. For a discussion of the psychocritical dimensions of the author-narrator-character relationship, see my "Displacement and Reversal in *Saint Julian,*" in William J. Berg, Michel Grimaud, and George Moskos, *Saint/Oedipus: Psychocritical Approaches to Flaubert's Art* (Ithaca: Cornell University Press, 1982), 25–67.

tion in the scene from *Germinal* examined earlier, an image stimulated progressively, dialectically, from without (by the colors of the setting sun) and from within (by the increasing fears of the bourgeois observers), Jacques's vision emerges solely from within, a sure sign of impending disaster, as will be seen in the section on hallucination later in this chapter.

In the vast majority of cases, however, the figure, the image, is produced dialectically, stimulated from without by the light-governed "impression," focused and shaped from within by desire's "expression." Formed by the interplay of reception from without and projection from within, the image is the intermediary between individual and milieu, or between competing components of the individual's psyche, as articulated by Zola's contemporary, Henri Bergson: "the image is the intermediary between the deep self and the surface self. . . . it helps us to conceptualize change itself, the undulations of reality, the continuity of substance, duration."[39]

Figuration furnishes yet another example of the significance of dialectical interplay in Zola's perceptual and stylistic modes. Imagination functions in the same way as the dialectic of color (reception) and line (projection) formulated by Arnheim[40] and the range of relationships between the individual and the milieu, running from determinism to projection, discussed in the previous chapter. The process of figuration or imagination, itself dialectic, fits into the broader process of visual perception, many of whose stages also operate dialectically. In fact, imagination is usually accompanied by a stage of rectification (or repression) that negates it.

Rectification: From Imagination to Identification

Imagination is part of the visual process by which the hazy impression first acquires the contours of the object, then yields to identification. In Zola's works, imagination nearly always occurs between the stages (light and line) of step two in the visual process (Diagram 20). In "figurative" perception, the lines that characterize "literal" perception are gently and temporarily distorted to espouse the contours of the figure, of the image. The figure must be corrected, replaced by the lines of the real object, if identification is to occur. This process of correction or rectification is thus a necessary component of perception and, as such, a significant aspect of

39. "l'image est l'intermédiaire entre le moi profond et le moi superficiel. . . . elle nous aide à penser le changement même, les ondulations du réel, la continuité substantielle, la durée." Cited in Yvon Belaval, *Poèmes d'aujourd'hui* (218–19), as quoted by Pierre Caminade, *Image et Métaphore* (Paris: Bordas, 1970), 59.

40. See Chapter 4, note 53.

$$1 \qquad\qquad 2 \qquad\qquad 3$$

observation \rightarrow sensation \rightarrow perception

(looking) (light \rightarrow line) (identification)

\uparrow

imagination

Diagram 20.

Zola's style. Although the "pavillon de Flore" may be transfigured temporarily by light and color and transformed into a "dream castle," the eye quickly rectifies this hazy image by supplying the line and form of the real object: "le pavillon de Flore sortait du rêve, se solidifiait dans la flambée dernière de l'astre" ("the pavillon de Flore was emerging from the dream, was solidifying in the final blaze of the sun," 103). The object returns from the space of imagination and desire (the dream) to reality, where its solidity is restored and its identity recuperated.

This figurative process, identical to literal vision except that a figure is also inserted between light and line, occurs with great frequency and impact in Zola's novels. In *Le Ventre de Paris,* for example, "Florent regardait les grandes Halles sortir de l'ombre, sortir du rêve, où il les avait vues, allongeant à l'infini leurs palais à jour. Elles se solidifiaient" ("Florent watched the large Halles emerge from the shadows, emerge from the dream, where he had seen them, extending their open-work palaces infinitely. They solidified," 626). Here the Halles emerge not only from the state of impression (the shadows), but from imagination (the dream), where they had been figuratively embedded by both metaphor (the palaces) and metonymy (the effect of extending). Similarly, in *Une Page d'amour,* Paris is at one point covered by clouds, when "une à une, les mousselines s'en allaient, l'image de Paris s'accentuait et sortait du rêve" ("one by one the muslins were leaving, the image of Paris was intensifying and emerging from the dream," 849; see also 1029).[41]

41. Likewise, in the opening chapter of *Germinal,* the mine appears to emerge not only from darkness but from imagination. The obscurity and sporadic light, which had led to "une vision de village, des lunes fumeuses, cette apparition fantastique" ("the vision of a village, murky moons, this fantastic apparition"), are rectified: "Le Voreux, à présent, sortait du rêve" ("The Voreux, at present, was emerging from the dream," 1135). The importance of visual rectification is evident in Zola's notes for this scene: "Comme distribution de la description, il ne faut d'abord qu'une masse presque informe, une vision fantastique de la fosse aperçue dans la nuit. Les quelques lanternes accrochées aux tréteaux, la porte de générateurs, les trois ou quatre fenêtres éclairées, et surtout les feux du terri. Etienne monte sur le terri et là trouve Bonnemort. Leur conversation s'engage. Bonnemort lui nomme le Voreaux. Et reprise de la description précisée, les choses sortant du rêve (ce qu'on voit du haut du terri, les forges lointaines, Montsou caché dans la nuit. Le vieux

This process of rectification characterizes Zola's vision and thus his style, on the level of the paragraph, the sentence, and the phrase, in the same way that emergence, causality, the dialectic of light and line, the three steps of the visual process, and the progression from impression to identification have been shown to characterize his vision and style. In fact, rectification is like emergence or identification, except that imagination has intervened in the process, and thus a return to reality is involved. In *La Fortune des Rougon,* for example, as Silvère engages in battle: "Ce fut alors qu'une ombre lui passa sur la face, comme si un oiseau eût effleuré son front d'un battement d'aile. Et, levant les yeux, il vit le drapeau qui tombait des mains de Miette" ("It was then that a shadow passed over his face, as if a bird had brushed his forehead with a fluttering wing. And, raising his eyes, he saw the flag fall from Miette's hands," 216). The impression (the shadow) opens the space of imagination and figuration (the bird), which is rectified by the real object (the fallen flag), itself a metonymy suggesting Miette's wounding. As Nana gathers strawberries, "Il lui avait semblé voir glisser une ombre. —Une bête! cria-t-elle. Mais la stupeur la planta au milieu de l'allée. C'était un homme, et elle l'avait reconnu" ("She had thought she saw a shadow gliding along. —An animal! she yelled. But astonishment froze her in the middle of the row. It was a man, and she had recognized him," 1235). The example is identical to those discussed in the preceding chapter, except that imagination ("an animal") interrupts the process before form ("a man") and identification ("she had recognized him") reinstate reality.[42] In the para-

désigne les lieux du doigt, dans le noir" (from the "Premier plan détaillé" to *Germinal,* in *R-M,* III, 1855). A strikingly similar scene occurs as Denise tries to cross the department store at night in *Au Bonheur des Dames:* "ces clartés éparses, pareilles à des taches jaunes, ressemblaient aux lanternes pendues dans des mines. Des grandes ombres flottaient, on distinguait mal les amoncellements de marchandises, qui prenaient des profils effrayants, colonnes écroulées, bêtes accroupies, voleurs à l'affût. Le silence lourd, coupé de respirations lointaines, élargissait encore ces ténèbres. Pourtant, elle s'orienta" ("these scattered lights, like yellow spots, resembled lanterns hanging in mines. Large shadows were floating, making it difficult to distinguish the piles of merchandise, which assumed frightening shapes, crumbled columns, crouching animals, thieves lying in wait. The heavy silence, broken by distant breathing, enlarged the shadows even more. Just the same, she oriented herself," 532). Again the lights and shadows disrupt literal perception and open up the space of impression, imagination, and fear, whose figures bear forms remarkably similar to those in *Germinal,* which are, as in the previous examples, subsequently rectified by spatial location, as Denise orients herself.

42. Similar examples occur in *Germinal* ("une ombre mouvante, une bête rampante et aux aguets, qu'il reconnut pour Jeanlin," 1491; see also 1151 and 1161) and *La Terre* ("il vit, sur la route, une ombre se détacher de la fenêtre et galoper au fond des ténèbres. L'idée lui vint de quelque chien rôdeur. C'était Buteau," 772; see also 619).

graph from *La Bête humaine* where Flore, spurned by Jean, walks down
the tracks toward the oncoming train (1273–74), effects of light and
darkness motivate a comparison of the train's light to a star—"elle
aperçut, très lointain, le fanal de l'express, pareil à une petite étoile,
scintillante et unique au fond d'un ciel d'encre" ("she saw, far away, the
headlight of the express, like a little star, sparkling and alone in the depths
of an inky sky"). As the train approaches, and Flore's suicidal desire
intensifies, imagination heightens and replaces reality, causing the previ-
ous comparison to become metaphor—"l'étoile était devenue un oeil
énorme, toujours grandissant, jaillissant comme de l'orbite des ténèbres"
("the star had become an enormous eye, still growing, spurting as from
the shadows' socket")—which intensifies and is transformed again—
"l'oeil se changeait en un brasier, en une gueule de four vomissant
l'incendie" ("the eye was changing into an inferno, into an oven's mouth,
vomiting fire")—in a manner marked clearly by Flore's desire—"fascinée
ainsi qu'un insecte de nuit, qu'une flamme attire . . . comme si . . . elle
eût voulu étreindre le colosse" ("fascinated like a nocturnal insect that a
flame attracts . . . as if . . . she had wanted to hug the colossus")—just
prior to the inevitable return to reality, as imagination fades out—"sa tête
avait porté en plein dans le fanal, qui s'éteignit" ("her head had hit
straight into the light, which went out").

Near the end of *L'Oeuvre,* as Claude peers at the Seine, contemplating
suicide, he sees "quelque chose d'énorme et de lugubre, un corps à la
dérive, une péniche détachée sans doute" ("something enormous and
lugubrious, a drifting body, a barge adrift no doubt," 340). Again impres-
sion ("something") precedes imagination ("a body") then identification
("a barge"). The extent to which Zola is intent on illustrating the interven-
tion of imagination and the role of rectification is evident in the notes for
the above example: "On peut mettre un gros bateau noir qui s'est dé-
taché, quelque péniche, et qui file toute noire, dans les reflets lumineux,
vaguement entrevus parfois, sans lanterne" ("I can use a large black boat
set adrift, some barge, that passes by all black, in the luminous reflec-
tions, glimpsed vaguely sometimes, without a lantern," 1482). Once the
character Claude has been conceived and begins to take life, the visual
scene documented in the notes is transformed by death wish into the
image of a floating corpse, which Zola inserts into the perceptual process
in the exact order detailed over the last several pages.

All of the above examples involving the rectification of metaphor incor-
porate the rectification of metonymy as well, since the very ordering of
the process gives effects (impressions, figures) before showing their
causes (identification). Indeed, Zola's "progressive" style, with the inter-
vention of imagination at the stage of the impression, inevitably involves

the rectification of metonymy. Furthermore, within the metonymical process, specific figures are also rectified. In the syntactic structure of remission, discussed in the preceding chapter, for example, the structure itself is metonymical, because of the ordering of the steps; any one of those steps can itself involve the figure of metonymy, which, along with the other steps, will be rectified, as in the following example from *L'Oeuvre:* "Mais ce qui tenait le centre de l'immense tableau, ce qui montait du fleuve, se haussait, occupait le ciel, c'était la Cité" ("But what occupied the center of the immense painting, what rose from the river, lifted itself, took over the sky, was the Cité," 213). The impersonal pronoun "what," requiring no antecedent, produces clauses involving effects (such as occupying the center of the painting), before we discover the cause (the Cité). Furthermore, some of these clauses also involve metonymies of effect, that is, actions such as "rose" and "lifted itself," which are attributed to the inanimate Cité, even though they are effects of perspective. Each of these effects or "impressions," the neutral as well as the metonymical ones, is "corrected" by the identification of the Cité later in the sentence. The entire process, as well as some of its individual components, is metonymical and is ultimately "rectified."

Synecdoche is also affected by rectification. In fact, Zola's preferred form, the nominal structure, where a quality precedes the object ("the green of the tree") is not a pure synecdoche, since the part, the quality, does not replace the whole but merely precedes it. The whole is "restored" at the end of the sequence. The nominal form is an example of rectified synecdoche, although both part and whole coexist simultaneously, rather than as steps in a visual process; here the steps are purely part of the linguistic form. However, as with metonymy, particular examples of the synecdoche figure often occur as part of a temporal sequence, and are also rectified, as in *L'Oeuvre,* where Claude sees "deux larges épaules, dont le dandinement lui était bien connu. C'était Bongrand" ("two large shoulders, whose waddling was well known to him. It was Bongrand," 274). Here the part (shoulders) momentarily dominates perception, but then gives way to identification of the whole. Similar examples occur in *La Fortune des Rougon*—"il vit apparaître, au-dessus du chaperon, une tête rieuse, ébouriffée, qui lui cria joyeusement: 'C'est moi!' Et c'était Miette, en effet" ("he saw appear, above the crown of the wall, a laughing, tousled head, that called out joyously to him: 'It's me!' And, indeed, it was Miette," 192)—and *Pot Bouille*—"elle voyait seulement le dos, mais qu'elle reconnut à ses larges épaules. C'était Verdier" ("she saw only the back, but she recognized it by its wide shoulders. It was Verdier," 154).

Imagination involves a temporary interruption of the visual process,

involving focus on parts (synecdoche), absorption in effects (metonymy), or distortion of form (metaphor). In normal perception this gentle disruption of the visual process is quickly rectified to produce identification of the whole, the source, the literal or "real" object. When imagination is not triggered by external visual effects of light, color, and movement, or when rectification does not occur readily, one enters into the dangerous state of hallucination.

Hallucination

Figuration and hallucination are, for Zola, simply two forms of imagination. The line between them is fine—indeed, in many cases, no more than a matter of degree. In other cases, what is figure for the reader is hallucination for the character; that is, Zola's figures are often presented as "visions" spawned by the visual characteristics of the milieu and shaped by the character's fears and desires into images that deform or distort literal vision. Nonetheless, Zola's figures share many properties that, taken together, make them distinguishable from hallucinations:

1. Figures are activated or motivated from the outside world, often by effects of light or color, movement or viewpoint.
2. Distortion, change of focus, or shift of emphasis is often gentle, sometimes voluntary.
3. The two parts of the figure—compared/comparing; part/whole; effect/cause—remain in contact; even when the figure is not an enhancement (desire) but the intensification of a negative aspect (fear), it is "true" to its source, the literal or whole object.
4. The figure is rectified, either by a spatial relationship (as with the coexistence of part and whole in the nominal form) or, especially, by a temporal process, and thus constitutes merely a temporary distortion of reality.
5. Consequently, there is a constant interaction or dialectic between character and world, an interplay where each feeds upon the other in a relationship of desire (imagination) and repression (rectification), as reality reappears only to engender another foray into the imaginary.

When one or more of these conditions is not fulfilled—when motivation is from within, distortion great, figure and object separated by a gap, deformation prolonged, vision unchecked by contact with reality—

then, for the purposes of this discussion, hallucination can be said to occur.[43]

With hallucination, as with figuration, the image forms progressively, but the stimulus is often from within and the image more obsessive and untainted. In *La Joie de vivre,* for example, the narrator describes the hypochondriac Lazare's obsession as follows: "Le phlegmon se matérialisait en une image vive, il le voyait énorme, barrant la trachée" ("The phlegm materialized in an intense image, that appeared enormous, blocking the trachea," 920). In other cases, as in the following examples from *Une Page d'amour,* idea can give rise to image—"l'idée fixe qui battait dans sa tête levait continuellement les mêmes images entre ses yeux et la page commencée" ("the obsession that beat in her head continually lifted the same images between her eyes and the page she had begun," 993)—or image to idea—"Des images, grandies par l'insomnie, la poursuivaient. Puis, une idée se planta dans son crâne, elle avait beau la repousser, l'idée s'enfonçait, la serrait à la gorge, la prenait tout entière" ("Images, enlarged by insomnia, pursued her. Then, an idea planted itself in her brain; it was useless to resist it, the idea took root, gripped her, took her over completely," 1000). Rather than form progressively, the hallucinatory image can sometimes arise rapidly and uncontrollably—"les choses ne surgissaient que très rapprochées, ainsi que du fond d'un rêve" ("things only surged very near, as from the depths of a dream," *La Bête humaine,* 1162).

Whatever the mode of forming, progressive or sudden, hallucinations occur prominently in virtually every novel of the Rougon-Macquart series, and, in several cases, the character is dominated by an obsessive image, whose very existence forecasts doom. Losing control of the image-making process leads to alienation, madness, and death.

In *La Fortune des Rougon,* Silvère is haunted by the image of Rengade, the policeman whom he accidentally blinded: "Silvère, à ce moment,

43. Indeed, for Taine, Zola's avowed mentor and master, all mental images, including those resulting from literal perception, are forms of "hallucination." Taine distinguishes between "true hallucinations," which are verified (or "rectified" as we have put it), through contact with the external world, and "false hallucinations," generated by dreams, hypotheses, or other "internal" mechanisms, which are not subject to external confirmation. "Our external perception is an internal dream which is found in harmony with external things; and instead of saying that hallucination is a false external perception, it is necessary to say that external perception is a *true* hallucination" (*De l'intelligence* [Paris: Hachette, 1880], II, 7–13) as quoted by Richard Shiff, "The End of Impressionism," in *The New Painting: Impressionism, 1874–1886* (San Francisco: The Fine Arts Museums of San Francisco, 1986), 82–83. I shall return to Taine's concept of art as "creative hallucination" later in this chapter.

dans la fièvre qui le secouait, crut voir passer devant lui l'image du
gendarme dont le sang lui avait taché les mains. . . . il le distinguait
nettement, avec son orbite vide, saignant, horrible. . . . Il serrait violem-
ment sa carabine, brûlant de décharger son arme, de chasser l'image du
borgne à coups de feu" ("Silvère, at that moment, in the fever that shook
him, thought he saw pass before him the image of the policeman whose
blood had stained his hands. . . . he saw him distinctly, with his empty
socket, bloody and horrible. . . . He grasped his carabine violently, burn-
ing to discharge his arm, to ward off the image of the one-eyed man with
gun shots," 215). In the final chapter of the novel, when captured and
confronted by Rengade, Silvère escapes into images from his past, espe-
cially memories of his dead lover, Miette: "Il songeait à Miette. Il la
voyait étendue dans le drapeau, sous les arbres, les yeux en l'air. Depuis
trois jours, il ne voyait qu'elle. A cette heure, au fond de l'ombre crois-
sante, il la voyait encore" ("He thought about Miette. He saw her
stretched out in the flag, under the trees, her eyes upward. For three
days, he saw only her. At this moment, in the depths of the growing
darkness, he saw her still," 308). He attempts to avoid looking at
Rengade's "lone eye" (309) by closing his eyes and resurrecting the image
of Miette (310), only to have it disappear (310), threatened by the painful
images of reality: those of Rengade—"dont l'oeil farouche le brûlait, lui
causa un malaise. Il détourna le regard" ("whose wild eye burned him,
caused him anxiety. He looked away," 313)—Justin (313), and Tante Dide
(314). Finally, imagination obliterates reality: "Silvère, fermant les yeux,
entendit les vieux morts l'appeler furieusement. Dans le noir, il ne voyait
plus que Miette, sous les arbres, couverte du drapeau, les yeux en l'air.
Puis le borgne tira, et ce fut tout" ("Silvère, closing his eyes, heard the
past dead calling him furiously. In the darkness, he saw only Miette,
under the trees, covered by the flag, her eyes looking upward. Then the
one-eyed man shot, and that was all," 314). The divorce between reality
and imagination, aggravated by fear, guilt, and despair, inevitably leads
to death.

In *La Curée*, Renée's hallucinations before the mirror, first of Saccard
and Maxime (574), then of her own cadaver (576), foreshadow her death
in the following chapter. Florent (*Le Ventre de Paris*) is obsessed by the
recurrent memory of a girl shot dead in the streets during the uprising for
which he was deported (611), while Marthe (*La Conquête de Plassans*),
subject to mystical visions, sees the hallucinatory image of the asylum
where her ancestor, Tante Dide, and her husband, Mouret, are housed
(1136).

In *La Faute de l'abbé Mouret*, Serge shares his family's penchant for vivid

visions, where imagination dominates and replaces reality.[44] Hallucinations occur especially in church, a place at some remove from external reality. In chapter XIV of part I, he has a lengthy vision of the Virgin Mary ("he was hallucinating to the point of seeing her," 1287), smacking of regression ("he was becoming very young again," 1287) and reeking of sexual desire ("she was wearing a bridal dress," 1295). In a parallel scene in chapter IX of part III, his hallucination involves his "sin" with Albine ("the fall began over again, took form with frightening clarity" 1483), culminating with a vision of nature attacking the church ("Abbé Mouret applauded furiously, like a condemned man faced with this vision. . . . the crazy laugh he uttered pulled him out of his hallucination," 1490). While this vision may mark a desire for the victory of reality, the hallucination is again followed by death—first of the past (1502), next of the garden (1503), then, literally, of Albine (1527), and finally, figuratively, of Serge (since he returns to the church).

Eugène Rougon is pursued by the image of Clorinde (*Son Excellence Eugène Rougon,* 120), much as Octave is by that of Denise (*Au Bonheur des Dames,* 707), and Jean by that of Françoise (*La Terre,* 577). In *Une Page d'amour,* Hélène is also obsessed by Henri's image ("on the inky black background, Henri appeared with singular sharpness," 903), which she is unable to erase: "lorsque d'un suprême effort elle avait chassé la vision, elle la voyait se reformer plus lointaine, lentement grossie. . . . elle s'efforçait d'échapper à l'image d'Henri . . . il surgissait obstinément" ("when by supreme effort she had warded off the vision, she saw it reform farther away, gradually enlarged. . . . she tried to escape from Henri's image . . . it surged back obstinately," 903). Hélène remains conscious of reality, which serves as a backdrop for the image superimposed upon it (904), but there is no interplay between imagination and reality,

44. Serge also has a recurring nightmare, generally acknowledged to reflect that of his literary creator, as one might deduce from the importance of dark, twisted corridors in Zola's novels: "Toujours le même cauchemar me faisait ramper, le long d'un souterrain interminable. A certaines grosses douleurs, le souterrain, brusquement se murait; un amas de cailloux tombait de la voûte, les parois se resserraient, je restais haletant, pris de la rage de vouloir passer outre; et j'entrais dans l'obstacle, je travaillais des pieds, des poings, du crâne, en désespérant de pouvoir jamais traverser cet éboulement de plus en plus considérable" ("Always the same nightmare made me crawl, along an endless tunnel. With certain heavy pains, the tunnel, abruptly, walled up; a pile of pebbles fell from the vault, the walls closed in, I remained panting, seized with rage at wanting to pass by; and I entered into the obstacle, working with my feet, my fists, my head, in despair at ever being able to cross this growing landslide," 1319). For Zola's description of a similar childhood dream see "Printemps: Journal d'un convalescent," in *Oeuvres complètes,* ed. Henri Mitterand (Paris: Cercle du Livre Précieux, 1966–69), ix, 909.

rather a struggle, temporarily dominated by imagination, then tentatively controlled by reality as Henri disappears (904). Indeed, Hélène's visions themselves often conflict:

> Lorsqu'elle s'abandonnait à une de ces rêveries qui la berçaient, quelque rêve vague où elle se voyait marcher avec Henri dans un pays inconnu et charmant, tout d'un coup l'image raidie de Jeanne se levait; et c'étaient de continuels déchirements dans ses entrailles et dans son coeur. Elle souffrait trop de cette lutte entre sa maternité et son amour.

> (When she yielded to one of these reveries that cradled her, some vague dream where she watched herself walking with Henri in a charming unknown land, all of a sudden the stiff image of Jeanne would arise; and there were continual rifts in her guts and in her heart. She suffered too much from this struggle between her motherhood and her love. 948)

Hélène's obsession with the image of the room where Juliette and Malignon are to have a rendezvous and with the projection of herself and Henri into that image (987) leads her to recreate the scene with Henri, thereby marking an end to their love and leading, in her mind, to the death of Jeanne. Henri's image reappears briefly in the final chapter, superimposed on the cold Parisian landscape, where it dies the death of all fantasies born of pure desire that then attempt to reconcile themselves to reality. Hallucination resurrects the forbidden desire from the sanctioned realm of the dream and brings it to consciousness, which can tolerate neither the content nor its lack of fulfillment, thus leading to death.

Gervaise sees herself as she was—"un jour, se penchant, elle eut une drôle de sensation, elle crut se voir en personne là-bas, sous le porche, près de la loge du concierge, le nez en l'air, examinant la maison pour la première fois; et ce saut de treize ans en arrière lui donna un élancement au coeur" ("one day, leaning over, she had a strange sensation, she thought she saw herself in person down there, under the porchway, near the concierge's room, her nose in the air, examining the building for the first time; and this leap backwards of thirteen years gave her a sharp longing pain in the heart," *L'Assommoir,* 673)—a striking vision that poignantly underscores her present downslide and future demise.

Gervaise's daughter Nana has a recurrent vision of the gracefully aging courtesan Irma d'Anglars (see 1256), an image of transparent desire into which she projects herself—"her eyes lost, seeing the vision of a very rich and admired Nana as it arose" (1258)—and which she resurrects when the

vision is threatened, as when she sees another former courtesan in rags (1374–75).

In *La Joie de vivre,* Pauline hallucinates images of the room where Louise and Lazare are to spend their wedding night: "From her troubled brain, images grew sharper and stronger, the other two in their bedroom" (1043). This vision, spawned from within ("her troubled brain") through jealousy and desire, triggers the long-awaited flood of puberty in the following paragraph.

Near the end of *Germinal,* trapped in the flooded mine, Catherine also has a vision: "Tous leurs sens se faussaient . . . et elle sentait un violent parfum d'herbes écrasées, et elle voyait clair, de grandes taches jaunes volaient devant ses yeux, si larges, qu'elle se croyait dehors, près du canal, dans les blés, par une journée de beau soleil" ("All their senses erred . . . and she smelled a violent odor of crushed herbs, and she saw clearly large yellow spots floating before her eyes, so big that she thought she was outside, near the canal, in the wheatfields, on a beautiful sunny day," 1577). This hallucinatory vision is followed by making love with Etienne (their first time, her first time after puberty), then her death, again linking the fatal trio of hallucination, desire, and death.

For Claude Lantier, in *L'Oeuvre,* the same tripartite pattern occurs with a recurrent "hallucination such that the Cité seemed to rise up," (318; see also 168, 224, 259, 266, 319, 337, etc.), the scene of his ultimate masterpiece. This increasing dominance of inner vision is paralleled by a progressive loss of his visual talent and contact with reality, which Zola clearly attributes to a visual problem: "La question est de savoir ce qui le rend impuissant à se satisfaire: avant tout, sa physiologie, sa race, la lésion de son oeil" ("The question is to determine what makes him impotent, [unable] to produce: above all, his physiology, his heredity, the lesion of his eye," 1353). Here sexual desire takes the form of an urge for artistic creation, and madness precedes death, where Claude's eyes bulging from their sockets again underscore the failure of vision, the dominance of inner vision or hallucination.

Nowhere is the link between desire and hallucination made more explicit than in *Le Rêve.* Angélique's "unconscious pubescent desires" (869) produce an imaginary "supernatural world" (869), which leads to the occurrence of "her dream, like the fulfillment of vague childhood wishes" (870) and "visual hallucination" (871). This vision materializes ("what came from the dream ended up assuming the silhouette of a body," 871), finally taking the form of Félicien, who has had the same vague vision. Their attempt to rejoin reality—"after the triumph, she emerged from the dream, she was walking along, to enter into reality" (993)—leads immediately to her death. Desire born of imagination, un-

like imagination engendered by reality, cannot survive the encounter with reality: "For some time, he felt indeed that he possessed a shadow. The vision, born from the invisible, returned to the invisible" (994).

The same confusion of dream and reality persists in *La Bête humaine*. Here the "real" scene of murder is perceived by Jacques as an hallucination—"il n'osait plus affirmer la réalité de cette vision. . . . tout se confondait, s'évaporait, comme en un rêve. . . . il finissait par admettre une hallucination, née de l'affreuse crise qu'il venait de traverser" ("he no longer dared to assert the reality of this vision. . . . everything was confused, evaporated, as in a dream. . . . he ended up by admitting an hallucination, born from the frightful crisis he had just endured," 1047)—which becomes a fixation—"il ne lutta plus, resta sur le dos, en proie à cette vision obstinée" ("he no longer struggled, remained on his back, prey to this obstinate vision," 1206)—leading to Séverine's murder and his own death.

True to his genetic heritage, the speculator Saccard also has a "visionary's brain" (*L'Argent,* 55), which leads to hallucinations—"par une sorte d'hallucination, s'évoquèrent les pâles, les désolés visages de la comtesse de Beauvilliers et de sa fille, qui le regardaient éperdument de leurs grands yeux pleins de larmes" ("by a sort of hallucination, were evoked the pale, distressed faces of the Countess de Beauvilliers and her daughter, who watched him desperately with their wide, tear-filled eyes," 331)—whose power momentarily affects even the cold-blooded mercenary. The more sympathetic Mme Caroline also has visions, but hers are engendered by the paintings before her (224) and produce more positive images (397–98). The sporadic hallucinatory images of *La Débâcle* are, not surprisingly, often linked to death: "Il vécut encore une minute, les yeux élargis, voyant peut-être monter à l'horizon la vision vraie de la guerre" ("He lived for one more minute, his eyes enlarged, seeing perhaps rising on the horizon the true vision of war," 704; see also 444, 555, 715, and 873).

Doctor Pascal also shares his family's penchant for visual hallucination, which he attributes, as did Zola for Claude, to physiological cases: "Les jours où son intelligence était plus paresseuse, où il croyait éprouver des phénomènes de vision particuliers, il inclinait à une prédominance de la lésion nerveuse originelle" ("The days when his mind was lazier, when he thought he was having singular visual phenomena, he was inclined toward a predominance of the original nervous lesion," 1034). He also has an obsessive, recurrent dream, one involving an older man and a young woman, fueled by the biblical story of King David and Abishag (1048), later materialized in his own relationship with Clotilde. Clotilde herself is subject to visions, as in the final pages where she watches over the dying

Pascal: "Et, de tous les meubles, à présent, lui venaient des souvenirs. Leurs deux images lui semblèrent renaître, du fond argenté et pâle de la grande psyché" ("And, from all the furniture, at present, memories came to her. Their two images seemed to be reborn, from the pale, silvery background of the large mirror," 1190; see also 959, 1190).

Throughout the novels of the Rougon-Macquart series, the same pattern prevails. When imagination is unchecked by reality, desire dominates but remains unfulfilled, even doomed, as destruction and death reign. For the artist Claude and the scientist Dr. Pascal the result can be sterility, death of the creative process. Sandoz, the naturalist novelist in *L'Oeuvre,* who is the most obvious *porte-parole* in the Rougon-Macquart series, in summarizing the failure and death of Claude Lantier, points out the necessity of contact with reality, while reaffirming the role of imagination in artistic creation:

> Seule, la vérité, la nature, est la base possible, la police nécessaire, en dehors de laquelle la folie commence; et qu'on ne craigne pas d'aplatir l'oeuvre, le tempérament est là, qui emportera toujours le créateur. Est-ce que quelqu'un songe à nier la personnalité, le coup de pouce involontaire qui déforme et qui fait notre pauvre création à nous!

> (Truth, nature, is the only possible basis, the necessary police, outside of which madness begins; and let's not fear to diminish art, temperament is always there to lift up the creator. Is anyone talking about negating personality, the involuntary thrust that modifies and makes our limited creations work! 359)

Indeed imagination, even hallucination, play a key role in creation, provided they remain faithful to vision, the intermediary between the real and the imaginary.

Creation

In defining the role of imagination in creation, Zola commonly distinguishes between the visual artist, whose analytic and creative eye interacts with reality, and the "visionary," whose "inner vision" reflects a visual defect. Chief among the latter is Victor Hugo, who repeatedly draws the criticism implicit in the term "visionary": "Victor Hugo, tout en voulant aller à l'homme et à sa nature, passe à côté d'eux, par une

lésion de ses yeux de visionnaire" ("Victor Hugo, while wanting to move toward man and his nature, passes beside them, due to a lesion in his visionary's eyes," *Nos auteurs dramatiques,* 64; see also 62, and *Documents littéraires,* 59).[45] Furthermore, Zola states clearly that by "lesion" he means a definite physical handicap of the visual faculties: "Enfin, il y a des yeux qui ne voient rien du tout. Ils ont sans doute quelque lésion, le nerf qui les relie au cerveau éprouve une paralysie que la science n'a pu encore déterminer ("Still, there are some eyes that see nothing at all. They have no doubt some lesion, the nerve linking them to the brain has a paralysis that science hasn't yet identified," *Roman ex.,* 167–68). The writer whose imagination relies on invention and abstraction rather than on a creative approach to real phenomena, exhibits above all else a defect in seeing, akin to hallucination. Zola further says of Hugo—"Je le comparerais volontiers à un homme qui resterait pendant vingt années les yeux fixés sur le même horizon; peu à peu, il y a hallucination, les objets s'allongent, se déforment, tout s'exagère et prend de plus en plus l'aspect idéal que rêve l'esprit éperdu" ("I would compare him willfully to a man who would spend twenty years with his eyes fixed on the same horizon; little by little, hallucination occurs, the objects grow longer, become deformed, everything becomes exaggerated and gradually assumes the ideal appearance that the lost mind is dreaming of," *Mes Haines,* 82)—and he adds later that Hugo has replaced creative vision with a fantastic "inner vision," which, rather than embellishing reality, negates it (83).

Zola regarded Manet and the impressionists as possessing the most creative eyes, as being among the greatest "observers," but the visual arts also had their "visionaries." Zola says of Gustave Doré, for example: "Je me demande, avant tout, quelle a été la grande vision intérieure de l'artiste, lorsque, ayant arrêté qu'il entreprendrait le rude labeur, il a fermé les yeux pour voir se dérouler le poème en spectacles imaginaires" ("I wonder, above all, what was the great interior vision of the artist, when, having decided that he would undertake the hard task, he closed his eyes to see the poem unfold in imaginary spectacles," *Mes Haines,* 72). Zola contends of Doré that his work, stemming from a "visionary's eye" (71), is condemned to repeat itself, lacking the poetry of change and variation that reality provides for the creative eye.

Zola frequently distinguishes between "invention," a purely fantastic process that creates its own dream world, and imagination, which is firmly anchored in reality. The novelists he admires are imaginative, because they add poetry and life to reality, but they are not inventive

45. For another accusation of "visual lesion," see the quote from *Le Roman expérimental,* 168, cited on the second page of this chapter.

because they never depart from the observable phenomena of nature. Thus, he concludes of Daudet that "J'ai dit qu'il n'inventait rien. Il n'a pas du tout l'imagination dans le sens que je viens d'indiquer" ("I said that he invented nothing. He has no amount of imagination in the sense I just indicated," *Romanciers naturalistes,* 254; see also 212 for a similar judgment on Balzac). Zola asserts that he himself was totally incapable of invention: "Je ne sais pas inventer des faits: ce genre d'imagination me manque absolument. Si je me mets à ma table pour chercher une intrigue, un canevas quelconque de roman, j'y reste trois jours à me creuser la cervelle, la tête dans les mains, j'y perds mon latin et je n'arrive à rien" ("I don't know how to invent facts: I lack this type of imagination entirely. If I sit down at my desk to look for a plot, a fictional canvas of any sort, I stay there three days racking my brain, my head in my hands; I'm completely lost and I end up with nothing.")[46] He recounts that this same inability to invent also characterized Edouard Manet: "Souvent, quand il traitait un détail secondaire, je voulais quitter la pose, je lui donnais le mauvais conseil d'inventer. —Non, me répondait-il, je ne puis rien faire sans la nature. Je ne sais pas inventer" ("Often, when he was treating a secondary detail and I wanted to quit the pose, I gave him the poor advice to invent. —No, he answered me, I can't do anything without nature. I don't know how to invent," *Salons,* 125).

Although invention must be ruled out of the naturalist aesthetic, imagination—founded on reality, yet pointing beyond it to a more poetic representation of real phenomena—is an integral part of the modern novel. Zola notes that Edmond de Goncourt's imagination is based on reality: "Donc, lorsque M. de Goncourt parle d'imagination, il n'entend pas ce que la critique courante entend par ce mot, l'imagination à l'Alexandre Dumas et à l'Eugène Sue; il entend un arrangement poétique particulier, une rêverie personnelle, faite en face du vrai, mais basée quand même sur le vrai" ("Thus, when M. de Goncourt speaks of imagination, he doesn't mean what current criticism means by this word, imagination like that of Alexandre Dumas or Eugène Sue; he means a particular poetic arrangement, a personal reverie, made in contact with reality, but based just the same on reality," *Roman ex.,* 223).[47]

46. Part of an interview with Edmondo De Amicis, reported by Paul Alexis in *Emile Zola, notes d'un ami* (Paris: Charpentier, 1882), 157. See De Amici's *Studies of Paris,* 211.

47. Similarly, Zola contends that Daudet's imagination adds to reality, rather than denying it, by the creation of a purely invented world: "Remarquez que l'imagination lui manque, au sens donné à ce mot par les conteurs. Il n'a point d'invention, je veux dire qu'il se sent incapable de bâtir des fables en l'air, d'entasser les aventures, ou du moins qu'il dédaigne ce métier de romancier à la grosse. Le réel seul lui paraît être une base solide" (*Une Campagne,* 309–10).

The naturalist imagination must affirm the importance of everyday reality by rendering it poetic: "Il faut, donc, je le répète encore, faire une différence profonde entre l'imagination des conteurs, qui bouleverse les faits, et l'imagination des romanciers naturalistes, qui part des faits. C'est là de la réalité poétique, c'est-à-dire de la réalité acceptée, puis traitée en poème" ("We must, therefore, I repeat again, make a profound distinction between the imagination of storytellers, which turns fact upside down, and the imagination of naturalist novelists, which is based on fact. The latter is poetic reality, that is, reality accepted, then treated as a poem," *Roman ex.,* 244).

Zola contends, in effect, that reality itself, not the author's inventive mind, is the true source of poetry and imagination, a belief held by the realists before him. Champfleury had noted that "here's what we call imagination, when nature (but we must be submissive, humble, and docile toward her) offers at every moment dramas, comedies, stories, novellas that require high intelligence to be utilized, but that strike the reader's mind by the accent of Reality at their core,"[48] and Courbet had remarked to his students that "imagination in art consists in knowing how to find the most complete expression of an existing thing, but never to suppose or create the thing itself."[49] Zola himself had apparently espoused this belief long before he became a thoroughgoing realist, as is evident in a letter written to Cézanne in 1860: "Que voulez-vous dire avec ce mot de réaliste? Vous vous vantez de ne peindre que des sujets dénués de poésie! Mais chaque chose a la sienne, le fumier comme les fleurs" ("What do you mean with this word realist? You brag about painting only subjects devoid of poetry! But each thing has its own [poetry], manure as well as flowers").[50] This belief in reality as the source of imagination and poetry was to become a central canon of the naturalist aesthetic:

> Les naturalistes arrivent et disent très carrément que la poésie est partout, en tout, plus encore dans le présent et le réel que dans le passé et l'abstraction. Chaque fait, à chaque heure, a son côté

48. "voilà ce qu'on appelle imagination, quand la nature (mais il faut être soumis, humble et docile vis-à-vis d'elle) vous offre à chaque instant des drames, des comédies, des contes, des nouvelles qui demandent une belle intelligence pour être mis en action, mais qui frappent l'esprit du lecteur par l'accent de la Réalité qui en est le coeur." *Le Réalisme* (Paris: M. Lévy, 1857), 98.

49. "l'imagination dans l'art consiste à savoir trouver l'expression la plus complète d'une chose existante, mais jamais à supposer ou à créer cette chose même." In René Huyghe, "La Vision réaliste au XIXe siècle," *Revue de Paris* 68 (April 1961), 8.

50. In *R-M,* IV, 1344.

poétique et superbe. La poésie coule à plein bord dans tout ce qui existe, d'autant plus large qu'elle est plus vivante. Et j'entends donner à ce mot de poésie toute sa valeur, ne pas en enfermer le sens entre la cadence de deux rimes, ni au fond d'une chapelle étroite de rêveurs, lui restituer son vrai sens humain, qui est de signifier l'agrandissement et l'épanouissement de toutes les vérités.

(The naturalists appear and state very clearly that poetry is everywhere, in everything, even more in the present and the real than in the past and in abstraction. Each fact, at each moment, has its side that is poetic and superb. Poetry runs freely in everything that exists, all the larger since it is more alive. And I mean to give this word its full value, not enclose it's meaning within the cadence of two rhymes, nor within a narrow dreamers' chapel, restore its true human sense, which is to signify the enlargement and expansion of all truths. *Le Nat. au théâtre,* 24)

These antitheses between vision and inner vision, between imagination and invention, which arise so often in Zola's judgments concerning creation, not only point out once again the extreme importance of visual perception in his work, but point to a structural feature detected in virtually every novel, where the increasing incidence of hallucination signals impending sterility, madness, and death. The thematic contrast between vision and inner vision is particularly striking in *L'Oeuvre* and *Le Docteur Pascal,* due especially to the presence of the visual artists, Claude Lantier and Clotilde Rougon, respectively.

In *L'Oeuvre,* I have already examined the progressive loss of vision (and visual contact with reality) mirrored in Claude's eyes in discussing visual themes (Chapter 2). There is a parallel reliance on a fixed hallucinatory inner vision: "Il ne regardait ni à droite ni à gauche, filant sans rien distinguer des champs ni des arbres, n'ayant au crâne que son idée fixe, dans une hallucination telle que, par moments, la pointe de la Cité lui semblait se dresser et l'appeler du milieu des vastes chaumes" ("He was looking neither right nor left, passing without distinguishing anything of the land and trees, having in mind only his fixed idea, in an hallucination such that, at times, the point of the Cité seemed to rise up and call him amidst the vast fields," 318). He is progressively unable to respond to external reality, except when it corresponds to this inner vision, as when he peers into the Seine at Bennecourt and "il crut y apercevoir des reflets glorieux, les tours de Notre-Dame et l'aiguille de la Sainte-Chapelle que le courant emportait à la mer" ("he thought he saw glorious reflections, the towers of Notre-Dame and the steeple of the Sainte-Chapelle that the

current was carrying off to sea," 319–20). Claude is increasingly prey to an inner vision—"cette vision qui le hantait toujours et partout" ("this vision that haunted him always and everywhere," 312)—which replaces reality—"les visions qui redevenaient les seules réalités" ("the visions that were becoming once again the only realities," 346). The narrator is finally led to call his former "observer" a "visionary": "il peignait le ventre et les cuisses en visionnaire affolé, que le tourment du vrai jetait à l'exaltation de l'irréel" ("he was painting the belly and buttocks like a panicked visionary whom the torment of truth was pushing toward exaltation of the unreal," 343).

While the contrast between vision and inner vision, imagination and invention, is less central to the structure of *Le Docteur Pascal,* it is sustained throughout the novel and articulated very clearly through the art of Clotilde. In the opening pages the reader learns that she has two manners of drawing: on the one hand, after nature—"elle apportait, dans ces sortes de copies, une minutie, une exactitude de dessin et de couleur extraordinaire" ("she brought to these sorts of copies a precision, an extraordinary accuracy of drawing and color," 920)—on the other, after her fantasies—"elle avait repoussé la copie exacte et sage des roses trémières, et elle venait de jeter, sur une autre feuille, toute une grappe de fleurs imaginaires, des fleurs de rêve, extravagantes et superbes. C'était ainsi parfois, chez elle, des sautes brusques, un besoin de s'échapper en fantaisies folles, au milieu de la plus précise des reproductions" ("she had pushed aside the exact, controlled copy of the hollyhocks and had just set down, on another sheet of paper, a whole bunch of imaginary flowers, dream flowers, extravagant and superb. It was that way, sometimes, with her, sudden changes, the need to escape into mad fantasies, in the middle of the most precise reproductions," 921). Later, when she defiantly turns away from the copies of reality toward her dream flowers— "elle avait abandonné les pastels, les dessins de fleurs très exacts qui devaient servir de planches à un ouvrage sur les fécondations artificielles . . . elle se passionna encore sur un dessin fou, des fleurs de rêve, une extraordinaire floraison épanouie au soleil du miracle, tout un jaillissement de rayons d'or en forme d'épis" ("she had abandoned the pastels, the very accurate drawings of flowers that were supposed to serve as plates in a work on artificial fertilization . . . she became impassioned over a mad drawing, dream flowers, an extraordinary bouquet blooming in a miraculous sun, a gushing of golden rays in the form of sheaves," 986)—she is chastised by Pascal in a formula smacking of Champfleury, Courbet, Sandoz, or Zola: "Il n'y a ni santé, ni même beauté possible, en dehors de la réalité" ("There is no possible health, nor

even beauty, outside of reality," 986). In the novel's final chapter, she acknowledges this dual aspect of her art and character:

> Sa pensée, d'abord, retourna à ses pastels, les exacts et les chimériques, et elle se disait maintenant que toute sa dualité se trouvait dans cette passion de vérité qui la tenait parfois des heures entières devant une fleur, pour la copier avec précision, puis dans son besoin d'au-delà qui, d'autres fois, la jetait hors du réel, l'emportait en rêves fous, au paradis des fleurs incréées.

> (Her thought, at first, returned to her pastels, the accurate ones and the chimeric ones, and she told herself now that her entire duality resided in this passion for truth that held her sometimes for hours on end before a flower, to copy it precisely, then in her need for the beyond that, at other times, pushed her outside of reality, carried her in mad dreams to the garden of unreal flowers. 1208)

While opting for the real, "she understood that the chimeric was not dead in her" (1211). Indeed the hallucinatory, the imaginary, is not dead for any artist, certainly not for Zola, whose dualism places him closer to Clotilde than to the more unidimensional Pascal (himself, however, subject to hallucination and visions).

The occurrence of hallucination in virtually every novel, its effect on the artists Claude and Clotilde and the scientist Pascal, as well as its similarity to figuration, suggest its importance in the creative process. It is at least as appropriate to read the incidence of hallucination as a metaliterary clue to Zola's creativity as it is to read Emma Bovary's "dreaming" as being like that of Flaubert.[51] In some ways, the text itself is a figure, the reading experience an hallucination that absorbs the reader and thus constitutes an essential component of the creative exchange, provided it remains linked to reality through visual perception.

But what does the link between vision and imagination mean in concrete terms? What types of "hallucination" or image-making occur in the creative process? What are the areas, modes, and mechanisms of interaction? Essentially, there are two areas of interaction that are detectable in Zola's creative processes: one involves the resurrection of past images,

51. While the authenticity of Flaubert's reputed (because reported) pronouncement—"Madame Bovary c'est moi"—is debatable, the narrator's statement in *Madame Bovary*—"nous battons des mélodies à faire danser des ours, quand on voudrait attendrir les étoiles" (Paris: Garnier Frères, 1961), 179—suggests a direct link between the artist and his character involving the limits of human expression.

the visual memory; the other concerns the forming of images in immediate perception. Together they constitute the visual imagination.

As is evident from the preparatory notes for the Rougon-Macquart series, Zola had discovered the link between memory and imagination as early as 1868–69 in Letourneau's *Physiologie des passions:* "la *mémoire,* le souvenir et l'évocation des faits cérébraux accomplis, d'où naît l'*imagination,* le pouvoir d'employer de diverses façons personnelles les faits gardés par la mémoire" ("*memory,* the remembrance and evocation of completed mental facts, from which is born *imagination,* the power to use in various personal ways the facts retained by memory").[52] It is clear that the personal form of use for Zola is visual, and he later came to adopt Littré's definition of imagination as a faculty for vivid visual recall:

> A ce propos, je signale la définition du mot imagination, dans le Dictionnaire: "Faculté que nous avons de nous rappeler vivement et de voir en quelque sorte les objets qui ne sont plus sous nos yeux." Ces trois lignes bouleversent toutes les idées littéraires acceptées: elles remplacent la fiction, la fantaisie comique ou lyrique, par les documents évoqués et classés. Je n'ai jamais dit autre chose, je n'ai jamais réclamé que les faits pour base et la vérité des êtres et des choses pour étude.

> (In this regard, I point out the definition of the word imagination in the Dictionary: "Faculty we have to recall vividly and to see in a certain way the objects that are no longer before our eyes." These three lines upend all preconceived literary ideas: they replace fiction, comic or lyric fantasy, by documents that are evoked and classified. I have never said otherwise, I have never demanded other than facts for foundation and the truth of beings and things for study. *Une Campagne,* 249)

Indeed, by making imagination visual (seeing objects that are no longer before one's eyes), Zola is able to remain faithful to the givens of reality (facts and truth) and refrain from what he termed "invention."

In the Introduction it was shown that Zola's own visual memory was extremely acute, as several critics have pointed out[53] and as Dr. Toulouse had noted in attempting to locate the seat of Zola's genius.[54] Indeed, Zola

52. In *R-M,* v, 1681.

53. See, for example, Jean and Hélène Adhémar, "Zola et la peinture," *Arts* 389 (12–18 December 1952).

54. "La mémoire des objets est une mémoire synthétique de la forme et de la couleur et parfois du mouvement. Elle est très développée chez M. Zola. Les objets les moins

himself recognized that his capacity for visual recall was exceptionally powerful: "Mes souvenirs visuels ont une puissance, un relief extraordinaires. . . . Quand j'évoque les objets que j'ai vus, je les revois tels qu'ils sont réellement avec leurs lignes, leurs formes, leurs couleurs" ("My visual memories have extraordinary power and contour. . . . When I evoke objects I have seen, I see them again just as they really are, with their lines, their shapes, their colors").[55]

The extent to which this visual memory contributed to the imagination necessary for artistic creation is evident in the following statement he made to the Italian writer De Amicis: "Après deux ou trois mois de cette étude, je me suis rendu maître de ce genre de vie; je le vois, je le sens, j'y vis en imagination, et je suis sûr de donner à mon roman la couleur et le parfum spécial de ce monde-là" ("After two or three months of this study, I have mastered this kind of life; I see it, I feel it, I live there in my imagination, and I am certain of giving my novel the color and special smell of that world").[56]

The importance of visual imagination for the construction of a novel can be followed in this passage from the *ébauche* (sketch) for *Germinal:* "Dans la première partie je vois bien Catherine. Elle partage son pain avec Etienne, elle se pose par le chapitre de sa conversation pendant le déjeuner. Dans la seconde partie, je la vois encore, cédant brusquement à Antoine, par les fatalités du milieu. . . . Mais c'est à partir de la troisième partie que je ne la vois plus" ("In the first part I see Catherine well. She is sharing her bread with Etienne, she establishes herself through the chapter on the lunchtime conversation. In the second part, I still see her, yielding suddenly to Antoine [the future Chaval], through the fatalities of the milieu. . . . But it's from the third part on that I no longer see her").[57] The repetition three times of the verb "see" (*voir*) shows the importance of visuality, but, of course, since seeing a fictional character is involved, one could ask whether Zola is going beyond visual memory, beyond imagination, into the realm of invention. Nonetheless, throughout the notes, Zola's generally concrete point of departure in resurrecting visual images, which spawn the fictional yet remain faithful to the visual, limits the role of invention, lessens its autonomy, and ensures fidelity to reality. Henri Mitterand offers a fascinating supposition concerning Zola's cre-

importants—s'ils l'intéressent—laissent des souvenirs visuels; cela est vrai pour les objects inanimés comme pour les physionomies et les paysages" (*Enquête médico-psychologique sur la supériorité intellectuelle: Emile Zola* [Paris: Société d'Editions Scientifiques, 1896], 195).

55. In Armand Lanoux, *Bonjour Monsieur Zola* (Paris: Hachette, 1954), 195.

56. Reported by Alexis in *Emile Zola, notes d'un ami,* 158.

57. In *R-M,* III, 1843.

ative process at work, suggesting the interplay of the real and the imagi-
nary through the image: "the raw reality to which the writer had previ-
ously seemed submissive is engulfed by a wave of images through which
reality no longer appears to be any more than a backdrop, if not a pretext,
for verbal invention. Metaphors, explicit or implicit, crowd in. Symbols
overlap. . . . This is the moment when the writer feels at once suffi-
ciently *penetrated by* and sufficiently *liberated from* his 'documents' to subor-
dinate them to his initial intuition, discovered again."[58]

But the visual memory, although essential to Zola's construction of
plot, character, and imagery, is not the principal source of imagination
for the naturalist, for whom "poetry is everywhere, in everything, even
more in the present and the real than in the past and in abstraction."[59]

Indeed, Zola's personal and nonfictional writings clearly illustrate his
own sensitivity, his spontaneously emotional and imaginative response to
light and color. In the following passage from the *Salons,* for example,
where Zola records his own visual reaction to a barrage of color, note the
power and immediacy of his response to the scene:

> On commence par cligner des yeux, aveuglé à la vue de quelques
> centaines de tableaux où s'entremêlent toutes les couleurs de l'arc-
> en-ciel. Il est difficile de décrire le sentiment de stupéfaction qu'on
> éprouve au premier abord. Cela chatoie et flamboie.

> (One begins by blinking one's eyes, blinded by the sight of several
> hundred paintings where all the colors of the rainbow intermin-
> gle. It is difficult to describe the feeling of stupefaction that one
> experiences at first glance. It shimmers and flames. *Salons,* 148–
> 49)

In another example, again from his *Salons,* Zola describes his immediate
response to effects of light:

> Une lumière crue tombe, jetant des reflets blanchâtres dans les
> toiles luisantes, égratignant l'or des cadres, emplissant l'air d'une
> sorte de poussière diffuse. La première sensation est un aveugle-

58. "le réel brut auquel l'écrivain semblait jusqu'à-là demeurer asservi s'est enrobé dans
un flot d'images à travers lequel il n'apparaît plus que comme le support, sinon le prétexte,
de l'invention verbale. Les métaphores, explicites ou implicites, se pressent. Les symboles
se chevauchent. . . . C'est le moment où l'écrivain se sent en même temps assez *pénétré* et
assez *libéré* de ses 'documents' pour les dévouer à son intuition primitive retrouvée." In *R-
M,* III, 1698.
59. *Le Naturalisme au théâtre,* 24; see full quote earlier in this chapter (254–55).

ment, un ahurissement qui vois plante sur les jambes, les bras ballants, le nez en l'air.

(A raw light falls, casting whitish reflections onto the glowing canvases, scratching their golden frames, filling the air with a sort of diffuse dust. The first sensation is one of being blinded, a stupefaction that leaves your legs riveted, your arms dangling, your nose in the air. *Salons,* 119)

Nor is Zola's visual response limited to an unformed "sensation" or a "sentiment," however powerful or emotional. His preliminary notes for his novels, such as the following for *Le Ventre de Paris,* jotted down during a night spent in the Halles, suggest strongly that Zola's eye generated specific figures upon direct contact with certain effects of color and light:

Peu à peu cependant le jour grandit. Au fond de la rue Rambuteau, dans le ciel des déchirures blanches. Puis tout devient d'un gris tendre. . . . Les gaz palissent. St. Eustache est brun; la rue Montorgeuil s'enfonce, noire; la rue Montmarte est en pan coupé. On dirait que les légumes sont une vaste aquarelle lavée; très tendres, très délicats de ton. Le vert glauque des choux, dont les feuilles semblent en bronze; les choux rouges, bronze violacé. Puis sur tous les légumes. Le jour grandit sur la foule. On déballe toujours, on charge les bottes. Le jour sur les blouses bleues, les corsages noirs, les bonnets blancs. Les halles sont bleu sombre. . . . Le tout dans cette claire lumière du matin qui décolore.

(Little by little meanwhile daylight grows. At the end of the rue Rambuteau, in the sky, white gaps. Then everything takes on a tender gray. . . . The gas lamps grow pale. St. Eustache is brown; the rue Montorgeuil descends, black; the rue Montmartre is cut off. One could say that the vegetables are a vast washed watercolor; very tender, very delicate in tone. The dull blue-green of the cabbages, whose leaves seem bronzed; the red cabbage, violet-bronze. Then on all the vegetables. Daylight grows on the crowd. They are still unpacking, loading bundles. Daylight falls on blue shirts, black bodices, white bonnets. Les Halles are dark blue. . . . Everything in that clear, diffuse morning light that discolors.)[60]

60. "Une Nuit aux Halles: Les Légumes," Ms. 10.338, fols. 173–74, paragraph 15, Département des Manuscrits, Nouvelles Acquisitions Françaises, Bibliothèque Nationale.

Here it would appear that Zola's own imagination, like that of his characters, functions through his vision and that, through the mediums of light and color, Zola's eye creates a kind of visible poetry that complements and completes the natural phenomena before him. Figures, stimulated by the visual conditions, seem to spring spontaneously from the scene: metonymies, like "the rue Monorgeuil descends"; synecdoches, like "blue shirts, black bodies, white bonnets"; metaphors, like "the vegetables are a vast washed watercolor." Indeed, it is as though Zola's eye, extremely sensitive to light and color, temporarily and gently distorts the lines and forms of the market scene and actually views the imaginative effects that the author jots down in his sketches.

Dr. Toulouse noted that Zola's eye was particularly responsive to colors,[61] adding that his perception of line and shape was much less acute.[62] It is also known that red and blue (the color pairing most often found in Zola's novels), while highly emotive, afford the least sharpness of detail and line[63] and that the normal human eye (less sensitive, no doubt, than Zola's) is more directly and emotively affected by light and color than by line and design.[64] Furthermore, Rorschach claims that the predominance of color response in an individual indicates an openness to external stimuli, whereas a more ready response to shape and line is likely to indicate introverted tendencies in the observer.[65] For all of these reasons, color response is likely to be more imaginative and emotional than the response to shape or volume,[66] and, as one critic concludes, there is "little wonder that descriptions of psychological and emotional states are commonly expressed in various metaphors of light."[67]

61. "Il semble donc que la sensation de couleur ait été plus intense et par conséquent ait donné l'illusion d'une plus longue durée que les autres. Il est à rappeler que M. Zola est très frappé par la couleur des choses, ainsi qu'il le montre dans ses descriptions" (Enquête, 177). See the Introduction, pages 10–11, for a translation.

62. "L'acuité visuelle est faible chez M. Zola qui est myope et astigmate," Enquête, 170.

63. See, for example, James R. Johnson, "Art History and the Immediate Visual Experience," Journal of Aesthetics and Art Criticism 19, no. 4 (Summer 1961): 401–6.

64. According to Ruth Moser, for example, "le dessin est un art matériel puisqu'il est lié à la matière; son objet est l'imitation, ou la représentation, ou la création des corps et de l'espace. C'est un art intellectuel en tant qu'il signifie, que l'esprit reconnaît les objets et les nomme, en tant qu'il obéit aux lois géométriques élaborées par l'esprit et qu'il les fait secrètement présider à la représentation des corps. Et voici la couleur, qui est l'élément sensuel, certes, de la peinture . . . cependant, je ne l'appellerai pas seulement un élément sensuel, mais encore immatériel, ce qui n'est pas une antinomie. La couleur agit immédiatement, à travers les sens, sur l'esprit de l'homme, sans rien signifier, sans rien représenter" (L'Impressionnisme français [Geneva: Droz, 1952], 27–28).

65. In Rudolf Arnheim, Art and Visual Perception: A Psychology of the Creative Eye, rev. ed. (Berkeley and Los Angeles: University of California Press, 1974), 335–36.

66. See Arnheim, Art and Visual Perception, 334–35.

67. Johnson, "Art History and the Immediate Visual Experience," 405.

Hippolyte Taine contends further that the spontaneous colorful imagery that characterized the art of many of his contemporaries stemmed from a type of momentary hallucination: "What's involved are those precise, intense, colorful representations attained by the imagination of the great artists, Balzac, Dickens, Flaubert, Heinrich Heine, Edgar Poe; I've cited a few. They are able to give themselves moments of hallucination; but only moments."[68] Taine adds that these hallucinations are quickly and continuously rectified by the somewhat firmer perception of the real world that completes the process of poetic vision: "A sequence of very short hallucinations that, being willful, can be and in fact are broken and negated at each moment by the more or less vague perception of the real world, that is the picturesque or poetic vision, very different . . . from what is properly termed hallucination, which is born randomly and without the aid of willpower."[69]

Zola, of course, also felt that imagination, occurring in a flash of light and color,[70] was a momentary "impression," a temporary and gentle distortion that was quickly rectified by the firm, well-focused perception of reality produced by the complete visual process. Zola clearly takes his place in Taine's list of hallucinatory artists, whose vision makes provision

68. "Il s'agit de ces représentations précises, intenses, colorées, auxquelles atteint l'imagination des grands artistes, Balzac, Dickens, Flaubert, Henri Heine, Edgard Poe; j'en ai cité quelques-unes. Ils arrivent à se donner des moments d'hallucination; mais ce ne sont que des moments." *De l'intelligence,* 8th ed. (Paris: Hachette, 1897), II, 59–60.

69. "Une suite d'hallucinations très-courtes qui, étant voulues peuvent être et sont effectivement rompues et niées à chaque instant par la perception plus ou moins vague du monde réel, voilà la vision pittoresque ou poétique, très-différente . . . de l'hallucination proprement dite qui naît à l'improviste et sans le concours de la volonté." Ibid., 61. Flaubert also distinguishes clearly between these two types of hallucination: "N'assimilez pas la vision intérieure de l'artiste à celle de l'homme vraiment halluciné. Je connais parfaitement les deux états, il y a un abîme entre eux. Dans l'hallucination proprement dite, il y a toujours terreur; vous sentez que votre personnalité vous échappe; on croit que l'on va mourir. Dans la vision poétique, au contraire, il y a joie; c'est quelque chose qui entre en vous. Il n'en est pas moins vrai qu'on ne sait plus où l'on est. . . . Souvent cette vision se fait lentement, pièce à pièce, comme des diverses parties d'un décor que l'on pose; mais souvent aussi elle est subite, fugace comme les hallucinations hypnagogiques. Quelque chose vous passe devant les yeux; c'est alors qu'il faut se jeter dessus avidement" (in Pierre Martino, *Le Roman réaliste sous le Second Empire* [Paris: Hachette, 1913], 160–171). See also John C. Lapp, "Art and Hallucination in Flaubert," in *Madame Bovary and the Critics,* ed. B. F. Bart (New York: NYU Press, 1966), 169–88.

70. Taine even makes provision for a "luminous" hallucination, triggered by light and color, when he notes that "lorsqu'on a regardé un objet lumineux ou fort éclairé, l'excitation de la rétine dure après qu'on a cessé des la regarder. De là naissent les phénomènes singuliers nommés images consécutives. En fait, ce sont des sensations visuelles complètes qui survivent et se prolongent en l'absence de leur objet" (*De l'intelligence,* II, 139).

for imagination and poetry by entertaining an intense but temporary "hallucination."

Armed, then, with these data concerning the imaginative response of the normal individual's eye to color and light, the hallucinatory response of the artist's eye, and the extreme sensitivity of Zola's own eye to these same luminous and colorful phenomena, can one not ask whether Zola might have actually seen the figurative images he describes, whether his poetry is not only stimulated by reality but is "real"? Can one not ask whether, in that brief moment of raw sensation about which the impressionists had made Zola's generation so keenly aware, in that instant where light and color stand for all reality and line has not yet furnished the more conservative mind with a solid point of reference, in that brief moment of confusion and poetry did Zola actually see "a dream castle," which his eye quickly focused into the pavillon de Flore? Can one not ask whether the poetry of impressionism—"the joy, the drunkenness produced by a sunny day, a pure sky, a seething sea, the impressionists are the first and perhaps the last to have experienced them with senses exalted by nature more surely than by any drug promising forgetfulness and happiness"[71]—was not also that of Zola, a purely visual poetry of light and color spilled over an infinitely changing reality? Can one not state, literarily if not literally, that the band of light and color that stretches elastically and fluidly from reality to the artist's eye, is the taut and springy surface on which Zola hoped to achieve his aim of "leaping toward the stars on the springboard of precise observation"?

Vision and Phenomenism

Whether or not Zola actually saw the images he describes, it is important to recognize the unique nature and the far-reaching consequences of his

71. "la joie, l'ivresse que procurent un jour ensoleillé, un ciel pur, une mer agitée, les impressionnistes sont les premiers et peut-être les derniers à les avoir éprouvées avec des sens exaltés par la nature plus sûrement que par n'importe quel poison promettant l'oubli et le bonheur." Ruth Moser, *L'Impressionnisme français*, 230. Many critics have spoken of the spontaneous and poetic "joy" of impressionism; for example, André Fontainas, *Histoire de la peinture française* (Paris: Mercure de France, 1922), 233, notes: "Mais surtout, et c'est l'éperdue leçon de sagesse héroïque et fraternelle que Claude Monet a enseignée aux hommes, son art splendide est éclos en pleine joie. La joie! la joie de vivre parmi l'avalanche en pierreries des lumières en fleurs, de respirer un air riche, radieux et enflammé, auprès des eaux qui chatoient et des gouffres flamboyants de la montagne en fête, devint bien vite le principe de tout son art."

creative process. The immediate effect of Zola's visual imaginative is to reinforce the already tight relationship in the naturalist doctrine between the individual and his/her world. In augmenting the determinism of the individual *by* things with what one critic calls "the naturalist character's responsiveness *to* things,"[72] Zola tightens and strengthens the bond between individual and world that is central to his concept of human experience. In effect, by making imagination direct and visual, Zola draws the artist outside his/her own mind and toward the visible world; by making light and color, themselves visible and external phenomena, the principal basis for imagery, Zola anchors the artist's creative temperament in external reality. At the same time, in finding reality meaningless without the poetic re-creation of the artist, Zola draws the objects of external reality toward the human mind. In short, Zola reduces the subjectivity of the artist and the objectivity of external reality by rendering both phenomenal, by making both integral parts of the visual act.[73] Zola can no more conceive of the mind without an object to be conscious of than he can conceive of an object without an observer to verify its existence. In effect, Zola bridges the Cartesian gap between mind and matter by making both more visual, more phenomenal, and less independent. He suppresses the interval between the individual and the universe by stressing their point of contact in visual perception.[74] Thus, Zola's insistence on vision reinforces the firm contact between the human being and nature that is the very basis of the naturalist doctrine.[75] This continuity between the indi-

72. J. H. Matthews, "Things in the Naturalist Novel," *French Studies* 14, no. 3 (July 1960): 218.

73. Indeed, Emile Littré sees the breakdown of the subject/object distinction as the very definition of the "impression": "Yes, there is something that is primordial, but it is neither the [internal] subject nor the [external] object, neither the self nor the non-self: it is the impression perceived" ("De quelques points de physiologie psychique" [1860], *La Science au point de vue philosophique* [Paris, 1876], 315, in Richard Shiff, "The End of Impressionism," 70–71). Shiff explains that "the impression, in other words, is the embryo of both bodies of one's knowledge, subjective knowledge of self and objective knowledge of the world; it exists prior to the realization of the subject/object distinction" (71) and goes on to note Zola's place alongside the impressionists and the physiologists as proponents of this notion: "Just as contemporary psychologists defend the impression as both objective and subjective, external and internal, Zola considered the naturalist or impressionist painting as representing both object and subject, nature and man" (75).

74. As Philip Walker so aptly puts it, Zola's is "a vision resulting from the endless dialogue that goes on in his fiction between appearance and reality, the thing seen and the medium through which it is seen, sensation and imagination, the real and the ideal, objective creation and the magic mirror of the mind" ("The Mirror, the Window, and the Eye in Zola's Fiction," *Yale French Studies* 42 [June 1969]: 62).

75. As Patrick Romanell reasons, "Either man is conceived as *part* of nature, or he is conceived as *apart* from it. Now, what makes a philosopher a thoroughgoing naturalist is

vidual and the world is expressed with utmost clarity in Zola's definition of art as "un coin de la nature vu à travers un tempérament" ("a corner of nature seen through a temperament"), where the individual ("a temperament") and the universe ("nature") are joined neatly, necessarily, and firmly by vision ("seen").

The consequences of this visual bond between the individual and the universe are far-reaching. First of all, this relationship helps in situating Zola's approach to literary creation within the artistic and philosophic currents of his time and in assessing the weight of his contribution to these currents. Conrad Fiedler, Zola's German contemporary and fellow "pure visualist," contends that the very essence of art is to enlarge and display the primitive contact with which the individual first encountered the world: "In the artist, a powerful impulse makes itself felt to increase, enlarge, display, and to develop toward a constantly growing clarity, that narrow, obscure consciousness with which he grasped the world at the first awakening of his mind."[76]

Henri Bergson, in several striking pages from *Le Rire,* also finds in the direct, sensual communication of the artist with his/her world the secret of artistic creation:

> What is the purpose of art? If reality came and struck our senses and consciousness directly, if we could enter into immediate communication with things and with ourselves, I believe indeed that art would be useless, or rather that we would all be artists, since then our soul would vibrate continually in unison with nature. Our eyes, aided by memory, would select out of space and fix in time inimitable paintings. Our gaze would seize in passing, sculpted in the living marble of the human body, fragments of statues as beautiful as those of antique statuary. We would hear singing from the depth of our souls, like music—sometimes gay, more often sad, always original—the uninterrupted melody of our interior life. All of that is around us, all of that is in us, and yet nothing of all that is perceived distinctly by us. Between nature

that he dares to bring together the two key generic concepts of nature and man, which philosophers of other persuasions, especially the metaphysical dualists and the supernaturalists, manage to keep asunder in one way or another. In a word, the philosophical naturalist is opposed to the traditional 'bifurcation' of nature and man, believing as he does in their continuity" ("Prolegomena to Any Naturalistic Aesthetics," *Journal of Aesthetics and Art Criticism* 19, no. 2 [Winter 1960]: 140).

76. *On Judging Works of Visual Art,* trans. Henry Schaefer-Simmern and Fulmer Mood (Berkeley and Los Angeles: University of California Press, 1949), 50.

and us—what am I saying?—between us and our own conscious-
ness, is interposed a veil, a thick veil for the common man, a thin
veil, almost transparent, for the artist and the poet.[77]

There is little difference between Bergson's "veil" and Zola's "screen."[78]
Moreover, this kind of direct, immediate contact with physical reality in
a moment of heightened sensual awareness, which Fiedler and Bergson
find to be at the core of artistic activity, was the basic philosophical
assumption of naturalism, the point of departure for impressionism, and
the principal characteristic of Zola's own descriptive passages. This "inte-
gral phenomenism,"[79] achieved by the fluid exercise of creative and imagi-
native visual perception, may well be considered the chief legacy of Zola
and his generation. Indeed, Bergson, whose thought had such a profound
effect on Proust, among others, speaks, in *Matière et mémoire,* of a pure
perception that would abolish the distinction between spirit and matter.
Maurice Merleau-Ponty, whose doctrine of phenomenology exerted con-
siderable influence on existentialist thought as well as on phenomenologi-
cal criticism, speaks, in *Phénoménologie de la perception,* of sensation as a
"sacrement" linking the individual to the real. In short, sensation and
perception assumed an intellectual status that they had not enjoyed before
the late nineteenth century. The naive, primitive eye, coupled with di-
rect, spontaneous contact with the visible world, constitutes a major
portion of the heritage passed on to modern art by the impressionists in
painting and the naturalists in literature.

77. "Quel est l'objet de l'art? Si la réalité venait frapper directement nos sens et notre
conscience, si nous pouvions entrer en communication immédiate avec les choses et avec
nous-mêmes, je crois bien que l'art serait inutile, ou plutôt que nous serions tous artistes,
car notre âme vibrerait alors continuellement à l'unisson de la nature. Nos yeux, aidés de
notre mémoire, découperaient dans l'espace et fixeraient dans le temps des tableaux inimita-
bles. Notre regard saisirait au passage, sculptés dans le marbre vivant du corps humain, des
fragments de statue aussi beaux que ceux de la statuaire antique. Nous entendrions chanter
au fond de nos âmes, comme une musique quelque fois gaie, plus souvent plaintive,
toujours originale, la mélodie ininterrompue de notre vie intérieure. Tout cela est autour de
nous, tout cela est en nous, et pourtant rien de tout cela n'est perçu par nous distinctement.
Entre la nature et nous, que dis-je? entre nous et notre propre conscience, un voile
s'interpose, voile épais pour le commun des hommes, voile léger, presque transparent, pour
l'artiste et le poète." *Le Rire* (Paris, 1928), 152–53, 157, as quoted by Ruth Moser,
L'Impressionnisme français, 267.
78. In a letter to his friend Antony Valabrègue in 1864, Zola outlines his theory of a
"screen" (*écran*) interposed between the artist and reality. For the realists, the screen, meta-
phorically representing the artist's temperament or personality, is nearly transparent, an
exceedingly "thin veil," so to speak.
79. The phrase is Georges Poulet's. See the Conclusion, note 37, and the accompanying
discussion.

By the turn of the century, the classical realm of reason and the romantic realm of emotion pass into the naturalist realm of vision. Artists are no longer concerned with photographic objectivity, as were the realists, or with self-centered subjectivity, as were the romantics, but with "pure visuality," as were Zola, Fiedler, and their contemporaries. An art prevails where neither the object nor the observer is the target of description, but rather where observation itself is explored and represented by the artist. Owing mostly to the efforts of Zola and the impressionists, the prime goal of much of modern art became an intimate contact with physical reality, and the prime means of achieving it an active visual prowess. Art, in the last years of the nineteenth century and the early years of the twentieth century, seems less concerned with the intuition of pure, rational form or the exploration of the emotional foundations of human behavior than with the expansion of that moment of contact with the exterior universe where separation and even identity are abolished, where "I" becomes "other,"[80] and where objects sift softly into the self. This moment of contact is the legacy of Zola and his contemporaries to the art of the following generation, and I shall examine in my conclusion the specific visual inheritance of Marcel Proust, among others.

More easily assessable, no doubt, is the effect of Zola's phenomenism on his own art. His close visual contact with the universe goes far in explaining much of the primitive animism that characterizes his novels. Georges Poulet contends that a heightened contact with reality inevitably breeds a sort of pantheistic identification of the self with the universe, and he finds that Flaubert, at least in his youth, displayed just such a brand of "naturism": "The state of being glimpsed by Flaubert in his great sunny days is thus the very one experienced by all the great naturist mystics: a moment of ecstasy where, in the union of intimate feeling and pure sensation, the self identifies itself with the universe and experiences in that moment the feeling of eternity. But with Flaubert, even in his great sunny days, this state is only *glimpsed*."[81] For Zola this feeling is not just a fleeting glimpse, but a powerful vision of sunlight and splendor spilling over reality in a shimmering, colorful sheen; the primitive pantheism of Flaubert's youth became a permanent and prominent aspect of Zola's representation of human experience.

80. The phrase "je est un autre" was formulated by the poet Arthur Rimbaud, a contemporary of Zola's.

81. "L'état d'âme entrevu par Flaubert dans ses grands jours de soleil, est donc celui même qu'ont éprouvé tous les grands mystiques naturistes: moment d'extase où, dans l'union du sentiment intime et de la sensation pure, le moi s'identifie avec l'univers et fait dans l'instant l'expérience de l'éternité. Mais chez Flaubert, même dans ses grands jours de soleil, cet état n'est qu'*entrevu*." *Etudes sur le temps humain* (Paris: Plon, 1950), 313.

In *L'Oeuvre,* for example, Sandoz formulates several times the feeling by which the self becomes identified with the universe in the continuous flow of external reality:

> Ah! bonne terre, prends-moi, toi qui es la mère commune, l'unique source de la vie! toi l'éternelle, l'immortelle, où circule l'âme du monde, cette sève épandue jusqu'à dans les pierres, et qui fait des arbres nos grands frères immobiles! . . . Oui, je veux me perdre en toi, c'est toi que je sens là, sous mes membres, m'é-treignant, et m'enflammant, c'est toi seule qui seras dans mon oeuvre comme la force première, le moyen et le but, l'arche im-mense, où toutes les choses s'animent du souffle de tous les êtres!

> (Ah! good earth, take me, you who are the common mother, the sole source of life! you the eternal one, the immortal one, where the soul of the world circulates, this sap that reaches even into stones and that makes the trees our inanimate brothers! . . . Yes, I want to lose myself in you, it's you I feel there, under my body, hugging me, fueling me, it's you alone who will be in my work like the prime force, the means and the end, the vast arch, where all things come alive with the breath of all beings! 162; see also 46)

Sandoz's feeling was clearly meant to express Zola's, as witnessed in the following note from the *ébauche* of *L'Oeuvre:*

> Si je me mets en scène, je voudrais ou compléter Claude, ou lui être opposé. D'abord, tout le côté philosophique: psychologie nou-velle, l'âme dans toute la nature, non plus prise à part, mais répandue partout; l'homme, non plus vu dans le cerveau seule-ment, mais dans les organes; les bêtes aimées, peintes; les milieux complétant l'être, l'expliquant, etc.

> (If I play a role, I would like either to complement Claude or to contrast with him. First, the whole philosophical side: new psy-chology, soul in all of nature, no longer on the side, but spread throughout; man, no longer seen in the brain alone, but in his organs; animals loved, represented; the milieus completing the human being, explaining him, etc.)[82]

A contemporary of Zola's, the eminent psychologist, Théodule Ribot, in analyzing this kind of pantheism or "primitive animism," locates its

82. In Patrick Brady, *"L'Oeuvre" de Emile Zola,* 432–33.

origins in a fast and fluid interplay between the artist and the universe, where the visual image, moving rapidly and readily between the poles of perception and abstraction, gives birth to imagination:

> But if it happens that the two elements, sensorial and affective, are of equal power; if there is both the intense, adequate vision of reality and the profound emotion, the violent upheaval; then appear artists of extraordinary imagination like Shakespeare, Carlyle, Michelet . . . let's note only that their psychology can be reduced to a movement alternately ascending and descending between the two end points: the perception, the idea. The ascending process lends life, desires, passions to the inanimate. —The descending process concretizes the abstraction, gives it body, makes it flesh and blood: . . . In this splendor of imagery, there is a momentary return to primitive animism.[83]

It is striking how well Ribot's analysis of the primitive imagination, alternating between the poles of perception and abstraction, complements Arnheim's description of vision as a reception of color and a projection of form,[84] Taine's conception of the fundamental tension in artistic creation between hallucination and perception,[85] and Zola's own understanding of the visual process, where the hazy and potentially imaginative "sensation" gives way to the solid, well-focused "perception" of external reality. In dissecting the mechanisms of visual perception, Zola has uncovered the workings of the visual imagination—a spontaneous and primitive imagination whose images oscillate so rapidly and fluidly between the matter of the universe and the mind of the artist that they threaten to abolish the interval between these two entities . . . and even their identity.

83. "Mais s'il arrive que les deux éléments, sensoriel et affectif, soient d'égale puissance s'il y a à la fois la vision intense, adéquate de la réalité et l'émotion profonde, la secousse violente; alors surgissent des imaginatifs hors ligne comme Shakespeare, Carlyle, Michelet . . . notons seulement que sa psychologie se réduit à un mouvement tour à tour ascendant et descendant entre les deux points-limites: la perception, l'idée. Le procédé ascendant prête à l'inanimé la vie, les désirs et les passions. —Le procédé descendant matérialise l'abstraction, lui donne un corps, la fait chair et os: . . . Sous cette splendeur d'images, il y a retour momentané à l'animisme primitif." *L'Imagination créatrice* (Paris, 1900), 154–55.

84. See Chapter 4, note 53.

85. See above, notes 43 and 68–70.

Conclusion:
Vision and the Novel

The late nineteenth-century novel can be approached, in certain respects, as a visual art form. By developing and implementing a visual methodology based on the innovative concepts of Zola and his contemporaries in painting, experimental science, and criticism (itself drawing heavily from painting and science), I have traced the impact of vision in many of the major areas of novelistic endeavor:

1. Zola's theories, not just of painting but of literature, stress the key role of vision at the core of the experimental method.
2. Optical instruments and effects permeate the content of Zola's novels, emerging especially through the central theme of looking (*le regard*), which constitutes an alternative communication system, in many ways more authentic, if not as efficient, as the verbal sign system.
3. Viewpoint, fundamental to Zola's program of narrational objectivity,

is characterized by a multiplicity of perspectives, often crossing the boundaries between the spaces of narrator, character, and reader.

4. Descriptive passages display a progressive, "perceptual" style, where the hazy impression yields to the solid, material perception of reality. The visual process, broken into discrete steps and linked causally to the phenomena of the material world on the one hand and the mind of the observer on the other, is embedded in Zola's style, thus embodying the essential notion of determinism on the most concrete level of the text.

5. Zola's figuration (metaphor, metonymy, synecdoche) reveals a preferred form for each figure, emphasizing its visual, perceptual aspects and, in effect, leading to a phenomenological assessment of Zola's fundamental relationship with the universe.

Together, these conclusions can be said to constitute a new, unified approach to Emile Zola's art. However, to what degree do they reflect the art of Zola's times, as promised in the subtitle of this study? Links between Zola and the painters, scientists, and critics of his times have been made at every turn, but what of other novelists? To what degree does Zola's vision and its implementation in the novel reflect that of his generation of writers?

The noted art historian Heinrich Wölfflin once stated that "vision itself has its history, and the revelation of these visual strata must be regarded as the primary task of art history."[1] Certainly the visual strata of literary history are no less rich in their potential yield to the critic. The visual method can lead both to a delineation of the principal stratum of Zola's times and to an evaluation of the individual minerals and patterns that comprise it; that is, it can describe the vision of a period, while defining the perceptual properties particular to each author. To this end, I shall tackle, however briefly, each of the domains of novelistic enterprise outlined above, suggesting areas of further investigation.

1. The importance of vision in the novel is reflected in the *theories* of many novelists of Zola's times, as evidenced by the quotations from Flaubert, Maupassant, Proust, and James in the Preface to this study. It is, in fact, from this cast of writers, along with several others, like Stendhal and Mark Twain, that examples of visual impact on the novel will be drawn.

2. *Optical instruments* hold the same fascination and display the same thematic prominence for Proust as for Zola, as is evidenced by the "magic lantern," whose kaleidoscopic images appear in the early pages of

1. *Principles of Art History*, trans. M. D. Hottinger (New York: Dover, 1950), 11.

Combray, where they serve as an emblem of human consciousness and perception, projected from the past onto the contours of material reality.[2] The celebrated "voyeurism" of the narrator throughout *A la recherche du temps perdu* further illustrates the thematic importance of looking.

The role of looking as a communication system is also evident in Maupassant's stories, often to the point of parody. In *Le Signe,* for example, the "petite baronne de Grangerie" observes the power of a courtesan's gaze with no little fascination:

> Elle était accoudée, et elle guettait les hommes et les hommes aussi la regardaient, tous ou presque tous. On aurait dit qu'ils étaient prévenus par quelque chose en approchant de la maison, qu'ils la flairaient comme des chiens flairent le gibier, car ils levaient soudain la tête et échangeaient bien vite un regard avec elle, un regard de franc-maçon. Le sien disait: "Voulez-vous?" Le leur répondait: "Pas le temps," ou bien: "Une autre fois," ou bien: "Pas le sou," ou bien: "Veux-tu te cacher, misérable!" C'étaient des yeux des pères de famille qui disaient cette dernière phrase.

> (She was leaning out of the window, looking out for men, and men were looking at her also, all or nearly all. It was as if they were warned by something in approaching the house, as if they caught her scent much as dogs smell game, since they would suddenly raise their heads and very quickly exchange a glance with her, a freemason's glance. Hers said: "Do you want to?" Theirs answered: "No time," or else: "Another time," or else: "No money," or else: "Get lost, you miserable wretch!" It was the eyes of family fathers that said this last sentence.)[3]

It is the gaze that constitutes the sign alluded to in the title and, in fact, that forms the sign system leading to the humorously elaborate and precise communication between courtesan and gentlemen that fascinates the baroness and leads her to her own interpretations of the system itself, comparing it to the hunt and freemasonry.

2. Roger Shattuck's classic work, *Proust's Binoculars: A Study of Memory, Time, and Recognition in "A la recherche du temps perdu"* (New York: Random House, Vintage Books, 1967), is a brilliant and comprehensive analysis of the modalities and impact of vision in Proust's work. See especially 146–47 for a fascinating description of the extent to which optical instruments and, indeed, the science of optics, played a significant role in Proust's thought and that of his generation.

3. "Le Signe," in *"La Parure" et autres contes parisiens* (Paris: Editions Garnier, 1984), 766–67.

Perhaps the most sustained parallel to Zola's depiction of authentic visual communication on a profound level, bypassing psychological and social barriers (and certainly the superficial coding characterizing the example from Maupassant), is in the novels of Stendhal.[4] In the *Chartreuse de Parme*, for example, the imprisoned mock hero Fabrice and the jailer's daughter Clélia, unable to speak or write to one another due to "physical" barriers (symbolic of psychological and social ones), establish several alternative means of visual contact, which produce a profound joy not unlike that of Zola's Silvère and Miette in *La Fortune*. However, Stendhal's characters soon grow impatient with the simplicity and imprecision of the visual and begin to fashion a large alphabet, reflecting a desire for and return to the verbal. In Zola's novel a similar desire for direct contact leads, as we have seen, to death; such is also the fate that befalls Fabrice and Clélia.

3. The pervasiveness of dual *viewpoint*, where the character's perspective is supplemented, even supplanted, by the narrator's, as in Zola's *Une Page d'amour*, is especially characteristic of Flaubert's narrational tendencies. In the opening chapter of *Madame Bovary*, for example, Flaubert establishes a personalized perspective, that of a schoolboy, whose limitations he does not fail to immediately point out, thereby necessitating the narrator's intervention:

> Resté dans l'angle, derrière la porte, si bien qu'on l'apercevait à peine, le *nouveau* était un gars de la campagne, d'une quinzaine d'années environ, et plus haut de taille qu'aucun de nous tous. Il avait les cheveux coupés droit sur le front, comme un chantre de village, l'air raisonnable et fort embarrassé. Quoiqu'il ne fût pas large des épaules, son habit-veste de drap vert à boutons noirs devait le gêner aux entournures et laissait voir, par la fente des parements, des poignets rouges habitués à être nus. Ses jambes, en bas bleus, sortaient d'un pantalon jaunâtre très tiré par les bretelles. Il était chaussé de souliers forts, mal cirés, garnis de clous.

> (Remaining in the angle, behind the door, such that one could barely see him, the *new guy* was a country boy, about fifteen, and taller than any of us. His hair was cut straight across the forehead, like a village choirboy, seeming well behaved and quite embarrassed. Although he wasn't broad shouldered, his green cloth jacket with black buttons must have been tight around the arm-

4. See, for example, my "Cryptographie et communication dans *La Chartreuse de Parme*," *Stendhal Club* 78 (January 1978): 170–82.

holes and showed, through the slits in the facing, red wrists unaccustomed to clothing. His legs, clad in blue stockings, emerged from yellowish pants, pulled tightly by suspenders. He had big shoes, poorly polished, garnished with nails.)[5]

Whereas Hélène, in *Une Page,* cannot name the monuments she perceives, the schoolboy here cannot even perceive what is being described ("one could barely see him"), although the description is detailed down to the slits in the sleeves and the nails in the shoes. Flaubert purposely locates Charles in the one position (behind the door) where his ostensible observer cannot see him. Presumably Hélène could have learned the names of the monuments, just as Charles could have stepped into the classroom in full view of his classmates. Like Zola, Flaubert creates a contradiction so blatant that the necessity of the narrator's perspective is pointed out. Although Hélène's failure to name the monuments serves partially to undermine the character, for the most part Zola utilizes dual viewpoint to create a wealth of complementary perspectives and thereby to enrich perception. Flaubert undermines not only the character's viewpoint and the reader's credulity but vision itself, seeking ultimately to create the impression of an invisible, transcendent narrator: "The artist must be in his work like God in creation, invisible and all-powerful; one should feel him throughout, but one should not see him."[6] Zola's narrator is also invisible, but, unlike Flaubert's, remains limited and immanent; Zola's aesthetics are atheistic.[7]

4. The *progressive style,* where phenomena emerge from vague images, impressions, parts, and effects to gradually assume line, form, definition, then identity, is also typical of Zola's generation. In *Madame Bovary,* for example, as Emma returns from one of her early morning rendezvous with Rodolphe, Flaubert depicts a perceptual event as follows:

Un matin qu'elle s'en retournait ainsi, elle crut distinguer tout à coup le long canon d'une carabine qui semblait la tenir en joue. Il dépassait obliquement le bord d'un petit tonneau, à demi enfoui

5. *Madame Bovary* (Paris: Garnier Frères, 1961), 3. In a similar example, also from the opening chapter, the narrator states that "il serait impossible à aucun de nous de se rien rappeler de lui [Charles]" (8), followed by a detailed description of Charles's every habit.

6. "L'artiste doit être dans son oeuvre comme Dieu dans la création, invisible et tout-puissant; qu'on le sente partout, mais qu'on ne le voie pas." From a letter of 18 March 1857, *Correspondance,* nouvelle édition augmentée (Paris: Conard, 1926–33), IV, 164.

7. Though not, as Philip Walker contends, his metaphysics. See *"Germinal" and Zola's Philosophical and Religious Thought* (Amsterdam: John Benjamins, Purdue University Monographs in Romance Languages, 1984).

entre les herbes, sur la marge d'un fossé. Emma, prête à défaillir de terreur, avança cependant, et un homme sortit du tonneau, comme ces diables à boudin qui se dressent du fond des boîtes. Il avait des guêtres bouclées jusqu'aux genoux, sa casquette enfoncée jusqu'aux yeux, les lèvres grelottantes et le nez rouge. C'était le capitaine Binet, à l'affût des canards sauvages.

(One morning as she was returning, she thought she saw suddenly the long barrel of a rifle that seemed to be aimed at her. It stuck out obliquely beyond the edge of a small cask, partly hidden in the grass, on the side of a ditch. Emma, ready to faint from fear, advanced just the same, and a man came out of the cask, like those devils that rise from the depths of sausage containers. He had gaiters buckled up to his knees, a hat pushed down over his eyes, chattering lips and a red nose. It was Captain Binet, lying in wait for wild ducks.)[8]

Here Emma perceives the general indefinite impression of a man, along with various attributes or parts, before being able to identify the perception (Binet) and its cause (duck-hunting, illegal incidentally), the progressive revelation prolonging the sense of danger and suspense.

In *La Femme de Paul,* Maupassant uses the progressive style to capture the effects produced as the moon gradually appears in the sky:

Tout à coup le Mont-Valérien, là-bas, en face, sembla s'éclairer comme si un incendie se fût allumé derrière. La lueur s'étendit, s'accentua, envahissant peu à peu le ciel, décrivant un grand cercle lumineux, d'une lumière pâle et blanche. Puis quelque chose de rouge apparut, grandit, d'un rouge ardent comme un métal sur l'enclume. Cela se développait lentement en rond, semblait sortir de la terre; et la lune, se détachant bientôt de l'horizon, monta doucement dans l'espace. A mesure qu'elle s'élevait, sa nuance pourpre s'atténuait, devenait jaune, d'un jaune clair, éclatant; et l'astre paraissait diminuer à mesure qu'il s'éloignait.

(Suddenly Mount-Valerien, in the distance opposite, seemed to light up as if a fire had started behind it. The glow increased,

8. *Madame Bovary,* 154. Flaubert also makes sustained use of the progressive style for purposes of suspense in depicting the arrival of the leper in the final part of *La Légende de Saint Julien l'Hospitalier* (see my "Displacement and Reversal in *Saint Julian,*" in William J. Berg, Michel Grimaud, and George Moskos, *Saint/Oedipus: Psychocritical Approaches to Flaubert's Art* [Ithaca, N.Y.: Cornell University Press, 1982], 57–58).

became more pronounced, gradually invading the sky, inscribing a large luminous circle of pale white light. Then something red appeared, grew larger, fiery red like metal on an anvil. It developed slowly in circular fashion, seemed to come out of the earth; and the moon, detaching itself soon from the horizon, rose slowly in space. As it went up, its purple nuance subsided, yellowed, with clear, bright yellow; and the disk appeared to grow smaller as it drew farther away.)[9]

Again the description begins with the perception of effects and parts or features, opening up the space of imagination to figures of fires and forges, before leading to an indefinite impression ("something," "it"), which finally focuses itself as a complete identification ("the moon"), replete with the causes of previous impressions ("rose slowly in space").

In *A la recherche du temps perdu,* the narrator represents an auditory effect in a similar manner:

> Un petit coup au carreau, comme si quelque chose l'avait heurté, suivi d'une ample chute légère comme de grains de sable qu'on eût laissés tomber d'une fenêtre au-dessus, puis, la chute s'étendant, se réglant, adoptant un rythme, devenant fluide, sonore, musicale, innombrable, universelle: c'était la pluie.

> (A small tap on the pane, as if something had struck it, followed by an ample light fall like grains of sand that someone had dropped from a window above, then, the fall increasing, stabilizing, adopting a rhythm, becoming fluid, sonorous, musical, infinite, universal: it was rain.)[10]

The pattern of general indefinite impression ("something") accompanied by effects ("ample light fall"), which generate comparisons ("like grains of sand"), prior to identification, is typical of the times; the crescendo of qualities ("fluid, sonorous, musical, infinite, universal") stretching upward, only to be let down by the reality of the phenomenon itself, is a hallmark of Proust.

This progressive style, while characteristic of the late nineteenth century, is by no means limited to writers in France; in fact, one finds it rather frequently in the works of Mark Twain, as in the following exam-

9. In *"La Parure" et autres contes parisiens,* 212.

10. *A la recherche du temps perdu* (Paris: Gallimard, Bibliothèque de la Pléiade, 1963), I, 101–2. Further references to Proust's work are from this edition and will be included parenthetically in the text.

ples from *The Adventures of Tom Sawyer*—"The man moaned, writhed a little, and his face came into the moonlight. It was Muff Potter"[11]—and *Adventures of Huckleberry Finn*—"by and by a flash showed us a black thing ahead, floating, and we made for it. [new sentence and new paragraph] It was the raft."[12] In a more sustained example from *Tom Sawyer,* Twain uses the progressive style to capture at once the impending arrival of a storm and the mystery and suspense it produces on the runaways, Joe, Tom, and Huck:

> Beyond the light of the fire, everything was swallowed up in the blackness of darkness. Presently there came a quivering glow that vaguely revealed the foliage for a moment and then vanished. By-and-by another came, a little stronger. Then another. Then a faint moan came sighing through the branches of the forest, and the boys felt a fleeting breath upon their cheeks, and shuddered with the fancy that the Spirit of the Night had gone by. There was a pause. Now a weird flash turned night into day, and showed every little grass-blade separate and distinct, that grew about their feet. And it showed three white startled faces too. A deep peal of thunder went rolling and tumbling down the heavens, and lost itself in sullen rumblings in the distance.[13]

As in the examples from French contemporaries, Twain depicts an imprecise impression ("vaguely") through its effects ("a quivering glow"), whose indefinite origin is enhanced by the impersonal verbal constructions ("there came"), the sentence structure ("then another"), and onomatopoeics ("rolling and tumbling"), which open the space of imagination ("a faint moan . . . a fleeting breath") and capture the boys' fears as well as their indistinct perception, the causes of which are finally suggested ("peal of thunder"), if not identified (as a storm).

This "intuitive or sensorial" style, which suits the suspense of *Tom Sawyer* and the sign-reading prevalent in *Huck Finn,* may well be typical of the English language, as noted by the Canadian linguists Vinay and Darbelnet, but it is at odds with the traditional norms of French style: "In the description of reality, English generally follows the order of the images, the unraveling or, if you will, the film of the action. Even in the

11. *The Adventures of Tom Sawyer* (Harmondsworth, Middlesex, England: Penguin Puffin Books, 1950), 77.

12. *Adventures of Huckleberry Finn* (New York: New American Library, Signet Classics, 1959), 77; see also 88.

13. *Tom Sawyer,* 112–13.

realm of concreteness, French prefers an order that is not necessarily that of the sensations. French goes immediately to the result . . . then it indicates the manner in which the action was accomplished . . . this is an almost constant procedure of the French mind: first the result, then the means."[14] This tendency of French style to be abstract rather than sensorial, mentally rather than visually governed, is also identified by the Swiss linguist Charles Bally, who compares it with German: "Let's take a concrete example: initially I have only a vague impression of whiteness, only gradually do I distinguish *various* whitenesses; then I recognize that these whitenesses are columns, and only then do I judge that the columns *have* these whitenesses, *are* white. French, which expresses thought in formation quite poorly, cannot, like German, render these diverse stages by means of verbs."[15]

The break with classical French expression—"which expresses thought in formation quite poorly"—that Zola and his contemporaries effected in order to represent the order of visual perception, makes it a distinctive feature of their visual stratum, and indeed it was noted by a number of critics at that time, among them David-Sauvageot, who states, in speaking of "classical expression": "It finally ends up melding in the crucible of the intellect where it disengages itself from all material alliance, and becomes abstract feeling and pure idea. . . . Today, completely to the contrary, thought barely crosses the mind in going immediately to make its impression on paper, keyboard, or canvas. One could even say that the intermediary of the mind is eliminated and that the finger obeys the ear or the eye directly."[16] The more traditional critic, Ferdinand Bru-

14. "Dans la description du réel l'anglais suit généralement l'ordre des images, le déroulement ou si l'on veut le film de l'action. Même dans le domaine du concret, le français préfère un ordre qui n'est pas nécessairement celui des sensations. Le français va tout de suite au résultat . . . ensuite il indique la façon dont l'action s'est accompli . . . c'est là une démarche à peu près constante de l'esprit français: d'abord le résultat, ensuite le moyen." J.-P. Vinay and J. Darbelnet, *Stylistique comparée du français et de l'anglais* (Paris: Didier, 1958), 221.

15. "Prenons un exemple concret: je n'ai d'abord qu'une vague impression de blancheur, peu à peu seulement je distingue *des* blancheurs; puis je reconnais que ces blancheurs sont des colonnes, et seulement alors je juge que les colonnes *ont* ces blancheurs, *sont* blanches. Le français, qui exprime assez mal la pensée en formation, ne peut pas, comme l'allemand, rendre ces diverses phases au moyen de verbes." "Impressionnisme et grammaire," *Mélanges Bernard Bouvier* (Geneva: Sonor, 1920), 268.

16. "Elle va se fondre enfin au creuset de l'intellect où elle se dégage de tout alliage matériel, et devient le sentiment abstrait et l'idée pure. . . . Aujourd'hui, tout au contraire, la pensée traverse à peine l'esprit pour aller aussitôt faire son impression sur le papier, le clavier ou la toile. On dirait même que l'entremise de l'esprit est supprimée et que le doigt obéit directement à l'oreille ou à l'oeil." *Le Réalisme et le naturalisme* (Paris: Calmann Lévy, 1890), 290.

netière, analyzing *La Faute de l'abbé Mouret,* makes this same distinction between the "noble" reason of the classical French style and the "vulgar" representation of the sensation attempted by Zola: "One can imagine what happens, amidst this furor of description, to the honest clarity of the French language. It isn't about no longer seeing but about no longer understanding that is the complaint. The sensation is there perhaps, the vague and indeterminate sensation, the sensation of bedazzlement and dream; but the soul is absent. . . . [The artist] should eliminate, choose, only borrow from reality its forms and its means of expression in order to transfigure that very reality, obliging it to translate the interior idea that we have of a higher beauty. In effect, we belong to reality only through the least noble parts of ourselves."[17] Finally, the poet Apollinaire, speaking to a friend, mentions the visual depiction of suspended time as the principal contribution of naturalist description to French expression: "In front of us, one day, comparing the books of the Céards and the Henniques to those films that are sometimes projected 'in slow motion' on cinema screens. . . . 'Time is suspended, Guillaume Apollinaire was saying; one can see the ballerina hanging in the air; all her movements are decomposed, one can study them at leisure, whereas, in reality, which is rapid, we can't perceive them.'"[18]

In short, the progressive style, which evolved through a conscious effort to describe the order of events as they occurred in the act of seeing or perceiving, emerged from a traditional (even hostile) classic stratum to effect a major revolution in French prose style, a revolution that permitted events to be depicted in a temporal, chronological sequence and that led Georges Poulet to state that during the nineteenth century, time itself became visible and entered into the realm of visual perception: "Never as much as in the nineteenth century had time appeared as so perceptible to

17. "On peut penser ce que devient, au milieu de cette fureur de description, l'honnête clarté de la langue française. Ce n'est pas de ne plus voir, c'est de ne plus comprendre qu'il faut se plaindre. La sensation y est peut-être, la sensation vague et indéterminée, la sensation de l'éblouissement et du rêve; mais l'âme en est absente. . . . Il faut éliminer, choisir, n'emprunter enfin à la réalité ses formes et ses moyens d'expression que pour transfigurer cette réalité même, et l'obliger à traduire l'idée intérieure que nous nous formons d'une beauté plus haute. C'est qu'en effet nous n'appartenons à la réalité que par les parties les moins nobles de nous-mêmes." In *Le Roman naturaliste* (Paris: Calmann Lévy, 1892), 16 and 24.

18. "Devant nous, un jour, comparant les livres des Céard et des Hennique à ces films qu'on projette parfois 'au ralenti' sur l'écran des cinémas. . . . 'Le temps est suspendu, disait Guillaume Apollinaire; on voit la ballerine rester en l'air; tous ses mouvements sont décomposés, on peut les étudier à loisir, tandis que, dans la réalité, qui est rapide, nous ne les apercevons pas.'" In Léon Deffoux, *Le Naturalisme* (Paris: Les Oeuvres Représentatives, 1929), 138.

the eyes of the mind, as so assimilable by thought. . . . But this percepti-
ble time is only such because it is conceived of as a vast causal chain.
Everything is manifest in the form of a continuous impression of causes
and effects."[19]

Although the progressive style may be characteristic of Zola's genera-
tion, underlying visual properties reveal clear distinctions among the
various authors utilizing it. For all but Zola the intent seems primarily
dramatic, producing a suspense akin to mystery, where the ultimate cause
or identity is finally discovered. In Flaubert, where the stages of percep-
tion often seem separate, disconnected, even disparate, the progressive
style betrays a fundamental fragmentation, in Maupassant a parody, in
Proust a pastiche. Only in Zola's works does the progressive style incor-
porate the stages of visual perception itself (he represents not only the
emergence of the object, but the stages of observation) and embody the
strict causal chain of determinism, alluded to by Poulet.

5. For all of the authors discussed above, as for Zola, *figures* are also
"sensorial" and "phenomenal," not mental and ornamental; they reflect
visual components, relationships, and processes rather than abstract or
emotive ones; and for each figure the same form dominates—motivated
comparisons, synecdoche of the part for the whole, and metonymy of
effect for cause.

Flaubert's comparisons are perhaps more traditional than those of his
contemporaries, in their tendency to relate "inner" phenomena (emotions,
dreams, memories) to "outer" objects, as Auerbach was among the first to
observe in analyzing the famous "toute l'amertume de son existence lui
semblait servie sur son assiette" ("all the bitterness of her existence seemed
served to her on her plate") from *Madame Bovary*.[20] However, the compo-
nents of Flaubert's figure remain close to the provincial milieu ("her
plate"), and the figure is mediated by the character ("seemed"). In another
oft-cited example of the same form—"ses rêves tombant dans la boue
comme des hirondelles blessées" ("her dreams falling into the mud like
wounded swallows")—"swallows" not only belong to the provincial land-
scape, but recall the name of the coach that leads out of Yonville. Flaubert's
comparisons, generally motivated by the milieu and mediated by the char-

19. "Jamais autant qu'au XIXe siècle le temps n'était apparu comme aussi perceptible
aux yeux de l'esprit, comme aussi assimilable par la pensée. . . . Mais ce temps perceptible
n'est tel que parce qu'il est conçu comme une immense chaîne causale. Tout s'y manifeste
sous la forme d'une impression continue de causes et d'effets." *Etudes sur le temps humain*
(Paris: Plon, 1950), 42.

20. See *Mimesis: The Representation of Reality in Western Literature*, trans. Willard Trask
(Garden City, N.Y.: Doubleday Anchor Books, 1957), 426–34.

acter, are often overdetermined and constitute a principal structuring feature of his novels.[21]

Though Maupassant's comparisons tend to be considerably leaner than Zola's, the same visual components and motivations prevail, as in the following passage from *Pierre et Jean:* "Sur la mer plate, tendue comme une étoffe bleue, immense, luisante, aux reflets d'or et de feu, s'élevait là-bas, dans la direction indiquée, un nuage noirâtre sur le ciel rose. Et on apercevait, au-dessous, le navire qui semblait tout petit de si loin" ("On the flat sea, stretched out like blue fabric, vast, gleaming, in the reflections of gold and fire, there arose far away, in the direction indicated, a blackish cloud on the pink sky. And one could see, below, the boat that seemed so small from such a distance").[22] Here Maupassant depicts the sea, a concrete object, as "stretched out" and "gleaming," physical details that motivate a comparison with another concrete object ("blue fabric"), whose perception is mediated through the character's viewpoint ("perceive," "seemed").

Proust's comparisons are also frequently based on visual components, as in the following example from *Combray:* "la fine pointe du clocher de Saint-Hilaire, mais si mince, si rose, qu'elle semblait seulement rayée par un ongle qui aurait voulu donner à ce paysage, à ce tableau rien que de nature, cette petite marque d'art, cette unique indication humaine" ("the fine point of Saint-Hilaire's steeple, but so thin, so pink, that it seemed only scratched in by a fingernail that wanted to lend this landscape, this painting of nature alone, this small mark of art, this sole human sign," I, 63). Here visual motivations of line ("so thin") and color ("so pink") betray the "invisible" hand of the artist, whose artifact ("landscape," "painting," "art," "sign") dominates the metaphor. Frequently, comparisons involve terms stemming from different places (and times) within the text, as in the following example from *A l'ombre des jeunes filles en fleurs:*

> Tout d'un coup, dans le petit chemin creux, je m'arrêtai touché au coeur par un doux souvenir d'enfance: je venais de reconnaître, aux feuilles découpées et brillantes qui s'avançaient sur le seuil, un buisson d'aubépines défleuries, hélas, depuis la fin du printemps. . . . Je leur demandai des nouvelles des fleurs, ces fleurs de l'aubépine pareilles à de gaies jeunes filles étourdies, coquettes et pieuses.

21. In another comparison of the same form—"Dès lors, ce souvenir de Léon fut comme le centre de son ennui; il y pétillait plus fort que, dans un steppe de Russie, un feu de voyageurs abandonné sur la neige" (*Madame Bovary,* 156)—the comparing term comes from afar (Russia) but stems, in fact, from Emma's readings and dreams.

22. *Pierre et Jean* (Paris: Garnier Frères, 1959), 32–33.

(Suddenly, in the small hollow path, I stopped, touched at heart by a gentle childhood memory: I had just recognized, by the brilliant, silhouetted leaves that were sticking out over the threshold, a bush of hawthorns, flowerless, alas, since the end of spring. . . . I asked them for news of the flowers, those hawthorn flowers resembling gay young girls, scatterbrained, coquettish, and dutiful. I, 922)

Here the comparison of the hawthorns to young girls reflects the title of the volume, while the allusion to the hawthorns of Combray, where the narrator had first seen Gilberte Swann (I, 138–45), binds this text to the earlier one. The comparison becomes a tool for uniting visual entities separated in time and space, for regaining lost time through art.

Metonymy often involves the replacement of effect for cause, presented as a visual (or otherwise sensorial) experience, as in the following passage, taken from the beginning of Flaubert's *L'Education sentimentale:* "Enfin le navire partit; et les deux berges, peuplées de magasins, de chantiers et d'usines, filèrent comme deux larges rubans que l'on déroule" ("Finally the boat left; and the two banks, crowded with shops, worksites and factories, passed by like two large ribbons being unfurled").[23] Here the phrase "the two banks . . . passed by"—a physically impossible situation that suggests the effect produced on the spectator— replaces the actual cause of the impression, the movement of the boat seen from a passenger's perspective. This form of metonymy, where effects prevail perceptually, masking hidden causes, is especially adaptable to Maupassant's mania for mystery, as with the discovery of Paul's body in *La Femme de Paul:* "Puis quelque chose de gros apparut à la surface de l'eau" ("Then something large appeared on the surface of the water").[24]

Synecdoche of the part for the whole is the most prevalent form of the figure found in realist texts, as evidenced by the following example from *Madame Bovary:* "Les pieds retombaient en mesure, les jupes se bouffaient et frôlaient, les mains se donnaient, se quittaient; les mêmes yeux, s'abaissant devant vous, revenaient se fixer sur les vôtres" ("Feet fell in time, skirts puffed and rustled, hands joined, parted; the same eyes, lowered before you, returned to stare at yours").[25] Here disembodied parts—feet, skirts, hands, eyes—seem to detach themselves and move independently, merely hinting at the entities to which they belong, much

23. *L'Education sentimentale* (Paris: Garnier Frères, 1964), 1.
24. In *"La Parure" et autres contes parisiens*, 216.
25. *Madame Bovary*, 47.

as they would be perceived during a waltz. The same dehumanizing use of the technique also characterizes Maupassant, as in this passage from *Boule de Suif*—"Les bouches s'ouvraient et se fermaient sans cesse, avalaient, mastiquaient, engloutissaient férocement" ("Mouths opened and closed continuously, swallowed, chewed, gobbled ferociously")[26]— where it highlights the theme of eating, which itself underscores the materialist consumption of the bourgeois class.

Certainly the primary function of any figure varies according to the specific text where it appears, highlighting themes, revealing character traits, and binding the text together. The function of the figure also varies according to the role it fulfills in underlining the vision of the individual author; for example, the exterior causing of metaphor, where the invented image, presumably generated in the character's mind, is motivated by the physical surroundings, serves as a concrete illustration of the determinism of the individual by the milieu in Zola's novels, while the frequent use of synecdoche, where the part replaces the whole, underscores a fragmented vision of the universe for Flaubert. The function of a figure may also vary according to the times. Michel LeGuern contends, for example, that synecdoche of the part for the whole is a tool that forces the reader to focus on concrete, physical details and objects, a major tenet of realism.[27]

But perhaps a primary function of the realist trope is its very visuality, which reinforces the phenomenal concept of human experience for Zola and many major writers of his times. Observation, perception, the continuity of mind and matter, the interaction of the individual with the exterior world, are essential keys to the late nineteenth-century literary text, ones that link it to its contemporaries, the impressionists, and to numerous successors, Proust, Sartre, and Robbe-Grillet the most obvious among them. In short, metaphor, metonymy, and synecdoche are not merely rhetorical figures found in realism, but modes of perception that are at the root of the individual's relationship with the universe.[28]

26. In *"Boule de Suif" et autres contes normands* (Paris: Garnier Frères, 1971), 14.

27. "La synecdoche de la partie pour le tout . . . tient une place privilégiée dans les textes réalistes; c'est un des moyens dont se sert le plus volontiers un écrivain lorsqu'il désire faire porter l'attention de ses lecteurs sur les détails de la réalité qu'il décrit, et c'est là sans doute une des préoccupations essentielles de l'écriture réaliste" (Michel LeGuern, *Sémantique de la métaphore et de la métonymie* [Paris: Larousse, 1973], 104).

28. On this point I cannot agree with Charles Bally, who sees in figures an error of vision and analysis: "Celui qui a dit pour la première fois: 'Voici une *voile*' en voyant un bateau à *voiles*, l'a fait parce que, positivement, il ne regardait que la voile en voyant le bateau; on a appelé cela faire une *synecdoche*. Il y a analyse imparfaite lorsque nous confondons deux choses distinctes, mais unies par un lien constant, p. ex. lorsque nous

Jacques Rivière noted that late nineteenth-century France would be fertile ground for a comparative study of the relationship between the individual and the visible world: "Someone will have to try one day to describe in detail, and with supporting illustrations, the gradual modification that occurred during the course of the nineteenth century in the mental attitude of the writer. In broad terms, it consisted of a progressive weakening of the objective instinct, in an increasingly frailer faith in the importance of exterior models."[29] Although space does not allow the "detail" and "illustrations" called for by Rivière, I shall briefly compare Emile Zola's vision with that of two immediate neighbors on the temporal continuum that runs through the period, Gustave Flaubert and Marcel Proust.

Maupassant—so close to Flaubert that it has been alleged that he was the latter's natural son—writes that "Flaubert was capable of judging only from a distance; he suffered from a contact ailment. Seeing from too near gave him vertigo, the interval blurred, he could no longer distinguish anything."[30] Georges Poulet also contends that between Flaubert and his world was "an absolute gap. Sometimes this gap is depicted in the form of a general petrification of things," and he goes on to quote Flaubert concerning this relationship between the object and the observer: "Then it appears to you, this interval, like an immense precipice."[31]

désignons le contenu par le contenant." This passage, from Bally's *Traité de stylistique française* (Heidelberg: Carl Winter, 1909), 188–89, is quoted by LeGuern (*Sémantique,* 79) and alluded to by Albert Henry in his *Métonymie et métaphore* (Paris: Klincksieck, 1971). Henry disagrees with Bally and offers his own notion that figures represent a mental and perceptual process of focusing: "il braque, concentre (focalise) ou dilue (défocalise) son faisceau inquisiteur et éclairant selon ses préoccupations ou ses intentions, qu'il s'agisse de métonymie ou de synecdoche, l'esprit joue sur la contiguité entre certains concepts, sur les rapports entre concepts, en faisant abstraction, ou en feignant d'ignorer certains éléments de la compréhension véritable. *Voile* pour *vaisseau:* l'esprit éclaire vivement cette caractéristique du navire, voile les autres et utilise ensuite le terme désignant la partie, pour évoquer le tout" (23). Henry's description of figures as mental and perceptual processes is clearly borne out by the texts cited here.

29. "Il faudra tâcher un jour de décrire en détail, et avec illustrations à l'appui, la lente modification qui s'est produite au cours du XIXe siècle dans l'attitude mentale de l'écrivain. En gros, elle a consisté dans un progressif affaiblissement de l'instinct objectif, dans une foi de plus en plus grêle à l'importance des modèles extérieurs." "Reconnaissance à Dada," *Nouvelles Etudes* (Paris: Gallimard, 1947), 301.

30. "Flaubert n'était capable de juger que de loin; il souffrait d'une maladie du contact. Voir de trop près lui donnait le vertige, l'intervalle se troublait, il ne distinguait plus rien." Cited by Jean-Pierre Richard in *Littérature et sensation* (Paris: Seuil, 1954), 126–27.

31. "un écart absolu. Parfois cet écart est dépeint sous l'aspect d'une pétrification générale des choses" and "Puis, il vous apparaît, cet intervalle, comme un immense précipice." Both quotes are from *Etudes sur le temps humain,* 327.

Indeed, Flaubert himself described a many-colored barrier interposed between himself and the world:

> Entre le monde et moi existait je ne sais quel vitrail, peint en jaune avec des raies de feu et des arabesques d'or, si bien que tout se réfléchissait sur mon âme comme sur les dalles d'un sanctuaire, embelli, transfiguré et mélancolique cependant; et rien que de beau n'y marchait, c'étaient des rêves plus majestueux que des cardinaux à manteaux de pourpre.

> (Between the world and me existed some sort of stained-glass window, painted in yellow with stripes of fire and arabesques of gold, such that everything was reflected on my soul as on the flagstones of a sanctuary, embellished, transfigured, yet melancholic; and nothing unbeautiful occurred there, there were dreams more majestic than cardinals in purple robes.)[32]

In short, visual perception for Flaubert was most comfortable at a distance and refracted through a colored glass—smacking of Zola's "screen" or Bergson's "veil"[33]—constructed from within to transfigure the raw matter of external reality into objects of Byzantine splendor. Poulet concludes that "the first movement of the Flaubertian reconstruction [of the world in the mind] will thus be the ascending movement by which thought climbs through a series of inferences the stairway of causes, and thus distances itself progressively from the realm of sensation or present images, in order to pass into that of the order of things, into the realm of laws."[34] For Flaubert, the randomness of the impression must yield to the order of style as the top priority among artistic concerns—"le style étant à lui tout seul une manière absolue de voir les choses" ("style being in and of itself an absolute manner of seeing things").[35]

For Zola, on the other hand, it is precisely the artist's vision that determines his style. In Zola's descriptive passages the reader is immersed in a purely visual and phenomenal world, where the author is ultimately less interested in describing objects than in describing the human eye as it

32. *Correspondence*, II, 179.
33. See Chapter 5, note 78.
34. "le premier mouvement de la reconstruction flaubertienne va donc être le mouvement ascendant par lequel la pensée gravit en une série d'inférences l'escalier des causes, et s'éloigne ainsi progressivement du domaine de la sensation ou des images actuelles, pour passer dans celui de l'ordre des choses, dans le domaine de la loi." *Etudes sur le temps humain*, 324.
35. *Correspondence*, II, 70.

encounters, records, and grasps these objects. Zola's repeated insistence on vision enables him to bridge the "gap" or "interval" that separated Flaubert from external reality and to establish a direct and firm point of contact between the object and the observer in the act of observation. Unlike Flaubert, Zola, as Antoinette Jagmetti has put it, "sees reality only from close up. It only surges before him at a hand's distance. He approaches it nearsightedly in order to recognize from nearby what from far away he perceived only vaguely. The world appears to him 'under a sort of milky fog, where things emerged only very close up, as from the depths of a dream.'"[36] This visual "closeness," this "act of identification by which are abolished not only the interval between subject and object, but the existence of one and the other as distinct beings" that Poulet calls "integral phenomenism,"[37] moves Zola further into the flow of life and adds to the dynamic, sweeping effect that characterizes his novels.

Certainly Proust inherits Zola's faith in a perceptual or phenomenal approach to reality. As Roger Shattuck notes: "Proust drew on an incredibly rich repertory of metaphors. But it is principally through the science and the art of *optics* that he beholds and depicts the world. Truth—and Proust believed in it—is a miracle of vision."[38] Proust also believed that style was a miracle of vision—"le style pour l'écrivain, aussi bien que la couleur pour le peintre, est une question non de technique mais de vision" ("style for the writer, just like color for the painter, is a matter not of technique but of vision," III, 895)—and that the work of art must reflect this visual miracle—"l'ouvrage de l'écrivain n'est qu'une espèce d'instrument optique qu'il offre au lecteur afin de lui permettre de discerner ce que, sans ce livre, il n'eût peut-être pas vu en soi-même" ("the writer's work is simply a type of optical instrument that he offers to the reader in order to enable him to discern what, without this book, he might perhaps not have seen on his own," III, 911).

Proust's vision, especially in *Du côté de chez Swann* and *A l'ombre des jeunes filles en fleurs,* has the same cinematographic quality found in Zola's temporal perception of reality. Shattuck notes that Proust makes extensive use of "the cinematographic principle," which "employs a sequence of separately insignificant differences to produce the effect of motion or

36. "ne voit la réalité que tout près. Elle ne surgit devant lui qu'à la distance de sa main. Il s'approche d'elle en myope pour reconnaître de près ce que de loin il n'aperçoit que vaguement. Le monde lui apparaît 'sous une sorte de brouillard laiteux, où les choses ne surgissaient que très rapprochées, ainsi que du fond d'un rêve.'" Antoinette Jagmetti, "*La Bête humaine*" *d'Emile Zola* (Geneva: Droz, 1955), 15.

37. "acte d'identification par lequel se trouvent abolis non seulement l'intervalle du sujet à l'objet, mais l'existence de l'un et de l'autre en tant qu'êtres distincts." *Etudes,* 310.

38. *Proust's Binoculars,* 6.

animation in objects seen. It vividly conveys the sensation of flux, of a steady linear change from one moment flowing into the next. Thus a series of stills in sequence can create the illusion of movement when riffled through rapidly under our eyes or thrown on a screen. . . . it appears to conform to the continuity of normal experience."[39] Indeed, many of Proust's early descriptions create an effect of suspended time akin to the slow-motion film, which Apollinaire found to characterize the naturalist novel, as when the narrator analyzes and decomposes, to the point of comic absurdity, Legrandin's sweeping bow:

> La figure de Legrandin exprimait une animation, un zèle ex-traordinaires; il fit un profond salut avec un renversement se-condaire en arrière, qui ramena brusquement son dos au delà de la position de départ et qu'avait dû lui apprendre le mari de sa soeur, Mme de Cambremer. Ce redressement rapide fit refluer en une sorte d'onde fougueuse et musclée la croupe de Legrandin que je ne supposais pas si charnue et je ne sais pourquoi cette ondulation de pure matière, ce flot tout charnel, sans expression de spiritualité et qu'un empressement plein de bassesse fouettait en tempête, éveillèrent tout d'un coup dans mon esprit la possibilité d'un Le-grandin tout différent de celui que nous connaissions.

> (Legrandin's face expressed an animation and a zeal that were extraordinary; he made a deep bow with a secondary reversal backwards, which suddenly returned his back above its initial position and which the husband of his sister, Mme de Cambre-mer, must have taught him. This rapid straightening up made Legrandin's rump, which I hadn't suspected to be so fleshy, flow back in a sort of spirited, muscular wave, and I don't know why this undulation of pure matter, this flow of flesh, without expres-sion of spirituality and which a hastiness full of baseness whipped into a tempest, wakened suddenly in my mind the possibility of a Legrandin completely different from the one we knew. I, 124–25)

But if Proust does momentarily adopt the cinematographic principle of perception and representation, he quickly abandons this vestige of natural-ism. The narrator notes that "quelques-uns voulaient que le roman fût une sorte de défilé cinématographique des choses. Cette conception était absurde. Rien ne s'éloigne plus de ce que nous avons perçu en réalité qu'une telle vue cinématographique" ("some wanted the novel to be a

39. Ibid., 49.

sort of cinematographic procession of things. This conception was absurd. Nothing is farther from what we have perceived in reality than such a cinematographic view," III, 882–83). He later adds that such a manner of seeing, bent on capturing the temporal sequence of perceived events, works against truth, which, for Proust, lies, of course, outside time:

> Ce que nous appelons la réalité est un certain rapport entre ces sensations et ces souvenirs qui nous entourent simultanément—rapport que supprime une simple vision cinématographique, laquelle s'éloigne par là d'autant plus du vrai qu'elle prétend se borner à lui—rapport unique que l'écrivain doit retrouver pour en enchaîner à jamais dans sa phrase les deux termes différents.
>
> (What we call reality is a certain relationship between those sensations and those memories that surround us simultaneously—a relationship eliminated by a simple cinematographic vision, which thus moves even farther from truth, since it claims to be limited to it—a unique relationship that the writer must rediscover in order to capture forever in his sentence the two different terms. III, 889–90)

While Proust perhaps inherits his sense of vision from Zola and the naturalists, he expands his manner of seeing far beyond the cinematographic principle that dominates their work, and he turns to modes of vision that will allow him to transcend the flux of time. Shattuck finds that Proust's first reaction against a vision based on linear and temporal sequence resulted in the juxtaposition (sometimes violent) of visual images that characterizes much of *A la recherche du temps perdu:*

> The *montage principle* employs a succession of large contrasts to reproduce the disparity and contradiction that interrupt the continuity of experience. In the international vocabulary of filmmaking, montage is the term meaning the arrangement of shots or footage in an order designed to produce a particular effect. . . . The montage principle rejects the accumulation of small differences (cinematographic principle) for the exploitation of larger associative or dissociative leaps that suggest the meaning of a scene or situation by contrast. . . . Montage vividly conveys the sensation of intermittency or jump that remains in any grasp we have of life and the tendency of what we see and what we feel to resist any prolonged order or linear sequence in time. The complex art form which we call "the movies" employs both cinemato-

graphic and montage principles. The former without the latter would lead to monotony; the latter without the former would lead to incoherence.[40]

Ultimately Proust embraces a vision that will combine two images, removed from one another in time, to achieve a coherent and meaningful, fourth-dimensional perception that Shattuck calls "stereoscopic" or "binocular" vision: "The *stereoscopic principle* abandons the portrayal of motion in order to extablish a form of arrest which resists time. It selects a few images or impressions sufficiently different from one another not to give the effect of continuous motion, and sufficiently related to be linked in a discernible pattern. This stereoscopic principle allows our binocular (or multiocular) vision of mind to hold contradictory aspects of things in the steady perspective of recognition, of relief in time."[41]

Proust moves beyond the direct vision of external phenomena and seeks the patterns of perception that will transcend the temporary and temporal qualities of purely immediate vision. Perception, for Proust, becomes, finally, a matter of mind—"Je m'étais rendu compte que seule la perception grossière et erronée place tout dans l'objet, quand tout est dans l'esprit" ("I had realized that only crude, erroneous perception places everything in the object, when everything is in the mind," III, 912)—but it should be remembered that he passes through and remains within the framework of visual perception. He never rejects vision in favor of pure abstraction, as Flaubert might seem to do; rather, Proust widens the scope of vision to include reason, memory, and other internal phenomena. His spiritualism, unlike that of Flaubert, does not reject the possibilities of perception but moves to understand, reaffirm, and refine them. In this regard, Proust's efforts might be fruitfully compared to those of Zola's boyhood friend Cézanne, as described by the eminent art critic, Pierre Francastel:

> The point of departure for Cézanne is sensation, but whereas baroque artists amplify and display their sensations, Cézanne departs from his in order to elaborate it, refine it, understand it and, especially, remove from it precisely that fragile aspect that Baroque art espouses. His intimate torment is born from the desire to surpass the level of pure sensation in order to attain the conception of form, and his classicism is essential, because it seeks to

40. Ibid., 50–51.
41. Ibid., 51.

substitute for the order of sensations that of reason—but solely in order to better conserve the quality of the sensation itself.[42]

This all too brief examination of visual phenomenality in Flaubert, Zola, and Proust suggests a rather complete spectrum of possibilities, ranging from Flaubert's multicolored inner vision, through Zola's integral phenomenism, to Proust's spiritual and extratemporal perception of reality. As the immense distance, the gaping interval, between Flaubert and his world is breached by Zola and abolished by Proust, it has been possible to identify a progressive assimilation of the object into the mind and lend some confirmation to Jacques Rivière's claim that "the slow modification that occurred during the course of the nineteenth century . . . consisted of a progressive weakening of the objective instinct."[43] In short, a rich sample (however small) of the strata of vision in late nineteenth-century France has been examined, and some of the veins that run through these strata and branch out into the separate and unique pockets of individual artistic creation have been identified. It is clear that an approach based on vision has numerous possibilities, many of which have been treated only sparely here; but it would be appropriate, perhaps, to conclude by mentioning the intrinsic value inherent in exploring how we see the world about us.

Indeed, we today may have lost the sense of seeing sought by Zola and those of his generation. Henry James contends that "we have doubtless often enough the courage of our opinions (when it befalls that we have opinions), but we have not so constantly that of our perceptions."[44] Paul Valéry complains that "most people see through their intellect much

42. "Le point de départ de Cézanne c'est la sensation, mais tandis que les baroques amplifient et étalent leurs sensations, Cézanne part de la sienne pour l'élaborer, l'affiner, la comprendre et surtout lui enlever précisément cet aspect fragile dont le baroque s'éprend. Son tourment intime naît du désir de dépasser le plan de la sensation pure pour parvenir à la conception de la forme et son classicisme est essentiel parce qu'il vise à substituter à l'ordre des sensations celui de la raison—mais uniquement afin de mieux conserver la qualité de la sensation elle-même." Pierre Francastel, *L'Impressionnisme: Les Origines de la peinture moderne* (Paris: Les Belles Lettres, 1937), 233. Richard Shiff ("The End of Impressionism," in *The New Painting: Impressionism, 1874–1886* [San Francisco: The Fine Arts Museums of San Francisco, 1986], 74) also notes that "later, during the 1890s, Maurice Denis would argue repeatedly that the end of art must be a synthesis of object and subject; eventually he would praise Cézanne for accomplishing a 'reconciliation between the objective and the subjective'" (see Denis, "Préface de la IXe exposition des peintres impressionnistes et symbolistes," *Théories* 29 [1895]; and "Cézanne," *L'Occident* 12 [September 1907]: 120).

43. "Reconnaissance à Dada," 301.

44. *The Future of the Novel*, ed. Leon Edel (New York: Random House, Vintage Books, 1956), 198.

more often than through their eyes. . . . They neither do nor undo anything with their sensations. Knowing that the level of calm waters is horizontal, they fail to see that the sea is *upright,* in the back of one's view."[45] Rudolf Arnheim introduces his study of *Art and Visual Perception* by noting that "our experiences and ideas tend to be common but not deep, or deep but not common. We have neglected the gift of comprehending things through our senses. Concept is divorced from percept, and thought moves among abstractions. Our eyes have been reduced to instruments with which to identify and to measure; hence we suffer a paucity of ideas that can be expressed in images and an incapacity to discover meaning in what we see. . . . the inborn capacity to understand through the eyes has been put to sleep and must be reawakened."[46]

The advent of the motion picture and then television has no doubt played a more than minimal role in the progressive anesthesizing of visual capacities. In some small sense, perhaps, this study of vision may contribute to a reawakening of dormant eyes, by resurrecting the vanishing period of Zola and his contemporaries, where the human eye achieved, however momentarily, that endless summer of sunlight and splendor, where light and color spill freely over an ever-changing world, open to the many modes and miracles of visual perception.

45. "la plupart des gens y voient par l'intellect bien plus souvent que par les yeux. . . . Ils ne font ni défont rien dans leurs sensations. Sachant horizontal le niveau des eaux tranquilles, ils méconnaissent que la mer est *debout,* au fond de la vue." From "Introduction à la méthode de Léonard de Vinci," *Variété* (Paris: Gallimard, 1948), 237–38, quoted in Ruth Moser, *L'Impressionnisme français* (Geneva: Droz, 1952), 219.

46. *Art and Visual Perception: A Psychology of the Creative Eye,* rev. ed. (Berkeley and Los Angeles: University of California Press, 1974), 1.

Bibliography

I. Zola's Writings

Zola, Emile. *L'Atelier de Zola: Textes de journaux 1865–1870*. Ed. Martin Kanes. Geneva: Droz, 1963.

———. *Carnets d'enquête*. Ed. Henri Mitterand. Paris: Plon, Terre Humaine, 1986. (Includes many of Zola's preliminary notes for the settings of his novels.)

———. *Correspondence*. Ed. B. H. Bakker et al. Montreal and Paris: University of Montreal Press and Editions du Centre National de la Recherche Scientifique, 1978–. (Seven of eleven eventual volumes have been published through 1991.)

———. *Lettres de Paris*. Ed. Phillip Duncan and Vera Erdely. Geneva: Droz, 1963.

———. *Mon Salon/Manet/Écrits sur l'art*. Ed. Antoinette Ehrard. Paris: Garnier Flammarion, 1970.

———. *Oeuvres complètes*. 15 vols. Ed. Henri Mitterand. Paris: Cercle du Livre Précieux, 1966–69.

——. *Les Oeuvres complètes.* Ed. Maurice LeBlond. 50 vols. Paris: Typographie François Bernouard, 1927–29.

——. *Les Rougon-Macquart.* 5 vols. Ed. Henri Mitterand. Paris: Editions Fasquelle et Gallimard, Bibliothèque de la Pléiade, 1960–67. (Accompanied by thorough appendices, describing the genesis of each novel and including selections from Zola's preliminary notes, sketches, and outlines, along with textual variants and bibliographies.)

——. *Salons.* Ed. F. W. J. Hemmings and R. J. Niess. Geneva: Droz, 1959.

II. Writings of Other Novelists

Balzac, Honoré de. *Le Père Goriot.* Paris: Garnier Frères, 1963.

Chateaubriand, François-René de. *René.* Paris: Garnier Frères, 1962.

Flaubert, Gustave. *Correspondence.* Nouvelle édition augmentée. 9 vols. Paris: Conard, 1926–33.

——. *L'Education sentimentale.* Paris: Garnier Frères, 1964.

——. *Madame Bovary.* Paris: Garnier Frères, 1961.

James, Henry. *The Art of the Novel: Critical Prefaces.* Ed. R. P. Blackmur. New York: Charles Scribner's Sons, 1934.

——. *The Future of the Novel.* Ed. Leon Edel. New York: Random House, Vintage Books, 1956.

Maupassant, Guy de. *"Boule de Suif" et autres contes normands.* Paris: Garnier Frères, 1971.

——. *"La Parure" et autres contes parisiens.* Paris: Editions Garnier, 1984.

——. *Pierre et Jean.* Paris: Garnier Frères, 1959.

Proust, Marcel. *A la recherche du temps perdu.* 3 vols. Paris: Gallimard, Bibliothèque de la Pléiade, 1963.

——. "Chardin ou le coeur des choses." *Le Figaro littéraire,* 27 March 1954, 5.

Twain, Mark. *Adventures of Huckleberry Finn.* New York: New American Library, Signet Classics, 1959.

——. *The Adventures of Tom Sawyer.* Harmondsworth, Middlesex, England: Penguin Puffin Books, 1950.

III. Works Dealing with Zola

Adhémar, Hélène, and Jean Adhémar. "Zola et la peinture." *Arts* 389 (12–18 December 1952): no page numbers.

Adhémar, Jean. "La Myopie de Zola." *Aesculape* 33 (November 1952): 194–97.

Alexis, Paul. *Emile Zola, notes d'un ami.* Paris: Charpentier, 1882.

Allard, Jacques. *Zola: Le Chiffre du texte: Lecture de "L'Assommoir".* Grenoble: Presses Universitaires de Grenoble, 1978.

Baguley, David. "Image et symbole: La Tache rouge dans l'oeuvre de Zola." *Cahiers naturalistes* 39 (1970): 36–46.

———. "Les Paradis perdus: Espace et regard dans *La Conquête de Plassans* de Zola." *Nineteenth-Century French Studies* 9, nos. 1–2 (Fall–Winter 1980–81): 80–92.

———. "Le Récit de guerre: Narration et focalisation dans *La Débâcle.*" *Littérature* 50 (May 1983): 77–90.

Belgrand, Anne. "Espace clos, espace ouvert dans *L'Assommoir.*" In *Espaces romanesques,* ed. Michel Crouzet, 5–14. Paris: PUF, 1982.

Berg, William J. "*L'Oeuvre:* Naturalism and Impressionism." *L'Esprit créateur* 25, no. 4 (Winter 1985): 42–50.

———. "A Note on Imagery as Ideology in Zola's *Germinal.*" *Clio* 2 (Fall 1972): 43–45.

Berg, William J., and Laurey K. Martin. *Emile Zola Revisited.* Boston: G. K. Hall, Twayne's World Authors Series, 1992.

Bernard, Marc. *Zola par lui-même.* Paris: Seuil, 1952.

Bertrand, Denis. *L'Espace et le sens: "Germinal" d'Emile Zola.* Paris: Hadès-Benjamins, 1985.

Bertrand-Jennings, Chantal. *Espaces romanesques: Zola.* Sherbrooke, Québec: Editions Naaman, 1987.

Borie, Jean. *Zola et les mythes, ou: De la nausée au salut.* Paris: Seuil, 1971.

Borneuf, Roland. "L'Organisation de l'espace dans le roman." *Etudes littéraires* 3, no. 1 (April 1970): 77–94.

Brady, Patrick. *Le Bouc émissaire chez Emile Zola.* Heidelberg: Carl Winter Univeristätsverlag, 1981.

———. "*L'Oeuvre*" de Emile Zola: Roman sur les arts, manifeste, autobiographie, roman à clef. Geneva: Droz, 1967.

———. "Pour une nouvelle orientation en sémiotique: A propos de *L'Oeuvre* d'Emile Zola." *Rice University Studies* 63, no. 1 (1977): 43–84.

Citron, Pierre. "Quelques aspects romantiques du Paris de Zola." *Cahiers naturalistes* 24–25 (1963): 47–54.

Cocteau, Jean. "Zola, le poète." *Cahiers naturalistes* 1 (1955–56): 442–43.

De Amicis, Edmondo. *Studies of Paris.* Trans. W. W. Cady. New York: G. P. Putnam's Sons, 1887.

De Carli, Antonio. *En relisant Zola.* Torino, 1932.

Dewart, Gordon. "Emile Zola's Critical Theories on the Novel." Ph.D. diss., 2 vols. Princeton: Princeton University, 1953.

Doucet, Fernand. *L'Esthétique d'Emile Zola et son application à la critique.* The Hague: Smith, 1923.

Duncan, Philip. "The 'Art' of Landscape in Zola's *L'Oeuvre.*" *Symposium* 39, no. 3 (Fall 1985): 167–76.

Faria, Neide de. *Structure et unité dans "Les Rougon-Macquart": La Poétique du cycle.* Paris: Nizet, 1977.

Féral, Josette. "La Sémiotique des couleurs dans *Germinal.*" *Cahiers naturalistes* 49 (1975): 136–48.

Gauthier, Guy. "Zola et les images." *Europe* 46, nos. 468–69 (April–May 1968): 400–416.

Girard, Marcel. "L'Univers de *Germinal*." *Revue des sciences humaines* 69 (January–March 1953): 59–76.

Grant, Elliott. *Emile Zola*. New York: Twayne Publishers, Twayne's World Authors Series, 1966.

Hamon, Philippe. "A propos de l'impressionnisme de Zola." *Cahiers naturalistes* 34 (1967): 139–47.

———. *Le Personnel du roman: Le Système des personnages dans les "Rougon-Macquart" d'Emile Zola*. Geneva: Droz, 1983.

Hemmings, F.W.J. *Emile Zola*. 2nd ed. Oxford: The Clarendon Press, 1966.

Herriot, Edouard. "Hommage à Zola." In *Esquisses*. Paris: Hachette, 1928, 38–52.

Hertz, Henri. "Emile Zola, témoin de la vérité." *Europe* 30, nos. 83–84 (November–December, 1952): 27–34.

Jagmetti, Antoinette. "*La Bête humaine*" *d'Emile Zola*. Geneva: Droz, 1955.

Jennings, Chantal (Bertrand). "La Symbolique de l'espace dans *Nana*." *Modern Language Notes* 88, no. 4 (May 1973): 764–74.

Kamm, Lewis. "The Structural and Functional Manifestations of Space in Zola's *Rougon-Macquart*." *Nineteenth-Century French Studies* 3, nos. 3–4 (1975): 224–36.

Knapp, Bettina. "The Creative Impulse—to Paint 'Literarily': Emile Zola and *The Masterpiece*." *Research Studies* 42 (June 1980): 71–82.

Lanoux, Armand. *Bonjour Monsieur Zola*. Paris: Hachette, 1954.

Lapp, John. "The Watcher Betrayed and the Fatal Woman: Some Recurring Patterns in Zola." *PMLA* 74, no. 3 (June 1959): 276–84.

Marcussen, Marianne, and Hilde Olrik. "Le Réel chez Zola et les peintres impressionnistes: Perception et représentation." *Revue d'histoire littéraire de la France* 80, no. 6 (November–December 1980): 965–77.

Martin, Laurey K. "L'Elaboration de l'espace fictif dans *L'Assommoir*." *Cahiers naturalistes* (forthcoming).

Matthews, J. H. *Les Deux Zola: Science et personnalité dans l'expression*. Geneva: Droz, 1957.

———. "L'Impressionnisme chez Zola: *Le Ventre de Paris*." *Le Français moderne* 29 (1961): 199–205.

Max, Stefan. *Les Métamorphoses de la grande ville dans "Les Rougon-Macquart*." Paris: Nizet, 1966.

Mitterand, Henri. "Poétique et idéologie: La Dérivation figurale dans *Germinal*." In *Fiction, Form, Experience: The French Novel from Naturalism to the Present / Fiction, forme, expérience: Le Roman français depuis le naturalisme*, ed. Grant Kaiser, 44–52. Montréal: Editions France-Québec, 1976.

———. "Le Regard d'Emile Zola." *Europe* 46, nos. 468–69 (April–May 1968): 182–202.

Moore, Mary Jane Evans. "The Spatial Dynamics of *L'Assommoir*." *Kentucky Romance Quarterly* 29, no. 1 (1982): 3–14.

Newton, Joy. "Emile Zola and the French Impressionist Novel." *L'Esprit créateur* 13 (1973): 320–28.

———. "Emile Zola impressionniste." *Cahiers naturalistes* 33 (1967): 39–52, and 34 (1967): 124–38.

Newton, Joy, and Basil Jackson. "Gervaise Macquart's Vision: A Closer Look at Zola's Use of 'Point of View' in *L'Assommoir.*" *Nineteenth-Century French Studies* 11, nos. 3–4 (Spring–Summer 1983): 313–20.

Niess, Robert J. *Zola, Cézanne, and Manet: A Study of "L'Oeuvre."* Ann Arbor: University of Michigan Press, 1968.

Pasco, Allan H. "Myth, Metaphor, and Meaning in *Germinal.*" *French Review* 46 (1973): 739–49.

Proulx, Alfred. *Aspects épiques des "Rougon-Macquart" de Zola.* The Hague: Mouton, 1966.

Ripoll, Roger. "Fascination et fatalité: Le Regard dans l'oeuvre de Zola." *Cahiers naturalistes* 32 (1966): 104–16.

———. *Réalité et mythe chez Zola.* 2 vols. Paris: Champion, 1981.

Robert, Guy. *Emile Zola: Principes et caractères généraux de son oeuvre.* Paris: Société d'Editions, Les Belles Lettres, 1952.

———. "Trois textes inédits de Zola." *Revue des sciences humaines* 51–52 (July–December 1948): 181–207.

Schober, R. "Observations sur quelques procédés stylistiques de Zola." *Cahiers naturalistes* 28 (1964): 149–61.

Schor, Naomi. "Zola: From Window to Window." *Yale French Studies* 42 (June 1969): 38–51.

Seillière, Ernest. *Emile Zola.* Paris: B. Grasset, 1923.

Tintner, Adeline. "What Zola's *Nana* owes to Manet's *Nana.*" *Iris: Notes in the History of Art* 8 (December 1983): 15–16.

Toulouse, Dr. Edouard. *Enquête médico-psychologique sur la supériorité intellectuelle: Emile Zola.* Paris: Société d'Editions Scientifiques, 1896.

Van Buuren, Maarten. "La Métaphore filée chez Zola." *Poétique* 57 (1984): 53–63.

———. *"Les Rougon-Macquart" d'Emile Zola: De la métaphore au mythe.* Paris: Corti, 1986.

Van Deventer, Susan. "Color in Zola." *PRom* 5, no. 2 (Spring 1983): 65–83.

Walker, Philip. *"Germinal" and Zola's Philosophical and Religious Thought.* Amsterdam: John Benjamins, Purdue University Monographs in Romance Languages, 1984.

———. "The Mirror, the Window, and the Eye in Zola's Fiction." *Yale French Studies* 42 (June 1969): 52–67.

———. "Prophetic Myths in Zola." *PMLA* 74, no. 4, pt. 1 (September 1959): 444–52.

———. "Zola's Use of Color Imagery in *Germinal.*" *PMLA* 77, no. 4, pt. 1 (September 1962): 442–49.

Wenger, Jared. "The Art of the Flashlight: Violent Technique in *Les Rougon-Macquart.*" *PMLA* 57, no. 4, pt. 1 (December 1942): 1137–59.

Wilson, Angus. *Emile Zola: An Introductory Study of His Novels.* New York: William Morrow, 1952.

IV. Works Dealing with Literature

Auerbach, Eric. *Mimesis: The Representation of Reality in Western Literature.* Trans. Willard Trask. Garden City, N.Y.: Doubleday Anchor Books, 1957.

Bally, Charles. "Impressionnisme et grammaire." In *Mélanges Bernard Bouvier,* 261–79. Geneva: Sonor, 1920.

———. *Traité de stylistique française.* 2 vols. Heidelberg: Carl Winter, 1909.

Barthes, Roland. *S/Z.* Trans. Richard Miller. New York: Hill and Wang, 1974. Originally published in Paris: Editions du Seuil, 1970.

Berg, William J. "Cryptographie et communication dans *La Chartreuse de Parme.*" *Stendhal Club* 78 (1978): 170–82.

Berg, William J., Michel Grimaud, and George Moskos. *Saint/Oedipus: Psychocritical Approaches to Flaubert's Art.* Ithaca, N.Y.: Cornell University Press, 1982.

Bergson, Henri. *Le Rire.* Paris, 1928.

Bonnefis, Philippe. "Fluctuations de l'image, en régime naturaliste." *Revue des sciences humaines* 39, no. 154 (April–June 1974): 283–300.

Booth, Wayne. *The Rhetoric of Fiction.* Chicago: University of Chicago Press, 1961.

Brunetière, Ferdinand. "L'Impressionnisme dans le roman." *Revue des deux mondes,* 15 November 1879: 446–59. Repr. in *Le Roman naturaliste,* 81–110. Paris: Calmann Lévy, 1892.

Caminade, Pierre. *Image et métaphore.* Paris: Bordas, 1970.

Champfleury (Jules Fleury). *Le Réalisme.* Paris: M. Lévy, 1857.

David-Sauvageot, A. *Le Réalisme et le naturalisme dans la littérature et dans l'art.* Paris: Calmann Lévy, 1890.

Deffoux, Léon. *Le Naturalisme.* Paris: Les Oeuvres Représentatives, 1929.

Dubois, Jacques, Francis Edeline, Jean-Marie Klinkenberg, Philippe Minguet, François Pire, and Hadelin Trinon. *Rhétorique générale.* Paris: Editions Larousse, 1970.

Fontanier, Pierre. *Les Figures du discours.* Ed. Gérard Genette. Paris: Garnier Flammarion, 1977.

Friedman, Norman. "Point of View in Fiction: The Development of a Critical Concept." In *Approaches to the Novel,* ed. Robert Scholes, 113–42. San Francisco: Chandler Publishing Co., 1961.

Genette, Gérard. "La Rhétorique restreinte." In *Figures III,* 21–40. Paris: Seuil, 1972.

Gibbs, Beverley Jean. "Impressionism as a Literary Movement." *Modern Language Journal* 36, no. 4 (April 1952): 175–83.

Hamon, Philippe. "Qu'est-ce qu'une description?" *Poétique* 12 (1972): 465–85.

————. *Texte et idéologie.* Paris: PUF, écriture, 1984.

Hatzfeld, Helmut. *Literature Through Art: A New Approach to French Literature.* New York: Oxford University Press, 1952.

Henry, Albert. *Métonymie et métaphore.* Paris: Klincksieck, 1971.

Jakobson, Roman. "Deux aspects du langage et deux types d'aphasie." In *Essais de linguistique générale,* trans. Nicholas Ruwet, 43–67. Paris: Editions de Minuit, 1963.

————. "Linguistics and Poetics." In *Style in Language,* ed. Thomas Sebeok, 350–77. Cambridge, Mass.: MIT Press, 1966.

Johnson, J. Theodore, Jr. "Literary Impressionism in France: A Survey of Criticism." *L'Esprit créateur* 13 (1973): 271–97.

Lapp, John C. "Art and Hallucination in Flaubert." In *"Madame Bovary" and the Critics,* ed. B. F. Bart, 169–88. New York: NYU Press, 1966.

LeGuern, Michel. *Sémantique de la métaphore et de la métonymie.* Paris: Larousse, 1973.

Lubbock, Percy. *The Craft of Fiction.* New York: The Viking Press, Compass Books, 1957.

Lyotard, Jean-François. *Discours/Figures.* Paris: Klincksieck, 1974.

Martino, Pierre. *Le Roman réaliste sous le Second Empire.* Paris: Hachette, 1913.

Matoré, Georges. "A propos du vocabulaire des couleurs." *Annales de l'Université de Paris* 28, no. 2 (April–June 1958): 137–50.

Matthews, J. H. "Things in the Naturalist Novel." *French Studies* 14, no. 3 (July 1960): 212–23.

Moser, Ruth. *L'Impressionnisme français.* Geneva: Droz, 1952.

Neefs, Jacques. "La Figuration réaliste: L'Exemple de Madame Bovary." *Poétique* 16 (1973): 466–76.

Paris, Jean. *L'Espace et le regard.* Paris: Seuil, 1965.

Pontmartin, A. de. *Souvenirs d'un vieux critique.* Paris, 1881.

Poulet, Georges. *Etudes sur le temps humain.* Paris: Plon, 1950.

————. *Métamorphoses du cercle.* Paris: Plon, 1961.

Richard, Jean-Pierre. *Littérature et sensation.* Paris: Seuil, 1954.

Rice, Donald, and Peter Schofer. *Rhetorical Poetics.* Madison: University of Wisconsin Press, 1983.

Rivière, Jacques. "Reconnaissance à Dada." *Nouvelles Etudes.* Paris: Gallimard, 1947.

Romanell, Patrick. "Prolegomena to Any Naturalistic Aesthetics." *Journal of Aesthetics and Art Criticism* 19, no. 2 (Winter 1960): 139–43.

Ruwet, Nicholas. "Synecdoques et métonymies." *Poétique* 23 (1975): 371–88.

Shattuck, Roger. *The Innocent Eye: On Modern Literature and the Arts.* New York: Washington Square Press, 1986.

————. *Proust's Binoculars: A Study of Memory, Time, and Recognition in "A la recherche du temps perdu."* New York: Random House, Vintage Books, 1967.

Starobinski, Jean. *L'Oeil vivant.* Paris: Gallimard, 1961.

Vinay, J.-P., and J. Darbelnet. *Stylistique comparée du français et de l'anglais.* Paris: Didier, 1958.

V. Works Dealing with the Visual Arts/Vision

Arnheim, Rudolf. *Art and Visual Perception: A Psychology of the Creative Eye.* Rev. ed. Berkeley and Los Angeles: University of California Press, 1974. Original version, 1966.

Bataille, Marie-Louise, and Georges Wildenstein. *Berthe Morisot: Catalogue des peintures, pastels et aquarelles.* Paris: Les Beaux Arts, 1961.

Beardslee, David, and Michael Wertheimer, eds. *Readings in Perception.* Princeton: D. Van Nostrand, 1958.

Bergson, Henri. *Matière et mémoire: Essai sur la relation du corps avec l'esprit.* Geneva: Skira, 1946. Originally published in 1896.

Bernard, Claude. *Introduction à l'étude de la médecine expérimentale.* Paris: Librairie Larousse, 1951.

Bertin, Jacques. *Graphics and Graphic Information-Processing.* Trans. William J. Berg and Paul Scott. Berlin: Walter de Gruyter, 1981.

———. *Semiology of Graphics: Diagrams, Networks, Maps.* Trans. William J. Berg. Madison: University of Wisconsin Press, 1983.

Brown, Richard. "Impressionist Technique: Pissarro's Optical Mixture." In *Impressionism in Perspective,* ed. Barbara Ehrlich White, 114–21. Englewood Cliffs, N.J.: Prentice-Hall, A Spectrum Book, 1978.

Bruner, Jerome, Leo Postman, and John Rodrigues. "Expectation and the Perception of Color." In *Readings in Perception,* ed. Beardsley and Wertheimer, 267–78. Princeton: D. Van Nostrand, Co., 1958.

Canaday, John. *Mainstreams of Modern Art.* New York: Holt, Rinehart and Winston, 1959.

Clark, T. J. *The Painting of Modern Life: Paris in the Art of Manet and His Followers.* Princeton: Princeton University Press, 1984.

Denis, Maurice. "Cézanne." *L'Occident* 12 (September 1907). Repr. in John Rewald, *The History of Impressionism,* 4th rev. ed. New York: MOMA, 1973.

———. "Préface de la IXe exposition des peintres impressionnistes et symbolistes." *Théories* 29 (1895). Repr. in Richard Shiff, "The End of Impressionism." In *The New Painting: Impressionism, 1874–1886,* ed. Charles S. Moffett, 37–49. San Francisco: The Fine Arts Museums of San Francisco, 1986.

Duranty, Edmond. *La Nouvelle Peinture: A propos du groupe d'artistes qui expose dans les galeries Durand-Ruel.* Paris: Marcel Guérin, 1876. Repr. in *Impressionism and Post-Impressionism 1874–1904,* ed. Linda Nochlin, 3–10. Englewood Cliffs, N.J.: Prentice-Hall, 1966. Repr. in *The New Painting: Impressionism, 1874–1886,* ed. Charles S. Moffett, 37–49. San Francisco: The Fine Arts Museums of San Francisco, 1986.

Fiedler, Conrad. *On Judging Works of Visual Art.* Trans. Henry Schaefer-Simmern and Fulmer Mood. Berkeley and Los Angeles: University of California Press, 1949.

———. "Three Fragments." In *From the Classicists to the Impressionists,* ed. Eliza-

beth Gilmore Holt, 450–66. Vol. 3 of *A Documentary History of Art*. New York: Doubleday Books, 1966.

Fontainas, André. *Histoire de la peinture française au XIXe et au XXe siècles*. Paris: Mercure de France, 1922.

Francastel, Pierre. *L'Impressionnisme: Les Origines de la peinture moderne, de Monet à Gaugin*. Paris: Les Belles Lettres, 1937.

Geffroy, Gustave. *Claude Monet: Sa vie, son temps, son oeuvre*. Paris: Les Editions G. Crès et Cie., 1922.

Gombrich, E. H. *Art and Illusion: A Study of the Psychology of Pictorial Representation*. Princeton: Princeton University Press, The Bollingen Series, 1960.

Gregory, R. L. *Eye and Brain: The Psychology of Seeing*. New York: McGraw-Hill, 1966.

Hanson, Anne Coffin. *Manet and the Modern Tradition*. New Haven: Yale University Press, 1977.

Hauser, Arnold. *Naturalism, Impressionism, the Film Age*. Vol. 4 of *The Social History of Art*. New York: Vintage Books, 1951.

Hochberg, Julian E. *Perception*. Englewood Cliffs, N.J.: Prentice-Hall, 1964.

Holt, Elizabeth Gilmore, ed. *From the Classicists to the Impressionists*. Vol. 3 of *A Documentary History of Art*. New York: Doubleday Books, 1966.

Huyghe, René. "La Vision réaliste au XIXe siécle." *Revue de Paris* 68 (April 1961): 3–15.

Impressionism. Secaucus, N.J.: Chartwell Books, *Réalités*, 1973.

Januszczak, Waldemar, ed. *Techniques of the World's Greatest Painters*. Secaucus, N.J.: Chartwell Books, 1980.

Johnson, James R. "Art History and the Immediate Visual Experience." *Journal of Aesthetics and Art Criticism* 19, no. 4 (Summer 1961): 401–6.

Laforgue, Jules. "Critique d'art—L'Impressionnisme." In *Mélanges posthumes*. Vol. 3 of *Oeuvres complètes*, 4th ed. Paris: Mercure de France, 1903.

Leroy, Louis. "L'Exposition des impressionnistes." *Charivari* 25 (April 1874). Repr. in John Rewald, *The History of Impressionism*, 4th rev. ed., 318–24. New York: MOMA, 1973.

Martelli, Diego. "Gli Impressionisti." In *Impressionism and Post-Impressionism*, ed. Linda Nochlin, 21–25. Englewood Cliffs, N.J.: Prentice-Hall, 1966.

Mauner, George. *Manet, Peintre-Philosophe: A Study of the Painter's Themes*. University Park: The Pennsylvania State University Press, 1975.

Merleau-Ponty, Maurice. *Phénoménologie de la perception*. Paris: Gallimard, 1945.

Moser, Ruth. *L'Impressionnisme français*. Geneva: Droz, 1952.

Nochlin, Linda, ed. *Impressionism and Post-Impressionism 1874–1904*. Englewood Cliffs, N.J.: Prentice-Hall, 1966.

Perry, Lilla Cabot. "Reminiscences of Claude Monet from 1889 to 1909." *The American Magazine of Art* 17 (March 1927): 119–25.

Pollack, Griselda. *Vision and Difference: Femininity, Feminism, and the Histories of Art*. London: Routledge, 1988.

Pool, Phoebe. *Impressionism*. New York: Praeger Publishers, 1967.

Reutersvärd, Oscar. "The Accentuated Brush Stroke of the Impressionists." *Journal of Aesthetics and Art Criticism* 10, no. 3 (March 1952): 273–78.

———. "The 'Violettomania' of the Impressionists." *Journal of Aesthetics and Art Criticism* 9, no. 2 (December 1950): 106–10.

Rewald, John. *Cézanne, sa vie, son oeuvre, son amitié pour Zola.* Paris: Albin Michel, 1939.

———. *The History of Impressionism.* 4th rev. ed. New York: The Museum of Modern Art, 1973. Original version, 1946.

Ribot, Théodule. *L'Imagination créatrice.* Paris, 1900.

Richardson, John P. "Georges Braque." In *Impressionist and Post-Impressionist Paintings from the U.S.S.R.,* 11. Washington: National Gallery of Art; and New York: Knoedler and Co., 1973.

Rouart, Denis. *The Correspondence of Berthe Morisot.* Trans. Betty Hubbard. New York: Wittenborn, 1957.

Sérullaz, Maurice. *The Impressionist Painters.* Trans. W. J. Strachan. New York: Universe Books, 1960.

Shiff, Richard. "The End of Impressionism." In *The New Painting: Impressionism, 1874–1886,* 61–89. San Francisco: The Fine Arts Museums of San Francisco, 1986.

Silvestre, Armand. Article on impressionists in *L'Opinion,* 2 April 1876. In Lionello Venturi, *Les Archives de l'impressionnisme,* vol. 2, 286. Paris: Durand-Ruel, 1939.

Snyder, Joel. "Picturing Vision." In *The Language of Images,* ed. W.J.T. Mitchell, 219–46. Chicago: University of Chicago Press, 1974.

Taillandier, Yvon. *Claude Monet.* Trans. A.P.H. Hamilton. New York: Crown Publishers, 1967.

Taine, Hippolyte. *De l'intelligence.* 8th ed. 2 vols. Paris: Hachette, 1897. (First published in 1880.)

Tucker, Paul H. *Monet in the '90s: The Series Paintings.* Boston: Museum of Fine Arts; and New Haven: Yale University Press, 1989.

Valéry, Paul. "Autour de Corot." In *Pièces sur l'art.* Paris: Gallimard, 1946.

———. "Introduction à la méthode de Léonard de Vinci." *Variété.* Paris: Gallimard, 1948.

Venturi, Lionello. *Les Archives de l'impressionnisme.* 2 vols. Paris: Durand-Ruel, 1939.

White, Barbara Ehrlich, ed. *Impressionism in Perspective.* Englewood Cliffs, N.J.: Prentice-Hall, A Spectrum Book, 1978.

Wölfflin, Heinrich. *Principles of Art History.* Trans. M. D. Hottinger. New York: Dover, 1950.

Index